The SHORT! Guide to Producing

In this book, Charles Merzbacher offers a concise, definitive guide to the essential skills, techniques, and logistics of producing short films, focusing on the practical knowledge needed for line producing and overseeing smaller-scale productions. Merzbacher, a longtime instructor and accomplished filmmaker, takes producers through every stage of the production process—from preproduction and planning to the producer's role in postproduction and distribution—weaving together best practices with insights from real-life production scenarios.

Key topics include:

- Finding a worthy project
- Schedules and budgets
- Managing the casting process
- Recruiting and managing crew
- Location scouting
- Legal and safety issues
- Running a production
- Negotiating music rights
- And much more!

An accompanying website—available at *theshortseries.com*—offers document templates (for contracts, call sheets, budgets and other production paperwork), fully-completed paperwork to use as samples, video interviews and more.

Charles Merzbacher has been a member of Boston University's Film & Television faculty for over twenty years. As a filmmaker, he has won several awards for his many short productions. His work has been exhibited around the world, including at the Sundance, San Francisco, Seattle and Montreal International Film Festivals. As a media educator, Merzbacher has overseen the production of several thousand student films and has also delivered workshops and lectures at other institutions at home and abroad.

The SHORT! Guide to Producing

The Practical Essentials of Producing Short Films

Charles Merzbacher

Routledge
Taylor & Francis Group

NEW YORK AND LONDON

First published 2018
by Routledge
711 Third Avenue, New York, NY 10017

and by Routledge
2 Park Square, Milton Park, Abingdon, Oxon OX14 4RN

Routledge is an imprint of the Taylor & Francis Group, an informa business

Library of Congress Cataloging-in-Publication Data
Names: Merzbacher, Charles, author.
Title: The SHORT! guide to producing : the practical essentials of
 producing short films / Charles Merzbacher.
Description: New York : Routledge, 2018. | Includes index.
Identifiers: LCCN 2018001269 | ISBN 9780815394204 (hardback) |
 ISBN 9780815394211 (pbk.) | ISBN 9781351186551 (e-book)
Subjects: LCSH: Short films—Production and direction.
Classification: LCC PN1995.9.P7 M44 2018 | DDC 791.4302/32—dc23
LC record available at https://lccn.loc.gov/2018001269

ISBN: 978-0-815-39420-4 (hbk)
ISBN: 978-0-815-39421-1 (pbk)
ISBN: 978-1-351-18655-1 (ebk)

Typeset in Times New Roman
by Apex CoVantage, LLC

Contents

Introduction
Looking Before Leaping

Be Prepared

Whether it is made for profit or not, a film is always a business enterprise. It involves contracts, budgets, schedules and personnel. The people who oversee these aspects of a production are called line producers, though more often than not they carry other titles. This book will focus on the skills related to what is sometimes called **line producing** or **physical production** as they relate to short films and videos. The following topics are addressed:

- Financing the production
- Schedules
- Budgets
- Recruiting and managing crew
- Legal issues
- Running a production

While all these issues are central concerns of feature or television production as well, they frequently require a different approach on shorts. In all cases, however, line producing is where the rubber meets the road, where we deal with the nuts and bolts of getting a film made.

The Boy Scouts of America was founded before the Producers Guild of America. We know this because, were that not the case, the Producers Guild rather than the Boy Scouts would have as its motto, "Be prepared." Even so, while the Scouts may be able to lay official claim to these watchwords, they remain the unofficial credo of every producer. Throughout this book, we'll stress the importance of thinking like a producer. In the realm of media production, producers carry crucial responsibilities that require a particular mindset. This involves a great deal of both tactical and strategic thinking, but above all, it involves *being prepared*.

Pro Tip

"Great producing almost doesn't draw attention to itself. That's really what a great producer is: a great producer is somebody who can create a great environment where great artists can do great work. When that happens, it's magic."

—*Jay Roewe*

A talented friend has brought you a proposal. She has a story from her childhood that she wants to turn into a short film. She'll direct; you'll produce. Great! But before you raise one dollar, make one call for crew or launch one promotional tweet, take a deep breath and a big step back. Ask yourself: is this the right project to take on now? Do you feel passionate about this? Producing is hard work, and there is little reward in working on an unsuccessful or (worse yet) incomplete production. So, take a moment to assess the project in the starkest terms. This is the first step toward being prepared.

Although much of what we'll cover in this book is equally applicable to producing documentary or other non-fiction fare, the assumption throughout this text is that you are producing a drama or comedy that will be scripted and acted out. That being the case, your first concern is that you have a great story and that it's told well—in other words, a killer script. What makes for a killer script? Consider these questions:

- *Does the script have an ingenious central concept or tell a compelling story?* Shorts are different from features in this regard. A short (provided it really is *short*) can sometimes survive by wits alone. As YouTube teaches us every day, a clever idea—even a gimmick—can suffice to hold our attention for a few minutes. Of course, a fascinating narrative certainly is a winning asset as well, but take care: not all stories fit the short form, which leads to the next point . . .

- *Does the story work as a short?* Again, the rules here are different than for features. After spending two hours with a group of characters, we feel entitled to some resolution of their struggles. Conversely, a story that takes us through enormous upheaval only to wrap everything up neatly in eight minutes may feel contrived and pat. We often accept and even welcome a degree of ambiguity and open-endedness with shorts. Fundamentally, there are stories that, in scope and conception, fit the scale of a short film. Make sure yours is one of these.

- *Is the script finished?* Sounds funny even to ask this, doesn't it? But many screenplays have very appealing qualities and yet aren't ready to go

before the camera. Are there plot points that ring false? Does the dialog sound convincing? For reasons that will be apparent as we follow the producing path, it's essential that you go into production with a thoroughly polished script.

Pro Tip

"I've seen a number of times—brilliant short films—that don't land the ending. So, when judging for the Oscar shorts, we watch this film, and it's great and you're there with the filmmaker, but they haven't thought about what the ending is. A lot of times, it comes down to the final shot. We've gone on this whole journey, and they didn't resolve it."

—*Bob Degus*

- *Does the script employ the language of cinema effectively?* By this, we aren't referring to filmmaking terminology. When films work, it's almost always because they deliver an experience that is distinct from what can be found by going to the theater, looking at a painting or listening to the spoken word. Does your screenplay take advantage of the particular assets of motion pictures? Does it suggest opportunities for visual storytelling or for the interplay of sound and image? Simply put, is this the right medium for this story?

- *Is the script producible?* The process of making an accurate tally of all the resources required by a script requires painstaking analysis. This is why it's never safe to start bandying about budget figures after reading a script through once. Even so, as you read a screenplay, you must make a broadbrush assessment of its production demands and then ask yourself if you can realistically expect to meet those demands. A twenty-page script that takes place on an alpine glacier can't be produced over a long weekend in St. Louis. Therefore, ask yourself: are you sure that you have the means to make this project?

- *Is funding for the project in place?* In the world of commercial filmmaking, the team that manages physical production seldom plays a role in securing financing for a movie. Such distinctions don't always hold up on shorts, and as the producer, you may be called upon to help or even spearhead fundraising efforts. Even if this is the case, you need to enter into the fray with a realistic picture of the project's finances. If a director is planning to make an adventure set in outer space yet has no firm prospects to back the venture, you should think very hard before attaching yourself to the project.

If your screenplay meets the criteria posed by these six questions, it is well on its way to being a killer script. But before you sign on to the project, there is one more question to consider, a question that you as producer must worry about more than any of your collaborators. Because this is so, I've given it a heading all its own . . .

Is There an Audience for This Short?

Courting an audience isn't anything to be ashamed of. Indeed, it's an absolutely essential part of filmmaking, and the process should start before anything else gets under way. If you can't think of concrete ways of attracting viewers to your movie while it is but a brilliant twinkle in your eye, what makes you believe you'll be able to do so once you've got a finished film on your hands? I have seen a number of delightful features and shorts wind up orphaned, never able to cultivate the audiences they deserved, simply because they had no obvious attributes that could lure viewers.

In saying this, I am categorically *not* suggesting that the answer is always to aim for mass appeal. Indeed, to apply a "blockbuster mindset" to shorts is to misunderstand the way that most shorts find their audiences. Consider that staple of feature filmmaking, the thriller. It's a mainstay of Hollywood filmmaking, and entire television series (think *24*) have been built around the thriller formula. It may therefore come as a surprise to learn that thrillers are a pretty tough sell in the realm of shorts. Film series curators and festival programmers are usually looking for more offbeat material. Meanwhile, on the more plebian side of the tracks—the world of YouTube and other online media outlets—folks generally aren't browsing for ten-minute thrillers. In fact, with the exception of comedy, they aren't searching by genre. Instead, they search for *subjects that they're passionate about.*

Pro Tip

"You really need to make a film for an audience. People try to dilute that for some reason. I think the best thing you can do for yourself as a producer of a short film is to imagine what the trailer is and to ask: what are your trailer moments? When people read the blurb or they see the still that's going to entice them in to see the movie—you should know that well in advance."

—*Georgia Kacandes*

So, ask yourself: does your script have elements that people are passionate about? This could include subjects, themes, actors or music, to name but a few key attributes. Elsewhere, we'll explore further the outlets and markets for short films, but for now, let's keep things simple and just rely on common sense as our guide. Apart from just being able to say, "It's a really good film!" what will you be able to say about your completed short that will get people to watch it, and who exactly are those people?

This discussion of the qualities that make a script great or a project viable is just the tip of an iceberg known as *development*. Finding and developing a winning concept for a short could be the subject of a separate book. The degree to which you should be involved in the development process depends on what kind of producer you are.

Defining the Producer's Role

As the opening credits of a feature film or television show roll along, you'll notice a plethora of titles involving some variant of "producer" or "production." In addition to plain old producer, you will also find some or all of these titles: executive producer, creative producer, associate producer, co-producer, line producer, unit production manager, production coordinator and executive in charge of production. Let's examine a few of these professional shingles:

• *Executive producer:* Usually, this is the person who lines up financing, completion funds or distribution for a feature. Shorts need funding and distribution too, so we sometimes see this credit on shorts, but—no surprise—the persons earning this credit often already have another important title: Mom or Dad.
• *Creative producer:* This is a term that is particularly popular in television. The Creative Producer is the captain of the entire creative team; the series or production manifests his vision. This title is not often found on shorts.
• *Executive in charge of production:* This refers to the liaison for the studio or network that is backing a project. Again, not a title we'll find on shorts.

This leaves us with a core set of terms: associate producer, co-producer, line producer, unit production manager, production coordinator. These credits all refer to people who in most instances are directly involved with the physical production of a film or series. Complex and ambitious short productions may have some or (in very rare cases) all of these crew positions. More often than not, one or two people fill these roles on shorts—perhaps just a single producer, or a producer and a production manager.

<div style="border:1px solid black; padding:10px;">

Pro Tip

"I prefer other titles like executive producer or co-producer when I'm doing the line producing job, because I think they're more descriptive of what the work really entails, which includes certain creative decisions."

—*Marie Cantin*

</div>

The Short Dilemma: Who's in Charge?

In certain respects, the division of authority in the realm of shorts is more straightforward than it is in the wider world of production. On short productions, directors tend to make the creative decisions while producers deal with the practical issues. This sounds simple, and indeed it would be, were it not for a couple of potential stumbling blocks.

Let's return to your friend who wants to make a short based on a story from her childhood. Obviously, this is a personal project for her, one she has been thinking about for a long time. She can probably see and hear the movie playing in her mind. At the same time, however, she's smart enough to know that she can't handle all the responsibilities involved in bringing this vision to life, so what does she do? She decides that she will hold onto the creative reins while finding someone else—you!—to manage the logistics. So far, so good, but as soon as this division of duties gets tested in the real world, questions will arise. Let's say that the story calls for several days of shooting at a high school dance, with hundreds of teenage extras. As the producer, you determine that you can't afford to feed and chaperone that many people, so you propose changing the setting to something more manageable—a house party. This new setting doesn't jibe with the movie the director has playing in her mind, however, so she is determined to hold onto the big dance at the high school. In such a situation, who ultimately calls the shots?

The answer to that question very likely comes down to an even more fundamental issue: who owns the project? At the end of the process, you will have a completed movie. A copy of your precious production on a disc or a hard drive might not feel like much in your hand, but it is something tangible, and somebody owns it. Naturally, in most cases, ownership goes to the person who either directly paid for the production or lined up the financing for it. On shorts, very commonly this person is the director.

This simple fact can cause major problems. You're worried about not having the money to feed and care for all the extras for those days of shooting the high school dance, but at the end of the day, *you don't hold the purse strings, the director does*. And since she's determined to keep the scene as is, what

real authority do you have to say or do otherwise? It should be apparent how quickly such an imbalance of power can quickly lead to chaos. The producer is supposed to be making the logistical decisions, but the director's authority trumps that of the producer as soon as those decisions impinge on creative considerations—as they invariably do.

Ideally, there should be a productive tension between the producer and the director. In our example, there is an honest debate to be had about how important it is to set the story at a high school dance versus a house party. The producer and director should work through the issue, each person maintaining a healthy respect for the other's authority. Naturally, this can't happen if one person holds all the cards. It's possible to avoid this dilemma, but doing so requires forethought and commitment from both parties. Here are three important steps you can take to steer clear of the minefield:

• *Put some skin in the game*: Though parents make wonderful executive producers, they may not be able to finance an entire production on their own. This is where you come in. Even if you raise only a portion of the overall budget, bringing in those last dollars can make a crucial difference, and this can translate into clout. I once supervised a student producer who was working with a particularly headstrong director. The producer managed to secure several thousand dollars' worth of film stock—an **in-kind** grant that permitted the project to go forward. You can be certain that the fact that the producer reeled in that free footage gave his views added weight.

• *Set up a joint account*: Imagine this scenario: the producer has lined up a church as a location. The congregation is only seeking a refundable $500 deposit—a great deal! Unfortunately, the producer can't seal the deal with a check because all the production funds are in the director's account. In the world of features and television production, such a situation would be patently absurd—a producer who can't spend money?!—yet it happens all the time on shorts. As we have already indicated, keeping all fiduciary control on a project in the hands of the director doesn't just produce logistical bottlenecks; it virtually assures that the producer is relegated to the status of glorified gofer. The easiest way to avoid this web of problems is to set up a joint bank account for which both director and producer have check-signing privileges. This may seem an obvious and simple step, but in fact it can be one of the hardest points to negotiate. For many young filmmakers, an ambitious short production is the costliest undertaking of their lives. They may have spent years lining up the money needed to make this project—and now they are going to put it into someone else's hands? Well, yes! Genuine collaboration requires a degree of *letting go*. Complicating matters, however, is the fact that sometimes our nightmares

come true. Consider the case of a film student I knew who got a fellow student to agree to produce her senior film. No sooner had she transferred all the funds for the production into the producer's account than—poof!—it was all gone in a cloud of cocaine. Yes, despite having been friendly with the producer throughout her years in college, the director was unaware that he had developed a devastating drug problem. After hearing this harrowing tale, I started advising filmmakers to parcel out funds to their partners in thirds, just as you might if you were paying a house painter or a landscaper: a third up front, a third at the start of production and a third as editing begins.

- ***Draw up an agreement***: When you sign on to produce a film, there is a lot of goodwill in the air. As the doctors say, this is perfectly normal. Nevertheless, you mustn't let all the bonhomie prevent you from nailing down the specifics of your job, and there is no clearer and safer way of doing this than putting it all down on paper. Make a list of responsibilities for the producer, director and any other key partners. Who has final say on hiring crew? Who keeps the production on track, especially when you need to make up time or recoup money? Write it all down, then go through this list point by point with your partners. When you believe that you are all in accord, write up an agreement that commits you all to abiding by these roles. Have everybody sign the agreement. If this makes you squeamish, get over it. In my view, forcing partners to take a hard look at their jobs is a step well worth any passing discomfort that the exercise might cause.

Whatever you do, don't ignore this issue. In studio productions, tussles between directors and producers are the stuff of legend, but in reality, such productions chug along like well-oiled machines in the great majority of cases. Why? Because there is a clear delineation of the rights and responsibilities that apply to each position. When the terms of these assignments become less clear-cut, as they inevitably do on shorts, it's necessary to redraw the lines of authority. Consider this your first official job as the producer.

Shoebox Redhead: A Textbook Case

Throughout this book, frequent reference will be made to *Shoebox Redhead*, a short film that was written and directed by Matt Lawrence. Matt made this short as he was completing his graduate degree at Boston University, where I was his faculty advisor. When I started to work on this book, I knew I would need a case study that I could return to as I guided the reader through the various stages of producing a film. I could have created hypothetical plans for an unproduced script, but it occurred to me that there was a key advantage to working from an existing production. There is always a wide gulf between the

idealized film we plan on the drawing board and the movie that actually gets made. The old saying tells us that "only a fool learns by experience," but surely it's far more foolish *not* to learn from experience that is available to us at no personal cost. By using *Shoebox Redhead* as a case study, I realized I could give the reader the best of both worlds—both the "textbook version" of how things should be done and some insight into what really happened.

In my teaching career, I have overseen several thousand short productions. Given all those potential examples to draw from, there are two principal reasons I selected *Shoebox Redhead* as the specimen we would dissect. First, while there is no such thing as a typical short film, as I got to observe *Shoebox Redhead* evolve from a first story pitch to a finished movie, I found that this project had a great deal in common with many other productions in terms of its scope and complexity. Second, while I certainly believe that there is much we can learn from our failures, it's very hard to lay out a path toward success if we have no positive models to follow. *Shoebox Redhead* is a great guide in this respect in that, although its cast and crew went through their share of misadventures, the film that emerged from the experience was highly successful. It toured on the festival circuit for a couple of years and even picked up some awards. But don't take my word for it: you can check the film out for yourself on Vimeo or by locating the link to it on the website associated with this book, *theshortseries.com*.

As we go through the steps of preparing *Shoebox Redhead* for production, we'll refer frequently to the script, which can be found in Appendix A. Here is a summary of the story:

> The demise of his relationship with ex-girlfriend Jacki has left Matt (played by Matt Lawrence) profoundly depressed. Determined to help him move on, best friend Ryan (Ryan Conrath) accompanies Matt to a garage sale, where he convinces the sellers to accept a box containing the last vestiges of his shared life with Jacki. At the garage sale, Matt finds a shoebox filled with an old Polaroid camera and an assortment of snapshots, all featuring Mandi, an alluring redheaded woman. Matt buys the shoebox and its contents. When he and Ryan test the camera moments later, they discover that it has magical properties. For example, when Matt takes a picture of Ryan, a clown appears in the photo in place of Ryan. Even this fanciful and miraculous development fails to lift the pall that surrounds Matt. Spooked and angered by the clown apparition, he tries unsuccessfully to return the camera to its previous owner at the yard sale. Driving home, Matt and Ryan are startled to discover Ira (Rob Ribera)—the very clown who had appeared in their Polaroid test shots—handing out burger samples at Big Top Drive-In. When interrogated by the two young men, Ira professes to know nothing about how he ended up in the photos. Playing

the role of paranormal sleuth, Ryan takes Ira's picture. This time, in place of an image of Ira at the drive-in, the Polaroid produces a view of a bench at a seaside amusement park. Ira identifies the location in the picture as Rigby Pier, a nearby attraction. Abandoning his job in favor of exploring the unfolding mystery, Ira joins Matt and Ryan as they head to the pier. Once there, Matt takes a snapshot of the same view of the pier seen in the previous photo. Out pops a Polaroid picture that does indeed show the pier, only now Mandi, the redhead seen in the shoebox photos, has magically appeared on the bench in the picture. Matt again reacts to this uncanny incident with bitter disbelief. His sour response provokes Ryan into confronting him about his bilious mood. Finally forced to face his demons, Matt owns up to his despair. He takes a seat on the bench where Mandi appeared. Ryan takes his photo, and in the image that emerges from the camera, Matt can be seen, seated next to Mandi the redhead. In a final twist, when Ryan looks back to the bench, he finds that his forlorn friend has disappeared. Their adventure complete, Ryan sets the shoebox and its haunted contents adrift in the ocean waves. He and Ira drive off, presumably to explore more of life's mysteries together.

For all its detail, this synopsis manages only to cover the facts of the story, while failing to capture its charm. *Shoebox Redhead* might be called a fairy tale for grown-ups. As with any good fairy tale, the spell cast by the narrative depends on its characters treating whimsical events with the utmost seriousness. I provide this summary as a ready reference for character names, settings and other story elements to which we will return again and again, but please don't let this serve as a substitute for taking a few minutes to read the screenplay. That time will be well spent, as it will provide you with a much firmer grasp of the material that we will be dissecting in the pages that follow.

Apart from the script, most of the documents related to *Shoebox Redhead* that I will share in this book are files that I have created as if I were producing the short. So as not to give the impression that I had any real role in producing this fine film, I have given the producer the name Alan Smithee, a pseudonym more commonly used by directors seeking to take their name off a work. The full documentation related to the production—both the idealized "textbook" versions and the real-world records—may be found at *theshortseries.com*.

Throughout the text, you will find sidebar passages. Some of these are identified as Shoebox Diaries. These segments offer commentary from the cast and crew of *Shoebox Redhead* about what actually went down on that production. These observations reveal how both human nature and Mother Nature played roles in determining how the film got made. The talented folks involved in *Shoebox Redhead* have since gone on to work on many other productions, including feature films and television shows, and some of their observations

reflect that broader perspective. Another set of comments are labeled Pro Tips. These notes come from veteran film producers. You can find information on all the contributors to these sidebar entries in Appendix E. It is my hope that, by assembling a chorus of voices to augment and at times challenge my approach, you'll come away from this book with a comprehensive understanding of the producing process. In some instances, the Pro Tips and Shoebox Diaries entries have been lightly edited for readability.

Terminology

Filmmaking has its own lexicon. In this strange terminology, a **cookie** is not for eating, lights come with **barndoors** and an ordinary clothespin can hide behind the opaque nickname **C47**. Even a common word like **coverage** can have unexpected meanings. Not everyone will come to this book with the same level of fluency in this language, so I have provided a glossary in Appendix F. As demonstrated in this paragraph, if a term that is defined in the glossary appears in the text, its first appearance will be noted in **boldface**.

Production Management Software

There are a number of software packages that streamline and optimize the production management process. These include Movie Magic Scheduling and Movie Magic Budgeting, Gorilla film production software and Showbiz production software. Should you buy one of these software packages? It depends. If you are already certain that you want to pursue a career as a production manager or producer, then go for it. The sooner you start to acquaint yourself with one or more of these programs, the better, and fluency with production management software looks good on a résumé. On the other hand, if you are just trying on the role of producer for size, you might wait. Software isn't like fine wine; there is no advantage to owning it if it's just going to sit on the shelf.

No matter how you decide to proceed, be advised that the paperwork discussed in this book was created using standard word processing and spreadsheet programs. Templates and sample documents in common file formats (.pdf, .doc, .xls) can be found on the *SHORT! Guide* website, *theshortseries.com*.

Chapter 1

Getting Down to Business

Financing Your Film

Before you start worrying about how you are going to pay for your movie, do yourself a favor: read the rest of this book. By the end of it, you will have a detailed understanding of the factors that determine a production's budget. In truth, you can only get an accurate picture of a project's budget once a number of important variables, from production format to cast and crew size, have been nailed down. This is why it is risky to talk in terms of a "typical budget" for a short film. I have overseen shorts that ranged in budget from a few hundred dollars to over $60,000. The great majority of productions have fallen within the range of $6,000–$12,000, but it would be foolish to therefore assume that $9,000 is a meaningful average. With experience, you will develop an ability to estimate budgets based on a couple of read-throughs of the script. Nevertheless, it will remain the case that every film's financial requirements are unique.

The production of a short film could serve any number of aims. It could help you develop your skills as a storyteller. It could be a calling card, a way to show the world what you can do. It could be a very effective vehicle for galvanizing support for a cause. There are plenty of good reasons to make short films, but making money is probably not one of them. The avenues for generating revenue are few, and even these scant opportunities are often more like mirages than real sources of income. Let's examine some of the claims that people make for turning a profit with a short film:

- *"Look at all these fabulous prizes!"*: Every week seems to bring the announcement of another short film contest, and some of these competitions offer cash prizes. In the great majority of cases, however, there are stipulations regarding either the nature of the content (e.g., entries must promote a particular product) or the conditions under which the production must occur (e.g., the well-known 48-Hour Film Project and its many imitators). We will take a much closer look at the film festival circuit in a

later chapter. For now, suffice it to say that relatively few give cash awards to shorts. It's worth keeping an eye out for those that do, especially when they pop up at smaller, less competitive events, but predicating your film's success on its winning cash prizes at festivals is like using the lottery as your retirement plan. Not only are the odds against you, but you'll also spend a fortune on festival entry fees chasing those elusive prizes.

- *"Our movie will go viral and we'll live off the online ad revenue!"*: Many believe that the ascent of YouTube, Vimeo and other online video sharing sites are fomenting a new golden age of short film, the last such epoch arguably being the advent of the music video almost 40 years ago. The good news is that the internet is indeed a game changer: it provides us with an immediate "frictionless" portal to a worldwide audience. The bad news is that relatively few filmmakers have proven adept at making smash online video hits, and unless your videos attract millions of eyeballs, you won't be able to support your filmmaking habit with the profit-sharing schemes that are presently out there. A sizeable gulf separates the multitude of popular and widely viewed online movies from the few shorts that genuinely go viral and generate revenue.

- *"We'll cut a distribution deal!"*: Since the advent of feature films back in the silent era, there has never been much of a market for the theatrical distribution of shorts. Should a distributor approach you about your movie, by all means see what they have to offer, but don't expect to walk away with more than $500. Much independent distribution is moving away from traditional venues and focusing on online platforms and streaming services like iTunes, Netflix and Amazon. To date, stand-alone short films haven't found a home in that market. When we discuss marketing strategies later in this book, we'll consider ways that producers of shorts might venture into growing the business of streaming content, but under even the sunniest of scenarios, revenues returned through online distribution are going to be modest.

I recognize that none of this is sounding very rosy. Actually, there are certain instances where a short film can make money—or at least not lose money. Let's examine them individually.

Television Distribution

The prospects of getting a short distributed via television stations or networks vary considerably by territory. In the U.S., arts-friendly networks such as IFC and Sundance have shown sporadic interest in shorts. Public broadcasting affiliates occasionally air short film series, and the PBS network has at times

incorporated shorts into its programming. The sums paid by these outlets are relatively modest—think $500—and keep in mind that distribution deals tend to be exclusive, so whatever you get paid by a channel or network is very likely to be all the money you will make from cable and broadcast.

In the rest of world, the situation can be more promising. In Europe, for example, governments still exercise—directly or indirectly—considerable influence over television outlets. In the classical model of the state-run television channel, programming isn't as formulaic as it is with commercial television. Shorts are often used to fill out an hour or to provide a break between longer offerings. State-funded channels pick up shorts from the international marketplace, but they may also have a mandate to encourage and support indigenous filmmaking. In such cases, channels acquire movies by commissioning them outright or by partnering with state-run film funds. In either case, the deal was more or less the same: in exchange for providing funding, the channel gets the right to show the finished film. Sometimes a state-run film school is involved. While he was a film student, the French filmmaker François Ozon made many short productions with funding from regional and national television channels. He continued to receive funding from these channels as he embarked on his professional career.

By now, this trajectory has been followed by several generations of filmmakers. As with so many government programs, subsidies for film production have been cut back as the media economy has become globalized. In most countries, state-funded channels now must compete with privately held networks and streaming media platforms. This undercuts the comfortable hegemony of state-owned media. Nevertheless, particularly in smaller countries, producers should check with their public and private television networks to see what sort of funding exists for shorts. Don't be surprised to learn that support and distribution schemes come and go, running for a few seasons before being axed or replaced.

As for hawking your short in the international television market, remember those hardy short film distributors? Some of them also act as **foreign sales representatives**. For a percentage of gross receipts, these agents will sell your film in various foreign territories. You won't make much money selling to any one territory, but if you can find a home for your movie in lots of small countries, the fees can add up. Even so, only the rarest of short films recoups its cost this way.

Government Support

In many countries, the notion that the state should support the arts is an article of faith. Before you rush out to buy a ticket to that Shangri-La where you need only ask in order to receive funding for your film, please understand that support for the arts—and perhaps especially for the costly process of making

movies—is always intensely competitive. Government funding for filmmakers does exist on many levels in various parts of the world, but it is impossible to generalize about the nature of that support. For example, it is wrong to assume that larger or richer countries are more generous than smaller and less advantaged ones. Nor can you draw a neat correspondence between political philosophy and state support. Government funding may be easier to come by for emerging filmmakers in Bulgaria than it is in China, despite the latter's enormous economic power and nominal adherence to communist principles. Actually, sometimes smaller nations are more entrepreneurial when it comes to supporting media makers. Sticking with Bulgaria as an example, some of the governmental grants are simply aimed at getting people to come and shoot in the country—you don't even have to be Bulgarian to apply.

While the nature and degree of government support varies widely around the globe, some common themes turn up from country to country. For instance, art and film funding often isn't only or even primarily offered on a national level. In many cases, more plentiful and generous support can be found on the regional or local level. In the United States, where government funding for the arts is notoriously scarce, town arts councils can be open to supporting a favorite daughter or son. Tapping into these local funds can be easier than wringing support from federal programs such as the National Endowment for the Arts, where short filmmakers must compete against the heavy hitters of independent cinema. In the United Kingdom, although there is a film fund that is administered on the national level by the British Film Institute, another large provider of funding, London Calling, is focused on supporting filmmakers in (can you guess?) London. There are also regional arts councils in the United Kingdom that have been instrumental in supporting filmmakers early in their careers. The same can be said of the film offices in some of the cities and provinces of South Africa. In Norway, filmmakers are encouraged to seek funding from their hometown arts councils, where the competition is said to be less severe than in the bigger cities. The moral of this story is that you shouldn't make assumptions about the existence or extent of government underwriting for media production in your area. Furthermore, as Dorothy learned after visiting Oz, sometimes the best support can be found back home.

A number of media and arts grants require that awarded funds be administered by **fiscal sponsors**. This is especially true in the United States. In exchange for a small percentage of the grant funds, a fiscal sponsor safeguards and vouches for the legitimacy of the grants collected. This system may sound like a legalized form of money laundering, but its purpose is to ensure that grants go to the purposes for which they were awarded. Many local and regional arts organizations provide fiscal sponsorship for filmmakers.

In the United States, it is quite common for film grants to awarded only once editing is under way. The rationale behind such "completion funding" is as

follows: filmmaking is such a complex enterprise that not a few great movie ideas end up stillborn. By insisting on funding only productions that are well on their way toward completion, the funder ensures both that the film will come to fruition and that a certain level of quality is attained. Of course, this stipulation leaves many producers with a Catch-22: they can't qualify for completion funds because they don't have the money needed to get their project **in the can**. Grants for completion funding do exist on the international stage as well. In Argentina, a state-backed film fund runs a contest each year to provide funding for postproduction on features and shorts. That said, in many countries, grants are not restricted in this way, or they might be targeted toward a different phase of production. As an example, the British Film Institute administers grants that can be applied toward the initial development of shorts. The takeaway: when applying for grants, read the guidelines carefully to determine if there are restrictions on the kinds of activities the funding can support.

The Funding of Student Productions

A significant portion of the short films made around the world is produced under the aegis of an educational institution. Before going any further on our tour of film financing, we should take a moment to consider the special status of student shorts. Being a student filmmaker has its pros and cons. On the negative side of the ledger is the fact that students are not always eligible for government grants. In the United States, this is a common restriction on the state and federal level. In the United Kingdom, full-time students are generally not eligible to apply for the various regional grants, even though some of these schemes are open to applicants as young as 16. The reasoning behind this policy is that students already receive special support for their productions, either through their home institution or through educational initiatives funded by the government.

The degree and nature of financial support provided to students in film schools and media programs varies enormously. Many schools provide support chiefly in the form of equipment. In Argentina, film students don't just have access to camera, **grip** and lighting gear; they may also receive in-kind contributions toward postproduction services and materials for distributing their finished films. Time for yet another vast generalization: in many smaller countries, admission to the national film school (and there may be just a single, state-funded institution) is harder than winning the lottery jackpot. In these cases, students selected for the program are provided with an exceptional level of support, including direct funding. At the Norwegian Film School, for instance, students can receive support for their productions to the tune of $50,000—and this is in addition to support the school provides in the way of gear and services. Keep in mind that this support is provided to an elite cadre. Furthermore, funding that is on par with professional productions usually means students are expected to pay their cast and crew at professional rates. In the commercial realm, $50,000 goes fast.

Private Foundations and Commercial Underwriting

In the United States, the arts rely very heavily on private philanthropy. This tends to be less true elsewhere. There are, however, plenty of exceptions to this generalization, and foundations exist in many countries, funded either by wealthy patrons or corporations, that are open to supporting budding filmmakers. Some organizations are very mission-driven, supporting media projects that advance conservation, medical research, addiction recovery or whatever fits a particular foundation's core purpose. Smaller countries with large expatriate communities sometimes have philanthropic societies overseas that encourage younger citizens to make films in or about their homeland. As with government support, it's essential to read the fine print. If you are a student producer, you don't want to waste a weekend filling out a grant application only to discover that the foundation involved doesn't fund student work.

When it comes to seeking support for your production, remember that money isn't everything. You may find that companies in your region are willing to provide in-kind contributions in lieu of a direct monetary outlay. This support could consist of professional services, supplies and equipment, such as time in an audio **mixing** suite or a free camera rental, but it could also take the form of prop loans or train tickets. Not surprisingly, you'll find that companies are more motivated to provide goods to productions in places where they are trying to make inroads into the local media industry. A film lighting company looking to drum up more business in China might set up a team of young Chinese filmmakers with a nice light kit. Some companies take a commercial or patriotic interest in developing the local media production community. Due to its scenery, workforce and low costs, many international companies shoot in South Africa. This business has allowed many South African rental houses to be quite generous in supporting local filmmakers with discounts and donations.

Pro Tip

"If you're receiving money from somebody who's underwriting a production, sometimes you won't get it in one lump sum. Sometimes you get a certain amount on signing the contract, a certain amount on the first day of production, then a certain amount on wrap or the **rough cut** delivery. And then you usually get the final check when you hand in all your receipts."

—*Corinne Marrinan*

Specialized Markets

There is one domain where shorts remain a viable business, and that can be broadly defined as "educational filmmaking." This category encompasses all manner of issue-driven motion pictures—everything from films used in driver's education classes to shorts shown in Sunday school. Believe it or not, entire companies have survived by making shorts for use in lifesaving, EMT training and childbirth classes, and there are filmmakers who have sustained fairly robust careers making shorts documenting psychological research or ethnographic studies.

Since we have said that we would focus on dramatic films here, such non-fiction subjects may seem irrelevant, but in fact even the fiction filmmaker can sometimes find funding for a story that addresses an important topic. A producer might approach an advocacy group for support in making a drama about brain injuries in sports, or he might take that same idea to a company that makes sports helmets.

Issue-oriented films can sometimes secure better distribution deals than are generally available for shorts. I recall a film about a family coping with an alcoholic mother. In truth, it wasn't a great movie. The acting was stiff and the story predictable. Nevertheless, the film got a distribution deal and slowly but surely made a small profit. There are a few organizations out there that provide support for the relatives of alcoholics, and these groups have hundreds of chapters that meet regularly. Meetings often include an icebreaker activity. A short film serves this purpose perfectly—hence the interest in this otherwise undistinguished project.

The connections that can be made between worthy causes or important topics and your movie idea might surprise you. I know a young filmmaker who made a beautiful short about an old woman who spent much of her time lost in memories of playing music as a child. It was only well after the filmmaker had completed the production that she realized that it could be read as evoking the experience of Alzheimer's disease. Had she made that connection earlier, she might have sought funding for the production up front from a foundation that supported Alzheimer's research. It's certainly worth thinking about tie-ins like this as you start your search for financing. Is there an element in your story that might be connected to some "bankable" topic?

Profit Versus Non-Profit

In certain respects, an enterprise that generates profit must be treated differently from a non-profit model. For one thing, the nature of the support you are seeking is different. If you expect to make money, you start out by looking for investors; if you don't expect to make money, you look for donors. These are very distinct propositions, and each deserves to be examined individually.

Investors want to know how their investment will grow. This means that you must provide them with a **business plan**, a document that explains why you think your idea will make money and how profits will be distributed. Whole courses in business school are devoted to the art of writing a good business plan, but here is a quick rundown of the elements that are often found in a plan:

- *A summary of the project*: This is the written equivalent of what is often called "the elevator speech." It is a brief, compelling statement of the scope and goal of the undertaking.

- *A synopsis or script*: Because the profit potential for any short film is limited, it's rare that producers seek investors for a single short production. Usually, there is a larger enterprise involved, such as a series of shorts or a short that will serve as the basis for a feature. Prospective investors may very well want to read scripts, but unless the page count is minimal, you shouldn't include screenplays in the business plan. Instead, include a synopsis or synopses.

- *A timeline*: A schedule detailing the stages of the project from preproduction to division of profits.

- *A budget*: A detailed and realistic projection of what the project will cost.

- *Case studies*: Examples of similar endeavors that have been successful. Sometimes this can include comparisons with ventures that aren't directly related to filmmaking. For example, if you had some model for monetizing short productions that relied on social networking, you might make comparisons to other social networking start-ups that you consider relevant.

- *Biographies*: Short summaries of the accomplishments of you and your collaborators.

- *An explanation of how profits will be divided*: This might sound straightforward, but it can be tricky. It may be possible to simply divide the spoils according to percentages of overall investment, but even then, some questions arise. At what point does a project become profitable? A business might appear to be "in the black" on paper, but if there are ongoing operational costs, determining when management can afford to pay back investors gets complicated. Then there is often the fact that not all investors are created equal. Suppose you, the filmmaker, are unable to put up much of your own money for the project. How will you get reimbursed for the sweat equity you have put in? Or suppose you have raised 80 percent of your investment but can't find that last 20 percent anywhere. You might have to sweeten the deal to attract those last partners. This could involve setting up a different class of investors. For example, you might ensure that these final investors are paid back before anyone else sees a return (this is referred to as "last money in, first money out"). See how complicated this becomes? How are you going to explain to those stalwart souls

who ponied up for the first shares in your venture that they must wait for a return on their investment while some Johnny-come-lately gets paid back?

This last item demonstrates why profit-sharing schemes must be very clearly and carefully spelled out. The hot water you can get into by mishandling your investment strategy isn't limited to hurt feelings or even legal challenges. Certain missteps can actually bring down the wrath of the government. Though it may not seem like it if you watch late-night infomercials, there are laws protecting the public from unfounded promises of quick windfalls. It is also illegal to take a shotgun approach to seeking investors. In other words, you can't simply go out on the street and hand copies of your business plan to pass-ersby. All of this is to say: don't try to do this on your own! If you are setting up a production as part of a business venture, make sure you have the advice of a reputable and experienced entrepreneur, and get a lawyer to review any documents you draw up.

Ownership Versus Sponsorship

Should you choose to produce your movie as a non-profit venture (as is likely), you mustn't think this absolves you from any responsibility to your backers. After all, without the lure of profit, why would anyone give you money to make a short? Mom and Dad may support you unconditionally, but don't be surprised to find that even dear Aunt Liz or Cousin Josh need some tangible reason to back your project. Here are some points to consider:

- *Your project as worthy cause*: You are more likely to find funding if you can convince your backers that you are telling an important story. This might mean that your screenplay tackles a pressing issue, but it could also simply be the case that you believe fervently in the project's artistic aims. A great producer can turn even the most abstract ideas into selling points.

- *Your project as tax shelter*: If your production is officially constituted as a non-profit venture, contributions to it may be tax deductible. This isn't as simple as declaring yourself to be working on a non-profit basis. You must work with an official non-profit organization that can vouch for your status. This is another area where those arts organizations that serve as fiscal sponsors can be of use.

- *Your project as ego booster*: There can be a coolness factor to being associated with a film production. Moreover, most people like seeing their names in lights. Therefore, the simple promise of either an acknowledgement in the film's end titles or (for the right price) a more substantial credit can be a real incentive. For a more detailed understanding of how such quid pro quos work, read on.

Online Fundraising Platforms

These days, many people raise funds for their productions through online platforms like Kickstarter or Indiegogo. If you plan to use one of these services, be sure to read the terms of use carefully, as the rules vary from site to site. Crowdfunding can be a powerful tool for harnessing grassroots support. It gets us away from the model of relying primarily on wealthy patrons and lets us tap into passions of people in every demographic. A friend of mine was seeking to direct a short based on Orson Welles' infamous *War of the Worlds* radio broadcast from 1938. His online fundraising campaign came to the attention of an enthusiast of early radio programs—a complete stranger. The director struck up a correspondence with the man, and he eventually made a substantial contribution to the production.

Pro Tip

"The fastest way to raise funds is to identify those groups of people who have an emotional investment in your project and the theme of your film. When people are invested emotionally, they do everything in their power to assist. Also, always ask for a donation from people you yourself contribute to financially on a regular basis. That could be your landlord, your hairdresser or the local liquor store around the corner."

—*Klaudia Kovacs*

The greatest misconception that anyone can have about crowdfunding is that it mechanizes the fundraising process, turning the messy and arduous business of asking for money into an algorithm that does all the work for you. While it's true that these funding platforms let you cast a wider net, successfully tapping online social networks requires tremendous tenacity. For starters, you need to build that network of contacts, and these shouldn't just be names or e-mail addresses; whenever possible, you need to establish a relationship. You also need to be relentless, creative and multifaceted in your outreach to prospective supporters. In our spam-clogged world, it need hardly be stated that just sending out an e-mail blast or two won't get the job done. Try to meet prospects face-to-face, call them up or invite them to fun events aimed at engaging people in your project.

People are primarily motivated to donate money to films either because they are passionate about the project (the subject, the story) or because they believe in the filmmakers. Most online campaigns offer a ladder of enticements for

contributors, but these offers are rather like a MacGuffin in a thriller: they help propel the action forward, but they aren't the heart of the story. The chief reason to use a tiered system for soliciting contributions is to motivate people to give at a higher level than they might if left to pick an amount on their own. The rungs of the ladder for a short with a budget of $10,000 might look something like this:

- *Extra*: For a contribution of $50, the backer receives a DVD of the completed movie, invitation to a private screening and acknowledgement on the production's website.
- *Supporting Role*: For a contribution of $100, the backer receives all the benefits provided at the Extra level, along with a clever keepsake (perhaps a prop from the film) and a thank-you in the film's end credits.
- *Leading Role*: For a contribution of $500, the backer receives all the benefits provided at the Supporting Role level, along with an invitation to a reception following the private screening and a special thanks in the end credits.
- *Associate Producer*: For a contribution of $1,000, the backer receives all the benefits provided at the Leading Role level, along with an associate producer credit.
- *Executive Producer*: For a contribution of $5,000, the backer receives all the benefits provided at the Leading Role level, along with an executive producer credit that will appear in the opening credits and on all flyers and posters.

Think of this scale of support as a starting point, not a model to be blindly copied. Every worthwhile project has some special quality. Tailor your offers to the elements that set it apart. T-shirts and decals still have their place in the realm of promotion, but if you can come up with more original gifts and inducements, you'll get more attention and have something to talk about. Remember, the object itself is always less important than the meaning people attach to it.

Appealing to Friends and Family

Regardless of whether you are trying to set up a business venture or trying to produce a single short on a non-profit basis, chances are that many of your backers are going to be friends or family members. For that matter, as we have established, even if you get an associate or new acquaintance interested in your venture, these people are only going to back you because they feel a genuine connection with the project. All of this is to say that you are asking for money from people with whom you have a relationship. Don't forget this fact—it's your ace in the hole!

If you aren't in regular contact with a prospective backer, you should reach out to them *before* asking for their support. How would you feel if a long-lost

friend or relation popped up out of nowhere and immediately asked you to support a business venture or worthy cause? Take the time to get them interested and involved. Always be personal, direct and sincere in your communication. People sometimes tense up when money is at stake. I have seen more than one young producer suddenly start to sound like a robot when they ask friends for financial support. It's important that your information package or business plan is stylish and articulate, but keep the tone of your communication with friends and family warm and genuine. Whenever you talk or write about your production, make sure to convey your passion for the material and your faith in your creative partners. Explain what this project could mean for your career. Don't take an initial lack of response to be a brush-off, and don't be shy about persisting and following up. You are likely to have to reach out repeatedly and through numerous channels to get donors to engage with you.

Pro Tip

"The rule of seven is a marketing concept that suggests that you need to communicate with your donors seven times before they get involved. For example, over time that could break down to three e-mails, one newsletter, two phone calls and one thank-you card. The point is that you need to establish a strong relationship with your donors before you ask for their contribution. Once you have a strong relationship, it's possible that you will only need to ask for their donation once."

—*Klaudia Kovacs*

Setting Up to Do Business

Some budding producers labor under the impression that the first order of business is to set up a production company. They seem to believe that establishing an official business entity is to producers what buying a doctor's bag might be to a physician graduating from medical school. This is not correct. As long as you are producing short films for little or no profit, there is no compelling reason to rush to set up any sort of company. Even if you anticipate producing films for profit, don't establish a company until you have to. Above all, resist any grandiose impulses. Establishing The Intergalactic Motion Picture Corporation might seem like a good way to set the bar high for yourself, but there are drawbacks to thinking too big too soon.

If you simply want to make your movie under a production banner, you can do so officially and legally without setting up a full-fledged company. Consider the hair salon down the street. The shop consists of one stylist—Dan—who also

happens to be the owner. He has a sign in the window that says "Bangs R Us," and this catchy name also appears on the receipt for your haircut. Sole proprietors like Dan often do business under another name, but this doesn't really require them to establish a company. Rather, they operate under what is known as a **DBA** (for "doing business as") arrangement. Dan is really just doing business as Bangs R Us. From the standpoint of the law or the IRS, there is no distinction between Dan and his business. Establishing a DBA called Bangs R Us simply permits Dan to use this name on all his professional paperwork. This minimalist approach to setting up a business is often a good place for a producer to start out.

The procedures for registering a DBA arrangement vary somewhat depending on where you live. In my hometown, you must go to the clerk at City Hall, fill out a form, swear under oath that the information you've provided is correct and pay a $50 filing fee. While you're there, make sure the clerk has checked the records to see that no one is using the name you've chosen. In my neck of the woods, once registered, my DBA status remains effective for four years.

If you are intent on setting up a commercial production company, especially one that involves several partners or owners, you should consider establishing a partnership or corporation. Partnerships and corporations provide a means for systematically dividing costs and profits and for sharing control of a business when there are multiple owners. Another key benefit of setting up a partnership or corporation is that these entities provide some degree of liability protection. Unlike with a DBA arrangement, when you establish a bona fide company, you are no longer synonymous with your business. Your personal assets and those of your company are at least somewhat separate. This is important if your work leaves you vulnerable to being sued for any reason.

Over the past twenty years, the **limited liability company (LLC)** has become a very popular structure for production companies. An LLC establishes a formal partnership among its members and also affords them a good deal of liability protection. Corporations provide still greater separation between owners and employees and the business entity. Incorporation seldom makes sense for the fledgling producer. Corporations are complex. They have shareholders, officers and a board of directors. Corporations must hold annual meetings, and they must pay corporate taxes. In the case of both LLCs and corporations, annual filing fees must also be paid—whether the business makes money or not. As you can see, the government views these more elaborate business structures differently from the humble DBA. A corporation may be expected to provide certain services, such as worker's compensation. Clearly, you don't want to take on such obligations until you have to.

We've slogged through a lot of fine print here, and I recognize that some of the details have been about as engaging as reading the tax code. But there's good news: now that we've taken care of these fiscal matters, we're ready to make a movie!

Chapter 2

Preproduction

Safety First

The stages of making a movie are divided into three phases that are called (rather unimaginatively) **preproduction**, **production** and **postproduction**. If I tell you that production refers to the shooting phase, you can pretty well figure out the rest. As they chug their way through the hills and valleys of the filmmaking process, even the most well-run projects inexorably gain momentum to the point where everything can seem to be hurtling past at blinding speed. Before we embark on this thrilling journey, it's important to take a moment to consider a subject that is literally a matter of life and death.

No aspect of a producer's job is more important than caring for the well-being of the cast and crew. Sadly, even within recent memory, filmmakers have been killed in preventable accidents on the sets of short productions. To put it bluntly, film sets are dangerous. A piece of gear as basic as a humble light stand can become a deadly instrument in the hands of an untrained worker. The major motion picture studios have safety manuals that run to hundreds of pages. These guides are used by professional crew members who work with production equipment every day. In contrast, the typical short production uses a crew of volunteers operating with no established safety guidelines whatsoever. When you consider these stark facts, it's probably just a matter of luck that tragedies on set are not more common.

As you go through the many steps of planning and running a production, never lose sight of the importance of safety. Let your vigilance on this matter inform every aspect of scheduling, budgeting and purchasing, as well as managing the cast and crew. Perhaps most importantly, don't let the crescendo of activity and stress that accompanies every shoot lead you to cut corners or overlook precautions. Remind yourself at all times that nothing is more important than operating the safest possible set.

Clearing Rights to Intellectual Property

As I have already suggested, not every action taken prior to the cameras rolling is considered part of preproduction. The writing and revision of the script, the raising of funds, the configuring of a production company or other producing entity—these are all steps taken prior to the start of preproduction. One step that emphatically *must* be completed before the gears of preproduction start to turn is the securing of any rights related to the material you are producing.

Guerilla filmmakers sometimes like to invoke Admiral Grace Hopper's famous adage, "It's easier to ask for forgiveness than it is to get permission." While this phrase evokes a seductive devil-may-care bravado, it's a philosophy that can get you into deep trouble as a producer. Nowhere is this more the case than when it comes to obtaining permission to tell somebody else's story. You absolutely, positively do *not* want to invest all the time, effort and money that goes into producing even a very short movie on the assumption that the person whose story you have "borrowed" will like and approve of the results. The ways that such rose-tinted thinking can backfire are too numerous to catalog, but consider just one scenario: You make a film based on a short story by a recently deceased author. The rights to the story now reside with the author's estate, which in turn is represented by a big entertainment law firm. The lawyers have neither artistic nor sentimental reasons to assist in your obtaining rights to the story. Quite the contrary: once they hear that you have already made the movie, that special lawyerly twinkle flashes in their eyes. That's because they know they now have you over a barrel, since without their cooperation, your production will never make it out of the editing room. In such a case, getting the rights to the story is likely to cost a bundle. Get the idea? It is essential to get the rights to any underlying intellectual property prior to proceeding with a project.

In the realm of filmmaking, **intellectual property** is a rather imposing term that refers to creative work by other people that we want to incorporate into our production. Later in this book, we'll return to the issue of intellectual property, with particular attention to one kind of creative work—music—but at this stage, the kind of intellectual property that we're most likely to be concerned with is material related to the story we're producing. We can divide screenplays into two broad categories. In the first group are original screenplays, where both the story and the interpretation of that narrative through action and dialog are solely the work of one or more screenwriters. In the second group are scripts that are adapted from someone else's story, be it a work of fiction, a person's life story or a factual narrative. The rights issues related to screenplays therefore also fall into two subsets: story rights and rights to the screenplay.

Copyright and the Public Domain

There are stories for which no rights need to be acquired. In the first place, facts cannot be copyrighted, so, in theory at least, no rights to stories "based on true events" would need to be cleared. Of course, the most elegant theories often crash and burn when subjected to the rigors of actual practice. There are plenty of reasons why we might want or need to secure the rights to a non-fiction story—and this is true whether we are dealing with a writer or a person who has lived through the events in question. Though facts can't be copyrighted, an author's unique reimagining of a set of facts certainly can be. While an event in a person's life might seem to be a matter of fact, we all know how divergent people's recollections of events can be. Furthermore, living persons (or their heirs) may not agree with your retelling of "actual events." This is why screenplays based on fact often secure story rights from authors and individuals.

> ### Pro Tip
>
> "When you're working to acquire a life story, it's very important not only to like the story but to like the character. You're collaborating with these people, and that means that you're entering into a relationship with them. One of the stories that I was working on was the life story of a convicted felon who had murdered his doppelgänger and stolen his life. The correspondence with him was good, but when I met him in person he was just a despicable character. Another story I acquired was with someone who was falsely arrested and accused of car theft. He was eventually exonerated. This fellow went on to become a lifelong friend."
>
> —Don Daniel

A copyright protects a work from being reproduced, adapted or shared without permission. Copyrights have existed in one form or another for over three centuries, and it's a safe bet that any work of fiction published in the western world in the modern era has been copyrighted. That said, all copyrights eventually come to an end. When the copyright on a work lapses, it falls into the **public domain**. Defining where the line is between works that are copyrighted and those that are in the public domain can be tricky. Works that are more than a century old are certainly safe, but most of the creative output of the twentieth century is still under copyright. Copyrights are not universal: they are a product of laws of individual nations. In the discussion that follows, we'll sometimes refer to U.S. copyright provisions. We do this for a couple of reasons. First, the

United States is generally too central a market for media distribution to be left out of any rights negotiation. Second, U.S. copyright laws are among the most restrictive in the world. Most nations have reciprocal copyright agreements, so rights cleared in one country are considered also to be cleared in all allied territories. By clearing the U.S. rights to a work, we are addressing a pretty comprehensive set of requirements, which means that we're likely to meet the standards for clearance in other territories as well.

The first step to clearing rights to a story or literary work is determining if the property in question is still copyrighted. Don't trust your gut on this. Plenty of work that seems like it *should* be free for the taking is in fact copyrighted. The novel *True Grit* is steeped, both in substance, style and tone, in the world of the western frontier. It has already been adapted twice to the screen. If all of that makes you believe the book is in the public domain, think again: it was first published only in 1968.

Figuring out precisely when a work passes into the public domain in the United States is not straightforward, in large part because copyright law has been repeatedly revised over the past 50 years. We are going to take the easy way out by confining ourselves to a simple fact: In the U.S., any work copyrighted before 1923 has passed into the public domain. Once we start to deal with works copyrighted in 1923 or later, things get much more complicated. There are a number of books, websites and clearance services out there that can provide detailed information about copyright status. Yet another word of caution, however: the internet is rife with dubious claims regarding contemporary works that are purported to be in the public domain. Check any information you unearth against a reliable source, such as the records of the Library of Congress, the branch of government that records all U.S. copyrights.

Copyrighted works usually say that they are copyrighted. The copyright information for printed works is usually located on the title page or on its reverse. On older films, it's common to find the copyright in fine print on the main title card. If you have reason to believe that a work is *not* in the public domain, the copyright notice is a good starting point for tracking down the party that controls the rights to a work. If a book says it is copyrighted by a publishing house or a movie says it is copyrighted by a studio, those are the companies you should call first. Literary and entertainment companies are in the business of promoting their intellectual property, so it usually isn't hard to get them to reply to initial queries about the status of a particular work. A couple of phone calls will usually uncover who controls the copyright on a given property and whether or not the rights for adaptation or appropriation are available.

Story Rights

When a novel is adapted into a feature film, the story rights often fetch tens of thousands of dollars. This makes life difficult for the humble producer of a short film. You have to convince publishers, agents and authors that you operate

in a completely different universe, one in which the prospects for generating profit are poor to non-existent. You must therefore make the case that the powers that be should give you the rights to their property for little or no money. You must hold firm on this position, even when you're seeking the cooperation of blockbuster authors or celebrities, because it's important to remember that even the most star-studded, platinum pedigreed project is ultimately going to result in a short film, and that changes everything.

If you make this case convincingly, you may be surprised to discover that, with perseverance, you can in fact negotiate the right to adapt even A-list material to the screen. Stephen King is one of the world's best-known living authors. He is also uniquely enlightened when it comes to his approach for dealing with budding filmmakers. King has long permitted filmmakers to produce shorts based on many of his works for next to nothing. However, it's important to note that his boilerplate agreement for these shorts comes with a number of restrictions, not the least of which is that there can be no commercial exploitation of the production.

Are these limitations compromises that are worth making? That of course depends upon the specific goals of your project. If you are just making a "calling card" film, the rights you need may be quite basic. Let's leave Stephen King's collected works on the shelf for a moment and consider the alternative scenario: a production for which you want to reserve the broadest possible range of rights. Let's say you want to adapt a story for a project that you hope to send out on the festival circuit, sell in the educational marketplace and eventually share via the internet. All of these distribution options need to be covered in the contract with the story's author. Appendix C provides a set of contract templates to which we'll be referring throughout this book. These documents can also be downloaded for free at *theshortseries.com*. They are a good starting point for grappling with the legal issues surrounding any production, but they are unlikely to serve all your needs. As the saying goes, a person who is his own lawyer has a fool for a client. You may not need to hire a lawyer to make your movie, but you will almost certainly need some reliable legal advice along the way, so you would do well to line up your legal support team at the outset.

The first of our sample contracts has been written to grant a broad set of rights to adapt a fictional or factual story into a screenplay. This story rights agreement gives us a chance to get acquainted with some legal terms that will crop up frequently as we dive deeper into producing. For instance, note that in the Scope of Rights section of the agreement, the term for the grant of rights is "in perpetuity" rather than for a limited period, and it covers "any and all media and formats now known or hereafter devised." This gives you ongoing rights to the material and ensures that, as technology continues to evolve, you'll be able to distribute the movie in all the as-yet-unknown media. Who knows what the future will bring? If someday your movie gets transformed into an immersive virtual reality experience, you're covered. Finally, rather than limiting the

territories in which the agreement is enforced, it applies "throughout the universe." If that sounds like science fiction, think about this: what territory governs in-flight movies, or media productions that are beamed up to a satellite?

Screenplay Rights

Depending on the nature of the project, you may or may not need to secure the rights to the story on which your short's screenplay is based, but unless you wrote the screenplay yourself, you will very definitely need to acquire the right to produce the script. Though they aren't always published in print form, screenplays are covered by copyright law in much the same way as books and other traditional kinds of publications, with one key distinction. If you refer to the Screenwriter Agreement Template in Appendix C, you'll find a paragraph that addresses the screenplay under negotiation as a **work-for-hire** (sometimes also called a "work made for hire"). Again, this is an important legal concept that will crop up from time to time. Simply put, in the eyes of the law, most intellectual property belongs to the people who make it. Given their collaborative nature, that model doesn't work so well for motion pictures. Even a short film may draw upon the creative contributions of dozens of artists. Interestingly, the courts recognized this distinctive characteristic of movies almost from the start, and for the past century, motion picture producers have been able to engage the services of various collaborators on a work-for-hire basis. When a work-for-hire agreement is in place, the fruits of an artist's labors belong to the production rather than the individual. If you plan to have a screenwriter write a script for your movie, you will want to engage the writer's services under a work-for-hire agreement, and you should get this deal sealed before the screenplay is written.

You might notice passing reference to **moral rights** in the paragraph of our screenwriter agreement that addresses the work-for-hire arrangement. Moral rights are an international legal concept asserting that artists retain some authority over how their work is used, exhibited or altered. For better or worse, moral rights aren't recognized in the United States, but American producers often address them in any agreements covering creative work. This is another example of keeping a global perspective. You don't know where your movie will be shown or distributed. One of the biggest festivals for shorts in the world is in France, the country where moral rights were invented and where the concept continues to hold the most sway. Therefore, regardless of where you are based, it is best to address moral rights.

Negotiating for the full menu of rights and permissions can be a tough slog, even when dealing with an unknown or unpublished author. Securing such a comprehensive agreement may require your offering some sort of payment. In legal agreements, payment is usually covered under the discussion of **consideration**. This is yet another widely used legal term, and it should be noted that consideration does not have to take the form of money—it refers to anything of value. In my experience, unless you are involved in commercial venture with

clear prospects for profit, it's unwise to offer more than $500 in total for story and screenplay rights. Of course, in lieu of payment, you might accept a less extensive rights package. If you are trying to secure the rights to a celebrated story or a work by a well-known author, don't be surprised if the rights holders balk at granting exclusive rights or the permission to produce sequels and remakes based on the material. Again, the degree to which you are willing to scale back the terms of the agreement depends very much on what you plan to do with the final product. Be careful not to get backed into a corner. For instance, in this day and age, a deal that forbids distribution of a short via the internet is a major issue. Such an agreement should be accepted only as a last resort, if at all.

The gears of any scripted production can't start to turn until the screenplay is well and truly finished. Keep this in mind if you are engaging someone to write your script. You don't want the project to hang in a state of cryonic suspension while the screenwriter waits for inspiration to strike. It is therefore critically important that the director, writer and producer confer and determine a viable set of deadlines for delivery of drafts of the script. Put this in writing and attach it to the screenplay agreement. You'll find an example of such a schedule in Appendix C. The timetable is designed to accompany the screenwriter agreement and is called Exhibit A.

One more point to consider before you sign any contract: As the saying goes, "for valuable consideration," the writer grants a set of rights. So far, so good, but how do you know that the rights being granted truly belong to the writer? Plagiarism is an obvious example of an instance where a writer falsely claims ownership, but there are plenty of less nefarious ways that writers get into hot water. We have all heard of cases where people accuse writers—rightly or wrongly—of stealing or misrepresenting their stories. How do you protect yourself against claims against a writer—or against any partner or collaborator, for that matter? The first step is to have clauses in your agreements that establish authority and indemnification. In legal terms, authority means what it sounds like: the person signing the agreement asserts that he has the right—or authority—to make the deal. As for indemnification, that's a way of stating who will be held financially responsible if another party challenges an agreement. If a writer indemnifies a producer, it means in effect that the writer will be the one holding the bag (definitely *not* a legal term) should someone come out of the woodwork to dispute the terms of the screenplay contract.

Assuming we have locked in all the necessary rights, polished our script to perfection and secured all our funding, we are ready to embark on preproduction. Onward!

An Overview of Preproduction and a Timeline

The start of preproduction signals that you are ready to start making your movie for real. It means you are prepared to lease locations, hire crew, secure

insurance, book equipment and so on. Most producers consider preproduction to be a precious commodity. Though it is a busy period, preproduction represents the last chance to plan and reflect before the juggernaut of the production phase takes off. Preproduction on a feature film can run anywhere from six months or more for a complex period production to as little as six weeks for a bare-bones affair. Various factors can constrain the preproduction period on a feature—anything from a studio's release schedule to a star's availability. It also costs money to rent production office space, to pay the production office staff, to build sets and even to rehearse with actors.

By comparison, preproduction on shorts is a bargain. Unless you are shooting in some remote location, chances are you won't incur many significant expenses prior to the start of production. This being the case, make the most of the planning phase. It isn't uncommon for a short that will be shot in four days to take months of preparation. The casting process alone can take many weeks, as can finding the right location. As long as you give yourself enough time to get these tasks done, it doesn't much matter how long they take. Conversely, if you put yourself into a position where you have to rush to assemble a production, you'll find yourself having to pay to get things done quickly and making decisions without due consideration. The only way to steer clear of such pitfalls is to have a firm grasp of the timeline for preproduction.

Pro Tip

"On any size feature, studio or indie, preproduction is really critical, because it allows you to solve problems cheaply, without the pressure of the ticking clock or the cost of a shooting crew sitting around waiting for you to make decisions. The more you can do in preproduction, the more decisions you can make ahead, the more you can be prepared for the inevitable unexpected events and the smoother the shooting process will be."

—*Michael Nozik*

The time required for any step of a production depends on the nature of the project. For instance, it will take much longer to cast a five-minute short about a kid's first day of school than it will to cast a twenty-minute movie about a couple on a bad first date. That's because talented and available 6-year-olds are in much shorter supply than are talented and available twenty-somethings. The same variability applies for everything from securing locations to completing **storyboards**. Keeping that proviso in mind, the timeline for preproduction on a fifteen-minute dramatic short might look like Table 2.1.

Table 2.1 A Timeline for Preproduction

	Week 1
Start scheduling (allow 2 weeks) Post casting calls (allow 2 weeks) Recruit crew (allow 5 weeks) Scout locations (allow 5 weeks)	
	Week 2
	Week 3
DEADLINE: Shooting schedule complete Start budgeting (allow 2 weeks) Begin auditions (allow 3 weeks)	
	Week 4
	Week 5
DEADLINE: Budget finalized Secure insurance Reserve equipment rentals	
	Week 6
DEADLINES: Crew finalized; all locations secured Send out location agreements (allow 3 weeks) Begin casting callbacks (allow 2 weeks) Start work on props, sets and wardrobe (allow 4 weeks)	
	Week 7
Start work on union contracts (allow 2 weeks)	
	Week 8
DEADLINE: Cast finalized Start storyboarding (allow 2 weeks)	
	Week 9
DEADLINES: All union paperwork and location contracts complete Start rehearsals (allow 2 weeks) Start drawing up call sheets (allow 2 weeks)	
	Week 10
DEADLINE: All sets complete; props and wardrobe secured *DEADLINE:* All storyboards complete Pick up rental gear	
	Shoot Starts

Many of the steps outlined in this timeline aren't the direct responsibility of the producer. However, since they are all tasks that must get done and that consume resources, the producer must oversee them. We'll be spending much of the remainder of this book exploring the steps in this timeline. For now, the goal is just to get the big picture of the preproduction process. Let's therefore outline some basic principles that dictate what happens when.

Time is money: This isn't just a platitude; it's the gospel truth. Clearly, the longer your shoot is, the more you have to pay for food, lodging and equipment rentals. Yes, time is money, but *timing* is also money. Sometimes the issue isn't just *what* you need, but *when* you need it. You'll generally reap big savings if you rent camera and lighting gear over a weekend as opposed to during the workweek. A ski house location is going to be much less costly to secure during mud season than it will be in the winter months. The theme that unifies all these considerations is this: *you can't determine your budget until you've drawn up your schedule*. This is a cardinal rule of producing.

Because so many other decisions depend upon them, the production schedule and budget are among the first documents to be drafted in preproduction. You probably had to come up with some provisional shooting dates and an approximation of a budget when you were raising money for the project. That's fine, but now it is time to get down to the nitty-gritty and make a really accurate assessment of the time and money that will be needed to bring your movie to fruition. When done properly, scheduling and budgeting are painstaking processes that require a great deal of thought and research. That's why we have allowed two weeks for each of these steps at the outset of the preproduction schedule.

Insurance isn't a luxury: Rightly enough, producers of shorts are always looking to economize, and production insurance might seem to be one of those budget line items that, while desirable, could be scratched out. Let's assume your production is going to be shot entirely in your apartment using just a couple of actors. Why on earth would you need insurance? Well, even if we set aside worst-case scenarios (one of your lights sets off the sprinkler system; an actor electrocutes himself with your toaster), there are reasons why production insurance can be not just a good idea but an unavoidable expense. If your actors are members of **SAG-AFTRA**, the giant performers union, you are required to carry certain kinds of insurance. Then too, most equipment rental houses require proof of insurance before permitting use of their stuff. Generally, the scope of a production is defined by its budget, which is why the amount and the cost of production insurance is often based on the budget. Once your budget is finalized (Week 5), you'll then be able to secure the insurance that you need for any union contracts, location agreements or rentals.

Cast considerations: Auditions and rehearsal time take up a big chunk of preproduction. Even so, the schedule outlined here is quite compressed. It

assumes no especially difficult casting challenges. Keep in mind that you won't be running your auditions all day every day. You'll need access to a proper space in which to meet people and try them out, and you'll have to work around everyone's availability. Moreover, if you're successful with your casting calls and your auditions, you'll need time to review all your choices. All of these considerations eat up time; the weeks will roll by. Too often, producers and directors can get caught up trying to see as many actors as possible, as opposed to forging a cast that has the right chemistry. That's why we've made sure to separate out **callbacks** as a discrete part of the process. This is when you bring in your most promising prospects to work together. Finally, once the cast is determined, rehearsals can begin. Directors differ in terms of how much they like to rehearse, but if you are working with a novice director, you should advocate for rehearsal time. Rehearsals offer a unique opportunity for actors and directors to mine the dramatic or comic possibilities inherent in a project, away from all the stresses and distractions of a shoot. Rehearsing for two weeks prior to the start of production is pretty much the minimum you should allow. Given the vagaries of people's schedules and their other obligations, two weeks will translate into a few days of actual rehearsal time—if you're lucky.

Let the director direct: It is the nature of small productions that everyone wears several hats. That's fine, but make sure that the director doesn't wear the producer's hat. Too often on shorts, the director gets consumed by logistical concerns: how many people need to be fed lunch, where vehicles will get parked at a location, who last had the office keys and so on. In truth, this tendency is often brought on by the director's own penchant for micromanagement. Be that as it may, your job is to insist that the director *directs*. When it comes to logistics, the producer is the ringmaster, not the director. Make sure that this is the case.

The last week: Be sure to maintain a steady pace and meet your various deadlines throughout preproduction. That way, everything won't come down to a few sleepless nights before the cameras roll. That isn't just important for your own self-preservation; it's crucial for the well-being of the director as well. You absolutely do *not* want to be overwhelming the director with decisions regarding locations or costumes as the shoot approaches. Your goal should be to manage the process so that, in the week prior to the start of production, the director can be focused on working with the actors, finalizing shot lists and getting some rest. Meanwhile, you and the rest of the crew can be using those last few days to address those inevitable intractable issues, such as tracking down that one prop that can't be found or that signed location agreement that hasn't come in. Finally, a day or two prior to the start of the shoot, you'll need to pick up any rented equipment. While you're at it, make sure that you and your crew get some sleep, too.

Pro Tip

"Sometimes, the longer preproduction periods can delay the directors, cinematographers or even producers from making the decisions they need to quickly because they feel that they have all of this time left. 'Oh, I've got four more weeks before I have to do this or that.' If you shrink the preproduction period, you force everybody to make decisions quicker, which isn't necessarily a bad thing."

—*Evan Astrowsky*

Chapter 3

Script Breakdown

What Exactly Am I Producing?

The director and screenwriter have burned through countless energy drinks and have crafted a script that is taut and funny—even moving. Now it's time for you to stock up on your own caffeinated beverage of choice and get to work on a production schedule. Note the choice of article—*a* schedule, not *the* schedule. In the course of making this project, you'll produce many drafts of the schedule, and you may even find yourself overhauling the schedule from scratch more than once. Naturally, changes in the script will require adjustments to the schedule. That's why you want to work from a highly polished screenplay. Warning: don't let endless tinkering with your script serve as a convenient excuse for putting off indefinitely the task of scheduling. As you'll see, the process of crafting a schedule is like taking a car apart and reassembling it, part by part. This takes some doing, but when you're done, you'll know your vehicle very well. Indeed, this is the only way you can get an accurate sense of the scope and demands of the project. Without at least a provisional schedule, you can't accurately gauge if you'll need to book an actor for Tuesday or Wednesday, or how many days you'll need to rent a generator; you're just guessing at dates and pulling numbers out of the air. So, time to get out the wrenches and pliers and have at it.

The road to a properly scheduled production starts with a careful **script breakdown**. Over the years, production managers have come up with a series of procedures to analyze scripts in terms of their logistical demands. Using a simple code of colors and special marks, production managers can identify all the elements required for any given scene: the cast involved, the number of extras needed, any special camera equipment or props that might be required and so on. The first tasks that need to be done when breaking down a script are numbering and then measuring scenes.

> **Pro Tip**
>
> "There is no shortcut to spending a lot of time doing the breakdown. For me,
> that's the gold standard of scheduling. If your breakdown's not that detailed,
> your schedule's not going to work and your budget won't be accurate."
>
> —*Marie Cantin*

Numbering Scenes

In the simplest terms, a scene is any dramatic action that takes place in a dis-
crete period at a specific location. Any change in time or place potentially has
logistical consequences, so the first order of business in planning a production
is determining how many such changes occur in a script, and this is where
numbering scenes comes in. Scenes are usually demarcated in screenplays by
slug lines, such as "EXT. SIDEWALK—DAY." Much of the time, then, we can
just add numbers to our slug lines and our job is done. Indeed, if you write your
script using Final Draft or some other screenwriting software, the program
will, if asked, assign scene numbers simply by numbering the slug lines in the
script. Be careful if you use any such automatic numbering function! While
the program will get it right more than nine times out of ten, there are special
considerations that the program will inevitably overlook or misinterpret.

Examining how a computer automates the numbering process can shed light
on the nuances at times involved in this first step in breaking down the script.
Consider Figure 3.1, which shows a portion of page 2 of the screenplay for
Shoebox Redhead.

How would a computer number this section? Like a trained chimp (admit-
tedly, a very clever chimp), it would simply label the first slug line—"EXT.
SUBURBAN NEIGHBORHOODS—DAY"—as one scene (Scene 5, as it
happens), and the next slug line—"EXT. SUBURBAN HOUSE—DAY"—as
Scene 6, and so on. We, however, are neither machines nor chimps, and we
know this won't suffice. Look closely at the business covered under "EXT.
SUBURBAN NEIGHBORHOODS—DAY." In my view, this is at least two
scenes. First, there is a montage (a series of shots) of suburban scenery, fol-
lowed by the arrival at the garage sale. The description of the montage suggests
several tracking shots of different neighborhoods, captured from the perspec-
tive of the characters in the car. This is why I argue that the slug line comprises
at least two scenes: in truth, I could break the montage up into many scenes,
each scene representing a different shot. After all, the shots are to be filmed
in different neighborhoods, so if I lump them together, isn't the basic defini-
tion for a scene (one time, one place) being violated? Well, yes, but from a

```
EXT. SUBURBAN NEIGHBORHOODS -- DAY

Shots of suburban homes, one after another.  Each one
indiscernible from the next and the one that came before.
The cuts signify a change in neighborhood but this could be
a single neighborhood.  A meta neighborhood.

A house having a garage sale is passed and then the car
(camera, whatever) slows down, almost to a stop.  It backs
up slowly and stops, looking straight at the house holding
the garage sale.

An OLD WOMAN sits at a table in the center.  Rummaging around
is an OLD MAN and TWO MIDDLE-AGED WOMEN with teased out hair
and wearing nylon jogging suits.

We cut 180 degrees to reveal Ryan, sitting in the passenger
side of a beat up wagon.  After a few seconds, Matt appears
from behind his friend.  Matt yanks up on the emergency break.

EXT. SUBURBAN HOUSE -- DAY

Ryan and Matt, who is carrying the box, walk to the front of
the driveway, passing tables full of junk and blankets below
those tables, full of more junk.  They approach the Old Woman.
Matt drops the box on the table in front of the her.

                        MATT
          Hi.  Do you want to buy this stuff?
```

Figure 3.1 Script Excerpt, Unmarked

logistical point of view, this series of shots is clearly one unit. Once the camera is mounted on the car, it will simply be a matter of driving through a few different sections of town, gathering shots. Therefore, I have opted to treat the montage as one entity, Scene 5.

Once the car arrives at the garage sale house, the action seems to flow continuously into the next scene, the one delineated in the screenplay by the slug line "EXT. SUBURBAN HOUSE—DAY." Here I must resort to a fairly unusual step: I'm going to count the next scene—Scene 6—as starting *before* the slug line, as in Figure 3.2.

By the way, this is in fact how I will go about numbering the script: using either software or a black pencil, I'll draw a line to demarcate the scene and then type or write the scene number in the left-hand margin.

When it comes to numbering, working from a "locked" script really helps. Dropping or adding scenes to your script after you have done a breakdown can cause headaches. For example, if you eliminate the montage in Scene 5 later on, you'll have to keep reminding yourself and your fellow crew members that the scene hasn't been inadvertently omitted from the schedule. On the other

5 EXT. SUBURBAN NEIGHBORHOODS -- DAY

 Shots of suburban homes, one after another. Each one
 indiscernible from the next and the one that came before.
 The cuts signify a change in neighborhood but this could be
 a single neighborhood. A meta neighborhood.

6 A house having a garage sale is passed and then the car
 (camera, whatever) slows down, almost to a stop. It backs
 up slowly and stops, looking straight at the house holding
 the garage sale.

 An OLD WOMAN sits at a table in the center. Rummaging around
 is an OLD MAN and TWO MIDDLE-AGED WOMEN with teased out hair
 and wearing nylon jogging suits.

 We cut 180 degrees to reveal Ryan, sitting in the passenger
 side of a beat up wagon. After a few seconds, Matt appears
 from behind his friend. Matt yanks up on the emergency break.

 EXT. SUBURBAN HOUSE -- DAY

 Ryan and Matt, who is carrying the box, walk to the front of
 the driveway, passing tables full of junk and blankets below
 those tables, full of more junk. They approach the Old Woman.
 Matt drops the box on the table in front of the her.

 MATT
 Hi. Do you want to buy this stuff?

Figure 3.2 Script Excerpt, Numbered

hand, if you add a new scene between Scenes 5 and 6, you must resort to an awkward designation like 5A. Someone tabulating the scenes in a script could easily overlook a scene with a special designation like this. As the assistant director ticks off the scenes that have been shot, "4 ... 5 ... 6 ... 7 ..." and so on, it's not readily apparent that scene 5A hasn't been accounted for. All of this can be avoided if you simply make sure your script is well and truly *done* before proceeding.

Measuring Scenes

Once the script is numbered, you need to measure the length of each scene. Scenes are measured in increments of eighths of a page. This is also the minimum increment used. Got a one-sentence scene? It still counts as 1/8 page. If your script is written in standard screenplay format (and it must be for any of the rules outlined here to work!), 1/8 page equals roughly 1 inch. Convenient, no? Simply take a ruler and measure each scene in inches, then convert to eighths. If you have a lot of very short scenes in quick succession, you may discover that you have a page where, once you've tallied up the lengths of all those brief scenes, the total comes to 9/8 or 11/8. Should this occur, don't sweat it. Such discrepancies tend to get balanced out over the course of an entire screenplay, so we just live with them. One important convention to keep

in mind: eighths are only used for fractions of a whole page. A scene that fills a single page would be tallied as 1, not 8/8, and if a scene runs two and half pages, it would be listed as 2 4/8, not 20/8 or 2 1/2. Such measurements should be written in the right-hand margin of the script. This information will subsequently be transferred to the **breakdown sheets** and **stripboard**.

Marking Up the Script: Know the Code

Production managers go into varying degrees of detail when marking up a script for breakdown. For those who find the system I advocate a bit compulsive, I plead guilty as charged. The foundation of our production is being laid here. If we plan adequately, every prop that we need to purchase, every song that we must license, every extra that we have to recruit will be accounted for in our breakdown. Conversely, if we do a slipshod job, these and many more details can slip through the cracks. Our motto is the truest of all clichés: better safe than sorry.

For several generations, production managers used a breakdown system that involved marking up a hard copy of the script with colored pencils. Even today, this system has its adherents. Colored pencils are about as foolproof a technology as you'll find; once you've used them to mark up the script, you have a single, inviolable bible for the production.

Pro Tip

"The classic script breakdown is to break down the sheet, every page, according to eighths of a page. Outline the characters, the locations, the set—interior, exterior, day, night. Mark up the script. And one of the reasons this is good to do is not just because it's the classic way to do it, but because when you do that, it kind of imprints the script in your brain. You get to know the script very well."

—*Barbara Doyle*

On the other hand, it's hard to edit and share a document drafted by hand, and not everybody has legible handwriting—all factors that would weigh in favor of using some sort of computer program to do the marking up. Fair enough, but before we go down this path, a couple of caveats. First, make sure that you use a program that doesn't add notes and marks that will only be visible when viewed within the program. You need all the added notation to be visible when you print this document (this is the problem with the tagging

functions in some screenwriting software: they permit you to annotate your script, but you can't always see the insertions and identifications on the printed page). Second, don't use a program that reformats or otherwise interferes with the text of the script as you add notes. Doing so will throw off your page count.

As long as you keep these words of warning in mind, there's nothing stopping you from doing your breakdown electronically. In fact, by dispensing with marks such as circles, boxes and asterisks that can be hard to manipulate on a computer, we've created a breakdown code that is particularly computer-friendly. Indeed, all the examples in this book were drafted on a computer. Our system relies entirely on a color-based system. Here's how it works: we're going to go through the script a number of times. In each pass, we're going to identify or tag one or two production elements by underlining those elements with a specific color:

- *CAST* is underlined in *red*
- *EXTRAS* are underlined in *green*
- *PROPS* are underlined in *orange*
- *VEHICLES* are underlined in *blue*
- *SOUNDS* are underlined in *yellow*
- *MAKEUP AND HAIR* requirements are underlined in *pink*
- *WARDROBE* needs are underlined in *violet*
- *STUNTS* are underlined in *brown*
- *SPECIAL EFFECTS* are underlined in *magenta*
- *CAMERA/GRIP* is underlined in *black*

It should be noted that this system is somewhat streamlined and simplified from one that might be used for a commercial feature. As always, the aim here is to provide you with tools that are especially suited to the demands of producing short projects.

Pro Tip

"The script isn't always going to spell out that in a certain scene you might need three goats, one car, two shepherds and blah, blah, blah. But, in reading the script, the scene in my mind won't work without those elements. And that's really the breakdown process: to think about every technical and creative element that is required to deliver each scripted scene to the screen."

—*Marie Cantin*

You might prefer to highlight elements rather than underscoring them. We won't think less of you if you follow this route, but keep in mind that highlighting elements can make them hard to read (especially in low-quality printouts) and it uses up a lot more printer ink than does underscoring.

Since these categories are going to be the building blocks for our breakdown, they bear closer examination:

- **CAST *(red)*** generally refers to characters who have speaking parts. As always, there are exceptions. Suppose you have a scene that calls for a group of dinner guests who utter small talk. Are all these chatty guests to be counted among your cast? Probably not. SAG-AFTRA, the union that represents screen actors, has its own specific definitions for various types of performers, and we'll touch on this issue again elsewhere. For now, however, let's stick with the rule of thumb that anyone who performs a *scripted* line of dialog should be counted as a cast member. We'll rely on common sense to deal with any aberrations that might arise.

- **EXTRAS *(green)*** are performers who don't play significant dramatic roles. This could include a waiter who does nothing more than hand someone a menu or an orderly who merely walks down a hospital corridor. In the professional realm, a distinction is often made between *extras* and *atmosphere*, the former being performers who serve defined functions (waiters, orderlies) and the latter being nothing more than background action (e.g., the crowd at a ball game). In our simplified system, we're lumping everybody together, but in doing so, we must exercise some caution. Always give some thought to those extras who must meet special requirements. Perhaps they must own a waiter's uniform, know how to drive a motorcycle or look good in spandex. But don't take more generic extras for granted, either. When you have a scene that calls for background action of a very general nature—a crowd at the beach, for example—don't let yourself be seduced into the convenient fiction that a photogenic crowd of beachcombers will simply materialize when you need them and then stay put for the duration of your shoot. Whatever the case, note down the specifics: what sort of extras are needed and how many.

- **PROPS *(orange)*** can sometimes seem like a bottomless pit. Let's say our movie takes place in the newsroom of a city paper. Picture that newsroom, then try to make up an inventory of every item filling each crowded cubicle—every birthday card, family photo, half-drunk cup of coffee . . . Okay, let's stop before our heads explode. We want to be thorough, but again, common sense must prevail. If we're going to transform a church basement into a newsroom, we'll have to round up a multitude of props and note them accordingly in our breakdown. If, on the other hand, we have

access to a working newsroom, we would only make note of the props that are essential to the scene. In the professional world, a distinction is made between *props* and *set dressing*, the former being broadly defined as stuff that can be moved about and the latter being items that are fixtures, such as a fireplace. In our system, we are again lumping everything into one category, but in the event that we're planning to build actual sets for our film, we should give some thought to amenities that we might take for granted when shooting on location. For instance, does the sink or stove in our kitchen set need to be **practical**, meaning that it must actually function, or is it merely there for appearances? If our project calls for very involved sets, we may want to create a separate category for set dressing. After all, the demands of outfitting the interior of a spaceship are entirely different from those of rounding up everyday dinnerware or an antique clock.

- *VEHICLES (blue)* are any conveyances—cars, trucks, ambulances, tractors—called for in a scene. The detail to which you must account for background traffic depends on the circumstances of your shoot. If you are filming on a city sidewalk and not blocking off traffic, you may not need to account for any vehicles other than those directly involved in the scene. On the other hand, if you have a night shoot scheduled for what is supposed to be a busy shopping center parking lot, you'll need to arrange for at least a small fleet of cars to fill the parking spaces during the wee hours. Production vehicles—cars, vans and trucks used behind the scenes—are not included in this category.

- *SOUNDS (yellow)* encompass everything from a gunshot to a song playing on a jukebox. Dialog is *not* considered part of the sound inventory, but if an actor's voice must be treated in a specific way (e.g., a pronounced echo applied to it), you should note this. As a rule, if an original music soundtrack (also called an **underscore**) is being composed, this isn't accounted for in the breakdown, but if the scene calls for **source music**— pre-existing or original music that is part of the action (think again of that tune playing on the jukebox)—then this must be noted. There is much more to be said about the role of music in film, but for the moment, our concern is very simple and concrete: though it almost certainly will *not* be playing during the actual filming, if music is to be heard in the background of a scene, it affects the way the actors speak, the level of background chatter and so on, and therefore it should be noted in the sound category.

- *MAKEUP AND HAIR (pink)* may seem like rather obvious considerations, but it's surprising how often people overlook the important dramatic role that cosmetic issues can play in a story. Perhaps a character has

been up all night or has simply been through an emotionally draining experience. Surely this would affect his appearance in a scene. Also, don't forget that—barring very involved prosthetics—bruises, wounds and scars also fall under this category.

- *WARDROBE (violet)*, like makeup and hair, can get lost in the shuffle. This is particularly true when actors are told to wear their own clothes. It is never wise to assume that an actor will know what wardrobe to wear for a given scene. The pitfalls here are numerous, but let's consider just one example. Your story takes place over two days in the life of a character we'll call Sarah. The shoot, however, is going to take *six* days, and—as is usually the case—it will require that the scenes be shot out of chronological sequence. It is therefore essential that you note in the breakdown for each scene whether Sarah is to be in the wardrobe for Day 1 or Day 2. Again, it's always wise to note signature details, such as a cook's apron or a soldier's helmet. In this domain, the line between prop and wardrobe item can get fuzzy. Take a name tag, for instance: prop or wardrobe? Our practice is that if the item accompanies a particular outfit, then it should be accounted for under wardrobe. Therefore, if a security guard carries a flashlight in a holster on her belt, it's a wardrobe item; if she retrieves the flashlight from a closet, it's a prop.

- *STUNTS (brown)* don't just refer to daredevil feats. They encompass the full range of staged combat, from a barroom brawl to a slap in the face. They can also come into play in less obvious situations. Suppose your script calls for a character to slam dunk a basketball. Unless you've already signed up the gravity-defying LeBron James to star in your movie, you should not assume that your actor will be able to pound the backboard convincingly without assistance. This is true even if your actor swears that he can dunk like a pro.

- *SPECIAL EFFECTS (magenta)* didn't used to play as large a role in shorts as they regularly do in features, but times are changing. I have seen student films that made extensive use of **green screen** effects, and it's become almost commonplace for short films to use **visual effects** to enhance the impact of explosions and gunshots. Special effects can be subdivided into two categories: **mechanical effects**, which are phenomena that must be created on set, in front of the camera, and visual effects, which are created through digital manipulation or other postproduction processes. As noted previously, when a scene calls for very involved prosthetics (severed limbs and other ghoulish stuff), you would generally account for such mayhem under special effects rather than makeup and hair, though clearly cosmetics will come heavily into play as well.

• *CAMERA/GRIP (black)* is really an abbreviation. At a minimum, this category should be called Camera, Lighting and Grip, but that wouldn't fit onto the various forms we're going to be using. We all know what cameras and lights are, but *grip* is less of a household word. Grip equipment refers to all the gear that supports and augments the camera kit and lights. This includes everything from the dolly that is used to move the camera to the stands and drapes used to black out a window. In general, you won't find camera, lighting and grip needs enumerated in a script, and that's the reason we've reserved black for this category. You'll almost always need to underline a particular phrase and write a note regarding the equipment that will be needed. On large-scale productions, camera, lighting and grip needs may be broken out into more specific categories. Once again, we're keeping things simple by combining several departments into one domain. By the way, were we to use a camera car or truck for filming, we would account for that in this category, not under vehicles.

Every production has its special considerations, and this might require you to modify your breakdown categories. Were you to film your short entirely at sea, you would have a plethora of nautical considerations to catalog. A fantasy film might require a number of sets, in which case it would make sense to have a category for Set Construction. We have limited ourselves to the most common categories, but you are not limited to this list.

Pro Tip

"When I'm looking at a script, I'll often look for things that are unusual, that are very specific to the script. Maybe it's an issue of rain, maybe there's a large visual effect or mechanical effect or there's an unusual **picture car**, a train or an airplane in the scene that's going to be a significant cost, something that we have to shoot that might be a **plate**, or a **process shot**—those are the sort of particular things that I would look for and note specifically. They would be in addition to a normal day cost."

—*Michael Nozik*

Putting the Code Into Action

So, how does all this labeling and pigeonholing actually work? Let's break down the first couple of pages of *Shoebox Redhead*. Remember that the entire script for *Shoebox Redhead* can be found in Appendix A, and the complete

script breakdown can be downloaded at *theshortseries.com*. Some things to look for in our breakdown:

- If something is mentioned in the script, it gets underscored. If it's not mentioned and needs to be accounted for, a note (in the appropriate color) is made in the margin.
- You should only underscore or note an element *once* per scene. As a rule, underscore the first time the element appears in a scene.
- As always, judgment and common sense frequently come into play. I have made a makeup and hair note regarding Matt's bloodshot eyes in the margins of Scenes 5 and 6, but I don't add any marginal reminders regarding the two middle-aged women's "teased-out hair." What gives? Well, I'm reasonably confident that the female extras will maintain a consistent look, but Matt's reddened eyes are both a key dramatic point and a detail that could be easily overlooked.
- As we'll see, the film contains many scenes that take place in or around a car. Whenever there is a chance that we'll have to shoot while the car is moving or through the car's windshield, I have made note that a **car mount** might be needed.

I have counted the title card at the end of Scene 3 as a special effect. That might sound like a stretch, but any element that involves the manipulation of the image through the editing process can be considered a visual effect. Besides, who knows? Maybe the director has in mind some more involved graphic element, like the title appearing as though it's painted onto the road. What's really important here is that we remind ourselves that there needs to be sufficient time and space at the end of Scene 3 to accommodate a title card.

> ## The Shoebox Diaries
>
> "Always have multiples if there is even the slightest chance something might happen to a prop, actor's wardrobe, etc. We had three shoeboxes—all identical. We ended up using all three for the beach scene. Thankfully, the third take was the charm."
>
> —*Matt Lawrence, Producer, Director, Writer & Editor*

There are a few more points to take into consideration, but they'll be easier to address once you've had a look at the first few marked-up pages of *Shoebox Redhead*, which you'll find among the color illustrations in the middle of this book. Please take a moment to review those pages now.

Every production seems to have some twist that poses a special challenge. *Shoebox Redhead* has a couple of related hurdles that both happen to appear in these first pages. Did you catch them? There are two key props that involve still photographs: the air freshener souvenir in Scene 2 and the shoebox full of Polaroids in Scene 7. These might not look like much on the page, but both of these props will require considerable preproduction planning, especially the air freshener, which not only will take some time to be manufactured but which calls for our lead actor Matt to be "clean-shaven." If Matt is going to sport a beard for the shoot, then this photo needs to be taken weeks if not months in advance.

Although Matt's ex-girlfriend Jacki hangs over the story like a dark cloud, her appearance in the photo on the air freshener is the only time we actually see her. Of course, we'll need to recruit someone with suitably heartbreaking attributes to be featured in this painful memento. This being the case, shouldn't we perhaps treat her as we would any other role in the film? While you're scratching your head over that one, consider the case of Mandi, the titular redhead whose exploits are documented in a bunch of Polaroids. Like Jacki, Mandi only appears in still photographs, but in other respects, her role is quite different. First of all, in the Polaroids in the shoebox, she appears in a variety of places, so assembling this portfolio of Mandi portraits will take some time and thought. Second, Mandi reappears in a crucial moment at the end of the film. At a seaside attraction called Rigby Pier, Ryan takes a Polaroid snapshot of Matt sitting alone on a bench, but when the photo develops, Mandi magically appears at his side. It's important to note that Mandi is only seen in the photograph and not in the flesh. Nevertheless, this character will clearly need to be on hand at the pier. Again, don't these considerations weigh in favor of treating Mandi as we would any other character in the script?

Without exaggeration, I can report that I spent many hours wrestling with how to treat Jacki and Mandi in the script breakdown and the production schedule. I even went so far as to do a version of the script breakdown where I treated the shooting of the stills for the air freshener and the shoebox Polaroids as stand-alone scenes. No doubt many professional production managers would shake their heads at this. After all, in a large-scale production, it would be the responsibility of the art department to make the necessary arrangements so that these props get produced and are ready when needed on set. On a shoot the scale of *Shoebox Redhead*, however, production of the photos has to be factored into the planning for the shoot as a whole. Consider, for example, the consequence of having either the director or the cinematographer go off with the actress playing Mandi to shoot those "dozens of old photographs" for the shoebox. In short order, the rest of the production would grind to a halt.

After much deliberation and trial and error, I decided to treat only Mandi as a cast member and not Jacki. For me, the fact that a living, breathing person

playing Mandi would need to be on hand for the scene at the pier was a crucial distinction. I also came up with a solution as to how to work the still photo shoots for both the air freshener and the Polaroids into the production schedule without making a complete hash of my script breakdown. You'll have to read on to see how I eventually solved that puzzle. For now, the key point is to not let these considerations get lost in the shuffle. In truth, my very orthodox breakdown, whereby I just mark the air freshener and shoebox photos as props, doesn't exactly sound any alarm bells. It would be prudent to add notes in the margins of Scenes 2 and 7 as reminders that these items will require special attention.

The Shoebox Diaries

"When shooting the photographs of Mandi, I spent a day before filming began shooting the single shots of her (the ones found at the garage sale) but forgot to grab the photographs at Rigby Pier (her alone, her and I). Luckily, after much cajoling, I convinced her to wake up at dawn and come take the photo while we shot the actual scene. Some things just escape you, and you have to hope luck is on your side."

—*Matt Lawrence, Producer, Director, Writer & Editor*

Have we lost you in the weeds, or are you still with us? If you've managed to navigate all the twists and turns of the script breakdown, then you're starting to think like a producer. This means both exercising Solomonic judgment and being willing to make a few false starts before finding the right path.

Breakdown Sheets

Creating Breakdown Sheets

Once you have marked up the script carefully and completely using the code in Chapter 3, you'll find it easy to compile your breakdown sheets. Breakdown sheets are forms that list the materials and personnel required for a scene or group of scenes. Since your marked-up script now identifies these elements, this information can be swiftly transferred to the sheets.

How Many Sheets?

In most cases, follow this simple rule for breakdown sheets: one scene, one sheet. The only exceptions are instances where two or more scenes contain the *exact* same elements. One example would be a scene (such as a traumatic flashback) that appears repeatedly in a screenplay. Each time the scene appears, it should have its own new number, but since the action is exactly the same each time the scene appears, all of its many iterations can be summarized on one breakdown sheet. Be careful, however: many times, a director might have very good reasons to shoot what is scripted as a recurring action in a variety of ways. Suppose our flashback is of a child being hit by a car. There might be entirely justifiable dramatic or stylistic reasons not to use the same footage of the accident over and over. Perhaps the director wants to show the accident from multiple vantage points. These diverse perspectives could have very different logistical requirements. In such situations, you may choose to fall back on the one scene per sheet rule.

Another common instance where one sheet might be used to account for multiple scenes is in the case where **parallel action** is employed. This is the practice of intercutting between two events. A familiar example would be a couple talking on the telephone. The conversation might be scripted to indicate frequent cuts back and forth between two locations—him in Seattle; her in New York. Since the conversation is meant to be continuous, however, we can

pretty much guarantee that we're going to shoot the entire seamless conversation on both the Seattle and New York sets. Therefore, the Seattle portion of the conversation (let's say this covers Scenes 35, 37, 39 and 41) can all be accounted for on one breakdown sheet, while the New York portion (Scenes 36, 38, 40 and 42) can all go onto another single sheet. Keep in mind that we are only lumping together the scenes from one end of the phone line and that we are dealing with a continuous conversation. Were we shooting multiple conversations that take place at different times, then each phone call would have to be accounted for separately.

It's easy enough to make a template for a breakdown sheet on the computer, but we've spared you the trouble: you can download a template in several common file formats at *theshortseries.com* and get right down to business. If you have opted to invest in scheduling software, you will definitely want to use the program to create breakdown sheets, since all the data entry work will then carry over into the next stages of the scheduling process (that, in a nutshell, is the key asset of these programs).

A Sample Sheet

Let's jump in and fill out the breakdown sheet for the very first scene in *Shoebox Redhead* (Figure 4.1).

There are eleven boxes in the lower portion of the breakdown sheet: one for each breakdown category, plus a box for notes. The varying space allocated to each category on the form is based on experience. Cast and Props tend to be big categories, whereas notes about Sounds are relatively rare. Every project is different, however; *Shoebox Redhead* happens to have a small cast.

Speaking of the cast, you'll notice that Ryan's name in the Cast box is preceded by the numeral 2. This is Ryan's identification or I.D. number. Whenever he pops up in a scene, his presence will be duly noted on the associated breakdown sheet with both his number and his name. If you've read the entire script of *Shoebox Redhead*, you can guess who gets I.D. number 1: Matt. In truth, in assigning Matt the top spot, we're violating the general rule for assigning I.D. number, which is that we should rank characters by the total number of scenes in which they appear. Both Matt and Ryan are in almost every scene in this screenplay, but because Matt magically disappears just before the end, leaving Ryan to carry on with his new friend, Ira, Ryan appears in a couple more scenes than Matt. For what it's worth, Ryan is also a more charming and lively character than Matt. So, why give mopey Matt the pole position on the cast roster? Simply because this is *his* story. Occasionally, you'll have to fudge rankings this way. For instance, suppose you get Lena Dunham to make a cameo appearance in your short (sounds like a stretch, but such things happen). In terms of

Shoebox Redhead		

Scene(s): 1 **Sheet:** 1
Script Pages: 1 **INT/EXT:** EXT
Length: 2/8 **DAY/NIGHT:** DAY
Scene Description: Ryan sets the shoebox out to sea
Set: Beach **Script Day:** 1
Location: Webster Ave. & Boardwalk, Seaside, NJ

CAST	EXTRAS	PROPS
2. Ryan		Shoeboxes (6)
		Cigarette Butts (3)
		Trash for Beach
	STUNTS	
CAMERA/GRIP	**MAKE-UP & HAIR**	
		SPECIAL EFFECTS
VEHICLES	**WARDROBE**	**SOUNDS**
	Ryan's Wardrobe	
	Extra Pants?	
	Extra Shoes?	
		NOTES
		Permit for beach shoot
		Protect Ryan's pants & shoes

Figure 4.1 Breakdown Sheet, Scene 1

scenes, she might have the lowest count of any character. Nevertheless, you won't put Ms. Dunham at the bottom of the cast list. Unless her agent makes a fuss, you probably wouldn't promote her to the top, either, but you'd at least rank her up with the principal characters.

Wardrobe is something of an anomaly, in that it contains a note—"Ryan's wardrobe"—that is not found in the marked-up script. Adding notes on wardrobe to a script is tricky. If you have a large cast and lots of wardrobe changes, you'll clutter up every bit of white space on the page with wardrobe notes. For this reason, we tend to make wardrobe notes on the script only when something unusual is called for, such as an extra set of clothes for a stunt. As it happens, in the case of *Shoebox Redhead*, wardrobe logistics are very straightforward, as all characters wear the same outfits throughout the story. Therefore, adding "Ryan's wardrobe" in the Wardrobe box here might be stating the obvious, but if you think of the breakdown sheet as being a kind of master checklist for the production, it certainly doesn't hurt to have a reminder that the crew needs to bring Ryan's wardrobe along to the beach shoot.

By the way, one of the handier functions provided by scheduling software is the ability to link elements so that whenever a character appears, any elements that are always associated with that character automatically go into the appropriate categories in the breakdown. Remember our security guard example? Since she never appears without her uniform, holster and flashlight, we can tell the scheduling software to add these items to the wardrobe box any time the guard appears—a nifty feature.

The Shoebox Diaries

"I cannot stress how important it is to have a handle on wardrobe when it comes to your breakdown sheets. Obviously, things were easy on *Shoebox*. For my most recent film, the main character had ten or twelve outfits. At one point, our wardrobe girl went home for a few days, and a **PA** had to take over. She didn't look at the breakdown sheets and merely asked the actor what he wore the day before. Needless to say, we shot out of order and there is a strange outfit change at one point in the movie."

—*Matt Lawrence, Producer, Director, Writer & Editor*

The notes added in the lower right are pretty straightforward: reminders to have a permit for shooting on the beach and to keep Ryan's shoes and pants from getting wet in the ocean. As you break down each scene, you'll often be struck by thoughts that begin with the phrase, "Oh, we have to remember to . . ." This is the box for those thoughts.

Filling in the Header

Let's now turn our attention to the upper or header portion of the breakdown sheet. Much of the information that must be filled in is self-explanatory, but there are a few surprises lurking here. Take the seemingly innocuous item "Sheet."

This refers to the number we assign to each breakdown sheet. What could be simpler? Well, in fact, there are at least two ways to organize and number breakdown sheets. You can put them into the approximate order in which the scenes appear in the script, allowing for the occasional kink caused by combined scenes. This approach is called "script order." Alternately, you can put them into the order that follows the shooting schedule, which is called "schedule order." As we'll see, the order in which we shoot things can change at the last minute or even in the middle of a shoot, and we don't want to renumber sheets once we've set up a system. Therefore, for *Shoebox Redhead*, we're numbering the sheets in script order.

It's obvious enough what to do with "Day/Night" most of the time, but even here the occasional wrinkle can appear. After all, *night* and *day* are about as descriptive as, well, black and white. Look at how Scene 1 is scripted: "EXT. BEACH—SUNSET." This evokes something quite different from "EXT. BEACH—DAY," doesn't it? Yet we have noted "DAY" rather than "SUNSET" on the breakdown sheet for this scene. What gives? As we will see once we get to the scheduling phase, we will be using another, simpler color code to sort through all the scenes. In its most basic form, this code only has four options: INT.—DAY, EXT.—DAY, INT.—NIGHT, EXT.—NIGHT. You can embellish this list, and many production managers like to use different shades for dawn or dusk. In our experience, however, this tends to introduce too many variables, so it's a practice we avoid. If we like the idea of shooting the scene at sunset, we can add a note or slip "sunset" into the scene description.

Speaking of which, the Scene Description slot should be filled in with care. You want to capture the action covered by the scene as succinctly as possible without repeating yourself or resorting to wording that is too generic to be meaningful. "Ryan and Matt travel in car," for instance, could apply to at least a couple of scenes. Try to zero in on the dramatic core of the scene.

For films shot on location, "set" and "location" may seem redundant. Isn't your set also your location and vice versa? Well, not always. Remember the example of the newsroom of the city paper? If we decided to shoot the newsroom scenes in that church basement, the information on the sheet would read, "Set: Newsroom" and "Location: Church basement." If possible, include the address.

The Shoebox Diaries

"It's imperative to include the address of your location on as many documents as possible. I included addresses in breakdown sheets, daily schedules and anywhere else I could find a space. People like to know where they are going and what to expect when they get there. We fear the unknown."

—*Matt Lawrence, Producer, Director, Writer & Editor*

Script Day refers to where the scene in question falls within the chronology of the script. In the case of *Shoebox Redhead*, this is a moot point since everything happens on one day. In many scripts, however, a consistent chronology is crucial to maintaining dramatic and material continuity. In our earlier example of the story of Sarah, which plays out over two different days, it would be very important to know whether a given scene takes place on Script Day 1 or Script Day 2.

Some Tricky Details

So far, this is mostly simple data entry—hardly rocket science. If you're ready for something more challenging, let's back up and examine the very first slot in the header: "Scene(s)." This is where you put the number(s) of the scene(s) covered by this sheet. Believe it or not, we wrestled mightily with the issue of what to list here. The problem is that, later in the script, the scene in Figure 4.2 appears.

Scene 19 is pretty much a seamless continuation of the first scene. The obvious question, then, is: can't we put these two scenes onto one breakdown sheet? Isn't this situation analogous to our earlier example, the Seattle–New York phone call, these two scenes being much like the snippets of one side of the telephone conversation that can be stitched together into one entity? In truth, there isn't one correct answer. This is how I thought it through: yes, Scene 19 is indeed a continuation of Scene 1 (see Appendix A if you need a reminder), but the scope of action is quite different in each case. Scene 1 deals only with Ryan, the cigarette, the shoebox and the ocean. In Scene 19, Ira appears, and not standing beside Ryan; he's "back where the beach begins." The focus of the two scenes is distinct enough that the director might choose to shoot them in very different ways. Moreover, there is no need to make Ira cool his heels while we get the shoebox to launch properly into the waves in Scene 1. It makes more sense to keep the production elements separate, even though we can be virtually certain that we'll shoot these two scenes back to back.

There is another instance in the script where two scenes are very closely connected. If you go back and look at pages 2 and 3 of the script, you'll see that there are back-to-back scenes at the garage sale—Scenes 6 and 7. A slug

```
19   EXT. BEACH -- LATER                                    (2/8)

     The water engulfs the shoebox, dragging it slowly to its
     watery grave.                                   Extra Shoeboxes (6)
                                                  Extra Cigarette Butts (3)
     Ryan takes a last drag from his found cigarette and turns
     around to Ira, who has been watching from back where the
     beach begins.  Ira waves.  Around his neck hangs the camera.
```

Figure 4.2 Scene 19, Marked Up

Shoebox Redhead

Scene(s): 7 **Sheet:** 7
Script Pages: 3-4 **INT/EXT:** EXT
Length: 1 3/8 **DAY/NIGHT:** DAY
Scene Description: Matt & Ryan discover & buy the shoebox
Set: Garage Sale **Script Day:** 1
Location: Barra St. & Bendermere Ave., Interlaken, NJ

CAST	EXTRAS	PROPS
1. Matt	Old Man	Jacki Box
2. Ryan	Middle-Aged Woman (2)	Garage Sale Junk
4. Old Woman		Card Tables (6)
		Lawn Chairs (3)
		Blankets (6)
		Sweatin' to the Oldies Tape
		Shoebox
		Old Polaroid Photos (30)
		Polaroid Camera
		Five Dollar Bill
		Ryan's Wallet
	STUNTS	
CAMERA/GRIP	**MAKE-UP & HAIR**	
	Matt - Red Eyes	
	Hair Spray	
		SPECIAL EFFECTS
VEHICLES	**WARDROBE**	**SOUNDS**
V1. Station Wagon	Matt's wardrobe	
	Ryan's wardrobe	
	Old Woman's wardrobe	
	Old Man's wardrobe	
	Nylon Jogging Suits (2)	**NOTES**
		Shoebox photos must be shot prior to this scene!
		Rights to Sweatin' tape

Figure 4.3 Breakdown Sheet, Scene 7

line tells me that the second scene occurs just "moments later." From a production standpoint, then, can't I treat the two scenes as one unit? As always, the devil is in the details. The table where Matt comes upon the shoebox filled with Polaroids only comes into play in Scene 6; it isn't mentioned at all in the previous scene, which seems to take place in a different part of the garage sale. Because the production elements are slightly different, I have opted to give each scene its own breakdown sheet. Examining the sheet for Scene 7 (shown in Figure 4.3) is a good way to walk through the last few steps in the breakdown process.

By now, the information I have put into the boxes should make sense. A garage sale is a cluttered affair, so a lot of props are called for, only some of which are explicitly mentioned in the script. I must take care to list *all* props, both those underscored in the script and those I have added in the margins.

The notes are important here. The first, "Shoebox photos must be shot prior to this scene!" ensures that we'll make time in our schedule to produce the Polaroids of Mandi. Next, "Rights to Sweatin' tape" reminds me to look into whether I need permission to show the copyrighted *Sweatin' to the Oldies* videotape packaging on-screen. I will address this and other issues related to copyright **clearance** in a later chapter.

If it weren't already obvious from the previous breakdown sheet for Scene 1, you can now see that "Script Pages" points to the page or pages in the script where the scene in question can be found. Scene 7 spans pages 3–4. "Length," of course, refers to the amount of the script that is covered in this breakdown unit. When two or more scenes are covered by a single breakdown sheet, their *combined* length should be reflected in the Length entry. For example, if I *had* combined Scenes 6 and 7 onto one breakdown sheet, the Length entry would have been 2 1/8. That accounts for the 6/8 page for Scene 6 and the 1 3/8 pages for Scene 7.

Pushing On

I previously referred to the breakdown process as being the foundation of our production. As with laying the foundation of a house, some of the work requires plain old hard work. Stacking building materials and grading a property aren't the most glamorous or edifying tasks, and this is also true of breaking down a script. Moreover, the result of your toil may not be very impressive at first blush. But as anyone who has worked construction can attest, once the foundation has been laid, the frame of a building can be put up quite quickly. Much the same can be said of my shooting schedule: it's the frame that rises on the foundation I've just created. And because I now know my building materials—the scenes and their constituent production elements—so well, assembling those materials should be a more creative and stimulating process.

Chapter 5

The Schedule

Building the Shooting Schedule

Here's a tasty analogy: if we think of the breakdown sheets that we've just compiled as the list of ingredients, then the schedule is the recipe and the production is the cake. The comparison is pretty apt. Breakdown sheets are indeed a roster of all the resources that will be needed to make our movie—everything from actors to vehicles and props—and just as there is a logical order in which we should combine ingredients when baking, so too is there an optimal sequence in which we should deploy the resources needed for our production. Coming up with that ideal arrangement is what the art of scheduling is all about.

As with all aspects of planning a movie, the trick with scheduling is to avoid getting distracted by the details. Even a short film involves thousands of moving parts. Therefore, it's important to come up with an overview or master plan that lets you see beyond the clutter. The collective wisdom of generations of production managers has yielded a system for scheduling motion pictures that is both efficient and handy. Once we have completed our schedule for *Shoebox Redhead*, we'll have a road map for our production that fits onto just a couple of sheets of paper.

The system we use for scheduling harkens back to a time before the computer age when production managers needed a way to distill a great deal of information and to redeploy resources quickly. They came up with a tool called a stripboard (some diehards still use bona fide stripboards: you can search for and find them online). As the name implies, the stripboard is a cardboard frame in which thin strips filled with coded information can be arranged. Each strip summarizes the information from a single breakdown sheet. The strips can slide in and out of the board, allowing the production manager to try out different combinations of production elements before settling on a specific order. Furthermore, if bad weather or a sick actor forces changes to the schedule during production, the production manager can simply shift the strips to adjust the shooting order.

We still use a version of the stripboard, the difference being that now we organize and store the information on computers. The process for making the stripboard is simple: first we'll transfer all the relevant information from the breakdown sheets onto strips, then we'll put the strips into a shooting order. If you are using scheduling software, some of this work is done for you automatically. For example, you won't have to make the strips; once you have filled in your breakdown sheets, the strips are instantly in the system. The rest of us have a little work to do before we can start tinkering with the schedule. I have provided a stripboard template in Excel at *theshortseries.com*. Download the template and follow the editing instructions on the website. As those instructions point out, you shouldn't edit the template. Duplicate it and then fill in the information on the copy.

As I have said, each strip in the stripboard is a distillation of the salient information on a single breakdown sheet. Much of the information is compressed into a simple code. For instance, each strip is color-coded to make it easy to see if a given production unit calls for shooting indoors or outdoors, or for filming in the daytime or at night. Here's the code:

- Interior Day = White
- Interior Night = Blue
- Exterior Day = Yellow
- Exterior Night = Green

Some production managers use a wider range of colors for specific situations, such as shooting at dawn or magic hour. I prefer to keep the system as straight-forward as possible.

You actually already know the rest of the stripboard code. Remember those I.D. numbers for cast, vehicles and gear? Here is where that system comes into its own. Instead of having to write out each character name and so on, we can simply put their I.D. numbers on the strips.

Options for Laying Out the Schedule

Broadly speaking, there are two stripboard layouts: vertical and horizontal. The original cardboard stripboards used very narrow vertical strips. The coded information on these strips is cross-referenced with a key, called the **header board**, on the left side of the board. The virtue of the vertical board layout is that it can compress a vast amount of information into a small space. This is very handy when we're dealing with a feature production that might have 200 scenes and 50 speaking roles. With the vertical format, we can squeeze all the critical schedule information for such a vast operation onto four or five

cardboard panels. The drawback of this format is that, in the interest of economy, it sacrifices detail and clarity. Now that our schedules can be based on computers, keeping the footprint of the stripboard as small as possible is less critical. This is why, over the past several years, the horizontal format has risen in prominence. The horizontal layout uses the same color coding and numerical system, but the information is laid out with a little more detail, making the individual strips easier to read.

Since we're dealing with short productions here, there is even less incentive to conserve space on the stripboard. Therefore, I have opted to use the horizontal format. If I fill in the information from Sheet 1 (covering Scene 1) onto a strip, Figure 5.1 shows what it should look like (use your imagination to see the strip in all its yellow glory).

Compare this strip with the first breakdown sheet in Chapter 4. I hope it's apparent how a good deal of the information from the breakdown sheet has been transferred into the strip. Just to drive the point home, Figure 5.2 shows the strip for the other example, Sheet 7, which covers Scene 7 (once again, imagine that it's yellow).

Get the picture? To start creating your stripboard, you should make as many blank strips as you have breakdown sheets. Then you just need to put on your headphones, crank up your favorite playlist (this isn't a process that involves mental strain) and start filling in the strip information. Make sure that all the data match up: you should use exactly the same slug lines and scene descriptions. This will make it easy to cross-reference sheets and strips. Once you have filled in all the strips, you now have the building blocks for your schedule. To complete the stripboard, you're going to move the strips into the preferred

Scenes: 1 Sheet: 1	EXT	BEACH	DAY	Cast: 2
		Ryan sets the shoebox out to sea		Vehicles: Camera/Grip:
Length: 2/8				Extras:

Figure 5.1 Schedule Strip, Scene 1

Scenes: 7 Sheet: 7	EXT	GARAGE SALE	DAY	Cast: 1, 2, 4
		Matt & Ryan discover & buy the shoebox		Vehicles: V1 Camera/Grip:
Length: 1 3/8				Extras: [3]

Figure 5.2 Schedule Strip, Scene 7

shooting order (if you're using our Excel file, the easiest way to do this is to paste the strips into a new document generated from the stripboard template). Insert solid brown strips to demarcate shooting days. In one sense, this is all there is to drawing up a schedule: You simply group your strips into shooting days. Of course, there must be a logic guiding your plan, and this is where a great deal of careful consideration comes into play.

Pro Tip

"Doing a schedule is like doing a three-dimensional puzzle in the dark. You never know what's going to happen, and you have to plan for everything."

—*Don Daniel*

What Has Priority?

When I first studied filmmaking, I was shocked to discover that movies were almost never shot "in sequence"; that is to say, following the order of scenes as they appear in the script. Instead, I learned that it was common practice for, say, Scene 14 to be shot after Scene 23 and so on. This revelation infuriated me. How could the actors summon up genuine and coherent performances when they had to play any given dramatic moment completely out of context? In truth, the righteous indignation I felt on behalf of all the long-suffering screen actors was not entirely amiss. Shooting in script order often helps maintain the dramatic logic and momentum in a film. Given this fact, why do we so frequently shoot productions out of sequence? To put it slightly differently, if our natural preference would be to shoot in script order, what factors could persuade us to do otherwise? To answer this question is to unlock the mysteries of the scheduling process.

What should we shoot first? How much ground can we cover in a day? Finding the answers to these questions involves first establishing a set of priorities. This list of factors will vary with every production. That's because the conditions that prevail on every shoot are different. If you are lucky enough to get Emma Stone to star in your short, Ms. Stone's availability will be your first consideration. On the other hand, if your cast is headlined by your underemployed roommate, his needs will be less critical to the production schedule. These and many other variables notwithstanding, there are still a few basic considerations that take precedence in drawing up a schedule. The issue we addressed earlier—shooting scenes in script order and maintaining the dramatic logic of the story—is certainly one of these factors, but usually it's not

at the top of the list. Indeed, there are generally four considerations that almost always trump shooting in sequence as priorities:

- Finish off a location
- Shoot exteriors, then interiors
- Work around cast availability
- Make the most of equipment rentals

Let's briefly examine each of these factors.

- *Finish off a location*: If there is a cardinal rule of scheduling, it's that you never want to return to a location. Setting up a production—even a very low-budget production with a small cast and crew—is a big operation. You do not want to go through the trouble of dismantling all the equipment, sets and props you've brought in (what's called a **company move**), only to have to bring it all back to the same location at a later date. Of course, as with every rule of filmmaking, there are exceptions. If you need to radically alter the look of a location (think of the plantation of Tara before and after the Civil War in *Gone With the Wind*), you might shoot at a location in two separate time blocks.

- *Shoot exteriors, then interiors*: All else being equal, we want to put all exterior locations onto the schedule ahead of the interiors. The logic is simple: weather is a factor with exteriors. If we have inclement weather early in the shoot, we might be able to move up an interior scene from later in the schedule to be shot while we wait for Mother Nature's mood to improve. Were we to do the opposite—schedule all interiors up front—we would have nothing to substitute when foul weather prevents us from shooting our exteriors.

 Notice the phrase I used: "All else being equal." This is a key point. I'm not suggesting that any one of these factors categorically overrides another. Take the last rule just discussed regarding shooting exteriors first and attempt to apply it to *Shoebox Redhead*. In truth, the great majority of this story is set outdoors. Indeed, that's a significant challenge posed by the screenplay. Nevertheless, there are some interiors (basically, all the car scenes). Would we necessarily put them at the end of the schedule? Well, to complicate matters, let's say that our cast is available to shoot over what is essentially a very long weekend, Saturday through Tuesday. Now suppose the Parks Department in Seaside, New Jersey, will only let us shoot on the beach on Tuesday because it's a slow day. How do I schedule Scenes 1 and 21, the two scenes that take place on the beach? If I acquiesce to the Parks Department, I violate the shoot-the-exteriors-first rule. What to do?

Well, I take some time to scout alternative beaches that have the requisite honky-tonk boardwalk backdrop. Of course, there are other boardwalks in New Jersey, but shooting at them would require hours of travel and sundry other headaches. I therefore weigh the factors and decide to stick with the beach at Seaside. This is how the scheduling process works: while I may give more weight to certain considerations, in the end, I must let common sense determine the best option.

As you consider which locations to shoot first, here's one more question to keep in mind: can an interior location be substituted for a given exterior setting? Scene 14 in *Shoebox Redhead* is supposed to take place "BACK OF BIG TOP BURGER." The scene opens with Ira the clown sitting "on the curb." This suggests that the action takes place in a burger joint parking lot. However, in the event of rain, would the scene be irreparably harmed by being moved indoors, perhaps to a restaurant kitchen, a store room, or simply a table in the dining area? Such an interior location that can be readily substituted for an exterior setting is called a **cover set**. Savvy producers always try to have a cover set on hand when shooting exteriors. Moving to an interior location may not be ideal, but often it beats getting behind in the production schedule. In order to have a cover set on hand, it must be initially scheduled at or near the end of the production. This way, you keep the scene viable as a substitution for as much of the shoot as possible.

Pro Tip

"Cover sets are something you always have to be thinking about—cover sets not only from the standpoint of weather but also other distractions or other things that may come up. So, you do think about cover sets, you always think about alternative locations if there's a problem."

—Jay Roewe

- *Work around cast availability*: That we must take our cast's availability into consideration may seem self-evident, but even the most basic principles can get distorted in the heat of battle. Therefore, let's state the obvious: having the right cast for our short is really, really important. That being the case, if we're given the choice between a second-rate cast that neatly fits all our schedule preferences and a first-rate cast that will require us to jump through some scheduling hoops, we'd better put on our gym clothes and start jumping.

Pro Tip

"Maybe on this particular short film, you're going to get a very famous actor who's going to do you a favor and come in, and they're in four scenes. Well, you know what? You're going to shoot that actor's work all on the one day you have them, and you're going to go to four different locations to shoot those four scenes. And then you're going to go back to those locations later to pick up the other scenes that take place there."

—*Bob Degus*

• *Make the most of equipment rentals*: Suppose you plan to rent a lens that will let you shoot in low-light situations or a set of powerful lights to use in exterior scenes. You don't need these pricey rental items for every scene, so why hold onto them for the entire shoot? If possible, schedule the scenes that employ this special gear in such a way that you can use it and then return it. Such concerns about equipment rarely supersede the first three considerations on this list, but they are still worth keeping in mind as the schedule takes shape.

How Many Days?

In a perfect world, I suppose, movies would be shot in as many days as it takes to shoot them. That is, we could take as much time as we needed to get everything just right, never having to crank through script pages or worry about losing our light. The world is not perfect. In fact, many times producers must get productions done within an arbitrary and abbreviated timeframe. We'll hear people discuss a "three-week feature" or a "one-day commercial shoot." The duration of these schedules is almost never dictated by creative interests. Instead, it's determined by budget or cast availability. The best we can generally hope for as producers is that we manage to strike a balance between the practical requirements of a project and the real-world constraints of time and money. This means determining a realistic pace at which a film can be made, one that pushes everyone to work hard without rushing to the point of sacrificing essential qualities.

It's the oldest cliché in the world: time is money. And in most realms of filmmaking, it's a gold-plated truism. On a conventional commercial feature production, for instance, everything from union rules to equipment rentals conspires to make each additional day of shooting a significant expense. The same logic generally applies to shorts as well, but there are exceptions. Let's say that you have a short script that takes place entirely in a fancy restaurant. You estimate that the script is going to take five days to shoot. How are you going to find a restaurant

that will shut down for almost a week while you film? Then your cinematographer tells you that her uncle owns the perfect place, and he's happy to have you shoot there, *but* you can only do so on the one day that the restaurant is closed each week, which happens to be Monday. Now you have a choice: rent a restaurant (perhaps a closed restaurant, which will require a lot of set dressing) and shoot as quickly as possible, or shoot the movie over five Mondays at no cost.

It's not such an easy call. Remember the rule about never returning to a location? How easy will it be to move your production in and out of the restaurant *five times*? Stretching a five-day production over five weeks also comes with certain pitfalls. That longer period gives more time for unwelcome changes to unfold—anything from hair growth to an actor running off to take a plum job offer. On the other hand, there are side benefits to consider: shooting at such a leisurely pace gives you lots of time to review and perhaps even edit your footage, meaning you can correct mistakes as you go. Arriving at the right decision involves weighing a whole host of factors such as these. The broader point is that, on very low-budget productions, it is occasionally (and only very occasionally) the case that the more viable and economical solution is to take more rather than less time to shoot the movie.

I projected that our restaurant short would take five days to shoot. How did I know that? Of course, an accurate estimate of the time required can only be arrived at after I've worked out the full shooting schedule. Nevertheless, I will have formed some opinions about the shooting schedule just by reading the script. All producers develop a mental gauge that helps them assess the demands of a production. As we read screenplays, we keep a running survey going in our minds: How many scenes? How many locations? Are there technically complex scenes? Does it seem like a script that will require a lot of camera movement? As a rule, scripts that have long scenes and lots of talk can be shot much faster than scenes with a great deal of action. Ironically, fast-paced movies often take a very long time to shoot. As we examine a screenplay, we'll tally up all these factors and come up with an initial estimate of the length of the production.

We might tend to talk about a "five-day shoot," but in truth producers tend to think at least as much about the *pace* of a production as we do the overall duration. If we are shooting a twenty-page script in five days, it means that we're averaging four pages a day. Seasoned producers know that four pages per day is a pretty fast pace—quite typical of independent and low-budget films, but very speedy for a large commercial production. As producers evaluate the complexity of a project, as well as its artistic and commercial goals, we'll often use the number of pages we can cover in a day as a general yardstick that will determine inform our broad assessments of both schedule and budget. The scale of the average number of pages that a production can cover in a day ranges from the snail's pace of one page per day up to the brutal rate of eight pages per day.

Keep in mind that this is the *average* number of pages we expect to shoot in a day. This is an important distinction. While it's helpful and even necessary to keep an average pace in mind as we build our schedule, most producers believe it's a bad idea to aim to shoot a consistent number of pages or scenes each day. Let's say you have a scene in which a car explodes in your script. The scene might occupy an eighth of a page on paper. Nevertheless, it could easily take a day or more to shoot. In contrast, a four-page scene in which a couple talk on a park bench might be shot between breakfast and lunch. Therefore, when we say that we expect to cover four pages per day, it's important to keep in mind that this is only a pace for the entire production and not a daily goal.

Pro Tip

"I was working in India on a project, and they told me that the average number of pages they shoot per day is one. And I said, 'Why do you shoot one page a day?' And they said, 'We have 500 people in the average Bollywood crew. How else are we going to do it?' On a Hollywood film, a big studio film, you can do two, three, even five pages a day if you have the right kind of scenes."

—*Evan Astrowsky*

What is the proper pace for *Shoebox Redhead*? As I read the script, some salient traits come to the fore. There aren't many characters in general and only three featured roles. The fact that the story mostly takes place outside and during the daytime means that we can take advantage of natural light, but it also means that we're constrained both by the hours of daylight and by the need to maintain pretty consistent weather conditions. Those considerations would argue in favor of shooting fairly quickly. A couple of the longer scenes in the script take place in one location—the garage sale—and this will also help us maintain a fast pace. On the other hand, shooting in a car is always a challenge. Controlling lighting in the cramped confines of an automobile is difficult, and it's hard to get a variety of interesting camera angles. Moreover, there is a broader concern that if we just shoot as quickly as possible, using **available light** and minimal staging of action, we'll sap the project of any distinctive voice or style. After weighing these factors, I conclude that four pages per day—fast, but not unreasonably fast—might be a good pace for this project. The script for *Shoebox Redhead* runs 12 1/2 pages. Do I therefore anticipate a three- or four-day shoot? Reviewing my breakdown sheets, I'm reminded that I need to set aside time to shoot the photos for the air freshener in Scene 2 and the box of Polaroids in Scene 7. As noted earlier, the air freshener photo must

be taken at least several weeks prior to the start of **principal photography**, so that doesn't really factor into my shooting schedule. On the other hand, the Polaroids of Mandi *do* need to be taken into consideration. Keeping this photo shoot in mind, I start the process of building the stripboard with the expectation that I'll need four days. Let's see how my forecast works out.

Taking a Stab at It

To get a sense of how the priorities I've set for the production help me draw up the schedule, it might be useful to envision an old-school stripboard. Back in the day, when a production manager worked with actual cardboard strips, she would lay the strips out on a table and then sort through the strips, first applying the top priority, then the second priority, then the third. So, for example, with *Shoebox Redhead*, I would start by separating all the scenes by location. All the scenes in and around the beach would go into one pile. The garage sale scenes would go into another pile, and so on. Next, I would subdivide my groups of scenes according to which were interiors and exteriors. Of course, the beach scenes are all exterior shoots, so I'm going to try to schedule them early in the shoot. But look at the several scenes that take place in and around Matt's station wagon—a mix of interiors and exteriors. My priority guide dictates that I would schedule the exterior scenes involving the car before the interiors.

Having performed this kind of filtering function according to my first couple of priorities, I now must consider actor availability. Since I haven't set the production dates yet, I can't get too exercised about cast requirements at this early stage in my planning. In point of fact, actor availability—for that matter, *crew* availability—can wreak havoc on the best-laid plans, but for now I'll confine myself to a basic concern: whenever possible, it will behoove us to keep all the scenes involving a particular actor clustered together. For instance, given that there are scenes in the car with and without Ira, it makes sense to group together those scenes involving Ira.

The Shoebox Diaries

"I always, even for a short, would give myself an extra two days, just in case, just so people know. If you go your eight days and there's no rain, there are no problems, there are no hiccups, there are no fires to put out, it's wonderful. You finish in eight days, everyone will be happy. But as long as you let them know it might go a couple days over, it won't be a surprise if you do run into those problems."

—*Matt Lawrence, Producer, Director, Writer & Editor*

The Arc of the Shoot

Since I probably am not going to use an old-fashioned stripboard, I'm going to perform this sorting process by dropping and dragging or cutting and pasting on the computer. The tools have evolved, but the system remains the same. Once I have shuffled the strips according to my list of priorities, I actually have the first vestiges of a shooting schedule. That's how it works sometimes: all you have to do is insert those solid strips that demarcate shooting days and you'll have a decent first draft of your stripboard. As I contemplate where those day markers go, I need to consider three factors, a couple of which we have already discussed. Yes, I'll keep in mind the average page count I've set for myself, and I'll also keep an eye out for scenes that are particularly simple or complex (any exploding cars?), but a third consideration is what I refer to as the arc of the shoot.

I borrow the term *arc* from screenwriting. Writers often discuss the "narrative arc" when describing the natural tendency for a well-told story to build in tension, rise to a climax and then settle back down after a resolution—whether happy or sad—has been achieved. A well-structured production schedule also has an arc. Instead of coming out of the gates at full speed, a production needs to ramp up gradually, and it often needs to taper off at the end. Thinking about the overall shape of a production schedule is especially important on longer shoots, but it applies to all kinds of productions. The planning of the first couple of days of a short project is particularly delicate. Shorts are usually produced by casts and crews that are pick-up affairs where a chemistry and familiarity haven't been established. In the case of student productions, you can add the fact that the crew is bound to be relatively inexperienced. All of this means that you must let the cast and crew find their rhythm during the first day or two of shooting. For this reason, it's often a good idea to start the shoot with one or two easy scenes. If everything clicks and the team shoots these scenes with ease, so much the better. Everyone from the director on down comes away with a healthy sense of confidence and momentum. On the other hand, if all hell breaks loose, at least you didn't crash and burn while shooting a critical or very complex set of scenes. With luck (and some quick reshuffling of your stripboard), you should be able to regain any ground you lost.

Pro Tip

"I never like shooting the most important scene on the first couple days of shooting. It always takes time for the team to settle into a good work tempo. Even on the biggest movies, with the most experienced crews, everyone starts out cold. They're all feeling each other out, they're all trying to figure out who's who, how it all works, how the director likes to work, and everyone's searching for the rhythm of the film."

—*Michael Nozik*

Let's sift through the strips I've made for *Shoebox Redhead*. If I group all our locations together and then sort by interior versus exterior, I find that scenes cluster around a few locations:

- *Station wagon*: Depending on how you count, up to twelve scenes take place in or around the station wagon. That's more than half the scenes in the film! From a scheduling standpoint, the car scenes pose a challenge in that some of them are clearly linked to another location, such as the board-walk or the garage sale, whereas others take place in unspecified settings.
- *Beach*: If I include the exterior scenes that take place close to the beach, such as Scene 18, when the three guys arrive at the boardwalk, and the final scene, in which Ryan and Ira drive off toward the sunset, there are four exterior scenes at the beach, totaling 1 7/8 pages.
- *Garage sale*: Three scenes take place at the garage sale, totaling 2 6/8 pages.
- *Big Top Drive-In*: Two scenes take place at the Big Top Drive-In, totaling 2 pages.

There are also a couple of one-off exterior locations that might be of interest: Scene 8 in the field with a tree, in which Matt tests out the magic camera, and Scenes 2 and 3, in which Matt picks up Ryan.

Which of these locations should I start with? I believe I should rule out the beach and garage sale. The beach scenes open and close the movie. They are critically important and logistically complex. The garage scenes involve a larger cast (including extras), extensive set decoration and longer stretches of dia-log. We also need to have the Polaroids of Mandi done prior to shooting those scenes. The problem with single scenes like the field with a tree is that they aren't substantial enough to fill up a day of filming, even if it's the first day. This means that we would have to do a company move on Day 1, which isn't ideal.

This leaves me with just a couple of options. I could start with the Big Top Drive-In scenes or with the collection of **drive-by scenes**—those quick scenes where we either see Matt's station wagon driving through the suburbs or view the suburban landscape from the car. The Big Top has one knock against it: When Matt, Ryan and Ira sit down to talk, they examine the photos in the shoebox. We could fake the snapshots in the box, but it would be preferable to have the real pictures available. By process of elimination, then, I have arrived at the first scenes for my stripboard. I'll start with the collection of car-related exteriors: Scenes 4, 5 and 13. These scenes aren't scripted to take place in the same setting, but they are all set in a nondescript suburban landscape. In my judgment, they therefore can all be shot in the same vicinity—no company moves. The scenes also have no dramatic content. The only element of techni-cal complexity is the fact that Scene 5 (a montage of suburbia, as seen from the car) calls for the camera to be mounted in the car. That isn't rocket science, but since Scenes 4 and 13 are simple drive-bys, let's shoot them first, then do the "meta neighborhood" montage.

Can we call it a day after shooting the montage? Well, Scenes 4, 5 and 13 add up to only 3/8 page. While it's certainly true that we shouldn't judge the difficulty of a day by its page count, it's also important to recall in this case that I chose these scenes specifically because they are easy. Allocating a full day to shoot such simple material is going to put us behind schedule. Besides, there is an element that has come up again and again that needs to be dealt with as early as possible: the Polaroids for the shoebox. If all goes well with the car scenes, let's allow most of the crew and cast to go home early. The director and cinematographer can then hop in a car with the actress playing Mandi and take off for the Rigby Pier location and other coastal points, where they can assemble a nice collection of Polaroids.

Hey, we're under way! Let's take a look at the start of our schedule. The full stripboard for *Shoebox Redhead* can be found among the color illustrations in the middle of this book. Take a look at the first page of that schedule now. It starts with a version of a header board, which identifies the abbreviations that will be used on the strips. The header board only appears on the first page of the schedule. No doubt the red banners that bracket the three scenes we have slated for Day 1 caught your eye. The first reminds us of the necessity of shooting the air freshener photo during preproduction, and the second stakes a spot in the first day of shooting to take the Polaroids of Mandi for the shoebox. This is the workaround I came up with to deal with the fact that, although they aren't actual scenes, these photo shoots must be planned and accounted for. I was struggling with this issue until I recalled seeing a production manager make frequent use of such banners to add important notes directly into his stripboard. It's an unorthodox technique, but it works! At long last, I can put our concerns about these photographs to rest.

The Schedule in Overview

I will spare you a strip-by-strip analysis of the schedule and will instead just highlight some points of general interest. One peculiarity of this project that is driven home when you look at the entire schedule is that this story takes place entirely during the daytime—no blue (night interiors) or green (night exteriors) strips at all. Another discovery will be apparent when you examine the schedule in full: in the end, I wound up with not three shooting days, and not four; my schedule calls for *five* days! To understand how I arrived at this outcome, we need to do a bit of scheduling archeology. You might note that the final schedule is the *sixth* draft. It is not at all uncommon for my schedules to go through multiple drafts as I try to weigh all the variables and arrive at the best approach. Were we to unearth an earlier draft of the schedule—a draft where I adhered to my four-day plan—here's how things would lay out:

- **Day 1**: No changes from the plan already discussed. We would have covered just the scenes of the station wagon driving around and the Polaroid shoot with Mandi.

- *Day 2*: I planned this day around the garage sale. The three scenes at the sale don't seem to require a lot of technical wizardry, but they involve elderly actors, extras and a multitude of props—all factors that will demand time and attention.

- *Day 3*: My plan covered the scenes in the car—talky scenes that could use the same camera setups again and again. I also planned to shoot the scene in a field with a tree where Ryan and Matt test out the Polaroid camera's magical properties. The brief early scenes of Matt picking up Ryan were also included in this day's schedule.

- *Day 4*: I saved the most dramatic and logistically complex scenes in the script for the end of the schedule. This was to be the day when the beach was the main event. It covered the scenes of Ryan putting the shoebox out to sea, Matt and Mandi disappearing on the boardwalk and Ryan and Ira driving off into the sunset at the end of the movie. I also tacked the two scenes at the Big Top Drive-In onto the end of the schedule. As noted earlier, for a script as lacking in conventional interior scenes as this one, the drive-in is probably as close as we'll get to a cover set. Remember: you always want to store your cover set scenes at the end of your schedule so that they can be moved up and shot earlier, should the weather deteriorate.

Initially, I was satisfied with this schedule. After that very light first day, it seemed to divide up the remaining work in a reasonable way. However, two considerations kept haunting me as I tried to move forward with my planning. First, waiting until the last day of shooting to film the scenes at the boardwalk—the emotional core of the movie—gave me no wiggle room if things went off the rails. Second, covering all the beach material and then doing a company move to the drive-in seemed like a big challenge.

My worries were compounded by a production element in one of the beach scenes. Figure 5.3 shows the strip for Scene 21.

This is the last scene in the movie. On paper, it's innocuous enough, but one detail should catch your attention: in the Camera/Grip slot is the notation "C4." If you refer to the header on the stripboard, you'll see that this refers to a **jib arm**. Jib arms (sometimes just referred to as "jibs") come in various sizes, but they all let you do small crane moves. This means that they permit you to swing the camera down low or up high while maintaining a level horizon.

Scenes: 21 Sheet: 21	EXT	HIGHWAY	DAY	Cast: 2, 3
		Ryan & Ira drive off into the sunset		Vehicles: V1 Camera/Grip: C4
Length: 1/8				Extras:

Figure 5.3 Schedule Strip, Scene 21

Matt Lawrence, the director of *Shoebox Redhead*, believes it's important to end the movie with the cinematic equivalent of an exclamation point. This isn't a story filled with thrilling chases or even conventional punch lines. Matt therefore feels that the film needs a bit of stylistic pizzazz, particularly in its final moments. I support this vision, but it means we must give some thought to logistics. Jibs are tricky. They can be quite large and require assembly. Some of the larger models can only be operated by trained personnel. We'll only be able to afford one of the smaller models that we'll operate by ourselves, but that means we must give ourselves time to assemble the gizmo and practice with it.

My misgivings preyed on me to the point where I decided to sketch the daily schedule for this final day of shooting—a process we'll cover in detail in a later chapter. I tried to estimate the time required for each of the following:

- Set up and shoot each scene
- Assemble and break down the jib arm
- Eat lunch and travel to the drive-in

No matter how many different ways I tried to slice and dice the minutes and hours, I kept coming up with a horrendously long day—fourteen or fifteen hours of work, if everything went smoothly. Anyone who has worked in media production has had plenty of days that went that long, but scheduling a marathon like that as Plan A should be done only as a last resort.

The Shoebox Diaries

"I think it was a Sunday morning, because we were only permitted until maybe 10 A.M. And we were shooting a pretty complex shot, and we had a jib, and it was the final scene of the movie, so you know, everything needed to go very smoothly, because that was the last image that we were going to see. And we had pretty much set up, and then we were looking at the location permit, and we realized we were actually permitted for a few blocks south of where we were. It was frustrating, because we had set up all this equipment and we had to move it."

—*Samara Vise, Assistant Camera*

How to fix this? An obvious first step would be to get rid of the company move. I could do this by moving the Big Top Drive-In scenes to Day 3. This makes my beach day immediately look much more manageable, but it does something very nasty to Day 3, turning it into a behemoth where we'd have to cover more

than *seven pages* of script. If we're attempting to produce work with a high degree of polish, that is a very heavy load to put on my cast and crew. Despite all these shortcomings, I proceeded with this as my game plan for quite some time. Here's how I rationalized this scheme. Apart from the drive-in material, the schedule for Day 3 consisted largely of several talky scenes inside the station wagon. Although shooting in an automobile involves special mounts for the camera, sound problems and other hassles, these challenges remain constant. I reasoned that, once we set up to shoot one scene, we would be set up to shoot them all. Therefore, by grouping these scenes, we should be able to cover a lot of ground efficiently.

The production planning process chugged along, but the schedule continued to haunt me. I would lie awake at night, staring at the ceiling and thinking, "Seven pages?!" Such are the occupational hazards of line producing. One particularly restless night, I found myself thinking back to all the shoots I had produced—with professional crews, mind you—using car mounts. Not one of them had ever transpired without at least a few delays and complications. How did I really expect a student production to crank through so many pages of script while also dealing with the complexities of shooting in a car? I finally got to sleep by resolving to fix this problem.

The Shoebox Diaries

"We were shooting a car scene. We had a camera rig set up on the hood of the car, and I was sitting on passenger side, and Matt was driving the car. There's a power button for the camera being fed through the passenger side window, and I'm starting the camera each time, and I think I'm also clapping the **sticks**. So basically, I was doing all that, and each time something happened. That was a really difficult moment. I hit a point where I wasn't sure how much longer I could do it. But it was fine. I was being a drama queen. That's what happens on film shoots: you sort of lose it, you lose perspective."

—*Ryan Conrath, Actor*

The next day, I took the bull by the horns by simply splitting the material between two days. One day would cover the preponderance of talking-in-the-car scenes, and the second would cover the approach to the drive-in and the drive-in scenes themselves. This solution adds an extra day of work with the car mount and prolongs the shoot for the lead actors and Ira, but those seem like small concessions next to the benefit of achieving a workable schedule.

Once I had split up the seven pages, I made one more key adjustment to the schedule: I placed these two days at the end, moving the beach day to the middle of my five-day schedule. This creates a much more satisfactory arc to the schedule. By moving up the boardwalk scenes, I give myself a couple of days "downstream" on the schedule where I can salvage that critically important material should something go wrong. I have also kept the drive-in scenes at the end of the schedule, permitting me to use them as my cover set. These revisions led me to the final draft of the schedule, which can be summarized as follows:

- *Day 1*: Very light day, just drive-bys and photo shoot with Mandi

- *Day 2*: Garage sale and early scenes of Matt picking up Ryan

- *Day 3*: Beach scenes, including the boardwalk, Ryan setting the shoebox out to sea and Ryan and Ira driving off into the sunset

- *Day 4*: Scene in field with tree and several scenes in the station wagon

- *Day 5*: Station wagon approaches Big Top Drive-In and two scenes at the drive-in

Once I finally arrived at this draft, I was able to sleep much better. Perhaps the ease-of-sleep meter is as good a gauge as you're likely to find for knowing when you've found the right solution to a producing dilemma.

Chapter 6

The Budget

The Secrets of Budgeting

In the commercial realm, budgets are one of the hardest documents to pry out of producers' hands. This isn't just because they know that the agents of Natalie Portman, Kevin Hart and the like wouldn't appreciate the public learning what their clients did or did not get paid. They also don't want word getting back to the equipment rental house that they have budgeted x amount for a dolly, nor do they want to set off squabbles between the cinematographer and the production designer because the camera department is budgeted at one level and the art department at another. If they are independent producers, they don't want to advertise the true cost of a production to prospective distributors. If you think over some of these considerations, you too might conclude that you would do well to keep your own budget under wraps, at least until you have completed the project. Over the course of the next couple of chapters, we are not only going to share a budget with you; we're also going to demystify the entire budgeting process.

Budgets are daunting documents. Although I have worked with budgets for decades, I still feel the need to splash cold water on my face when I first glance down at a spreadsheet. All those numbers and terms arrayed in columns and rows seem so abstract, so far removed from the dust and sweat of production, to say nothing of the creative process. However, once we buckle down and really examine those figures, we'll see that, more than any other document, the budget defines a production. It accounts for every mouth that must be fed, every lens that must be rented, every kilobyte of data that must be stored and even every favor that we hope to cash in. Simply put, if it's not in the budget, it's not in the movie.

> **Pro Tip**
>
> "Personally, even on small productions I'm working on, I don't leave budgets out for anyone to see. I think it can be bad for morale, especially when you're talking with someone making a modest salary. If they see how much you're spending on another department, it's possible they won't understand why you would allot more cash for a certain line item over another."
>
> —*Corinne Marrinan*

The Architecture of a Budget

If you are lucky enough to get hold of several budgets from different producers, you'll discover that certain elements are common practice. All well-crafted budgets group expenses into **accounts**: camera expenses go into one account, media storage expenses into another. Budgets also have a **top sheet**, a summary page that lists the totals for each account. The detailed account records come after the top sheet. Each account is made up of a number of **categories** (and sometimes subcategories) that address specific expenditures. For example, under the account called Transportation, we'll find the category Production Transportation, and then under that the subcategory Cargo Van Rental. Once we arrive at the level of a **line item** such as the van rental, budgets tend to follow the same formula, multiplying a certain quantity by a price or rate to arrive at an estimated cost. Let's again take our humble cargo van as an example. Table 6.1 shows how that item might appear in our budget.

If we multiply the numbers across, from left to right, we get: $6 \times 1 \times \$31.95 = \191.70. We round this off (most budgets don't use decimals in their totals; some don't use decimals at all) to arrive at $192.

There is often more than one way to fill in a budget. If I negotiated a weekly rate on the cargo van rental, I could reflect this in the budget by using weeks instead of days as my units. Let's say we were planning to rent *two* cargo vans, each for a week. The item might then look like Table 6.2.

Naturally, because we are now calculating in terms of weeks, we use the weekly rather than daily rate. Until now, we have conveniently avoided discussion of the mysterious "X" column. This is known as the **multiplier**, and

Table 6.1 Budget Line Item—Van Rental

Account	Item	Quantity	Units	X	Rate	Total
2701	Cargo Van	6	days	1	31.95	192

Table 6.2 Budget Line Item—Renting Two Vans

Account	Item	Quantity	Units	X	Rate	Total
2701	Cargo Vans	1	week	2	191.7	384

it is commonly used in budgets to allow calculations with multiple variables. In this example, there are two variables: the number of vehicles (2) and the number of weeks they will be rented (1). Therefore, we used the multiplier to factor in the two vans.

Despite their broad agreement on a number of practices, producers differ with regard to how they handle certain details. Picture the budget as being like a quartermaster's tent, filled with supplies. Every quartermaster stocks her shelves according to her own system. In one producer's budget, **craft services**, the fancy term for snacks and meals during production, might be accounted for under Set Operations, while in another it might have its own category. Within the craft services account, you might find great detail, or you might find little more than a flat sum that the producer has allocated to pay a catering company, with the understanding that the caterer will have to sweat the details. Certain expenses, such as production insurance, might appear as a regular line item in the budget or might be estimated as a percentage of the budget.

Another distinction is the way that producers number accounts. This might seem like an arcane topic, but believe me, it's important. All producers can agree on this much: the account numbers in your top sheet must correspond to the accounts within the budget as a whole, and the categories under a given account must share the account prefix. To get a sense of how this works, take a look at Table 6.3, which shows a portion of the budget I have drawn up for *Shoebox Redhead*.

In this example, 3100 is the account number for wardrobe. This means that any item that starts with the prefix 31 must be wardrobe-related. Wardrobe Purchases, 3101, is our first category in this account. I have included an unnumbered list of line items or subcategories under Wardrobe Purchases. Once I get to the last of these items—the clown shoes—I tally up all the subtotals for these purchases and put the figure ($110) in the Total column. The lack of any figures in the next category, 3102, indicates that we haven't budgeted anything for Wardrobe Rentals. It's an empty category.

It is indeed empty categories such as this that cause divergences in the way that producers number accounts. We seldom write a budget from scratch. Instead, we normally start from some sort of template. To ensure that we don't overlook any details, our template should be as comprehensive as possible, containing accounts that cover just about anything imaginable. The problem— and this is especially true on shorts—is that undoubtedly we won't fill in every line.

Table 6.3 Wardrobe Account

Account	Item	Qty	Units	X	Rate	Subtotal	Total
3100	**Wardrobe**						
3101	Wardrobe Purchases						
	Nylon Jogging Suits	2	items	1	25	50	
	Clown Suit	1	item	1	21	21	
	Clown Wig	1	item	1	10	10	
	Clown Nose	1	item	1	3	3	
	Clown Shoes	1	item	1	26	26	110
3102	Wardrobe Rentals		allow				0
	Account Total						**110**

There will be lots of empty categories and even some empty accounts. There are three ways to cope with this issue. Each has its pros and cons.

- *Edit and renumber. Delete any empty accounts and categories, then renumber everything*: According to this method, we edit our budget until we get to the final draft, then go through and renumber every remaining account and category. Pros: This produces the most streamlined budget. There are no extraneous entries and no breaks in the sequences of numbers for accounts and categories. Cons: Renumbering can take a great deal of time, and it's a mind-numbing process that is easy to botch. Once entries are renumbered, no trace remains of deleted information, which makes it harder to notice omissions. Finally, the only way you can add overlooked expenses to the budget after you've renumbered everything is to add the item to the end of the account or category. Otherwise, you'll corrupt your numbering sequence.

- *Edit but don't renumber. Use pre-existing numbers, deleting any empty accounts and categories*: The difference between this method and the first option is simply that you don't renumber after editing your budget. Pros: Still results in a more concise budget, since empty entries are deleted, but takes less work. Deleted entries are apparent, since their absence leaves a break in the number sequence. Cons: Not quite as sleek a final product. Although you can add deleted items back into the budget without upsetting the numbering scheme (a plus), you'll have to re-create the deleted material—a minor inconvenience.

- *Don't do anything. Use pre-existing numbers and leave empty accounts and categories in the budget*: According to this model, you don't delete any empty entries; you just let them be. Pros: Less work up front. Lets you

see all empty entries, thereby continually reminding you of everything you have *not* included in your budget. Cons: Makes a longer document, which can be harder to read. If you have a lot of empty entries, you'll waste a lot of paper and ink every time you print the budget.

There is no right or wrong method; pick the one that makes sense for your project. In drawing up a budget for *Shoebox Redhead*, we followed the last option. First, we weren't using such a massive template that we'd end up with miles of blank spreadsheet cells. Second, we wanted to remain aware of those empty entries. When producing on a shoestring (as is the case with most shorts), seemingly minute details can be budget busters. In examining the budget for *Shoebox Redhead* (which can be found in its entirety in Appendix B), I note that the category for Titles & Effects is empty. It's important to keep this in mind. If the director decides she wants a spiffy title sequence, that's all well and good, but we must always remember that there is no money allocated for animation, software, sock puppets, late-night meals or whatever else might be required for such a sequence.

Different Kinds of Zeroes

More often than not, short films are a labor of love, a euphemism for the hundreds of favors that their makers must cajole from friends and strangers in order to avoid paying the retail price for all the necessary goods and services. Hopefully, you'll be able to wrangle lots of stuff for free. There is a very important distinction to be drawn between "free" and "not in the budget." An easy way to grasp this concept is to think about our crew. As with any low-budget production, we have decided that we'll have to live without certain secondary and tertiary positions. We go through the crew positions listed in the budget template and decide the personnel that we can or cannot live without. This is a shoestring operation, so we're drawing up our budget on the assumption that (sorry, folks!) none of the crew will be paid. Even so, it's important to keep track of how many people are on the crew, since we are still going to have to feed them. If we're shooting farther afield, we'll even have to house them and provide transportation. Clearly, then, engaging the services of a crew member—even one who isn't paid—entails a number of expenses. How do we distinguish between a position that we aren't planning to fill at all from one that will be filled but won't be paid?

The simplest solution is to follow this practice: whenever we're planning to get someone's services or an item at no cost, we put a zero in the relevant entry. If we're excluding an item from our budget, then we leave the entry entirely blank—no zero, nada. If we're consistent about this, we'll be able to distinguish quickly and easily between items for which no money is allocated and items that we don't plan to need or use. A related tip for tech geeks: if you

are using movie budgeting software or are conversant in spreadsheet programs, you can set up a macro (a little computer code) that will let you indicate those places in your budget where you have assumed that you'll get away with paying nothing. The macro entries serve as a further reminder of the fact that you aren't planning to pay for an item, but they can be used in more sophisticated ways as well. There is a note at the end of the *Shoebox Redhead* budget that explains a little more about how macros can be used.

Fringes, Per Diems and Other Budgeting Terms

To be able to discuss budgets, we must first establish how certain terms are used by producers when talking about dollars and cents. Here is an annotated list of common expressions:

- *Allow*: The alphabet dictates that we start with my least favorite word, at least where budgets are concerned. When you put "allow" in the units cell of a budget, you are telling us that you are just using a lump sum instead of a price or fee that you have calculated in detail. For example, let's say that you know that your cast will occasionally need to be reimbursed for parking fees. You could attempt a very precise breakdown of all the times and places when you anticipate having to pay for cast parking, or you could simply allow a certain amount for cast parking, a figure based on a mixture of experience and speculation. My problem with allowing for budget items is that I believe we can almost always dissect costs to some extent. For instance, even if we are going to guesstimate cast parking expenses, we can come up with a figure that shows some forethought. We might say that an average of three actors will need $10 apiece for parking over the five-day duration of the shoot. To see how this would work in a budget, see Table 6.4. These are still very round, rough numbers, but they beat drawing sums from thin air. Whenever possible, I steer clear of using "allow."

- *Book rate*: This is the advertised price of a product or service. A camera rental company's book rate for a lens rental is the price that the company lists on its website or in its catalog, with no discounts included.

Table 6.4 Budget Line Item—Parking

Account	Item	Quantity	Units	X	Rate	Total
	Parking	5	days	3	10	150

- *Contingency*: The contingency is a buffer that we include to account for the facts that (a) nobody's perfect and (b) nothing ever goes entirely according to plan. Good producers do their utmost to cover every expense. Even so, certain things will get overlooked, or unforeseen circumstances will arise that create new expenses. Producers (and, in commercial situations, the companies they work for) have differing policies with respect to contingencies, but when it comes to budgeting the typical short film, a contingency is a must. Producers of shorts generally have very limited resources. At the same time, if they blow their budgets, no corporate minder is going to bail them out. This means that they want their budget figures to be simultaneously safe and entirely free of frills. How to strike this delicate balance? The answer is to budget everything as rigorously as possible, but then add a modest contingency for safety. I use a standard contingency of 10 percent. This permits me to run a tight production without setting myself up for disaster should I run into a patch of bad luck. The contingency is found on the top sheet of the budget, as it is based on a subtotal of all accounts. In my view, a contingency should never exceed 15 percent. Figures above 15 percent provide too much wiggle room, encouraging a lack of precision and discipline.

Pro Tips

"There are lots of differences between the studio film and the independent film. Obviously, the first is the structure: studio films don't have contingencies, they don't have a 10 percent contingency at the bottom line. The contingency, so to speak, is built into the budget. The expectation is that the budget should have a little wiggle room for the unexpected."

—*Michael Nozik*

"A **bond company** is the company that comes on board the film to assure the financiers that the film will actually get completed. So, the bond company usually insists that you have a 10 percent contingency of the entire film budget. Oftentimes that will exclude things like above-the-line costs—screenwriting, actors, directors, producers—because, at the end of the day, the contingency is more about the production period, the actual physical production contingency, as opposed to the above-the-line contingency. Because something could go wrong with the key grip, but it's very rare that something could go wrong with the screenplay."

—*Evan Astrowsky*

- *Flat rate*: A flat rate is a lump sum that we negotiate in lieu of paying by the hour, day, week, etc. We must often do a bit of math to determine if we're better off negotiating for a flat rate or paying as we go. For instance, let's say that we find an online sound effects library that will sell us the rights to sound effects for $50 per clip. They also offer a deal: for $500, we can get unlimited access to their library, and we can use as many effects as we want. Which deal we take would obviously depend on how many effects we anticipate using (keeping in mind that there may be perfectly suitable effects that we can get or record for free). If we're confident that we'll need more than ten effects from this library, then the flat rate would be the better deal.

- *Fringe*: Fringes are additional charges that are assigned to certain expenses. On commercial productions, a common area where numerous fringes come into play is in the realm of cast and crew salaries. In addition to paying the wages, you must add money to cover fringes such as unemployment insurance and **workers' compensation**. Such charges are less of a factor in the budgets of most non-commercial and student productions, but even there they can crop up occasionally. Suppose you need to hire a police detail in order to shoot on a city street. In addition to paying for the cops' services, the police department may require that you cover certain fringes. Be sure to account for such extra costs, as they can add up to 20 percent to the cost of a given service.

- *In-kind*: This refers to the value of goods and services that are provided at no charge. Let's say your family agrees to put up the cast and crew for the duration of the shoot—fourteen people for four nights. Were you instead to put all these people up in single-occupancy motel rooms, you would be paying for 56 nights. If we estimate the cost of a motel room at $85, your family's largesse has an in-kind value of $4,760. Shoestring productions always count on a mix of cash and in-kind contributions.

The Shoebox Diaries

"Matt's family was there. And they weren't just there to watch someone filming in New Jersey; they came and they stayed the long days with the crew. That's just essential support when it comes to making a movie on a very small budget."

—*Samara Vise, Assistant Camera*

- **Kit rental**: Also called a *box rental*, this is a fee paid to craftspeople for the use of their personal equipment. If your cinematographer owns a camera, you might negotiate a kit rental fee for the use of the camera. Makeup artists often get a kit rental fee for all the supplies they bring to a shoot.

- **Line**: In movie studio parlance, this term almost always comes up in the context of "**above-the-line**" and "**below-the-line**." Careful: in general accounting practice, these terms have a different meaning. In the world of filmmaking, "above-the-line" expenses refer to monetary commitments that are essential to a production getting off the ground, including star salaries and the cost of securing the story and screenplay. "Below-the-line" refers to everything else.

- **Overhead**: If you are making a project as a business endeavor, you might include a figure for overhead. Sometimes this amount is calculated based on the overall budget, like a contingency. Although overhead costs are completely logical—how can a concern stay in business if it doesn't make a profit?—clients often chafe at overhead being included in a budget. See the next item for ways of getting around this.

- **Padding**: Padding is the practice of adding extra costs or using inflated prices in a budget. If that sounds sketchy, it is, but sometimes padding is unavoidable. Producers who aren't allowed to use contingencies or to include an allowance for overhead have to pad in order to protect themselves. Assuming that the goal for our short budget is to arrive at the most accurate estimate of what the project is going to cost us, we would do well to eschew padding. At the same time, we should take care to avoid the opposite of padding (whatever that's called, perhaps "starving"?) by relying too much on sale prices and hoped-for discounts. Unless we are absolutely certain that we'll receive some in-kind donation or discounted price, we should use book rates and normal retail prices in our budget. Otherwise, we're setting ourselves up for failure when the special deals don't come through.

- **Per diem**: A per diem ("per day" in Latin) is an allowance that a person is given to cover living expenses. Per diems are typically given for housing, transportation or food. If you are shooting at a remote location, where your cast and crew must spend nights away from home, you might provide per diems of, say, $20 per person per day to cover the cost of dining out. Some producers use per diems to cover all food expenses during a shoot, but there is a reason why this isn't common practice. If you give your cast and crew money to feed themselves, they must disperse at least a couple of times a day to find their own food. This is a recipe for chaos and delay. It is therefore generally advisable to provide food on set during the workday.

Negotiating Rates With Vendors

A good line producer knows how to drive a hard bargain. But he must also know when to drive that bargain home. Movie budgets are sometimes drawn up many months before production starts. Quotes that we get on prices in February may not apply when we actually shoot in July. A camera rental company probably won't commit to a great deal on a lens package for six months in the future. The company simply can't know how busy or slow things will be that far in advance. Therefore, the process of estimating and negotiating prices for our budget often takes place in two phases. During the initial phase, when we first draft our budget, we'll do a lot of research on prices and rates, but we'll often have to make do with book rates or very standard discounts. Once we get into the bona fide preproduction period, the second phase begins. This is when we really nail down rates and prices. When the time comes to bargain, there are four rules that a producer should live by:

- *Rule 1—Never pay the book rate*: Though it's not true of most retail business in the United States, in many countries, bargaining is a way of life. In those parts of the world, you are considered a gullible chump if you pay the first price that a merchant quotes you. Think of the motion picture industry as though it were one of those countries. The vast majority of products and services used in media production are subject to negotiation. The book rate generally exists only to establish a starting point for haggling and to assist producers in padding their budgets for clients. How much you can get a vendor to discount their book rate depends on many factors. Is it a busy time of year? Are you buying in bulk or renting for an extended period? Many companies have a standard student discount of 10 or 15 percent. While that might sound enticing, the truth is that a crafty producer might well be able to drive a price down 30 percent from the initial rate. This is why I tell my student filmmakers that a 10 or 15 percent markdown is the *minimum* they should accept.

 The practices governing rental periods are something of a code unto themselves. Weekly rental rates are often based on a certain multiple of the daily rental rate. A "four-day week" means that a weekly rental (seven days) will cost you the equivalent of four days at the daily rate. For many companies, a four-day week is the equivalent of a book rate: it's a starting point for negotiating. It's not uncommon to get companies to agree to the three-day week, and even two-day weeks are possible when business is slow.

 Another way to wring discounts from rental houses is to shoot over a weekend. Many film and video equipment houses will treat a weekend as a

one-day rental. This means you can pick up your gear on Friday afternoon and return it on Monday morning and still have it considered a single day.

- *Rule 2—Get it in writing*: Let's say you've done a great job of negotiating deals with an equipment company. Perhaps you've negotiated for two-day weeks for all your rentals, or the rental agent agreed to throw in a day of training on the operation of their fancy new jib arm, free of charge. There are two very common ways that this good news can go bad. First, there is always a chance that something got lost in translation. Negotiations can get complicated. You might have discussed dozens of details with that rental agent. And, while I'm sorry to break the news, you might be a pretty small fish in that agent's pond. Chances are, as soon as she got off the phone with you, she was dealing with another, bigger job. Under such circumstances, it's easy for the specifics of your deal to get misconstrued or forgotten.

 The other scenario that frequently causes problems is what we might call Vanishing Rep Syndrome. You show up for your free day of training, and the person who made that offer isn't around. In fact, he's gone off to hike the Appalachian Trail. If you think this sounds farfetched, think again. And it's not just the lowly clerks who tend to disappear; it could just as well be the owner of the company (while we're on the subject, it's worth noting that it's usually easier to wrest perks and discounts from folks who are higher up the chain of command, since they are in a better position to give stuff away).

 These and other pitfalls can be averted if you get the nitty-gritty of any deal in writing. As logical as this step sounds, it is one that many novice producers tend to forget. There is a psychological rationale for this. When someone does us a favor, we are naturally disinclined to ask him or her to *document* the act of kindness or generosity. To do so can make you feel like you are overreaching or perhaps even doubting the person's largesse. Moreover, even if you can screw up the courage to ask for confirmation of the deal, there is no guarantee that the company rep is going to respond in a timely fashion or get all the details right.

 Therefore, the best way to proceed is to be proactive: as soon as you have concluded a bargaining session, write up a note outlining the deal just reached. You can start your message off with something like, "Thanks so much for taking the time to go over the details of our rental on the phone just now. Please have a look at these notes and let me know if they accurately reflect our arrangements." Then list, succinctly and completely, the specifics of the deal you've negotiated. Conclude with another appeal for confirmation while keeping the tone warm and personal: "Does that all sound correct? If so, please just send us a quick confirmation. We truly appreciate

your understanding the limitations of our budget. Thanks again for helping a couple of struggling filmmakers struggle a little less." E-mail the note to your contact person and wait a few days. If they don't respond, send the note again with a gentle nudge. All you need from them is an affirmative response, something as simple as, "Yup, that looks right." Store that confirmation— along with a record of the full thread of your correspondence—someplace safe. You should also print a hard copy so you can have that with you when you go to collect the goods or services. This is the famous "paper trail," and it's better than a magic amulet at warding off bad luck.

- *Rule 3—Be flexible . . . to a point*: It isn't quite accurate to say that no one in the world of media production pays the book rate. If you absolutely must have your rental package for two days next week, despite the fact that every production company in town happens to be shooting Christmas commercials on those dates, then—*ka-ching!*—you'll be paying the book rate. Indeed, book rates are set with just this scenario in mind: they reflect the rate that the service provider or dealer hopes to get when demand is high. If you can afford to be flexible with your dates, you can often avoid periods of peak demand and thereby secure better deals. However, be careful not to negotiate yourself into a corner. Just because you are operating on a budget doesn't mean you don't have deadlines and constraints. Let's say you negotiate a fabulous rate for a camera rental. The company that owns the camera agrees to the arrangement with the understanding that it is contingent on no client with deep pockets needing the camera on your shoot dates. You proceed to set up the shoot, which happens to involve a staged wedding with dozens of extras, a rented church, flowers, formal wear, bridal gown—the whole nine yards. The week of your shoot arrives and guess what? A big commercial producer has popped up, and she's hell bent on renting every camera in town. You can see where this is headed: you suddenly find yourself in a shotgun wedding, only it's *you* who is getting married—to the book rate for that camera! Which leads to a final dictum . . .

- *Rule 4—Sometimes the lowest price isn't the best price*: While there's no virtue in overpaying for anything, it's also the case that you can get yourself into deep trouble if you cut corners or go with bargain basement deals. Keep in mind that, broadly speaking, there is a logic to what things cost. A rental company that charges more for its equipment might have more overhead to cover than a one-man-band operation, but some of that overhead might take the form of a staff of veterans who are experts at maintaining gear properly. It's important to evaluate every deal in light of its potential ramifications to the production. Having a sweet deal on a lens fall through probably isn't the end of the world, but if you lose your camera rental to that fat cat producer, you are finished.

There is something to be said for paying for stuff—or at least offering up something of value in exchange. While you shouldn't turn up your nose at freebies, it's important to keep in mind that a person who is giving something away doesn't feel they owe you anything. Quite the contrary; they feel that they are doing you a favor. When someone has a little "skin in the game"—even if it's only a lower-than-normal rental rate—you are in a better position to hold them to the terms of a deal.

Pro Tip

"One of things I tell all the line producers working for me is, 'It's not about saving money; it's about spending wisely.' That is the most important thing. I see it in a lot of novice line producers. They want to impress, they want to be like, 'Oh, great, we saved all this money!' But then you look at the product and you realize the money didn't go on the screen."

—*Leah Culton Gonzalez*

To Buy or to Rent

If you search hard enough, just about everything—from antique lamps to camping gear—can be rented. You might think that the decision as to whether you should rent or buy an item comes down to a simple question: which costs more? Indeed, things often *are* that black and white. Go back to the summary of account 3100, Wardrobe. You'll note that we have no allocation there for rentals. We are planning to buy everything, even that staple of costume shops the world over, the clown suit. Why? Well, if we tally up all the costs associated with the clown outfit, right down to the foam nose, we find that it will come to a total of $60. We did some calling around to costume shops, and we found that it would cost $125—more than twice as much—to rent the same items for three days.

That's a no-brainer all right, but what if the costs to rent or purchase had been equal? In that case, the calculus would have to be a bit more nuanced. Among the factors we would need to consider are these:

- *How likely is it that we'll need the item again?* What if we have delays or reshoots? In this case, owning would clearly be desirable.
- *Can we repurpose the item?* Is Halloween just around the corner? If so, your chance to go to your friend's party as a killer clown has arrived!

- *Does the item take up a lot of space?* This is actually a major consideration. There is a reason professional prop masters own warehouses. Don't be a hoarder!
- *Which is more convenient?* Can the item be delivered? That clown costume isn't going to walk over to your apartment from the rental shop. You should factor in the time and mileage required to get the item.

When we weigh these considerations, the reasons to buy a clown costume—even if the cost were the same as renting—are compelling. However, when it comes to deciding whether to buy or rent an item, one size definitely does not fit all.

A Budget Template

We've provided a budget template in Excel at *theshortseries.com*. You can download it and use it as the basis for your budgets. In designing this template, we've attempted to cover a wide range of expenses without going into the detail that would be needed to plan a Hollywood blockbuster. That said, if your short involves animation or special effects, you'll find our recipe for a budget inadequate. If there are accounts that you don't need in our template, you can appropriate these to cover the areas that are missing, or of course you can simply add additional accounts.

In the case of large-scale productions like feature films and television series, the viability of the entire enterprise often rests on the participation of a number of key elements such as star talent, a high-profile literary adaptation, a celebrated director and so on. This is why these big-ticket items are segregated into above-the-line costs in budgets for commercial fare. This practice is followed in both Hollywood and the independent sector. Since shorts almost never depend on such factors, we have not applied the above-the-line/below-the-line structure in our budget template. Experience has shown that our model is far more practical for shorts, but don't lose sight of the above-the-line/below-the-line distinction, and be prepared to work with that format on any longer-form project. Our budget template for shorts is divided into three phases: preproduction, production and postproduction. As a project progresses, it's important to keep in mind how much money you allocate to each phase. Many a worthy movie has ground to a halt because the producer failed to reserve enough money for postproduction. Thinking in terms of funds allocated to each phase is a way to keep an eye on the big picture—even if your big picture is short.

Chapter 7

Beyond Budgeting Basics

Revealing Details

Apart from the script, nothing reveals more about the fundamental nature of a short than its budget. It's not just the bottom line that defines a project, either. The *balance* of expenses is just as telling. Are there lots of props, scads of extras that must be fed or multiple cameras that must be rented and supported? Every movie has special needs, requiring that we spend more in certain areas than we do in others. As we decide where to deploy resources, we are making hundreds or even thousands of choices, spending time and money here, saving it there. This is why the budget—the sum of all those choices—can be viewed as a portrait in numbers. As you become adept at reading budgets, you'll be able to discern a project's individual character.

Because every short is the product of a unique mix of ingredients, it can be hard to generalize about budgets. Travel costs might be of paramount concern here, whereas production design considerations might matter more there. Nevertheless, there are a few core principles that apply to almost all budgets, at least in the case of productions where money is in short supply. Let's examine some of these notions.

How Food Can (and Should) Eat Up Your Budget

Whether you are paying your cast and crew or not, you need to feed them. Craft services for your short production don't have to be fancy, but the food has to be tasty and nutritious. Food is literally the fuel that makes a production run. Empty calories will, in fairly short order, translate into fatigue and apathy (they call it junk food for a reason). Ample, hearty food, on the other hand, will keep the people both in front of and behind the camera going through the long hours.

When do you need to start and stop the gravy train? It depends. If you have a very early **call time**, then it's a good idea to provide breakfast. On the other end of the workday, it's not customary to provide everyone with dinner, but if

you have people who have to stay late, it's important to feed them. It's common for a small subset of the crew to work nights during the production period. The director and cinematographer might be reviewing footage while the assistant director is drawing up call sheets for the next day and the art department is dressing a set. The last thing we want is for these folks to get home late because they had to scrounge up dinner after they're done with work—or worse yet, go to bed hungry. It's therefore reasonable to add some money in the budget for a certain number of dinners.

Many short filmmakers believe that they can save money by getting some family member to cook for the production. Good idea? It depends. The designated caterer needs to know what he is in for. Feeding even a small crew on a short production is the equivalent of cooking for six or eight large dinner parties, all in quick succession. Does this person have the repertoire in the kitchen to pull this off? That famous chili recipe is great once, but what else is on the menu? Does the chef have the equipment needed to get the food to the set such that the hot stuff stays hot and the cold stuff stays cold? You get the idea: feeding a dozen or more mouths is a complicated business. In my experience, most shoots that have used homemade catering have mixed in some commercial fare.

Regardless of whether you get your food from home, the store or restaurants, remember that variety truly is the spice of life. Very few people want to eat the same food—even a favorite dish—day after day. The clever producer therefore will plan to mix things up and will allow for a slightly fancier meal after a few days of simpler rations. Food costs can surprise you. I have had students research the cost of a lunch of cold cuts and found that an inexpensive sub shop can be competitive with the cost of buying the fixings at a supermarket. On the other hand, a simple necessity like coffee can be very expensive when purchased at a doughnut shop—to say nothing of the time involved in picking it up. That is why I often counsel even productions that don't plan to self-cater to buy a coffee maker and have it running on set instead of paying the retail cost for caffeine.

We have noted elsewhere that giving folks money to buy their own meals is generally a costly, counterproductive option. At the same time, we must reckon with the fact that any other option—ordering take-out, buying prepared foods, doing it all yourself—requires personnel. At a minimum, you need someone to be in charge of overseeing replenishment of on-set snacks and delivery of meals. Delegating this job to a person with other on-set duties is only going to cause your production to grind to a halt. You need to have a competent person dedicated to craft services. Access to a car is also vital for this position. This can be a tough job to fill, but sometimes you can recruit someone who is curious about filmmaking but lacks experience in the field. Many a career in media production has started at the craft services table.

Taxes, Mileage and Other Details That Can Break the Bank

It is easy enough to work out the costs for tangible things like T-shirts or hard drives, but there are a number of hidden or ancillary expenses that can be easy to overlook. Take sales tax. When you combine state and local sales taxes, you can end up tacking on close to 10 percent of the cost of products. States and towns tax items like food, clothing and lodging differently, so accounting for tax isn't a simple matter, but you can't ignore it. Let's say you have $3,000 worth of goods in your budget that are taxable and that you live in a locale where these items would be taxed at 6 percent. That's $180 you'll need to cover. A 9 percent tax rate would raise that figure to $270.

Mileage can make an even bigger dent in your budget. Even when they are shot in a circumscribed area, movies require a lot of driving around. Locations must be scouted; actors must drive in from hither and yon; camera rentals must be collected and returned. You may be able to get your cast and crew to swallow the cost of driving, but don't assume that this is the case. The art department often covers the most terrain in a production as its members scour the countryside for props and supplies. It is therefore quite common to offer to reimburse this team for its mileage. The U.S. government regularly issues a figure that it uses for mileage reimbursement. The rate fluctuates with the price of gas, but it has been north of 50 cents per mile for some years now. This figure is a good one to use when calculating mileage reimbursement. There are other transportation costs that can add up. These range from big-ticket items like flying an actor in from the coast to paying for parking—or parking tickets!

The Shoebox Diaries

"Gas is a huge, huge expense that I hadn't thought of. Even on *Shoebox*, when you're driving people around for a week to ten days in four vehicles, you're taking care of gas for each of those vehicles. The same thing goes if you need to buy a plane ticket for people: you're spending $500 to $1,000 per person to fly them in or out to different locations."

—*Matt Lawrence, Producer, Director, Writer & Editor*

Other hidden costs that can take a bite out of your budget include postage, photocopying, texting and data charges. Some of these items bleed into the area of everyday living expenses, but they should be kept in mind as you weigh the cost of producing your project.

In many cases, the expenditures we are discussing can be accounted for simply by being vigilant and thorough. If you put your mind to it, you can come up with estimates for mileage or postage and include those costs in the relevant department's accounts. Sales tax is a bit trickier, because it is a percentage and applies only to certain items. Professional budgeting programs permit the user to tack sales tax onto line items very easily. If you are using a basic spreadsheet program, you may want to use a less meticulous method: just tally up all the line items to which sales tax should apply, calculate the total tax and add this figure to your subtotal charges in the top sheet of your budget.

A Walking Tour of a Budget

Let's take a quick stroll through the budget for *Shoebox Redhead*. We won't look into every category just now. Some sections of the budget will make a lot more sense once we've had a chance to explore them in more detail. For example, we can circle back around to look at the projected expenses for music rights and duplication later on.

First stop on our tour is the top sheet. The top sheet relates to the complete budget much as a film pitch relates to a screenplay. While it's no substitute for the full script (to say nothing of the finished product), a pitch summarizes the key attributes of a prospective movie. In the same way, the top sheet reveals a great deal about a project, particularly in terms of its scale and the priorities of its producers.

Figure 7.1 shows the top sheet for the budget for *Shoebox Redhead*.

One of the first things you might notice is the list of "Notes/Assumptions" near the top of the page. Not every film budget includes such a list, but in a more perfect world, they would. Any budget reflects a number of choices and assumptions. Perhaps you have chosen to use union actors, to shoot only on weekends, or—God forbid—to shoot the whole project on super-8 film. Such factors will have a profound impact on the budget, and by listing such considerations up front, we make it much easier to divine the logic behind all sorts of line items in the budget. In the case of the notes and assumptions listed for *Shoebox Redhead*, it's easy to see how two points—"All cast and crew can lodge with friends and family in New Jersey" and "Core camera and lighting packages will be provided by university"—will allow for enormous savings in the accounts for Lodging and Camera/Lighting/Grip, respectively.

One assumption that isn't stated in the top sheet but that should be evident as soon as you peruse the account totals is that we will not be paying our cast. Whereas cast salaries will take a very big bite out of even a low-budget feature, here you can see that the total amount allocated for the cast is a measly $60 for some token gifts for the principals. If we're not planning to spend money on actors, where will the lion's share of the dollars go? The $3,800 allocated to

Shoebox Redhead
Budget

Producer: Alan Smithee
Director: Matt Lawrence

Runcible Pictures
7 Lear Lane
Phone: (555) 555-1212
E-Mail: smithee@theshortseries.com

Notes/Assumptions: This budget is based on the following assumptions:
• Producer, Director and all post-production services are based in Massachusetts
• Shoot will be entirely in New Jersey
• Cast will be based in New Jersey/New York area or can relocate to that area for shoot
• All cast and crew can lodge with friends and family in New Jersey
• Core camera and lighting packages will be provided by university
• Film will be exhibited in the following formats: DVD, Blu-Ray disc, HDCam

Account	Item			Total
1000	Script			71
1100	Fundraising			452
1200	Casting			121
1300	Location Scouting			146
1400	Other Preproduction Expenses			98
	Total Preproduction			**888**
2000	Crew			180
2100	Cast			60
2200	Extras			260
2300	Camera/Lighting/Grip			3800
2400	Production Audio			90
2500	Production Media			210
2600	Craft Services			1917
2700	Transportation			1576
2800	Lodging			0
2900	Locations			300
3000	Props			470
3100	Wardrobe			110
3200	Make-up & Hairdressing			82
3300	Stunts			
3400	Weapons			
3500	Sets			
3600	Production Insurance			443
3700	Other Production Expenses			50
	Total Production			**9548**
4000	Editing			1545
4100	Post-Production Media			440
4200	Music			500
4300	Postproduction Audio			2100
4400	Titles & Effects			
4500	Publicity & Distribution			3710
4600	Other Postproduction Expenses			144
	Total Postproduction			**8439**
	Total Prepro/Production/Post			**18875**
	Sales Tax	Total Taxable Goods: 9432	Tax Rate: 6.25	**590**
	Contingency - 10%			**1946**
	Grand Total			**21411**

Figure 7.1 Budget Top Sheet

Camera/Lighting/Grip should catch your eye. What this tells you is that, even though a university film program is said to be providing the core equipment for this production, significant expenditures are projected in the area of camera, lighting and grip gear. The other key line item in the production portion of the budget is craft services. As you'll see when we dig a little deeper, I am practicing what I preach, ensuring that cast and crew are fed regularly and well.

Let's move down to the postproduction section of the top sheet. As already noted, we'll be able to make better sense of some of these accounts once we've delved into the intricacies of editing and preparing a movie for release to the public. For now, let's limit ourselves to a couple of general observations. First, note that total allocation for postproduction is very nearly equal to the production costs. Second, you can see that Publicity & Distribution is the big-ticket item in this section. Indeed, this is one of the more costly accounts in the budget. Just as there is no such thing as a "typical short film," there is no such thing as a generic short film budget. That said, I chose *Shoebox Redhead* as a case study because the project shares a lot in common with a great many other short productions in terms of scale, form and complexity. Not surprisingly, a number of the broad-brush attributes of the *Shoebox Redhead* budget can be seen time and again in other budgets. This is true of the balance of production and post-production costs. This tendency of postproduction expenditures to nearly equal the outlay for production surprises some people. It's easier to see the resources that go into a shoot; the costs that mount up when it comes to editing and distribution aren't always as tangible as a jib rental or a bagel. A word of caution: however elusive the financial commitments for postproduction might be, they are just as real and as important as those associated with production. Do not subscribe to the Scarlett O'Hara "I'll worry about that tomorrow" school of producing whereby you blow through your funds during your shoot, leaving too little money to see you and your production to the end of its journey.

You'll be relieved to hear that we won't be explicating every account in the budget, but a closer examination of a couple sections can establish some important general principles. Let's have a look at that pricey account, Camera, Lighting and Grip (see Table 7.1).

First, a reminder: items that have zeroes in the price column are understood to be provided at no cost. Here, a variety of gear, from the camera to the flags and frames used to block or filter a light source (known in the trade as **gobos**), are going to be provided by a university film program at no charge. However, the university's equipment room doesn't have every item we need. For example, like many cinematographers, our director of photography has certain lenses that he is very keen on, so we're allocating money to rent a set of prime lenses. Prime lenses have fixed focal lengths, meaning they can't zoom in and out. Many cinematographers like the optics of such fixed focal length lenses. Another request that the director of photography has made is for a set

Table 7.1 Camera Account

Account	Item	Qty	Units	X	Rate	Subtotal	Total
2300	**Camera, Lighting & Grip**						
2301	Camera Package	1	package	1	0.00		0
2302	Camera Support Rentals						
	Tripod	1	item	1	0.00	0	
	Baby Legs	1	item	1	0.00	0	
	Hi-Hat	1	item	1	0.00	0	0
2303	Prime Lens Kit	2.7	days	1	250		675
2304	Matte Box & Follow Focus Kit	1	kit	1	0.00		0
2305	Filters	2.7	days	3	7		57
2306	Monitor	2.7	days	1	190		513
2307	SDHC Card Adapter	1	adapter	1	45		45
2308	Camera Department Expendables	1	allow	1	77.95		78
2309	Lighting Rentals						
	Light Kit	1	kit	1	0.00	0	
	Portable LED Kit	2	kits	1	37	74	74
	Lighting Department Expendables	1	allow	1	205		205
2310	Grip Rentals						
	Dolly	2.7	days	1	300	810	
	Car Mount	2.7	days	2	90	486	
	Jib Arm	2.7	days	1	180	486	
	Gobos & Stands	6	items	1	0.00	0	
	12 x 12 Silk with Stand	3	days	1	65	195	
	Apple Boxes	6	items	1	0.00	0	
	Sandbags	3	days	4	1.50	18	1995
2311	Grip Department Expendables	1	allow	1	58		58
2312	Loss & Damage	1	allow	1	100		100
	Account Total						**3800**

of **neutral density filters**. These filters are nothing more than very carefully manufactured gray glass. The tinting of the glass allows us to cut the amount of light coming through the lens by a precise percentage. Having this extra tool for controlling exposure is essential when shooting exteriors throughout the day, as is the case for *Shoebox Redhead*. The large number of exterior scenes also accounts for the need for a battery-powered field monitor. This will permit the director to view camera compositions and review takes while shooting in places where AC outlets may be hard to come by.

Pro Tip

"You start out with these budget assumptions that, through experience, you hope are correct. Then, when you hire the **DP**, she comes in and she wants a certain set of lenses. And let's say they're expensive and you don't have that fully budgeted—but hopefully you've budgeted something else you might not need. So, you have this conversation. You say, you can have these lenses, or you can have this crane ..."

—*Bob Degus*

So much for our rationale for a few items in the camera category. If you look more closely at the tabulations for the prime lens kit, the filters and the field monitor, you'll notice that we use a recurring odd unit: 2.7 days. What's up with that? Remember the three-day week concept? Well, after calling around to some camera rental houses, we found that the best deal for these items was from a company that would give us a three-day week plus a 10 percent student discount. The math works like this: a 10 percent discount means we will be paying 90 percent, or 0.9 times the regular rate. 3 days × 0.9 = 2.7 days. We could have applied the student discount to the rental rate, but it's easier to spot if we factor it into the unit column instead. As you can see, we got the three-day rate minus 10 percent for some other gear as well, but certain grip items, such as the large silk-covered frame we'll use to soften the sunlight in some exteriors, exclude the student discount. That's because we got a better deal for these items from a small grip equipment supplier who didn't give students a special break.

The Shoebox Diaries

"For the most part, what I took away from student films that didn't light their exterior scenes was that they kind of suffered in terms of how they looked. So, I definitely factored into my budget the ability to light outdoors. That meant using a generator, those huge 20' × 20' flags and then lights."

—*Matt Lawrence, Producer, Director, Writer & Editor*

Perhaps you have noted some very precise numbers in the line items for the expendables in each category. Expendables are items that get used up in the course of production, such as lens tissue or lighting **gels**. Consider the camera

department expendables: $77.95 is an awfully exact figure to allow. As you might have surmised, these figures represent a separate tally of a shopping list for a variety of small items. It would have been simpler just to "allow" for a lump sum in these expendable categories, but again, hazarding a calculation, however rough, is usually more accurate than just taking a guess. Some producers and department heads will make a number of mini-spreadsheets to account for these shopping lists.

Pro Tip

"How do you budget 'ample' or 'enough'? How many is that? The budget wants you to say you need five of something, not 'enough' of something. You can't attach a dollar value to something that has no quantity. So, you need to train and discipline yourself. Think like a filmmaker when you go through the script scene by scene. And be very specific about all the elements you think each scene requires. Once you do that, you can attach a price tag."

—Marie Cantin

There is a theme that connects many of the camera, lighting and grip items that we've discussed, and that is the input of the crew. In addition to requesting that set of prime lenses and some filters, the cinematographer is a good contact for that list of expendables. Broadly speaking, a budget will be more accurate if it incorporates the input from the experts who manage each department. Be that as it may, it's often the case that we must make budgetary commitments before all the crew is on board. Like it or not, the producer will often find herself having to make judgment calls on her own. That's why it's important that she knows at least a little about every aspect of the production process. Even if she can consult with department heads regarding expenditures, the producer's faculties of common sense must be operating at full power. Keep in mind that what we want and what we need are not always the same. The art department might want several thousand dollars for prop purchases, but can they make do with less? As you gain experience as a producer, you'll be in a better position to separate valid requests from wishful thinking. You'll also find that certain expenses turn up again and again. Those shopping lists for expendables? They tend to be pretty predictable. This is why all producers recycle certain cost estimates from one budget to the next.

I promised that we would dig into those figures for craft services. Here goes, in Table 7.2.

Table 7.2 Craft Services Account

Account	Item	Qty	Units	X	Rate	Subtotal	Total
2600	**Craft Services**						
2601	Breakfast						
	Day 1	13	meals	1	4.50	59	
	Day 2	14	meals	1	4.50	63	
	Day 3	15	meals	1	4.50	68	
	Day 4	14	meals	1	4.50	63	
	Day 5	14	meals	1	4.50	63	315
2602	Lunch						
	Day 1	13	meals	1	8	104	
	Day 2	14	meals	1	8	112	
	Day 3	15	meals	1	8	120	
	Day 4	14	meals	1	8	112	
	Day 5	14	meals	1	8	112	560
2603	Dinner						
	Day 1	4	meals	1	6.50	26	
	Day 2	4	meals	1	6.50	26	
	Day 3	14	meals	1	14	196	
	Day 4	4	meals	1	27	108	
	Day 5	4	meals	1	14	56	412
2604	Snacks and Beverages						
	Day 1	14	snacks	1	5	70	
	Day 2	17	snacks	1	5	85	
	Day 3	19	snacks	1	5	95	
	Day 4	14	snacks	1	5	70	
	Day 5	14	snacks	1	5	70	390
2605	Wrap Party						
	Food	25	people	1	6	150	
	Drinks	25	people	1	2	50	200
2606	Craft Services Expendables	4	days	1	10	40	40
	Account Total						**1886**

If you get your hands on the budget for a feature from one of the major studios, you might find that the budget for craft services goes into considerably less detail than you see here. How is that possible? In Hollywood, craft services is an industry in its own right. Instead of fretting over the hundreds of mouths he must feed, the producer of next summer's blockbuster

is likely to simply hire a craft services company to feed the hungry hordes for the duration of the shoot. Once a price is agreed to, the craft services budget might essentially come down to a single lump sum that will be paid to a third party.

On shorts, you generally can't afford the markup that would come with letting a caterer feed your cast and crew. Moreover, since craft services comprises such a substantial portion of your budget, you need to make sure that you get the numbers right. Hence the need for such a thorough breakdown of expenses. As you can see, I have broken the food budget down in terms of meals and days. This system makes sense for *Shoebox Redhead*. This project calls for a short shoot, with different numbers of cast and crew working different hours on different days. Breaking things down this way makes it relatively easy to account for all those variables.

How did I come up with the number of people I'll need to feed? This is where the shooting schedule comes into play. At a glance, each strip in the schedule tells me how many cast members and extras are involved in each scene. I add to that number the estimated size of the crew that will be on hand, and—bingo!—I have my total for a given day. I anticipate that I must provide pretty much everyone with breakfast, lunch and snacks. As you can see, fourteen is a typical number for the size of the combined cast and crew. That total comprises a crew of eleven and a few actors. The tally swells occasionally due to the addition of extras for certain scenes.

The numbers I anticipate feeding at dinnertime are more variable. The key factor here is the length of the shooting day. Simply put, if I'm keeping people on set up to the dinner hour, I'd better plan on feeding them. Note that I have three different costs for dinner: $6.50 for Days 1 and 2, $14 for Days 3 and 5 and $27 for Day 4. This allows for some variety of fare over the course of the shoot. On the low end is the cost of sharing pizza and a few bottles of soda, on the high end is the cost of a meal in a sit-down restaurant, and in the middle is the cost of sharing Chinese take-out. These figures include beverages and tips.

In truth, I won't have an accurate take on how long our shooting days are until I've drawn up the daily production schedule—a topic addressed in a later chapter. At this juncture, I'm making an educated guess. For Days 1 and 2, I anticipate slightly shorter days and therefore am only providing dinner for four people. This would be the core group that needs to meet after the shoot has wrapped to compare notes and plan for the day ahead. That group consists of the producer, the director, the cinematographer and the assistant director. I anticipate that Day 3 (the beach day) will be long and challenging. What if our schedule runs a little long? We'll have a lot of grumpy, hungry people on our hands. I have therefore decided to provide everyone (fourteen people in total) with dinner.

Stunts and Special Effects on a Budget

When we hear the word *stunt* in relation to a movie, we all tend to think of great feats we have seen on-screen: perhaps a woman crashing through a plate glass window or a man getting run over by a train. In truth, most stunts are not so grandiose. The script you are producing may call for nothing more physically challenging than a slap in the face, but that slap is still a stunt, requiring forethought and planning. To understand this, let's imagine what might happen if we *didn't* treat the slap with special handling. Let's say that the actor being slapped is a masochist and has no problem with getting whacked in the face. Next, let's assume that you shoot this scene in the usual manner, with a single camera that records the scene from at least a couple different angles. You'll probably have to shoot several takes from each angle. Do you see where this is headed? By the time you have the scene in the can, your actor may well have received half a dozen or more blows. By now, no doubt the sting of impact is losing its novelty, but just as importantly, the actor's face is getting red and swollen, and tomorrow, he's going to sport some bruises. Who's sorry now?

The moral of this story should be obvious: every action in a movie that involves a challenge or risk must be carefully coordinated. Often, a single, contained gesture like a slap in the face can be simulated without physical contact. Careful camera placement can create the appearance of proximity; careful editing can enhance the sense of impact. Getting just the right formula for such actions requires lots of fine tuning, so be sure to mock up the scene with some friends. A word about stunts in general and fake punches in particular: You can rehearse a particular choreographed movement five times, only to find that, once the camera is turned on, the actors' positions shift, perhaps in dangerous ways. Why is this? Adrenaline is a funny thing. When the camera rolls and the action is "for real," we all tend to get a bit amped up, and this throws things off. Because of this, it's important to build in a bit of a buffer area to keep actors from inadvertently making contact.

If your script calls for any kind of combat or risky behavior, you will need a stunt person and perhaps a stunt coordinator. Enlist the services of a professional and not a wannabe. The same is true if your project calls for firearms: make sure you are working with someone reputable, and be sure to ask about insurance requirements. In the case of guns, you don't even have to use them to find yourself in a very dangerous situation. These days, it's possible to buy extremely realistic fake guns. That's the good news for budding action movie auteurs. The bad news is that police cannot readily distinguish real guns from fake ones, and you need only read the newspaper headlines to know that this confusion can have tragic consequences. If you are shooting scenes involving firearms in any way, you must either be filming in a setting that is entirely closed off from the public or you must have the cooperation of the local police.

These days, some actions that would have involved stunts or pyrotechnics can now be achieved more safely through visual effects. I once visited a visual effects house in Hollywood. The wizards in that shop were hard at work creating a couple of shots for a television series episode that showed a gas meter exploding. Perhaps half a dozen highly trained people were working on the material, which combined shots of actual gas meters and fireballs with lots of technical and artistic manipulation. The sequence of shots lasted all of a few seconds on-screen. The estimated cost? At least $50,000.

I hope this drives home a point. We live in an age where motion pictures are laden with effects and stunts, and this applies almost as much to movies that deal with everyday experience as it does with epics set in Middle Earth. The ubiquity of these elements does not change the fact that all this on-screen magic costs money. I cannot count the number of scripts I have read that call for boats sinking, humans levitating, rockets launching and cars colliding—all in projects with total estimated costs under $15,000. In other words, these filmmakers believe that they are going to pull off the requisite effects and make the rest of their movie for less than a third of what it costs for a team of experts to make one brief visual effect. As the robots used to say, "That does not compute."

This does not mean that short films can't have effects; it just means that you must have a realistic strategy for pulling them off. Here are three ways to think about effects in shorts.

- *Be ingenious*: Amazing effects can be done using relatively simple techniques. I am still mesmerized by some of the visual effects in Jean Cocteau's *La Belle et La Bête (Beauty and the Beast)*, all of which were realized through basic set design and camera tricks such as reverse motion. Using nothing more than a keen sense of craft, Cocteau caused statues to come to life and candles to light themselves. More recently, the dean of effects-driven films, Peter Jackson, has shown how the clever use of composition can subvert our sense of perspective and create magical illusions. The moral: before you blow your budget attempting some fancy effect, think about how you might use the basic tools of filmmaking to achieve the results you need.

- *Matching talent with the tool*: I have seen some fine animation created using a still camera and basic editing software, graceful aerial shots made with consumer-level drones and very sophisticated titles and visual effects designed in Photoshop. In each case, these projects worked not so much because of the equipment involved but because of the artist or technician at the helm. Visual effects software such as Maya and Flame are becoming more widely available. The effects achievable with these programs are almost unlimited in scope—but only in the hands of a talented expert. I always get a pit in my stomach when I hear a young filmmaker say, in

response to queries about how he will pull off a particular effect, "I have a friend who has AfterEffects." Like Photoshop, AfterEffects is part of Adobe's suite of visual effects programs. It is a versatile tool that can be used to create beautiful titles and amazing visual effects. I have seen it used on low-budget shorts to create very credible gun muzzle flares and glowing amulets. These effects didn't just require AfterEffects, however; they required someone with the time and skill to pull them off. If you plan to produce a project that has a number of visual effects, you need to do more than simply locate the right tools for the job. It's even more important that you recruit the talent that can use those tools and deliver the results on time and on budget.

- *When in doubt, do without*: When it comes to effects, more often than not, half an hour of brainstorming with the director can save your production hundreds of hours of work. Suppose your short is about a haunted house. The script calls for half a dozen scenes involving apparitions. If you really challenge your imaginations, you might find that most of these episodes of dark magic can be implied rather than shown. It might prove to be the case that you can get away with just a single clever effect. A word of caution, however: it is possible to take such austerity measures too far. It's very difficult to make a ghost story that's devoid of ghosts, or a tale of intergalactic adventure without space travel. In the same way that a period piece inevitably requires lots of period detail, some stories simply depend upon visual effects. Unless you are friends with the next James Cameron, you would do well to set such projects aside.

Chapter 8

The Crew

How Big Is Big Enough?

Just because a movie is short doesn't mean that the crew is small. There may be fewer scenes in a short, but you shoot them the same way you would a feature. Therefore, your personnel needs are not necessarily dramatically different for a short than would be the case for a longer film. The logistical demands of a short production can fall anywhere within a broad spectrum, and the crew required will vary accordingly. The beautiful but technically complex three-strip Technicolor process was first demonstrated through a very colorful short, and you can be sure that that project required a very large crew to handle everything from the cumbersome camera to the florid costumes. That said, the assumption throughout this book has been that most shorts are made on a budget and therefore must be of a limited scale. Movies—long and short—can be made with small crews, and having a smaller crew can allow for economies: fewer mouths to feed or bodies to transport and so forth. At the same time, there comes a point where lack of personnel becomes a hindrance. If you can't break crew free to prepare your next location, your shoot will progress more slowly. If your camera crew must also adjust the lights, or your wardrobe person must also handle all the props, you will wish that you had a cloning machine handy. There is a right-sized crew for every production, and there is also very definitely a minimum crew size below which we should not go. What are those essential crew positions?

Understanding Departments and Crew Hierarchy

A motion picture might be a product, but we don't roll films off an assembly line like cars or bars of soap. The crew that makes a movie is almost always assembled for a brief period of intensive work. More often than not, many of these individuals have never worked together before. If we stop and think

about that fact for a moment, the whole moviemaking process starts to seem a bit uncanny. How do a bunch of strangers gather at a film set and immediately go to work like a well-oiled machine?

The answer lies in the fact that, while the crew members may not have worked with each other before, they have been through the same filmmaking process, doing the same jobs. It's because each person understands his or her role in the sophisticated mechanism of the production that it can operate like clockwork.

Pro Tip

"You have to learn how to make decisions under pressure; you have to make the mistakes so that you never make them again. I did stand on the set once and yell at the DP in front of the whole crew, and I learned that that was incredibly damaging and a horrible thing to do, even though he was 1,000% wrong and I was 1,000% right. It didn't matter. It took me a long time to heal those relationships with his key people who were there to support him, which was our technical crew."

—*Georgia Kacandes*

If we had a blueprint or a wiring diagram of a film crew before us, we would find the crew clustered into various departments. The essential departments are:

- *Production*: This office handles the logistics of the shoot. It encompasses the various producers as well as subunits such as location management, transportation and craft services.
- *Direction*: This includes the director, assistant director and other support staff such as the script supervisor.
- *Camera and Lighting*: This department includes all the personnel involved with cinematography, including grips and data storage.
- *Sound*: Frequently, this unit consists of two people: a location sound recordist and a boom operator.
- *Art*: This large category encompasses everything related to the physical look of the production, from wigs and makeup to sets and props.

If our project called for extensive special effects, we would add a visual effects team to this list, but keeping our dreams of effects-driven extravaganzas at bay, let's stay with these five essential departments. Assuming that we have a simple, very streamlined shoot, what would be the minimum personnel we

would need to staff each unit? In the world of features, the top positions in each department or division are often referred to as **keys**. The persons working immediately under the keys are the **seconds**. This terminology is less commonly used on shorts, since it is often the case that the crews making shorts are, in essence, all keys. With this in mind, here is a list of the essential personnel that would likely be needed for a short production, with some job definitions added where they might be useful.

- *Production*

 ○ Producer
 ○ Craft services: As the saying goes, "an army marches on its stomach." We need to dedicate one person full-time to this task.

- *Direction*

 ○ Director
 ○ Assistant director: While the producer might plan the shoot, the assistant director oversees the logistics once the shoot is actually under way. This includes wrangling actors, policing the schedule, directing extras and serving as the intermediary between the director and the crew.
 ○ Script supervisor: Perhaps the most underappreciated job on a movie set, the script supervisor keeps copious notes on what gets shot. This information is important for maintaining seamless continuity within a scene. Suppose we shoot both a wide shot and a close-up of a character coming into her apartment. If we are using a single camera (still the norm for most film-style productions), we have to shoot these two angles separately. If the actor uses her left hand to open a door while carrying a portfolio in her right hand, we'll want to make sure that she does precisely this in both shots. It's the script supervisor's job to record details like this. Now, suppose the scene just prior to the character's arrival at her apartment shows her walking home. Clearly, the actress will need to be wearing the same clothes and carrying the portfolio in this scene as well. Chances are good that we will shoot these scenes—one interior, the other exterior—on separate days. Here again, it's the script supervisor's notes that will ensure we get these details right.

- *Camera, Lighting & Grip*

 ○ Cinematographer/camera operator: On Hollywood features, it is quite unusual to have one person oversee the cinematography while also operating the camera. On shorts, even commercials, merging these jobs is more common.

- ○ Assistant camera/gaffer/grip: These are three distinct jobs. The assistant camera (or AC) sets up the camera and lenses and controls focus during a shot. The AC (or Second AC, if there is one) also handles the **slate** on set. The **gaffer** oversees the lighting design and sets up the lights. The grip sets up and operates all the equipment that supports the lighting and camera gear. This includes car mounts and dollies but also gobos and stands—the devices that filter or flag off lights on set. The only reason we can even consider combining these important positions is because *Shoebox Redhead* calls for relatively little lighting.

- *Sound*

 - ○ Sound recordist/boom operator: As sound equipment has become more portable and budgets have gotten tighter, it has become increasingly common to combine these two jobs. This means that one person is both monitoring the audio recording and operating the microphones. The downside of using a recordist/operator is that one person can't easily adjust audio levels while wrangling a microphone on a boom—a pole that extends above the actors' heads.

- *Art*

 - ○ Production designer/props/wardrobe/makeup: Once again, we are calling upon one beleaguered crew member to play multiple roles. In effect, we have reduced the entire Art department to one person. While the cinematographer certainly exerts great influence over the look of the movie, the Art department determines the style and appearance of all the physical elements in the production, from sets to clothing. This isn't just a big responsibility; it's also a logistical challenge, because there is generally a lot of stuff to keep track of: myriad props, makeup supplies, duplicate wardrobe items and so on.

By combining roles, we have come up with a crew of nine. We might further reduce our crew by combining roles still further, but in the vast majority of cases, doing so would be a very bad idea. To understand why this is so, and to get a better grasp of the way a crew functions, let's consider how a day of shooting might unfold. If we consider the schedule of *Shoebox Redhead*, the first day of the shoot really consists of scenes that would very likely be shot by a **second unit** on a commercial feature. We only dig into the meat of the script in earnest on Day 2. Figure 8.1 gives the schedule for that day.

The better part of the day will be spent shooting the garage sale scenes. As we have noted elsewhere, these scenes are challenging because of both art department and casting considerations. We'll need to assemble lots of props

Scenes: 6 Sheet: 6 Length: 6/8	EXT	GARAGE SALE Ryan & Matt arrive at garage sale	DAY	Cast: 1, 2, 4 Vehicles: V1 Camera/Grip: Extras: [3]
Scenes: 7 Sheet: 7 Length: 1 3/8	EXT	GARAGE SALE Matt & Ryan discover & buy the shoebox	DAY	Cast: 1, 2, 4 Vehicles: V1 Camera/Grip: Extras: [3]
Scenes: 10 Sheet: 10 Length: 5/8	EXT	GARAGE SALE Matt & Ryan seek refund from Old Woman	DAY	Cast: 1, 2, 4 Vehicles: V1 Camera/Grip: Extras:
Scenes: 2 Sheet: 2 Length: 1/8	INT	STATION WAGON - RYAN'S STREET Quick glimpse of air freshener	DAY	Cast: 1 Vehicles: V1 Camera/Grip: C1 Extras:
Scenes: 3 Sheet: 3 Length: 6/8	EXT	STATION WAGON - RYAN'S STREET Matt picks up Ryan	DAY	Cast: 1, 2 Vehicles: V1 Camera/Grip: C1 Extras:

Figure 8.1 Stripboard, Day 2

while dealing with the needs of elderly actors. If we are to set up tables and arrange mountains of belongings for sale while ensuring that our cast doesn't get overheated or while helping the cast with their lines, we're going to need every one of those nine crew members' help.

Actually, even with all hands on deck, we'll still need to be savvy about how we deploy our troops. Because much of the Day 1 schedule can be handled by a small, agile crew, if the weather permits, a couple of people can be freed up for at least part of that first day to help the production designer get a jump on setting up the garage sale. We might be able to apply this strategy at the start of Day 2 as well. In the first scene on the schedule, the script calls for Ryan's car to pull to the curb, only revealing that the young men have arrived at a garage sale when we cut to the **reverse angle** as they walk up to the Old Woman. If the director chooses to shoot the scene just as it is written, some of our crew can help with finalizing the dressing of the garage sale set as we film the car pulling up. As we learned when designing the schedule, this kind of leapfrogging, whereby part of the crew is often sent ahead to lay the groundwork for the next shoot, is crucial to keeping a small-scale production operating at full speed—but we can only do this if we have enough personnel to divide and conquer when necessary.

The Shoebox Diaries

"I've seen so many DPs try to be their own gaffers. They'll frame up a shot and then run around the camera to set a light, because it's actually faster for them to do that than explain lighting to an untrained PA. So, the value of having a good gaffer is completely underrated."

—*Charlie Anderson, Sound Recordist*

Payments, Deferrals and Favors

If you are a student or weekend filmmaker, the very concept of hiring a crew might provoke a smirk. Your assumption might be that, since you don't have the funds to pay any salaries, the notion of officially hiring anyone sounds overblown. While that response is understandable, it overlooks a few important considerations. Remember the concept of work-for-hire that we touched upon in discussing screenplay rights at the start of this book? Copyright law (at least in the United States) has long acknowledged that crew members can contribute their efforts to a media production without necessarily earning any ownership stake in the resulting motion picture. Such work-for-hire agreements come with a caveat, which is that crew members—just like the actors in the cast—must accept the arrangement *before* the work is undertaken. Therefore, even if we can't pay our crew, we still need them to sign contracts acknowledging that they are working for hire. This applies even on student productions and even if you can't pay your crew. You can find an example of such a contract in Appendix C. Note that, as with the Screenwriter Agreement discussed earlier, this contract refers to a companion document, Exhibit A. In this case, Exhibit A is a description of the duties that pertain to the crew position in question. This description can take the form of a paragraph or a set of bullet points. It need not be complicated, but it should be thorough.

Even if our budget is very tight, the assumption that we won't pay any crew members should be scrutinized carefully. It's all well and good to expect friends to lend a hand as a favor, or that others will volunteer for our project to burnish their résumés, but if people have to make financial sacrifices in order to participate in our production, we may find that their enthusiasm starts to wane. If someone has to pass up paying work or simply has to take Uber home every night during a shoot, she may start to feel aggrieved. It's one thing to volunteer your services; it's another to see your wallet emptying out while you are slaving away for nothing. We may not have the resources to pay our crew a living wage, but we might be able to lessen the sting of working for free. One way to do this is to offer folks a per diem. For example, we could provide a per diem

of $10 to each crew member to cover personal expenses such as transportation. Ten bucks doesn't mean much as a wage, but it can carry a lot of clout as a goodwill gesture.

As this last point illustrates, while money may indeed make the world go 'round, deals don't simply depend on how much cash is on the barrelhead. Financial interest in a project can take various forms. Once upon a time, many independent filmmakers convinced key crew members to take "profit partici- pation" on their productions in lieu of wages. If the movie made a profit, these crew members would get a share of the proceeds, as determined by how many percentage "points" they agreed to. Because points only paid off in the rarest of rare cases, these kinds of profit participation schemes gradually lost their luster. Since the financial potential of shorts is limited, points aren't a viable bargaining chip for short productions per se. However, producers of short con- tent sometimes take a different tack when it comes to deferring compensation. Over the past two decades, many filmmakers have made short versions of long- form projects as a kind of proof of concept. The well-received features *Bottle Rocket*, *Frozen River* and *Whiplash* all started out as shorts. A producer might entice a crew member to work on a short for free by offering the promise of working for pay on the long-form version of the project. Note, however, the word *promise* in that last sentence. A promise is a promise. Any contractual deals you enter into that create an obligation are potential encumbrances when you seek financing for a larger commercial production. Suppose you promise a talented young cinematographer that, if she works on your short, she can shoot the feature-length version when the time comes. The short then wins a clutch of awards on the festival circuit and you attract the interest of an international film sales company. The firm wants to secure financing for the feature, but to do so, it insists that certain positions—including the cinematographer—be filled by veterans with proven track records. This cautionary tale isn't meant to convey the message that you shouldn't cut such deferral agreements with the crew of your short, however, just that you have to be willing to suffer the consequences that may come with them.

Pro Tip

"How do you get someone to be equally excited as you are about the film? How do you get five people excited, then ten, then a hundred? Because you're running for office, in a sense, when you're making a movie: you're con- vincing everybody that this is worth their time."

—*Glenn Gainor*

Cutting Deals: From Box Rentals to Favored Nations

When working with a tight budget, filmmakers are sometimes drawn to a one-size-fits-all approach to personnel issues. According to this mindset, since you can't offer anyone compensation that is commensurate with their worth, you're going to ask everyone to accept the same terms for their work. To put it another way, you're asking everyone to say, "Yes, this is a bad deal, but if you'll take it, I'll take it." Such provisions show up in contracts under a couple of terms, the most common being a **favored nations** agreement. The Latin phrase *pari passu* ("equal step") is a less popular expression of the same concept.

There is a compelling all-for-one-and-one-for-all ethos behind this gambit. Be that as it may, we should enter into favored nations agreements with caution. By definition, this deal only works if everyone agrees to the same terms. We can't have eight out of our nine crew people accept one set of provisions and then negotiate a different deal with one outlier. The logic of shared sacrifice underpinning favored nations agreements also might be suspect, especially on very-low-budget productions. The fact is that the value of the project will not be the same to every member of the crew. The assistant camera might have to show up just as early on set and work hours just as long as the cinematographer, but it's likely that the finished product is going to mean more as a work sample for the cinematographer than for the assistant camera. Yes, we might persuade some novice to serve as assistant camera just for the experience, but putting such highly technical tasks into untested hands can backfire horribly. This is why producers often find that, while they can fill principal crew positions with talented volunteers, they must sweeten the pot in order to secure the services of qualified crew in secondary roles like the assistant camera or assistant director. For the same reason, sometimes the hardest positions to fill are the least technical jobs, such as craft services. Not infrequently, you will need to be able to offer an additional incentive to lure one or another crew member to come on board. Under a favored nations agreement, you don't have that latitude.

Certain crew members might bring something of tangible value to the production beyond their services. For instance, a cinematographer might own a nice camera. This is where a kit or box rental—a term introduced in our discussion of the budget—can come into play. It is very common for certain crew members to be compensated for the use of their gear or supplies. All this may sound pretty straightforward, but here is a little secret about box rentals: on occasion, producers use them as a loophole to deal with the limitations of favored nations agreements. Let's say we have gotten all our crew to agree to work for free, plus a $10 per diem. The one position we haven't been able to fill is the assistant director slot. We know a crackerjack AD, but he says he needs at least $500 for the week he'll be on the job. Here's what we do: we negotiate a $500 box rental for the use of the AD's laptop, which includes various call sheets and other

forms that might come in handy. The assistant director then signs on to work under the same terms as everyone else; the laptop rental is a separate deal.

> ### Pro Tip
>
> "Makeup and hair people can show up with very extensive kits. Expendable products used on the cast can add up, so they can get a kit rental fee as well. Kits are always a good place to negotiate. Sometimes it's easier to bump up a kit rental over a fee, especially when trying to keep things equitable. It's a way to appease someone and make a deal without compromising the salary bottom line."
>
> —*Corinne Marrinan*

In economics, there is a fundamental concept called opportunity cost. As consumers, we all have an array of opportunities for spending our money. The price we are willing to pay for something is determined in part by the other opportunities we have to spend those dollars. This same principle can be applied to employment. We consider any job offer against any other opportunities we have. Everyone's opportunities are different, and each of us will value any given opportunity somewhat differently. In essence, a savvy producer determines the value of the project at hand for each individual on the crew and then negotiates a deal accordingly. All of this is a way of saying that we need to find each person's price. This means being tough-minded and wily, but sometimes it also requires us to be sensitive. It's one thing to drive a hard bargain, but if people feel like they've been taken advantage of, they may act out in unwanted ways. Maybe they won't show up to the shoot, or they'll give less than their full effort, or perhaps they'll simply carry a grudge and not want to work with us on future projects. A good producer knows how to read people so that they remain willing, active members of the team.

> ### Pro Tip
>
> "You're responsible: if people aren't getting along, you need to be the one sitting them down, saying, 'What's the problem here?' You have to be very proactive. The producer's job is to produce. That means to be proactive in every way. And being a psychologist is a big part of the talents that a producer must have."
>
> —*Michael Nozik*

Chapter 9

The Cast

The Producer's Role in Casting

Of all the many roles that the director must play in a production, none is more important than helping actors deliver a compelling performance on-screen. An effective actor/director relationship depends on concentration, camaraderie and trust. Where does the producer fit into this intense bond? To a considerable extent, your job is simply to stay out of the way and to ensure that the rest of the crew does the same. At the same time, there are ways the producer can encourage and facilitate the partnership between actor and director. The first opportunity to offer such assistance occurs in the casting process.

> ### Pro Tip
>
> "I think that the most important thing for students to learn about actors is that the quality of performance relies very heavily on the trust between the actor, the director and the cinematographer. If you surprise your actors, they can see it as a betrayal of trust in some way, and you are never going to get the level of performance that you want."
>
> —*Barbara Doyle*

The Casting Process

From the producing standpoint, there are two distinct goals for casting a production. The first is to connect the director with the best possible selection of actors; the second is to make sure that the director meets that pool of talent under optimal conditions. Let's consider these points one at a time.

Nationwide talent searches and the tales of how future stars are plucked from obscurity are the stuff of Hollywood legend; yet, despite the prevalence

of these narratives, many budding filmmakers grossly underestimate the time and effort required to find a great cast. Casting a production successfully requires that we keep our objective in mind. We aren't trying to reach out to all available actors in hopes that some of them will fit our needs. The fact is, in the vast sea of actors, there are relatively few that have the talent and drive we require—and let's not forget that they must also be available for our shoot dates and willing to work within our meager budget. It is that elect group—and *only* that group—we are trying to find. Once we start to think about the process in these terms, it becomes less about broadcasting our needs to the wider world and more about taking a series of targeted steps to reach the right people. The first goal isn't so much to get the talent to come to you as it is to go out there and find the talent.

Unless you are in New York or Los Angeles, the pool of available actors in your area is relatively defined. Once you start to get to know the drama community, you'll find that the same familiar faces turn up repeatedly in everything from car commercials to Shakespeare in the Park. While it's fine to be on the lookout for fresh faces and diamonds in the rough, you may well find that the talent you are looking for has already been discovered, at least on a local level. Gifted actors and directors tend to congregate. A successful theater company will often draw from a pool of fine local actors. By tapping into a group such as this, you put yourself miles ahead in your search. Getting acquainted with your local acting community requires attending plays and networking with other filmmakers. It's best if the director spearheads this outreach process, but as producer, you can be a partner and coach. Don't be afraid to call people up or to go backstage at theatrical productions. Meeting talented actors is never a waste of time. You might encounter a brilliant performer who isn't right for any of the parts you are casting but who can nonetheless point you toward two or three excellent prospects. Keep an open mind. If your director stays flexible with regard to considerations of gender and ethnicity, the pool of potential talent expands.

Insinuating yourself into the acting community won't happen overnight. This process takes time. If you make the effort to scout out talent, however, the actual audition process will go much smoother—instead of just praying that someone talented will walk through the door, you can recruit gifted performers to come in and read for the parts.

If your image of casting derives from the movies, the methodology we've focused on thus far may seem strange. What about that staple of backstage dramas, the "cattle call" scene where an endless parade of hapless ingénues is marched past the jaded gaze of a casting director in a darkened theater or sound stage? Is there never a need to cast a wider net like this? Indeed, there very often is. No matter how clever you are in beating the bushes for talent, you may find that certain roles are hard to fill, or perhaps you have a scene—a

wedding? a funeral?—that requires a lot of actors, few of whom need to be master thespians. In these cases, you may need to do what is termed an "open call." In this case, you'll publicize the audition as widely as possible and hope that a throng shows up.

Hiring a Casting Director

Before we address what is needed to run a successful audition, we should pause and consider the possibility of hiring a casting director. Here we're referring not to bringing on a friend to help with the casting process, but rather engaging the services of a professional casting agency. Again, we imagine a chorus of dry laughter: who has the money to hire a company for such a job? Not so fast. I'm sure we can all agree that bad acting is cinematic kryptonite: it is guaranteed to kill your movie. A casting director's livelihood depends on knowing which actors in a given market can deliver the goods. That is extremely valuable knowledge. Furthermore, the process of casting can take a great deal of time and even a bit of money. Viewed in this light, the cost-benefit analysis can certainly come down in favor of hiring a casting director.

There are scenarios where hiring a casting director is essential. Let's say you have a production that comes together very quickly and needs to be shot very soon. If necessary, a professional casting director can put together an audition in a matter of hours. If you want, she'll also run the audition, assemble all the actors' headshots and résumés, record the casting sessions and help you sort through the results. Another instance where it pays to pay a casting director is when you have a role with precise requirements. Perhaps your project calls for an eerily precocious child or someone who speaks with a convincing Cockney accent. In such cases, a casting director may be able to save you weeks of fruitless searching.

As noted above, a casting agency can provide a range of services—and they can charge handsomely for that work. On the other hand, if you make it clear that your budget is small and your needs are specific, you can often negotiate a deal that is affordable. Consider the case just mentioned of the elusive Cockney-accented speaker. In a typical American town, only a handful of capable actors will fit this bill—and a well-connected casting director will know right away who they are. You might be able to get such a director to point you toward some prospects for little or no money. While they can't afford to make a habit of it, I have known casting directors to let student filmmakers comb through their books of headshots as a favor. In another case involving a student film, a casting director produced a day of auditions, coordinating all the details and lining up dozens of actors for $500—a fraction of the commercial rate. As with all aspects of producing, when dealing with casting agencies, the key is

to make them realize that you are building a relationship. They may be willing to help you out in hopes that you'll remember them when you have a better funded project.

Producing Auditions

Let's assume that a casting director is *not* going to set up or run your auditions. What responsibilities does this put on your shoulders? Unless you have been entirely successful in your networking efforts, you'll need to put out a call for auditions. As you will have surmised by now, there are two kinds of first auditions: those that are arranged with a targeted set of actors and the unscheduled open call. Depending on your timeline, your acting needs and the response you anticipate to your call, you can determine whether to hold scheduled or open auditions. There are several common places for placing a call for auditions:

- *Local newspapers*: Classified ads aren't what they used to be, but casting happens to be an activity that still sustains local print media. Some newspapers in larger population centers have special classified sections just for theater and film auditions. In addition to newspapers, alternative weeklies with good arts coverage might be appropriate publications in which to place an announcement.

- *Professional publications*: If you are planning to cast your project from the acting communities in some of the major metropolitan areas, you might place a casting announcement in one of the publications that target those populations, such as *Backstage*. While actors in New York and Los Angeles still pick up print editions of these publications, listings are increasingly posted and shared online. As an example, you can set up a basic account at *backstage.com* for a small fee. This will let you post an online notice of your casting needs. A printed announcement costs considerably more, and charges accrue weekly.

- *Social media and other online resources*: If you do some snooping around on the internet, you may find that there are specific online groups in your area that bring actors together. Look for Facebook pages for drama schools and community theaters—some of these serve as bulletin boards. Craigslist is also an option (you can post in the Jobs section under TV/film/video/radio), but don't expect a lot of responses from seasoned veterans.

Depending on your project, you might want to take a more grassroots approach to reaching actors. If you are casting a high school drama, see if you can get the high school drama teachers in your area to pass the word along to their students. If you're telling an immigrant story and need a Cambodian family, you might post flyers at the local Asian market.

A true open call means that you'll be holding auditions at a certain date, time and place, and then you wait to see who shows up. Although I've hosted plenty of open calls, they are not my first choice when it comes to auditions as there is no quality control whatsoever. Whenever possible, I would prefer to vet the responses before deciding who to see.

It can be very hard to gauge the response you'll get to a casting call. I once produced a short that needed a lot of actors to read lines of voice-over narration. Since I wasn't offering pay and the actors wouldn't even appear on-screen, I didn't think my announcement would excite much interest. Without giving it more thought, I printed my phone number in the posting. My phone rang nearly round-the-clock for a week. Keeping this cautionary tale in mind, it's a good idea to set up an e-mail account that is dedicated to correspondence related to casting your project. Then the worst that can happen is that you'll get a very full inbox.

Once you have collected headshots and résumés from interested actors, you'll probably need to sift through the responses. You're not obligated to audition everyone, but how do you determine who is worth meeting in person? Don't put undue weight on the photographs. Headshots can be notoriously misleading. You'll often learn more about actors from their résumés. What credits do they have? Have they done work on-screen? Do they have formal training? After you have reviewed a couple hundred résumés, you'll get pretty good at separating the serious practitioners from the dilettantes.

The time has come to schedule auditions. Now that you're about to meet your prospective cast, give some thought to how you can make this first encounter a positive experience. Pay no heed to those grim, humiliating cattle call scenes in the movies. You only get one chance to make a first impression. Why not ensure that the introductory meeting between actor and director is given every chance for success? With all this in mind, I do *not* recommend holding auditions in cramped apartments or spare bedrooms. These are personal, intimate spaces that are likely to make some actors uncomfortable. Try to secure an open, flexible space in a professional building or academic institution. It's very helpful to have an area outside the audition space where actors can check in and wait their turn. If possible, have an assistant greet the actors as they arrive. Have the assistant ask the actors to fill out a simple information sheet with their current contact information. Résumés often have out-of-date addresses and phone numbers. This info sheet can also be used to ask about logistics, such as availability to shoot on specific dates. Casting can be an arduous process for all involved, so it's not a bad idea to have some modest snacks and water in the waiting area.

The amount of time the director will spend with an actor in a first audition depends on whether she is seeing a large number of aspirants or a select group. In the former case, the director might ask each actor to present a monolog of no longer than two minutes. The purpose of such very brief encounters is just to see and hear the actor in person. If you are ruthless in maintaining your

schedule, you can see close to 100 people in a single day this way. This is not an experience I would wish on anyone. To understand why, just imagine saying "Hello," "Thank you" and "Goodbye" a hundred times. Take a still picture of each actor, and if possible record video of each audition, making sure that the actor always states his name.

If you are working with a more targeted group of prospects, the director may be able to spend ten or fifteen minutes with each of them. This gives her time to let each actor try out a part. Directors develop their own particular methods for exploring an actor's abilities. Make sure you have discussed your director's plans in this regard well in advance of the audition sessions. A common practice is to have actors read **sides**, a term for a few pages from the script. You may want to provide the sides to the actors a day or two before the audition, but in any case, you'll need to have hard copies of the sides on hand. These often are put out in the waiting area so actors can review lines while they wait. You'll also need someone in the audition who can read lines with the actor.

Pro Tip

"Another thing, if you have the luxury of time, is bring the people you want to cast in for some chemistry tests—really see if they play well together, if they feed off each other. Those are things that are going to sell your piece. If that chemistry's not there, you don't have a show."

—*Leah Culton Gonzalez*

Unless she has prior knowledge of an actor's work, it's seldom the case that a director can cast someone on the basis of a one-minute monolog or even a brief reading of a scene or two. Therefore, after an initial audition, it is frequently the case that you'll need to do callbacks for a second or even a third meeting. Since the number of actors contacted for callbacks is generally a small fraction of the cohort called in for a first audition, you can allow for more time with each person. Again, recording these sessions is important, but be careful not to leave the camera running. Information overload is a very real hazard of the casting process, and you don't want to saddle your team with hours of video that no one will have the time or inclination to review.

Speaking of overload, at this point, you might be getting overwhelmed by the details I have thrown at you. Perhaps we should take a moment to summarize the steps that may be involved in running your auditions:

* Secure a suitable space for your auditions.
* Announce the audition.

- Make and post flyers for actors with harder-to-reach profiles.
- Review responses from actors—headshots or whatever has been submitted.
- Schedule audition times.
- If you plan to have actors perform material from the project, send out sides.
- Make hard copies of sides.
- Write up and copy an information sheet for actors to fill out.
- Secure at least two helpers: one person to greet people and another to record auditions and possibly read lines.
- Bring water and light snacks to the audition.
- Set up a camera for recording auditions.
- Review audition results and schedule callbacks.

Good news: there is one item that neither you nor the director needs to put on your to-do list, and that is to contact those actors who are out of consideration. The desire to reach out to every actor who has taken the time to audition—including those who don't make the cut—is a laudable impulse, but it is a waste of time. Actors are used to rejection, and frankly, hearing "no thanks" from you might sting more than hearing nothing at all.

Casting Professionals and Actors From Other Regions

There is a great deal to be said for working with veteran screen actors. They know how to hit their marks, how to deliver a consistent performance take after take and how to endure the long stretches of downtime on set. Understandably, seasoned actors come to a production with certain expectations with respect to professionalism and working conditions. If you plan to work with these folks, you need to be sure that you understand those expectations and are prepared to meet them. If you look through the filmographies of some of your favorite actors, you might be surprised to find that they have appeared in several shorts. Occasionally a rising star will agree to perform in a short project just for fun or as a favor. Getting "a name" to appear in your movie is very exciting, but again, make sure that the deal you are offering is understood. More than once I have heard of stars agreeing to act in shorts, but with the expectation that they will be flown coast-to-coast first class and put up in a four-star hotel—conditions that are guaranteed to bust the budget.

Anytime you use an actor who is not local—whether a star or not—you must accept an additional financial burden. The director and the actors may have to travel to or from your home base to audition and rehearse, and then of course any out-of-town cast will need to have their travel expenses covered and will

need to be put up for the shoot itself. These costs can seriously inflate your budget, but they also can affect the creative side of the project. The director and cast may not develop as deep a bond if they can't readily work together. Keep these considerations in mind before leaping to the conclusion that it's worth the trouble to bring in talent from far afield.

Working With the Actors' Unions

In the United States, unionized actors who work in radio, television and motion pictures are represented by a single organization, SAG-AFTRA. That ungainly string of letters represents the merging of two unions, the Screen Actors' Guild and the American Federation of Television and Radio Artists. In some sectors of the economy, the labor movement is in considerable disarray, but this is not the case in the motion picture industry. Most large-scale media productions, including feature films, television series and commercials, work with at least some unionized personnel.

Of course, it's not just the cast that might be unionized. Every discipline that goes into the making of motion pictures has been organized into powerful unions, notably **IATSE**, the International Alliance of Theatrical Stage Employees. However, since it's far more common for a short film to work under the terms of SAG-AFTRA than other performing arts unions, we are going to limit our discussion of unions to this summary of working with the actors' union. Don't feel shortchanged, however; when the time comes for you to work with IATSE or other unions, you'll find that many of the terms of their agreements mirror those of SAG-AFTRA. This isn't coincidental. The performing arts unions have long histories of working together and indeed have reciprocal agreements that require them to defend the interests of one another's memberships in the case of labor disputes.

Once upon a time, dramatic filmmaking was almost the exclusive purview of studios and television networks. Even student films were a rarity. A generation ago, union agreements still reflected that reality. In those days, SAG (this was before the SAG-AFTRA merger) had a student film agreement, but the terms were stringent, and if you couldn't meet those terms, you had to work under the same contract that applied to the very biggest Hollywood productions. Today, SAG-AFTRA's agreements reflect the enormous diversity of media productions, from straight-to-YouTube comic shorts to summer blockbusters. This is why, in the great majority of cases, I counsel producers and directors of shorts to find the best talent for their projects, irrespective of union affiliation. This is a good thing, because in many parts of the country, you'll find that most experienced actors are members of SAG-AFTRA. However, there are exceptions to my don't-worry-about-the-union rule. For instance, if your production is primarily a promotional or money-making venture, you will

want to pay special attention to the payments and provisions the union expects for its members for such projects.

While you needn't necessarily worry whether or not actors auditioning for your short are members of SAG-AFTRA or not, you will want to know their union status. That's because while union actors can perform alongside non-union actors, they must work under union rules. Every so often, I hear of a producer who has planned a production on the assumption that none of the cast belongs to SAG-AFTRA, only to discover on the eve of the start of the shoot that a key actor is in the union. At best, this produces serious heartburn. At worst, it delays the start of production as the producer scrambles to meet union requirements.

Union requirements? If that sounds ominous, don't worry; most of the provisions SAG-AFTRA places on a production are sensible. It's worth remembering that the reason unions rose to prominence in the motion picture industry is because, in the pressure-cooker environment of a shoot, there was a need to establish guidelines for working conditions. It's hard to argue with that aim. That said, the process of signing up to work with SAG-AFTRA does take some time, so as always, it's important to plan ahead.

While you can and should contact the union early—during the budgeting process, if not sooner—to find out which of their agreements might best suit your production, you don't want to become a **signatory** to the union until you are certain that you will be working with union talent. Becoming a signatory means you agree to abide by the terms of SAG-AFTRA's collective bargaining agreement. Taking that step brings with it certain responsibilities—and, of course, some paperwork.

These days, media productions are happening from Hollywood to the hinterlands, and SAG-AFTRA now has many different agreements to cover that spectrum. It would take a separate book to cover all the provisions of these agreements, and indeed the union's basic contract, from which all these agreements derive, runs to hundreds of pages. Many factors play into which agreement will apply to your production: Are you a student? What is your projected budget? What is the nature of your project? Where do you plan to show it? Here's how best to sort through these issues. First, visit the SAG-AFTRA website at *sagaftra.org*. Take a tour through the contracts sections and see what best applies to your production. Before your head starts to swim, look up the correct SAG-AFTRA office and contact a representative to discuss your plans. Unions are organized into "locals," and there are slight differences in the ways various locals conduct business, so you'll want to be sure to contact your local.

While the specific terms of the various union agreements vary, here is a summary of common concepts and provisions:

- ***Insurance and worker's compensation***: The union will want to see proof that your production has insurance to cover your liability in the case of

accidents. You will likely also have to show that you have worker's compensation coverage to provide an actor with income if he's laid up due to an injury sustained during production. We'll have more to say about insurance in the next chapter.

- *Deferral of payments*: With some exceptions that we'll touch on below, the SAG-AFTRA student agreement allows the student producer to defer payment to the actor. It's important to stress that *defer* does not mean *waive*: if your short gets distributed or otherwise makes money, you'll need to pay your actors according to the days and hours they worked. In my experience, making money off the distribution of a short—even if this means now needing to pay off the actors—is a problem most producers would welcome, since it means your movie has reached the broadest possible audience. Nevertheless, if you are trying to make a short as a commercial venture, this provision could be a showstopper.

- *Working, travel and living conditions*: The union has explicit rules about what constitutes a normal workday, how many hours can pass between meal breaks and even what kind of meals should be provided. There are also rules governing travel and housing arrangements. Some of these rules are more rigid than others. For instance, it is critically important to know when overtime kicks in (after eight or ten work hours, depending on the contract under which you are working). You should also be aware that, if your actors have to drive a significant distance to and from the set, commute time is counted toward work hours. If you have to put your actors up, you should anticipate providing separate rooms for them. Other provisions, such as the exact mode of transportation you need to provide, may be negotiable, but **parity** is an important concept to keep in mind in this regard. By parity, we mean that all actors must receive the same treatment, so if one person flies first class, then everyone flies first class. Remember the concept of *pari passu*? You can find the etymological root of *parity* in that term, and the notion of equal treatment it sets forth applies here.

- *Nudity*: Let's assume you have a legitimate need for someone to disrobe on-screen. How are you going to go about casting this role? Sorry, but in this day and age, if you post a casting notice that calls for nudity, readers of your announcement have good reason to assume that you're a pornographer. On the other hand, if you don't broach the subject of nudity fairly early in the casting process, you may be wasting everyone's time—and opening yourself to the accusation of deceit. In my experience, it's best to meet face-to-face with prospective actors before addressing specifics of a role, including nudity. Once an initial contact has been made, however, it's important to get all the cards on the table. If the first audition or meeting

goes well, the director can bring up the issue of nudity in an honest and straightforward manner. Immediately following the meeting, you can send the actor the full script so that he can place whatever on-screen intimacy is called for into the context of the project as a whole. However, it must be said that the process just laid out does not meet SAG-AFTRA's rules, which state that an actor must be notified of any nudity required for a role *prior* to a first audition. The union has very clear guidelines for dealing with nudity from the casting process onward. If this is relevant to your production, you should carefully review the section on nudity in SAG-AFTRA's basic agreement. One fundamental concept: the specific nature of any on-screen nudity must be agreed to by the actor *in writing*. This is called a nudity **rider**, and it's a good idea whether you are working with union or non-union actors. Look at it this way: if you think it's awkward to put the concerns and expectations with respect to on-screen intimacy or exposure into a formal agreement, just imagine for a moment how much more awkward it is to have a shoot fall apart because of a misunderstanding between an actor and a director on such a sensitive issue.

- *Stunts*: If you thought dealing with nudity was tricky, you might want to avoid stunt work. The term *stunt* appears almost 700 times in the SAG-AFTRA basic agreement. Under the circumstances, it's hard to summarize all the provisions regarding stunts. In addition to stunt performers, who often act as **stunt doubles** for actors, there are also stunt coordinators and fight coordinators who work with stunt doubles and/or the rest of the cast to orchestrate the action safely and effectively. Depending on the material you are producing, you may have some leeway for negotiating with the union as to how many performers and coordinators you'll need to hire. When you sign on to work with the union on a project, you'll need to provide them with a script. They will review the script for any potentially risky scenes. It's important to understand that stunts don't have to involve obvious derring-do, such as falls from tall buildings; your union rep may determine that riding a bicycle through downtown traffic or throwing a punch are stunts. You have to talk these issues through so that you and the union know what you are getting into. While you are at it, don't skirt the issue of compensation. Due to the risky and specialized nature of their work, stunt performers are paid differently than regular actors, and you may not be able to defer or discount payment.

- *Production paperwork*: Depending on the nature of your project, you may need to file more or less paperwork with the union. One document that you are certain to encounter is the so-called **Exhibit G**. That's an arcane name for a humble document. It's simply a form that shows how many days and hours an actor worked. If a performer or the union has any questions about

the length of a workday, when meal breaks occurred or anything else related to the work schedule, Exhibit G is the official record. That's why actors are required to verify the data entered on the form with their signature, and it's why producers must ensure that the information entered is accurate and up-to-date. I knew a student filmmaker who didn't take Exhibit G seriously enough and it came back to bite him. Instead of recording all the dates and hours worked during the shoot, he waited until the production had wrapped and then plugged a bunch of fudged figures into the form. He may or may not have even forged his actor's signature. As it happened, the film turned out remarkably well and attracted the interest of a distributor. Now that the production was on the threshold of becoming that rarest of entities—a short film that actually made some money—the union representatives went back to the Exhibit G on file to determine what deferred wages were due to the actor. This is the point where the actor learned of the phony numbers that had been entered ex post facto. To say that the actor got upset would be a gross understatement. Of the several bad outcomes that arose from this dispute, one of the worst was that a promising young filmmaker embarked on his professional career with a powerful labor union viewing his motives with distrust. Don't let this happen to you.

- *Overtime*: The specific provisions for overtime pay vary among the different SAG-AFTRA contracts. It may be the case, for example, that a regular work-day is considered to consist of ten hours, with any hours beyond that limit being paid at double the hourly rate (so-called "double-time" or "golden hour" rates). Before you draw up your schedule, you'll need to be very clear on the overtime provisions that apply to your production. If you are a student film-maker, you must understand that the deferral agreement with SAG-AFTRA does *not* give you license to shoot sixteen-hour days without consequence. Compensation for overtime work cannot be deferred, so overly long days are a budget buster, whether you are a student or a professional producer.

- *Turnaround*: Another common-sense provision that unions insist upon is a minimum period of rest between wrapping for one day and starting the next day of production. This is known as **turnaround**. In general, your cast will require at least twelve hours of turnaround time between shooting days. You also have to give people the equivalent of a weekend off each week—though the off days don't have to fall on Saturday and Sunday.

- *Child actors*: No surprises here—there are lots of stipulations that apply to working with children. In applying its guidelines in this area, in many cases SAG-AFTRA is only following the law, which also has a lot to say about employing minors. There are strict limitations on the number of hours children can work in a day and how late they can work. Depending

upon the time of year, the production may need to hire a tutor to permit children to continue with their studies. During summer months or over weekends, you may be able to get by with a child welfare worker on set.

- *Penalties*: Movie shoots have a tendency to take on a life of their own. Suppose you work the cast and crew for six hours without a meal break, or you start a night shoot at midnight, having only finished the last day of shooting at 5:00 P.M. You've broken a union rule. Now what happens? Chances are, your production will be assessed a penalty, usually in the form of a fine. Penalties can run the gamut from the equivalent of a parking ticket to thousands of dollars. Of course, a penalty that applies to one performer will have less impact than one that applies to the entire cast. To prevent inexperienced producers violating rules with impunity, penalties can't be deferred.

- *Internet exposure*: Collective bargaining agreements can take years to negotiate, and then those terms are in effect for many more years. As a result, at times union contracts can seem more a reflection of past practices than present conditions, and this is particularly noticeable when it comes to rapidly evolving technology. Distribution by streaming video (think YouTube and Vimeo) is a good example of this quandary. Not so long ago, SAG-AFTRA's policy for students and very-low-budget productions prohibited any online distribution. Since almost every short movie is eventually destined to be shared online, this was a real bummer—and a major disincentive to work with union talent. Adjusting with the times, the union then implemented a revised position that allowed for shorts producers to negotiate riders with individual performers that stipulate what sort of online distribution is allowed. This issue is a moving target: the next edition of the union's basic agreement is sure to address it in detail. Let's hope that any guidelines that emerge from these deliberations facilitate arriving at an equitable way to share content online.

I imagine this list might have caused more than a few readers figuratively to tuck tail and head for the hills. Maybe you're producing a simple little short on a microscopic budget. Why saddle such a project with all the considerations involved in working with a union? There are a couple of ways to answer this. First and foremost, I would again point out that—at least in many regions—the majority of seasoned actors will be SAG-AFTRA members, so if you want access to that talent pool, you must dive in. Second, unless you are working on a commercial project or one that has an unusually high budget, the union contract governing your production is not going to be that complex. In particular, SAG-AFTRA's student film agreement is really labor relations on training wheels. So, get on that bike! If you are planning to be a producer, you're going to need to learn your way around union paperwork and regulations. Why dodge or delay this important lesson?

Using Non-Actors, Using Friends and Other Special Cases

The casting process can be nerve-wracking. Aware of the difference a good performance can make to a movie, you sit there in your audition room, praying that the perfect actor will walk through the door. What if you could turn this process around—first find a group of brilliant actors and then find the perfect project for them? In effect, this is the approach Matt Lawrence took with *Shoebox Redhead*. He knew he could count on a talented and eager team of friends to work with him, so he wrote the script with those people in mind.

A number of filmmakers have applied this same method to working with non-actors—even non-humans. Zach Treitz based his acclaimed short *We're Leaving* on a couple in his hometown who had a pet alligator. The key here is that the project germinates and emanates from an interesting asset that is already available to you. Producing a short that calls for a domesticated alligator is a fool's errand—unless you happen to know someone who has just such a beast in their bathtub. Along the same lines, setting out to make a short about a Civil War battle is impractical—unless your best friend happens to be an avid Civil War reenactor.

The Shoebox Diaries

"When I think about my relationship with Ryan, I think it works in the film because he really cares about me. I know he cares about me. So, I think a lot of that can be seen in the film, without lines, without action. And it's the same thing with everyone who's acting together. There's an affection for each other, and I think it does transfer in the film and in films in general. That's one of the compliments we got at film festivals. People said, 'It really seems as if you guys have this great rapport. Have you guys worked together before?' And it's like, 'Yeah, I see him every day. He lives down the street from me.'"

—*Matt Lawrence, Producer, Director, Writer & Editor*

As appealing as this kind of organic approach to casting and developing a project might be, it's important to understand the complexity and potential pitfalls associated with working with non-actors. There is no greater fallacy than the notion that everyone is inherently able to "be themselves" in front of a camera. On-screen, that Civil War reenactor pal of yours may be as stiff as a tin soldier. Getting compelling performances from non-actors requires both finding the right people and adjusting your working methods to fit their

needs. *Five Feet High and Rising*, an award-winning short about coming of age in a New York barrio, is a good example of this. Director Peter Sollett had a story outline in place when he undertook an extensive search to cast his two young leads. Because he was working with children and non-actors, he let the performers come up with their own lines and he filmed them much as you would shoot a documentary. The result feels light, spontaneous and genuine—the very opposite of stiff. Had Sollett shot his production in a more conventional manner, requiring his actors to say the same predetermined lines and hit their marks take after take, it's a safe bet that his short would have had none of those qualities.

Casting Crowds

Many of life's most important rituals and challenges involve assembled groups of people. Proms, weddings, funerals, trials, sports contests, high-stakes exams—these are all situations that require lots of people. But ask any producer and she will agree: crowds cost money. If you are producing a scene that calls for a throng of people—even if they are merely "atmosphere"—it means that you have a small army of cars to park, mouths to feed and rear ends to seat. But before you even get to those headaches, you must clear a very tall hurdle: where are you going to find all those people?

Getting a crowd of people to show up for a shoot is one of the most difficult challenges a producer of a short can face. Chances are, there isn't much you can offer any individual recruit: not money, not bragging rights—not even much screen time. One of the most effective techniques I have used to solve this dilemma is to enlist the aid of an organization to turn out its membership. Here's an example of how this can work: suppose your script includes a scene at a high school basketball game. You need not just a couple of teams to battle it out on the court; you also need bleachers filled with fans. You can't possibly line up all the participants individually—players, coaches, cheerleaders, fans. Instead, you reach out to an athletic program, offering them a $500 contribution if they can provide the players, cheerleaders and the crowd for your shoot. Some high school sports programs have booster clubs associated with them, so if the price is right, they can provide the entire package. This might be a meaningful sum to a cash-strapped athletic program. Using the home and away uniforms, you dress the players up to look like two teams. You ensure that you have enough people to populate the bleachers by making your agreement with the program contingent on their turning out at least 40 onlookers (that might not sound like much of a crowd for a ball game, but if your director chooses his camera angles carefully, he can make it look like a multitude). This same strategy can work with community clubs, Girl Scout troops and church groups. And here's one more

tip: depending on the organization and how you make the payment, your contribution to their coffers may be tax deductible!

Of course, countless crowd scenes have been produced relying on no more than the kindness of friends. This may be the right approach, but proceed with caution. First, take a moment to consider if your cohort of friends really fits your needs. If you are a student and producing a funeral scene, ask yourself whether it makes sense for all the graveside guests to be in their teens or twenties. Weigh this as well: sadly, familiarity does indeed breed contempt. Precisely because they view you as a buddy—not as a filmmaker—your friends may not take your project as seriously as you need them to. Just because they are close to you doesn't necessarily mean that they will have the stamina and interest to stick around for the duration of your shoot. With all this in mind, consider incentives that you can provide even when working with groups of friends. Got a prom scene? Throw a party, requiring everyone to dress formally. The more resources you can throw into this—hiring a DJ or a band, assembling raffle items—the more time and effort will be invested by your friends.

Performer Releases

Chances are, if you have appeared in any kind of professional media production, you have given your consent to having your image recorded and disseminated. Perhaps your permission has been granted by doing nothing more than walking past a sign that says something like, "By proceeding past this point, you agree to participate in the filming of a scene for the production . . ." followed by a title and a lot of fine print. I have even seen such a statement of implied consent printed on the back of a ticket for a concert.

Given that professional productions occasionally use such minimal methods for soliciting permission to record subjects, you might be surprised that our model performer release in Appendix C runs to several pages. Of course, when it comes to legal matters, the devil is in the details—or lack thereof. Lawyers always want to minimize risk. To every producer who blithely asserts that she isn't worried about farfetched legal challenges, the dutiful lawyer responds that it is often precisely those unlikely scenarios that need to be accounted for. Happily, legal challenges involving short productions are rare. It's therefore not surprising that the cases that do arise often involve unusual or anomalous circumstances. Consider, for example, the case of an actor who appears in your production and then several years later becomes a superstar. What are the odds of that happening? The good news is that your old short now has new currency and is attracting the interest of distributors. The bad news is that, now that he's a household name, the superstar doesn't want the world to see how he looked before he got his teeth fixed.

This is where you really need to have all the *t*'s crossed and *i*'s dotted in your performer release document, because the superstar's lawyers are going to use any chink in your agreement to render it invalid. Spelling out all the permissions that an actor might grant to a producer can take a lot of words, which is how we arrive at a pretty lengthy release. Of course, there are times when it simply isn't practical to get all performers to sign a long letter of understanding. You may have to resort to using an abbreviated form of consent, but before we dispense with all the details, let's take a closer look at a few key elements in our performer's release.

Agreements with actors, extras, interview subjects—anyone who appears or is heard in a movie—usually refer to the person's **likeness**. A recording is not exactly the same as a live performance. You are not simply getting the permission from a performer to appear; you are getting the right to use any identifiable representation of a person or their attributes, or what is often referred to as a likeness.

It's important to define the term of any agreement. Bob Dylan may have sung that tomorrow is a long time, but in professional terms, five years goes by in the blink of an eye. If you are lucky enough to make an award-winning short, you are likely to use that production in various ways throughout your career. Therefore, if at all possible, have all performers agree to grant rights in perpetuity.

Speaking of granting rights, it's crucial that you understand *which* rights are covered by your agreements. Performers have certain **personal rights** that come into play when they appear in a media production. These include the right to privacy and the right to publicity. In very broad strokes, the right to privacy prohibits the public dissemination of images or facts related to an individual's personal life without that person's consent. The right to privacy is closely linked to an individual's expectation of privacy. For example, it protects individuals from being filmed in their own homes without their consent and from having private facts such as their sexual preference or financial status publicly disclosed (even if those facts are true). On the other hand, it does not protect individuals walking through a public space, and it does not prevent facts from being published that are already well known.

Celebrities and recognizable public figures have almost no expectation of privacy anywhere, meaning that their right to privacy is much weaker. Don't feel too bad for the rich and famous, though. While celebrities' right to privacy might be skimpy, their right to publicity increases as their star rises. That's because the right to publicity protects the commercial value of a person's likeness. If your likeness has no commercial value, then there is little for the law to safeguard. But if a performer's likeness becomes a marketable asset, then only that performer has the right to profit from it. In practical terms, this means that before you use a performer's likeness in a movie, advertisement or promotion,

you should always get the performer's consent to both use and commercially exploit their identity. A few more important notes on personal rights:

- There is a legal principle called **fair use** that permits authors and artists to use some copyrighted or trademarked material without permission. For example, fair use protects the right of a person to comment on or parody someone else's work. When filmmakers first hear about fair use, they sometime leap to the very dangerous assumption that it gives them all sorts of leeway when it comes to securing—or not securing—rights. We'll have more to say about fair use in the next chapter, but for now, heed this warning: while it may be a defense of copyright and trademark infringement, fair use does *not* defend against claims of violation of an individual's privacy or publicity rights.

- Privacy and publicity rights vary from state to state. Some states have much stronger protections than others, and some use different wording or have additional causes of action, such as false light publicity, false representation or misappropriation of name or likeness. Always check the rules of your state.

- An individual's right to privacy generally ends when the individual dies. Publicity rights associated with the commercial value of a person's likeness, however, can continue in perpetuity. Publicity rights of the deceased are usually controlled by the deceased's estate or representatives, so you may need to obtain permission or a license from them.

All this may sound a tad esoteric if you are producing a short with a few unknown actors, but I would remind you again that talented actors don't always stay unknown. It's also important to have a basic understanding of personal rights for reasons that have nothing to do with your cast. We live in such a media-saturated culture that it's all too easy for images and references to celebrities to find their way into our stories. It's therefore worth remembering that there are more than just copyright issues to consider when a familiar face shows up on-screen.

If your goal is to cover all bases with your cast, be sure to use an agreement as thorough as the one in Appendix C. If, on the other hand, you need to abbreviate the release, make sure it covers the essential points outlined above. If at all possible, have a lawyer review the shortened form. In rare instances, you may not be able to have every person who appears on-screen sign a release. This brings us back around to those signs posted at public events. According to this method, a posted perimeter warns audience members, bystanders or pedestrians that they may be recorded. This method holds the most legal weight in circumstances where the participants are *not* being directed in any way. They are simply doing what they would normally do:

watching the show, looking on, passing by. The law gives a good deal of lee-way to producers who capture people's likenesses coincidentally as they are just going about their business. In this context, those posted flyers are often just an assertion of our right to record images in public as a form of expression covered by the First Amendment.

Another minimalist approach to getting releases is to have people give their consent on-camera. This is a technique that is much more common in documentaries than in dramatic filmmaking. Some producers read a brief statement and ask the subject to agree to the stated terms on-camera. In its most extreme form, this kind of release may consist of no more than a person indicating that they are aware that they are being recorded. It almost goes without saying that such a bare-bones form of permission is going to leave the producer open to far more challenges than would a more detailed and explicit release. At the end of the day, however, having some sort of permission granted is better than nothing.

This brings us to a final, essential point: however you do it, get a release from your performers and get it *now*. The inconvenience of taking a moment before shooting a scene to fill out releases is nothing next to the hassle of chasing people down for their signatures after they have left the set. Moreover, superstars can blow up overnight, and you certainly don't want to be seeking their permission to appear in your movie when they are no longer answering their phones.

Chapter 10

Locations

Ask, Don't Steal

If you go to film festivals or preview screenings, you will occasionally hear interviews with filmmakers who regale audiences with stories of how they "stole" a location, meaning that they filmed somewhere without securing permission. These adventures make for good stories, but before you adopt such a shoot-from-the-hip approach, consider for a moment the fact that you don't hear anecdotes from all the producers whose shoots got shut down by property owners or authorities because they failed to secure access to locations. Imagine that you have all your crew and cast on hand to start a day of shooting in a city park. Suddenly, a ranger appears and shuts everything down. Getting permission to use a location can take ingenuity and perseverance, but you must weigh that effort against the pain and bad blood caused by having to send everyone home because your shoot is canceled.

Unfortunately, there are plenty of less predictable instances where a producer could be blindsided because of an unsecured location. Here's a true tale. A student production was filming a scene that called for a guy to pull a gun on someone in a restroom. Realizing the pitfalls of waving firearms around in public, the producer and director figured they would shoot the scene in the safety of their dormitory. Midway through the shoot, a custodian who was making her rounds popped her head into the restroom. She caught a glimpse of a man with a gun and ran off. Moments later, the police arrived. Tipped off that there was an armed man in the dormitory, they were in full SWAT mode. To say that the officers were not amused when they discovered what was really going on would be an understatement. I'm happy to report that this story ended with everyone shaken but unharmed. It could easily have unfolded otherwise, with someone getting shot or arrested. All of this heartburn and potential tragedy could have been avoided if the producer had just gotten permission from the building manager to film in the dorm bathroom with a prop gun. So, let's tackle locations with the expectation that we'll need to get permission for their use, and we'll only contemplate "stealing" anything when we have run out of other options.

Scouting Locations

What locations do we need for our production? An easy way to draw up a list is to thumb through our breakdown sheets. This makes sense for the vast majority of shorts, but before going any further down this path, let's consider an alternative approach for a moment. Scouting locations is not entirely dissimilar from casting. We are simply trying out places instead of people. Just as we can sometimes invert the casting process, designing a project around a gifted performer, so too can we build a movie around a great location that is at our disposal. Needing to find an amusement park where you can have the run of all the rides simply because it's called for in your script is a major headache. Building a story around an amusement park because your uncle owns such an attraction is genius. **Production value** is a term you'll sometimes hear producers use. When someone says that a movie has "high production value," they mean it looks like it cost a lot to make. Of course, the aim of every producer—and production designer and cinematographer—is to make something look like it cost more than it actually did. This is especially true on shorts, where money is almost always in short supply. One key way to get a lot of bang for your buck is to take advantage of unusual or valuable assets at your disposal, and this certainly includes locations. To do this, however, you need to think well ahead. You might even instigate a project based on such considerations. For instance, you might choose to produce an adaptation of a short story by Edgar Allan Poe because your university has a suitably creepy gothic clock tower that could work as a primary location.

The Shoebox Diaries

"Prior to even writing the script or outlining it, I knew I wanted to feature these locations. So, in the writing process, I would incorporate things I wanted. Like, I knew I wanted to do a scene in the stump yard. I didn't know what would happen, but I knew I wanted it. I knew I wanted to do something with that large liquor store building—and it's just in a shot of the car driving past. All of these places I wanted to feature, because when I think about my childhood or I think about this town, or this area, those are kind of the monuments in my life."

—*Matt Lawrence, Producer, Director, Writer & Editor*

In addition to not giving enough thought to ready-made locations that will add production value to their shorts, many filmmakers don't give sufficient consideration to the alternative to shooting on location: shooting in a studio. Before you start fulminating about the costs of studio rentals or building sets, hear me

out for a moment. Studios come in all shapes and sizes, and not all of them are expensive to rent. Yes, it's true that you'll have to build your sets, but you might not have to start from scratch. The studio might have a collection of **flats** that you can use; some even have props. If the studio comes with a lighting package, the savings in equipment rental may cover the studio cost. Then, too, there are logistics to consider. Studios are often built with holding areas for equipment, cast and crew. They have dressing rooms and restrooms—just the sort of things that can be in short supply on location. Finally, think about the degree of control you have in a studio versus on location. A studio is a closed-off environment. Lighting conditions don't change, and (in theory, at least) the noise of the outside world is blocked. This may permit you to work more quickly. Weigh all these factors carefully before launching your location search.

Pro Tip

"What usually will hurt a location is that you think you have negotiated a great rate, but then the permit office often will hold out until the last minute to issue the permit. The night before, they will add on your police fees, your fire marshal fees, additional fees that you were not expecting, to a point where it almost becomes cost-prohibitive to shoot."

—*Mark DiCristofaro*

Once you have determined which scenes, if any, can be shot in a studio, what is left on your location wish list? Make a list of all the buildings and spaces you know of that might suit your needs. This exercise will usually only get you so far. You may have specific parameters that restrict your options, such as the need to keep all your locations within a certain geographic area. So, go ahead and brainstorm and make notes, but pretty soon you're going to have to hit the pavement. On many occasions, I have literally had to walk up to strangers' doors, knock, then propose that I bring a film crew to their home in a week or two. Take heart: this exercise gets easier with repetition.

As you or your location scouts comb the countryside, take time to document your discoveries. Take notes on the electrical setup and the availability of areas for staging equipment, holding people and setting up craft services. Record video, take photos and draw up floor plans. These materials will allow you to share your findings with other crew members and will remind you of important details when, after a long day of scouting, the many locations you have seen become a blur. They can also later serve as the basis for set design and storyboarding.

When it comes to locations, don't confuse abundance with availability. Because bars and restaurants are plentiful, you may well be able to find an establishment

that will let you come and shoot, but . . . yes, there are always buts. Some places will insist upon you shooting when they are open and have staff on hand. Of course, they don't want you to interfere with customers' dining experience, so you have to shoot documentary style—no lights, perhaps not even a tripod. This almost inevitably means you will have huge audio issues, since you'll be contending with background chatter, piped-in music and noisy refrigeration units. Other places will only let you shoot *before* they open. This is generally a far preferable scenario, but don't be surprised if those industrial refrigerators are still a problem.

Nice coffee shops can be trickier than restaurants or bars to secure. These tend to be social hubs that are open from early till late. The only time you are likely to get access is after hours, which means evenings. That may not sound like the end of the world, but if there are windows, you'll have to contend with the fact that it's dark out.

What about those wedding and funeral scenes that seem to turn up in every other script? In my experience, churches are generally harder than cemeteries to secure, at least for productions with shoestring budgets. That quaint little chapel that caught your eye has probably also caught the eye of many a couple looking for a romantic spot to tie the knot. Many churches depend on revenue from weddings to sustain their operations, so you may find that you have to match the contribution that a wedding might make to the congregation's coffers, and that price can be steep.

I have known quite a few producers who have had remarkable success in getting free access to cemeteries for shoots, but then again, none of these projects have called for zombies to rise from the sod or other such untoward shenanigans. If you are intent on producing an outrageous romp about the undead, you might need to get creative with your location search. Perhaps you can dot a carefully mown pasture with a few Styrofoam monuments, thereby turning some secluded farmland into your graveyard set. This brings us to a broader point, which is that very often it pays to dress one location to pass for another. A hall in an old library might make a convincing church. You might be able to convert a friend's pool patio into a tropical nightclub.

Pro Tip

"A lot of times, you're making multiple sets out of one location. You'll go into a house and you'll do a set in a bedroom, but then downstairs in the basement, you'll turn that into an office that plays 50 pages from now in the script, so you can cross off two locations in one place."

—*Erika Hampson*

 Sometimes the most challenging location to secure can be one of the most common dwellings: an ordinary apartment. It isn't generally so hard to get someone to let you shoot an individual scene in a kitchen or dining room, but when a production revolves around an apartment—as is often the case with shorts that deal with the lives of young adults, for instance—the search can be grueling. This might come as a surprise to those of you who have rented apartments or other abodes through Airbnb or similar online services. No doubt you are thinking that the online "sharing economy" has revolutionized location scouting, right? The short answer: not really. While the efficiency with which apps like Airbnb let us browse properties across the globe is a technological marvel, online searching can't take the place of boots on the ground. The fact is that it would be beyond reckless to scout and secure a location simply based on pictures and descriptions provided online. You can only evaluate whether that "elegant and quiet artist's loft" is indeed elegant and quiet by visiting it. You also need to be entirely up-front with the property owner about your plans to shoot a movie on the premises. Finally, simply paying the rental is not enough to safeguard your interests or the owner's; you will both need to sign a location agreement. Most property sharing services do not lend themselves to this kind of in-depth negotiation. Before locking in a reservation online, you should get a message to the owner and arrange to meet in person.

 Let's assume that you do find a nice apartment to shoot in. The landlord has agreed to a short-term lease that fits your budget. Even so, problems may arise. Neighborly relations can be an issue. By definition, an apartment is part of a larger housing unit. Shared walls, floors and ceilings can often transmit noise from adjacent abodes. Then, too, those neighbors might not appreciate the added foot and vehicle traffic that accompanies a shoot.

 We tend to fixate on looks when scouting locations, and that can get us into trouble. Early in my career, I was producing a short that included a scene that called for a couple to be seen courting in a soda shop in the 1950s. Against all odds, I found a family-owned drugstore that looked like it had been frozen in time. Best of all, it had a soda fountain that was still equipped with all sorts of vintage appliances. The counter stools and booths were a symphony of chrome and vinyl. I almost levitated as I took it all in. A quick discussion with the obliging owner sealed the deal. I ran off to tell the director of our luck. Since our budget was minuscule and the place looked perfect, we didn't allocate any time or resources to prepping the soda fountain during preproduction. Before we knew it, the shoot date was upon us. We arrived with cast and crew, and the cinematographer started to plot out the lighting scheme. We weren't shooting with a heavy-duty lighting arsenal, but before he turned anything on, the cinematographer wisely took the precaution of seeking out the store's electrical panel to ensure that he wouldn't overburden a circuit. The outlets and other wiring in our walls and ceilings are clustered into circuits. If you draw

too much power from a circuit, at best you will blow a fuse or trip a circuit breaker. At worst, you'll start a fire. That's why, if you're using any lights for filming, it's always important to make sure you aren't overloading the wiring. When the cinematographer found the electrical panel in the drugstore, everything screeched to a halt. This is when we discovered that it wasn't just the soda fountain that was frozen in time; so was the wiring. Back in the 1940s and '50s, the number of electrical appliances any business or home used was a small fraction of what we use today. Reflecting that reality, this drugstore had exactly one tiny circuit. Everything in the store had to run on that fragile system. Turning on even one of our high-powered filmmaking lights was a risk, but the store was too dark to film in with the available lighting. In the end, we tried to make do with one small light unit. As a result, the lighting was harsh and the background was so underexposed that you couldn't really see any of the period detail that had gotten me so excited in the first place.

The Shoebox Diaries

"Ideally, the sound department is part of the conversation during preproduction. Sometimes it can be a voice of reason, saying, 'I know you love this location right by the airport, but it really isn't good for sound.' In our case, we shot at this circus drive-in. It was right by a major highway, and on top of that, they rented a generator. And you want to save money, so you're usually pinching pennies and getting the cheapest generator you can find. Well, that's also the noisiest generator."

—*Charlie Anderson, Sound Recordist*

To summarize, when scouting for locations, in addition to aesthetic concerns, keep the following considerations in mind:

- *Audio*: Don't just focus on noise problems that might be caused by traffic, ventilation systems and so on; think about the acoustic properties of each location. For instance, a cavernous space with lots of hard surfaces will be exceptionally reverberant, making it difficult to record clean, clear dialog.
- *Neighbors*: Pay attention to who and what is situated nearby. That preschool across the street could be a deal-breaker.
- *Electricity*: Check to see how many circuits are available, and try to determine if there are energy-hogging appliances in use.
- *Staging and rest areas*: You will need more space than just the area taken up by actors, sets, lights and camera. You'll also need room for equipment

storage and for all the people who aren't needed on set, including hair, makeup and wardrobe.

The bottom line: we mustn't let a location's charms blind us to other critical considerations.

Negotiating and Securing Locations

If you're working on a tight budget, you're often in the unenviable position of asking people to let you use their beautiful home, restaurant, synagogue, golf course, helipad or what have you for free. Looking back over my career, I'm reminded of how generous and open-minded people can be. On innumerable occasions, total strangers have given my crew access to their valuable properties at no cost. Drawing on this experience, I have exhorted many novice producers not to be afraid to ask an owner for the use of their property as a favor or in exchange for some token consideration, such as a special thank-you in the movie's credits. Quite often, these young producers come back from their location scouts beaming. They eagerly report that, after hitting it off with this landlord or that property manager, they were able to get permission to shoot at some place for free. "Great," I say. "So, now you need to go back with a location agreement." At this point, the beaming stops and the producers squirm before offering some variant of the following: "Look, this lady's doing me a favor. I don't want to destroy the goodwill we've established by sending her a contract."

In response, I explain that it's possible to craft a location agreement that isn't adversarial or one-sided. In fact, in my view, the essential point of a location agreement is to address the concerns of both parties. In the most basic terms, what does the producer want? Access to the location during a specified period, right? What about the property owners? They want to ensure that their premises and its surroundings suffer no loss or damage. By spelling out these terms—the period during which the property will be used and the notion that it will be returned to the owner intact—we're serving the interests of both the owners and the producer. If you present location agreements to owners in this light, you'll generally find that they are happy to sign the document, as well they should be. And by the way, when I say that you present an agreement, I mean just that. You absolutely need to make the case for signing an agreement in person. Just firing off a draft via mail, e-mail or text will indeed convey an impersonal disregard for the owner's concerns.

Occasionally, even after I have fervently made this case, a producer will sigh and say, "Yeah, I get all that, but my relationship with this property owner is just too fragile. I don't feel comfortable having that discussion."

"Wow, that's too bad," I say. "Then I guess you'll have to find another location."

"What?! Why?" exclaims the producer.

"Listen," I reply, "if your rapport with this owner is so tentative that you can't even discuss an agreement that is mutually advantageous, what will happen if even the smallest of accidents or delays occurs during your shoot?"

You will find an example of a location agreement in Appendix C. Some features of this agreement will be familiar from other contracts and releases we have already discussed. Other points just require a bit of common sense to be understood. One phrase that might be less familiar is **hold harmless**, a term that appears in the section on indemnification. This paragraph merits close examination. Here's how it starts out:

> Producer agrees to indemnify and hold harmless Licensor from and against any and all liabilities, damages, and claims of third parties arising from the Production Team's use of the Location, and from any physical damage to the Location proximately caused by the Production Team . . .

In other words, if the actions of your cast and crew at the location cause any problems, the responsibility rests with you, not whoever owns or controls the property. To understand the significance of this provision, let's consider an example. Suppose you secure the use of a minor league ball field. While you're shooting a staged ball game, the actor playing the pitcher hops to catch a ball and snaps his Achilles tendon. The actor is now out of commission and facing substantial hospital bills. Because you have agreed to hold the ball field harmless, you cannot claim that the costs associated with this accident should be covered by the property owners or their insurer. This application of the hold harmless clause provides another compelling reason for the property owner to sign our agreement. In essence, our agreement says, "What we do on your property during the shoot is our responsibility, not yours." In case you are wondering, yes, that baseball scenario really happened on a project I produced.

Hold harmless agreements can and often do cut both ways, defining the liabilities of both parties. This is the case with our model location contract. The same very long sentence in the agreement that introduced the hold harmless clause goes on to state some exceptions to this provision. For instance, the producer isn't to blame if the property owner or manager creates trouble through their own "negligent or intentional acts." Furthermore, while you are responsible for the actions of your production team while you are using the location, you aren't responsible for any claims that might be brought against the property licensor for letting you use the location. Do you understand the distinction? For instance, if a neighborhood association accuses the property owner of violating the association's bylaws by permitting you to film in the owner's home, the responsibility for resolving this dispute ultimately rests with the owner. I add "ultimately" here because, while this might be the owner's headache in the

strict legal sense, a good producer will always try to defuse and resolve any problems associated with the production.

Our agreement puts the onus for any legal permissions associated with the location on the licensor. It also makes the licensor vouch for something more fundamental: that the person signing the contract has the authority to enter into the agreement. We have touched briefly on the legal concept of authority before, but it is particularly relevant to locations. Why would someone agree to let you use a location if they didn't have the authority to do so? I can once again draw on personal experience to explain the wisdom and importance of the authority clause.

I wrote and directed a film that was largely set in a loft apartment in Manhattan. My producers quickly learned that rentals for such spaces were astronomical. After scouring the city for several weeks, a member of our crew saw a classified ad for artist's studios in a downtown weekly. This lead led us to a large loft apartment that was indeed being sublet to artists as studio space. The guy who posted the classified ad was an artist himself, so he was sympathetic to the difficulty of finding studios in the city. He proved to be equally compassionate when he learned of our difficulties, and the producers were therefore able to draw up an agreement that gave us access to the entire loft, the only restriction being that we had to vacate the premises at night. After toiling so long with this location quandary, we were beyond delighted with the deal. Not only was the location exactly what we were looking for, but the rent was in line with what struggling artists like us would be able to pay.

We got through several days of shooting at the loft without incident. It was summertime, so when cast and crew weren't needed on set, they would hang out in the stairwell or entryway of the loft building. So it was that one afternoon, members of our team encountered a woman who was uncommonly interested in what was going on in the apartment upstairs. One thing led to another, and pretty soon, one of the producers stepped outside to speak with her. It turned out that this woman owned the building in which we were shooting. Particularly in crowded urban settings, there are lots of ownership models for residential property—condos, co-ops and so forth. In this case, however, the arrangement was of the old-fashioned landlord-tenant variety. The person who had entered into the location agreement with us was a tenant, not a property manager or an owner. As such, he was subject to the terms of his lease with the landlady, and the increasingly incensed landlady was adamant in her position that the lease forbade any sort of sublease, to say nothing of letting a film crew have the run of the building.

The producer apologized profusely and explained that we had been operating on the assumption that the tenant had full control over the loft. To make his case, the producer hastily dug up our signed location agreement, which indeed had a clause that asserted that the tenant had the authority to enter into

the agreement. While this didn't make her any happier, the landlady seemed to accept our argument that we were innocent dupes and that her real beef was with the tenant, who—curiously enough—was nowhere to be found. The landlady eventually stormed off, shouting as she went that she intended to sue and evict the errant tenant.

Had the landlady followed through on her threat to sue and evict the tenant, our agreement might have been of real benefit to us. The indemnification clause states that the undersigned (in this case, the tenant) agrees to hold the producer harmless should anything bad result from his claiming authority to enter into the agreement. Notice how the hold harmless clause once again comes into play, in this case to protect the producer from the results of any false representations made by the putative property representative. So, while our location agreement was essentially with the wrong person, it did at least protect us from any fallout from the tenant having falsely claimed to speak for the owner. Fortunately, both the landlady and her tenant stayed away for the remainder of our shoot, and neither I nor the producers were ever summoned to appear in court to sort everything out.

Copyright, Trademark and Fair Use

In the early years of hip-hop, New York City was fairly covered with graffiti. Depending on your view of spray-painted street art, this was either a golden age or the plague years. In any case, I distinctly recall walking down a street in the East Village during that era and seeing a wall emblazoned with freshly painted graffiti. In the lower corner, I found not an artist's signature, but a copyright symbol, a date and a name. As I walked on, I wondered at the implications of this rather legalistic "tag." What did claiming copyright of the graffiti mean, and (thinking like a producer) what would happen if I filmed a scene with this copyrighted work as a backdrop?

The years that have intervened since my sighting of a copyright notice happen to coincide with the arrival of the information age. Much of what we value today is essentially information and ideas. The latest app, the slickest smart phone, the hottest movie—at their core, these products owe their success to the ingenuity that went into creating them. When creative ideas get packaged as products, we call the resulting entity intellectual property. There are several ways that creators can assert ownership over intellectual property, one of which is through copyright. We addressed the concept of copyright with respect to screenplays in Chapter 2. Lots of things besides the printed word can be copyrighted, however, including works of graphic art, such as a spray-painted mural. Of course, music and other kinds of audio are also often copyrighted, but the legal issues surrounding sound recordings require a separate discussion.

Staying in the visual realm for now, when you get permission to show some-one's copyrighted work, we say that you have "cleared" it or received clearance. Often, when filmmakers don't seek clearance for the inclusion of copyrighted material in their productions, it's because they are claiming fair use. As noted in Chapter 9, the concept of fair use protects our right to comment upon events of the day and to criticize or parody other people's work. Defining when to make a case for fair use can be a fraught process. There are already volumes of case law addressing what you do or don't need to clear, and more laws are being written every day. In this rapidly evolving area of jurisprudence, it's very risky to simplify or generalize. With that warning emblazoned over everything that follows, here is my attempt at offering a layperson's understanding of the current best practices regarding the photographing of copyrighted materials.

The first principle is that, generally, you do not have to clear copyrighted content that appears incidentally and unaltered in your movie. If our character happens to walk past that New York City mural, or is seen driving down the freeway with a billboard advertising Budweiser behind his car, we don't have to clear rights to either the mural or the billboard. If, on the other hand, we use some element from the copyrighted work as part of our story, we are likely to need clearance. For instance, if a figure painted in the mural magically comes to life and starts to talk to our character, we have crossed a line and we are not merely using the mural as part of the landscape.

So far, I hope the guidelines appeal to your common sense. Unfortunately, the rules get murkier when we move into the realm of sets that are entirely constructed for the purpose of making a motion picture. Suppose we build a dorm room set and we elect to put a commercially produced poster of Justin Bieber above the bed. Do we need to clear the rights to the poster, and just what are those rights? Do we only worry about the design of the poster, or about the photograph of Bieber that is incorporated into that design, or even about Bieber's rights to control the use of his likeness? There is not a simple answer to these questions, and even intellectual property lawyers get frustrated at how fraught these issues are. Quite a lot of case law backs up the principle that, as long as you are using a copyrighted work in the manner in which it is designed to be used, no clearance is necessary. According to this line of reasoning, a poster is meant to decorate a wall, so if you are just using it for that purpose, you don't need permission to photograph it in that setting. Unfortunately, rul-ings in some other cases have supported the proposition that a work of visual art is a statement, and if you incorporate that statement into your own work, you must clear the rights to it. What to do? After all, a dorm room without posters is like a sea without water. My non-lawyerly advice is to go ahead and use posters, but avoid iconic graphics, especially those associated with well-heeled celebrities whose legal teams earn their keep by protecting their client's image. If you are using reproductions of fine art, avoid works by well-known

contemporary artists and try to use works from smaller art collections rather than famous museums that are intent on protecting their brand. Taking these steps won't guarantee that the lawyers won't come knocking, but they should reduce the risk of legal entanglements to a level that will permit you and your crew to sleep well at night. To protect yourself fully, use posters depicting art in the public domain or, if you really want to go all-out, have your art department design posters expressly for the set.

Pro Tip

"You buy flea market art, and you think it's okay to use because you don't know who painted it. Well, that's the problem: just because you don't know who painted it doesn't mean it's okay to use, even if you only bought it for five cents. It's a piece of artwork; it's intellectual property, which is protected by copyright law."

—*Marie Cantin*

Of course, commercial brands are often trademarked rather than copyrighted, and most people don't understand the difference between these two forms of property protection. In broad strokes, a copyright asserts ownership of a piece of intellectual property, whereas a trademark identifies the seller of a product and distinguishes one product from another. A trademark isn't first and foremost about ideas; it's a way of stating to the consumer, "This is the real deal. Accept no substitute!" Given this essential purpose for trademarks, it stands to reason that you can use trademarked products within a movie without having to clear their use. If a character is seen enjoying a bottle of Coke, as long as the beverage is "the real thing" (an old Coca-Cola slogan), all is well.

That last statement may come as a surprise to those of you who have paid close attention to scenes shot in venues with a plethora of trademarked goods. It's not uncommon to see a scene where a character pushes a cart down a supermarket aisle where nary a single brand name can be seen on any of the goods on the shelves. This is because the production company has deployed a couple of PAs who probably spent a sleepless night carefully turning every product so that the logos cannot be seen by the camera. Why do this if no clearance was necessary? First, it's not uncommon for producers and production designers to have pretty profound misconceptions when it comes to issues of copyright and trademark, and their ignorance may encourage them to err on the side of caution. A more legitimate reason may have to do with commercial

rather than legal concerns. Companies pay thousands of dollars to feature their products on-screen. The value of that product placement is diluted if the production company gives free exposure to all sorts of other brands. Following this same line of reasoning, if a movie plays on some platform driven by advertising, such as broadcast TV, the advertisers will take umbrage if a production gives free exposure to a competitor's product. Finally, logos can often be visually distracting, so minimizing them can make for a more harmonious background.

This last point deserves a bit of extra emphasis. We live in a world permeated by commercial brands. Folks think nothing of wearing a T-shirt featuring a shoe company name in mile-high letters. Whatever you think of this as a fashion statement, you should instruct your art and wardrobe departments to be vigilant when it comes to these kinds of graphic statements. Setting aside all other considerations, commercial logos are simply distracting. They almost always undermine a movie's visual design. If you are planning to have your actors and extras wear their own clothes, be sure to have your team coach them on this point, but even so, have a collection of logo-free clothing on hand to be deployed as needed.

Thus far in this highly condensed summary, I have only addressed the use of trademarks in the more straightforward settings. In this happy world, brands are being put to their intended use: a drink is just a drink and a shirt is just a shirt. Complications arise when trademarked goods are put to unintended uses or when they are associated with unsavory behavior. Let's return to our character enjoying that bottle of Coke. What if she were suddenly to froth at the mouth and then keel over dead, the victim of poisoned pop? If we were to look up, we would now notice that the sky has gotten very dark indeed. Those storm clouds overhead contain buckets of legal woe that are now threatening to rain down on us. By associating a product with devastating effects on a person's health, we are open to accusations like **trade libel** and brand tarnishment. As you might surmise, these claims arise when someone casts unfounded aspersions on a business's services or products. Any company that believes its brand is being besmirched might well unleash its lawyers, who in turn could seek to block the exhibition of your movie—the ultimate calamity.

Trade libel is a very specific concept, and it doesn't protect companies from having their products shown in an unflattering light. For example, if a character becomes depressed and lets himself go, bingeing day and night on specific brands of doughnuts and beer, I doubt that any libel has occurred, inasmuch as the guy is only eating doughnuts and drinking beer as anyone might. Unfortunately, the fact that the filmmakers have the law on their side doesn't mean that the doughnut and beer companies' legal teams will take this affront lying down. However unsound their case, they may well threaten to bring suit against you—or even follow through on such threats. This is why it is always

necessary to keep in mind that what's just and what's smart are not always the same. In this case, the filmmakers would do well to dodge any lawsuits, however frivolous, by making sure that the brands of doughnuts and beer with which the character abuses his mind and body are not identified on-screen. Yes, indeed: better safe than sorry.

Insurance

A movie set is a charged environment that seems to lend itself to both magic and misery. Strange things happen once cameras start rolling. I have witnessed two actors get injured in freak accidents on film sets, and I doubt I could even tally up all the minor but costly mishaps that I have observed during production. Perhaps this isn't surprising. After all, a film set is generally populated by a large group of people who don't normally work together, and many of them are doing jobs—either on-camera or off—that ask them to do things they have seldom done. Given all those risk factors, the only prudent course is to insure your production. Depending on the scope and nature of your project, you may not even have a choice about this. In many cases, you can't rent equipment, secure locations or hire actors without insurance.

Insurance comes in many forms, but for our purposes we are going to discuss the three kinds of insurance that are fundamental to producing dramatic motion pictures: **general liability insurance**, workers' compensation insurance and **errors and omissions insurance**. Some of these terms may ring a bell, and in fact the insurance you might have in connection with your job or your home isn't entirely different from production insurance. The main distinction is that—unless you are operating a production company on an ongoing basis—the insurance you purchase for motion picture production is done on a project-by-project basis. This is why you will probably need to go to an insurance broker with experience in securing production insurance. If you can find a local broker, so much the better; they will be more likely to understand the nature of your production. But that is not at all essential. The broker serves as a go-between, taking your project to market, where insurance companies of every stripe can look it over and decide whether or not they want to assume the risk associated with your production for a certain price.

General liability insurance is coverage that indemnifies you against most kinds of loss or damage that occur during production. You need to make sure that your policy covers both production equipment and property on the set. Therefore, if the heat from your lights causes the sprinkler system to go off in the office where you are shooting, your liability insurance needs to cover both the flooding damage to the location and the harm done to the lighting equipment. Most equipment rental companies will insist on your having proof of an active liability insurance policy, and any savvy location owner is also likely to

want to see evidence of coverage. It is common for rental houses to ask for a minimum of $2 million in liability insurance.

Workers' compensation insurance, or workers' comp, covers the consequences of injuries sustained by employees at the workplace. If you are a student filmmaker, you might well think, "Employees? What employees? Are my fellow students, who are serving as my crew, my employees?" Generally, the answer would be no, students working on a class project are not employees. Along the same lines, if we consider our crew members to be subcontractors—as our crew agreements state—then they are not technically our employees. Following this logic, you may not need to secure workers' compensation insurance for your crew, since you are only required to provide workers' comp for employees. However, the situation with respect to your cast is likely to be different. For instance, if you use union talent, you are almost certain to need workers' comp. It's easy to see why a union would require this. Imagine an actor who slips and injures his back while working on a student film. He has already deferred his compensation for his work on the film, and now he can't take paying gigs while he waits for his back to heal. As the name implies, workers' comp compensates the actor for the wages lost while he is unable to work.

Pro Tip

"If you're doing a film—even a tiny film—that has a stunt, you must be insured and you must walk through the stunt with the insurance company, so that they know exactly what the risk is. Because they can help you assess the risk, and they can approve your safety precautions."

—*Georgia Kacandes*

The final insurance we need to discuss is errors and omissions insurance, more commonly known as E&O. This is an altogether different kettle of fish. Whereas liability and workers' comp insurance have to do with covering for accidents and injuries, E&O insurance relates to personal rights and issues of intellectual property. E&O insurance protects the policyholder from legal challenges tied up with any rights associated with the production. Let's return to the copyrighted mural mentioned earlier. Suppose you film a scene with the mural as a backdrop and nothing more than that. The film turns out great and is picked up as part of a collection of shorts shown on a prominent cable channel. The artist who painted the mural happens to catch your movie on TV

and decides to sue you for the unauthorized reproduction of copyrighted material. Good news: one of the requirements that the cable channel placed on you before agreeing to show your short film was that you secure E&O insurance. Should the artist choose to proceed with his lawsuit, any costs the legal battle incurs will be covered by the E&O policy, including damages (up to a certain cap) in the event that the artist wins the case.

E&O insurance is particular to motion picture production and therefore really needs to be handled by a specialist. Unlike other forms of insurance, on a short, it is almost always the case that we only secure E&O insurance when we have been offered distribution. Entertainment lawyers, sales agents, distributors and of course media production specialists often know who to contact for E&O coverage. When you apply for insurance, an actuary will examine your project very closely. This is where having all your performer and location releases in order come into play. The insurer will also look for any possible clearance issues related to story, script or music. In order to minimize their exposure, insurers want to be convinced that there are no chinks in your project through which a nasty lawsuit could slip in. Therefore, don't be surprised if a prospective insurer presents you with an extensive punch list of required documentation. In the case of the litigious mural painter just mentioned, we are assuming that the E&O insurer weighed the risk of a lawsuit related to the appearance of the mural as a backdrop and judged it to be acceptable.

A wider range of insurance brokers know how to handle general liability and workers' comp policies, and the process for securing this coverage is generally more straightforward. The broker will have you fill out a brief application that outlines the scope of production. If your project has stunts or pyrotechnics, you'll likely need to fill out paperwork describing these elements in detail. Because *Shoebox Redhead* was produced for degree credit at Boston University, where liability coverage is generally provided for student productions, the producers did not have to secure either liability or workers' comp insurance. Since we are using this project as a case study, I contacted an insurance broker in order to chart the process of purchasing coverage. One question I had to address in the application was about scenes taking place on or near open water. Of course, *Shoebox Redhead* opens and closes at the Jersey Shore, so I had to append the script pages covering those scenes to my application and explain the mundane and non-life-threatening nature of the action taking place therein. If all that sounds like just so much bureaucracy, consider this: just a year or two after the film was shot, the roller coaster that provided a charming backdrop for the seaside scenes in *Shoebox Redhead* was literally washed out to sea by Superstorm Sandy. Calamities like Sandy tend to fade from our memories with time; it's the job of the insurance specialists not to forget them.

A Note About Operating Vehicles and Heavy Machinery

If you plan to use any sort of heavy machinery in your production, such as tractors, scissor lifts or cherry pickers, you should make absolutely certain that your general liability insurance covers the operation of these machines. If the policy does not cover these items, then be sure to purchase a rider that expressly includes them. You can be pretty certain that your general liability policy will *not* cover anything to do with motor vehicles. Therefore, you need to be sure that anyone—whether in front of or behind the camera—is properly insured to operate any vehicle being used in the production. I underscore this point because we easily lose sight of the many unusual ways that we use vehicles in the making of a movie. It is not uncommon to ask some young PA to jump behind the wheel of a five-ton cube truck—despite the fact that she may never have driven such a large vehicle before. One of the most dangerous mishaps I ever witnessed on a film set occurred when we asked a crew member to drive a car with automatic transmission—nothing fancy. As it happened, however, the driver had only driven standard transmission cars in his native Australia, and he had some profound misapprehensions about how the pedals on our very ordinary car worked. Let's just say we were lucky that no one died. Any veteran producer will have similar war stories to share about accidents involving cars and trucks. This is why, perhaps more than in any other area where insurance comes into play, it is important to have proper coverage when it comes to operating vehicles.

Pro Tip

"Just make sure that everyone is licensed and trained—that they have done it before. A director can walk on the set having never directed, but the director should be relying on people who know what they're doing."

—*Glenn Gainor*

Chapter 11

Production Paperwork

Before You Roll: The Final Details

If you refer back to the timeline for preproduction laid out way back in Chapter 2, you'll note that all the preparations are supposed to be completed by the *start* of the tenth and final week of preproduction. By that point, you will have drawn up contact sheets for the crew and secured all location contracts, and the director will have finished all the storyboards and shooting diagrams. If we follow this blueprint, just about the only things going on in the week leading up to the start of the shoot will be rehearsals, equipment pick-ups and some production paperwork. Of course, things never go entirely according to plan. A crew member falls ill, a catering deal falls through, a landlord refuses to send back the signed location agreement. Part of the reason for giving yourself this uncluttered week is that a certain number of earlier deadlines will inevitably slide into this buffer period, whether we like it or not. In saying this, I am emphatically not giving anyone license to be lax about keeping preproduction on track. Did you happen to notice that casual reference to "some production paperwork" a moment ago? That pesky paperwork is a hint at the real reason we have everything in order at least a few days before the camera rolls.

Pro Tip

"A few days before production starts, all the crew members sit around the table and you read through the script scene by scene and discuss it. Who is going to handle what? What are the ramifications of that? How do we deal with a problem that could occur? That meeting can solve so many problems and make your life so much simpler, just by reading through the script."

—*Don Daniel*

You have spent a great deal of time and effort planning this production. You have thought about how many mouths you'll need to feed, what scenes to shoot each day, what data storage costs—you name it. All that preparation will be enormously helpful, but only if you also give plenty of thought to how all these moving parts are actually going to fit together and function as a unit. This final stage of planning can only occur when all the other variables have effectively been nailed down. Everything is interconnected, and taking any major part out of the preproduction process is like taking the rudder off a boat, setting the whole enterprise adrift just as steady navigation becomes essential. To take a random example of this point, let's consider those storyboards that the director is in charge of. If you haven't worked with storyboards before, imagine the movie you're making rendered as a comic strip or graphic novel. Not every director relies heavily on storyboards, but they are a useful tool for sharing the director's vision and showing how scenes will play out on-screen. Storyboards are compulsory when you have technically complex scenes, such as those involving stunts, choreography or elaborate camera moves. Now let's imagine that your project includes a fight scene. Your director meets with the stunt coordinator you've lined up to help design the scene. He comes back from the meeting clearly pumped up. He tells you he now knows exactly how he wants the scene to play, but when you ask for storyboards, he waves you off. Finally, the night before the start of production—ping!—in comes an e-mail message from the director, with storyboards for the fight scene attached. Upon inspection, you discover that he wants to shoot the scene tight and handheld, with "at least two cameras." Now you're in a jam, because not only does your budget not call for a second camera, but you don't have a second camera or camera operator lined up, regardless of the price tag.

I hope this sadly familiar scenario makes the case for why you need to have several days of breathing room to organize the last details. Had the director finished the storyboards earlier, you might have been able to find that second camera, or at the very least you could have had a level-headed discussion of alternatives. In truth, you would need this time even if a fairy godmother appeared with an extra camera and camera operator in tow, because you'd still need to figure out how this extra gear and personnel are going to fit into the overall schedule. As you'll see, this last stage of planning is where the rubber truly meets the road, and having a detailed and accurate road map is critically important. Fortunately, there are some common-sense tools that will help you chart your course, and yes, this is where that paperwork comes in.

The Daily Production Schedule

If we go back to our stripboard for *Shoebox Redhead*, we can tally up the color-coded strips and get a quick summary of what needs to be done on any given day of the shoot. Consider, for instance, the schedule for Day 3, shown in Figure 11.1:

Scenes: 1 Sheet: 1 Length: 2/8	EXT	BEACH Ryan sets the shoebox out to sea	DAY	Cast: 2 Vehicles: Camera/Grip: Extras:
Scenes: 19 Sheet: 19 Length: 2/8	EXT	BEACH Ryan watches shoebox sink into water	DAY	Cast: 2, 3 Vehicles: Camera/Grip: Extras:
Scenes: 18 Sheet: 18 Length: 1 1/8	EXT	BOARDWALK Arrival at Pier, Matt disappears	DAY	Cast: 1, 2, 3, 5 Vehicles: V1 Camera/Grip: C2 Extras: [4]
Scenes: 21 Sheet: 21 Length: 1/8	EXT	HIGHWAY Ryan & Ira drive off into the sunset	DAY	Cast: 2, 3 Vehicles: V1 Camera/Grip: C4 Extras:
Scenes: 20 Sheet: 20 Length: 1/8	INT	STATION WAGON - AT BEACH Ryan & Ira look at photo of Matt & Mandi	DAY	Cast: 2, 3 Vehicles: V1 Camera/Grip: Extras:

Figure 11.1 Stripboard, Day 3

There you have it: a radically boiled-down summary of the five scenes that you have to shoot on that day. To take up our map metaphor once more, using this inventory to guide you through production would be like using a satellite image as a road map. How long do you project those scenes by the water will take? When do the boardwalk extras need to arrive? How long will it take to set up and break down the jib arm we'll be using in Scene 21?

We discussed some of the complexities of working with a jib arm previously. Another consideration with respect to the jib is the rental arrangement. We're only using the jib in this one scene. Jibs are costly and bulky. If possible, it would behoove us to pick one up near the shooting location. That way, we can use it for a day and then return it without incurring multi-day rental

expenses and storage headaches. That's a good plan, but fetching and returning the jib is still going to peel crew away from the set. One more possibility: if we start our shoot on a Thursday, Day 3 would fall on a Saturday. You may recall that most equipment houses treat a weekend as one day in terms of rentals. Therefore, we could use the jib on Saturday and then wait to return it on Monday and still only pay for a one-day rental. This option may be worth exploring, but keep in mind that it presupposes that someone can pick the jib up on Friday and return it on Monday. It also assumes that we can shoot at the beach on Saturday, generally the busiest day of the week at the seaside. Ultimately, we're going to have to factor in many considerations—most critically, cast and crew availability—in determining how our shoot lays out on the calendar.

The Shoebox Diaries

"Gear is going to slow down any shoot. A professional Hollywood production, if it has a huge dolly track to set up, also has dolly grips, and it might take them a couple of hours, versus putting the camera in somebody's hands and they're up and running immediately. So, yeah, the more toys you throw into the mix, the more time you're going to spend, especially at our level, where we're doing these early student projects."

—*Charlie Anderson, Sound Recordist*

Using our Day 3 schedule as a case study, we're beginning to get a handle on the numerous activities and constraints that make most shoots feel a bit like a three-ring circus. Rather than trying to manage all this on the fly, we're going to lay out a plan in the form of a daily production schedule. If you take stock of the various considerations we've mentioned with respect to Day 3, these factors can be sorted into four categories:

- Setup
- Shooting
- Cast and crew call and sign-out times
- Breaks for travel, food and rest

We can further subdivide setup into two parts. First, there's the setup time any scene requires—time to dress the set, rig the lights, give the actors their marks and rehearse camera moves. Often, however, it's advantageous to have an advance team that can be dispatched to deal with a particularly complex or time-consuming task. Take the jib arm, for instance. If you can assign a couple

of crew members to the task of assembling the jib while the rest of the team proceeds with the shoot, you won't have the day's pace grind to a halt when you arrive at the jib scene. If we draw a distinction between the regular setup process and what we might call a staging team or second unit, we come up with *five* schedule categories:

- Setup
- Shooting
- Cast and crew call and sign-out times
- Breaks for travel, food and rest
- Second unit or staging team

Like an artist making a quick sketch of your subject, you can come up with an outline of your daily schedule by first laying out an alternating pattern of set up scene, shoot scene, set up scene, shoot scene. Don't worry about the other factors—in fact, don't even worry yet about what time you're going to start or finish the day. Just lay the scenes out in that pattern and then ask yourself how long each setup and shooting period is going to take. Obviously, the first scene you are going to shoot at a location is going to take at least a bit longer to set up than subsequent scenes at that same location. Take the two scenes in which Ryan sets the shoebox out to sea. We're going to start our day with these scenes. Since they are virtually identical, the time required to set up and shoot the second scene (Scene 19) should be very brief. If I can project that a scene is going to require multiple takes or more **coverage** (a greater variety of camera angles), then it will take longer to shoot. On Day 3, the scene in which Matt arrives at the boardwalk and disappears with Mandi is the narrative climax of the movie. I therefore need to allot enough time to cover the scene thoroughly and capture the right emotional tenor. In the case of the jib shot, on the other hand, the challenge is purely technical, but I know that I'll need to allow plenty of time for setting up and shooting this complex maneuver.

One consideration to keep in mind as you estimate the time required to set up and shoot scenes: remember the concept of the contingency that I applied to my budget? I allowed a 10 percent buffer to be added to my budget total. This amount is meant to "account for the unaccounted-for," to cover all the expenses that either escaped my notice or could not have been foreseen. I need to build a similar contingency into my schedule, but I can't do this by just adding twenty minutes of downtime to the end of a day's schedule. Rather, I'll need to give myself a little wiggle room as I go along. Everyone wants to manage a finely tuned operation that moves with impeccable efficiency, but in truth, arriving at a workable schedule requires allowing for just a bit of slack.

Once you have laid out your rudimentary schedule in terms of blocks allotted to set up and shoot scenes, it will be much easier to factor everything else

in. You can determine how far in advance an actor is needed prior to her first scene of the day, and you can pick a logical time for breaks and lunch. By now you'll have a pretty good sense of how long your day is shaping up to be, and you can determine an appropriate time to start and wrap. Working in this manner, I came up with a schedule for Day 3 of *Shoebox Redhead* that you can find in the color illustrations in the middle of this book. Take a look at it now. As you can see, we have again used a color-coded scheme. The key to the various colors is indicated at the top of the schedule. There is a treasure trove of information included in this chart, which can easily be printed onto a single sheet of paper. Perhaps first and foremost, this timetable reminds us that there is often more than one thing going on. Using this simple layout for the daily schedule ensures that you don't fall prey to the sort of tunnel vision that can too easily set in on a production. Remember my earlier reference to a three-ring circus? Here, you can see precisely how the big show will play out. As the line producer, you are the ringmaster.

Options for Displaying and Sharing Your Schedule

Over the years, I have used various tools to create the daily production schedule, including word processing programs, spreadsheet applications and even the humble ruler and pencil. A few years ago, it occurred to me that, like the rest of the world, I was using a calendar app on my phone. Why couldn't I make a daily schedule that would appear on my default calendar? Because it's so ubiquitous and its sharing capabilities are easy to use, I decided to use Google Calendar to try out this approach. The schedule I have shared for Day 3 is in fact a printout from Google Calendar. There are some limitations in terms of how the various blocks show up on the calendar, but all things considered, this system works fine. You are likely to achieve similar results using other calendar programs. Interestingly enough, most professional scheduling and budgeting software offers little in the way of tools for drawing up detailed daily schedules.

As for distributing the daily schedule to your cast and crew, probably the most foolproof method is to send it out as a PDF file. On the other hand, if you share the calendar via a commonly used application like Google Calendar, the calendar will constantly refresh and incorporate any revisions, and therefore your cast and crew will never be caught working from an outdated draft.

The Call Sheet and Other Paperwork

Call sheets come in a variety of layouts, but at a minimum, they contain information about when and where the cast and crew must show up for the day's work. Figure 11.2 is the crew call sheet for Day 3 of our *Shoebox Redhead* shoot.

SHOEBOX REDHEAD

CREW CALL		WEATHER		
Date:	Saturday, July 18, 2024	Low: 59	High: 82	
Production Day:	3	Forecast: Mostly sunny. 30%		
First Crew Call:	6:00 AM	chance of thunderstorms starting		
Wrap Crew:	4:15 PM	~2:00 PM.		

SCENES	MEALS	
1, 21, 20, 23, 22	Breakfast:	Coffee & Food on Set
	Lunch:	11:00 AM - Noon
	Dinner:	N/A

LOCATION(S)

Webster Ave. & Boardwalk, Seaside Heights, NJ.

NOTES

Must wrap on beach by 9:00 AM.

Do NOT park at Boardwalk! Use commercial parking lot at Barnegat & Sherman Aves. Get receipt!

POSITION	NAME	PHONE	FOOD	CALL
Producer	Alan Smithee	(xxx) xxx-xxxx		6:00 AM
Director	Matt Lawrence	(xxx) xxx-xxxx		6:00 AM
Cinematographer	Scott Ballard	(xxx) xxx-xxxx		6:00 AM
Assistant Camera	Dave Rosenblum	(xxx) xxx-xxxx		6:00 AM
Sound Recordist	Charlie Anderson	(xxx) xxx-xxxx		6:00 AM
Misc. Crew	Mike Lawrence	(xxx) xxx-xxxx		6:00 AM
Misc. Crew	Richard Lolla	(xxx) xxx-xxxx		6:00 AM

NEAREST HOSPITAL: Community Medical Center, 99 NJ Highway 37. Tel: (732) 557-8000

CAR TROUBLE: AAA Tel. (800) 222-4357

FOOD NEEDS: GF = Gluten Free LA = No Lactose PN = No Peanuts TN = No Tree Nuts
HA = Halal KO = Kosher PA = Paleo VE = Vegan VG = Vegetarian

Figure 11.2 Call Sheet—Crew

The contents of the call sheet don't require much explanation. Note the inclusion of the nearest hospital. If you are working in a remote setting with no hospital or urgent care facility nearby, you may need to have a trained medical professional on set. Although I haven't filled in any information about dietary needs in the "Food" column, you can see from the key at the bottom of the page

how that would work. I would guess that it's the very rare production these days that does not have cast or crew members with dietary restrictions. This is a handy way to keep track of all that and to plan snacks and meals accordingly. The cast call sheet in Figure 11.3 uses almost exactly the same layout.

SHOEBOX REDHEAD

CAST CALL		WEATHER	
Date:	Saturday, July 18, 2024	Low: 59	High: 82
Production Day:	3	Forecast: Mostly sunny. 30% chance of thunderstorms starting ~2:00 PM.	

SCENES	MEALS	
1, 21, 20, 23, 22	Breakfast:	Coffee & Food on Set
	Lunch:	11:00 AM - Noon
	Dinner:	N/A

LOCATION(S)

Webster Ave. & Boardwalk, Seaside Heights, NJ.

NOTES

Must wrap on beach by 9:00 AM.

Do NOT park at Boardwalk! Use commercial parking lot at Barnegat & Sherman Aves. Get receipt!

ROLE	NAME	PHONE	FOOD	CALL
Ryan	Ryan Conrath	(xxx) xxx-xxxx		6:00 AM
Ira	Rob Ribera	(xxx) xxx-xxxx		6:45 AM
Matt	Matt Lawrence	(xxx) xxx-xxxx		8:00 AM
Mandi	Mandi Illuzi	(xxx) xxx-xxxx		8:00 AM
Boardwalk Extra	Dorothea Brooke	(xxx) xxx-xxxx		8:00 AM
Boardwalk Extra	Edward Casaubon	(xxx) xxx-xxxx		8:00 AM
Boardwalk Extra	Mary Garth	(xxx) xxx-xxxx		8:00 AM
Boardwalk Extra	Fred Vincy	(xxx) xxx-xxxx		8:00 AM

NEAREST HOSPITAL: Community Medical Center, 99 NJ Highway 37. Tel: (732) 557-8000

CAR TROUBLE: AAA Tel. (800) 222-4357

FOOD NEEDS: GF = Gluten Free LA = No Lactose PN = No Peanuts TN = No Tree Nuts
HA = Halal KO = Kosher PA = Paleo VE = Vegan VG = Vegetarian

Figure 11.3 Call Sheet—Cast

If we had lots of extras for a big crowd scene, we could make a separate call sheet just for extras. On a small production like this, segregating the extras (who are getting nothing for helping us out) will only make them feel like second-class citizens.

Blank versions of this form are available for download at *theshortseries. com*. Of course, you can make PDF files of these forms and then distribute them electronically, but a lot of assistant directors and line producers prefer to hand out hard copies of the call sheet. If you go that route, you can print both cast and crew on two sides of the same sheet. In any case, the goal is to ensure that everyone, regardless of their position in the production, receives the same marching orders.

Purchase Orders

While you are using your production paperwork to keep track of who, what, where and when, don't lose sight of *how much*. At some point, those funds you worked so hard to assemble start to disappear from your production's bank account. The debits begin as a trickle during preproduction and turn into a torrent as your shoot gets under way. By then, it's too late to impose a system for keeping track of expenditures. That's why it's imperative to establish a rigorous and consistent accounting method before any money gets spent. The common practice in the professional realm is to use **purchase orders** for this purpose. A purchase order—also referred to as a PO—stipulates the quantity and agreed-on price for the items you wish to buy or rent. Think of it as the complement of a receipt: the buyer (that's you) issues a purchase order; the vendor issues a receipt. Remember how we emphasized the importance of putting negotiated rates in writing back in the budgeting stage? Using purchase orders is another way of ensuring that no communication breakdowns occur around transactions. POs also allow you to track financial outlays more accurately. As you enter production, you are less interested in what your bank reports as your current account balance; you want to know where you stand after factoring in funds already committed toward expenditures. Suppose you plan to rent ten tables and tablecloths for a party scene. The goods are going to cost $317 to rent. The party scene comes late in your production schedule. It might take days or weeks for that money to be drawn from your account. Be that as it may, since you know you will eventually need those tables and tablecloths, that money is effectively spent. You can take this into account by issuing a purchase order to your art department well in advance of the actual date when that team goes to pick up the items. If you track everything (and I do mean *everything*) by purchase orders and receipts for petty cash reimbursements, you'll always have a clear financial picture.

Pro Tip

"I'm a huge fan of purchase orders. I basically PO everything: the office, the monthly rental, the furniture that we're having to bring in. Just all of it. Because that way, when we hand it off to accounting, it gets entered into the system, and I can see it in the cost report every week. So, even if we haven't necessarily spent that money yet, I can see that it's accounted for, all the way through to the end of the job."

—Erika Hampson

Purchase orders don't have to be fancy. What's important is that you have one purchase order per transaction. Professional productions sometimes use special software to generate purchase orders, but you really don't need anything beyond a word processing app. If you want to go old-school, you can still buy pads of purchase order forms that you can fill out by hand. In addition to listing what you agree to buy, the PO should contain your contact information, the date and a unique purchase order number. This last point is important: if you keep a numerical register of your purchase orders, you won't accidentally issue duplicate authorizations. This gets to the last reason purchase orders are worth the effort. Imagine if you were running a production without POs. The day before your big party scene, you've got two teams running around town, pulling together all the props and set pieces. Both teams are under the impression that they are to pick up the tables and tablecloths, and at different points in the day, each shows up at the rental company and picks up ten sets of everything. Oof. This problem could not occur if everyone on the production knew that every transaction required a purchase order. Since only one purchase order would be issued for the rental, only one team would have the authorization for the pick-up.

Keep a record of all your purchase orders. Although going paperless is a worthy goal, most producers print hard copies of purchase orders. Those venerable handwritten purchase order pads produce duplicates, so you always have hard copies of all your POs. That feature largely accounts for their enduring popularity.

Pro Tip

"I personally prefer paper purchase orders. The whole reason is because you can't have duplicate POs. If I give POs 1–20 to one person and 21–40 to another person, I know they won't turn in a duplicate PO."

—Mark DiCristofaro

Working Away From Home

Overseeing preparations for a shoot becomes much more complicated when you cannot manage the arrangements in person. This may seem an obvious point, but it bears special mention at a time when many people who have grown up in the digital age take the notion of the world as a global village quite literally. In an era where meetings can take place via Skype and locations can be scouted using Google Street View, I often have to make the case for the importance of face-to-face contact to novice producers. It's easy to get a distorted impression of people and places when you only encounter them through some medium. There are details and nuances that can only be picked up through first-hand experience.

What, then, is to be done if you must produce a project away from home—especially if the remote location isn't an area you know well? First, at any cost, make a planning and scouting trip to the location at the very start of preproduction. If that trip must be very brief, make sure that you accomplish at least one thing during your time on the ground: find a local person who can serve as your "fixer." If you can't find someone with a background in filmmaking, look into the local theater and art scene. It is less important that the person have a knowledge of media production than that they be alert, receptive and level-headed. Offer them associate producer credit in exchange for their serving as your local liaison. Second tip: don't arrive at the remote location on the eve of production. You don't have to have all your crew with you, but make sure you give yourself a few days on the ground prior to the start of shooting to see that everything checks out.

Getting equipment to a distant location is a process that is guaranteed to give producers heartburn. Should you bring all your own gear, rent equipment on-site or use some combination of these options? The answer can only be found after doing a complicated calculus. You must consider the following:

- How far you are traveling
- How specialized your gear package is
- What rentals are available near your shooting location
- What shipping costs or luggage charges would be required to get your gear to the location

If you are working in a location that has few rental houses in the area, it may well be worth renting a truck or a van to cart everything to the site. This is especially true when the distance to the location is no more than a full day's drive. If your crew must stay overnight en route, not only does this add to the transit costs, but it also raises the issue of keeping the gear secure.

Traveling with gear on commercial airlines has never been fun, but in this era of heightened security and elevated baggage fees, the process can be

gut-wrenching and costly. Many crews make sure the camera and especially any lenses are taken aboard as carry-ons. There are good professional cases out there that will protect your gear, but I have also seen people make serviceable cases by filling standard hard-shell suitcases with foam inserts. One advantage to this method is that doesn't make your luggage scream out, "Hey, I'm carrying valuable technology here!"

When you're shooting abroad, another wrinkle comes into play: customs. Many countries have substantial taxes or tariffs that they levy on imported technology. These governments will want to make sure that you are not smuggling equipment across their borders. To do this, they will want to see an invoice of all your gear that they can check as you come and go to ensure that you take out everything you bring in. This inventory paperwork often goes by the French term **carnet**. Check with the consulate or embassy of the country in which you will be shooting to determine the customs and carnet requirements.

One final consideration for those shooting away from home: handling your data. I'm thinking here mostly about getting the recordings you make on the road safely home, but this is an opportune moment to take note of the fact that several different video standards are used throughout the world. Therefore, if you are shooting overseas—and especially if you are working with foreign crew or locally rented camera gear—you must ensure that everyone agrees on the format you are shooting. As for getting the data storage to and from the shoot, chances are that none of the security measures or storage conditions to which your equipment will be subjected while in transit will cause any damage. As a rule, the scanners used in airport security will not corrupt or erase your data cards or drives. That said, any time you travel, the opportunity for mishaps increases. Therefore, it is imperative that you back up all your data before you travel and that you make sure that the two copies of the recorded material don't travel together.

Got all that? Bon voyage!

The first three pages of the script for *Shoebox Redhead*, marked up

1 EXT. BEACH -- SUNSET (2/8)

RYAN CONRATH stands in front of a vast ocean, shoebox in
hand. The waves crash and come up to his shoes. *Extra Shoeboxes (6)*

 Extra Cigarette Butts (3)
Trash is scattered across the sand. Ryan finds a butt to a *Lighter*
half-smoked cigarette. He picks it up and lights it.

Ryan places the shoebox in the sand in front of him. A wave
breaks and rushes forward, enveloping the shoebox in water.

 DISSOLVE TO:

2 INT. BEAT UP STATION WAGON -- DAY *Matt clean-shaven in photo*

 (1/8)
An air freshener with a photo of MATT LAWRENCE, shaven and
clean cut, and JACKI hangs on the rear view mirror.

3 EXT. BEAT UP STATION WAGON -- DAY (6/8)

Matt, now bearded and haggard, sits in the driver side seat.
He stares at the air freshener. *Car Mount?*

Matt reaches for the air freshener and yanks on it, breaking
the elastic. He rolls down his window and tosses it out.

Matt closes his eyes and covers the bridge of his nose with
his hand. Silence.

Matt makes a loud snorting sound.

A KNOCK comes from the passenger side window. Matt snaps
out of his shame spiral and looks over.

Ryan stares into the car. He knocks again.

Matt reaches over and unlocks the passenger door. Ryan enters
the car and shuts the door behind him.

 RYAN
 Yo. You ready to do this?

A beat. Ryan looks over at his friend.

 RYAN (CONT'D)
 Have you been crying?

Matt shakes his head "no." He doesn't make eye contact.

 MATT
 It's a high pollen count today.

Matt puts the car in drive and pulls away.

TITLE CARD: SHOEBOX REDHEAD

4 EXT. BEAT UP <u>STATION WAGON</u> -- MOMENTS LATER (1/8)

The vehicle putters through a suburban neighborhood. Tied
to the top of the wagon is a <u>box labeled "Jacki."</u>

5 EXT. SUBURBAN NEIGHBORHOODS -- DAY (1/8)

Shots of suburban homes, one after another. Each one
indiscernible from the next and the one that came before. Car Mount
The cuts signify a change in neighborhood but this could be
a single neighborhood. A meta neighborhood.

6 A house having a garage sale is passed and then <u>the car</u> (6/8)
<u>(camera, whatever) slows down</u>, almost to a stop. It backs
up slowly and stops, looking straight at the house holding
the garage sale. Lawn Chairs (3)
 Matt - Red Eyes
An <u>OLD WOMAN</u> sits at a table in the center. Rummaging around
is an <u>OLD MAN</u> and <u>TWO MIDDLE-AGED WOMEN</u> with teased out hair
and wearing <u>nylon jogging suits</u>. Car Mount

We cut 180 degrees to reveal <u>Ryan</u>, sitting in the passenger
side of a <u>beat up wagon</u>. After a few seconds, Matt appears
from behind his friend. <u>Matt</u> yanks up on the emergency break.

EXT. SUBURBAN HOUSE -- DAY

<u>Ryan</u> and <u>Matt</u>, who is carrying <u>the box,</u> walk to the front of
the driveway, passing <u>tables full of junk</u> and <u>blankets</u> below
those tables, full of more junk. They approach the <u>Old Woman</u>.
Matt drops the box on the table in front of the her.

 MATT
 Hi. Do you want to buy this stuff?

 OLD WOMAN
 Why would I want to buy your stuff?

 RYAN
 Well, he can just trade it in for
 credit, right?

A beat.

 OLD WOMAN
 If you want to take a look around.

> RYAN
> Yeah. Thanks.

7 EXT. SUBURBAN HOUSE -- MOMENTS LATER (1 3/8

Matt and Ryan approach different tables. Ryan picks through
VHS tapes.

> RYAN
> Matt, they've got Richard Simmons'
> Sweatin' to the Oldies over here for
> only a buck.

> MATT
> Wow.

Matt comes upon a shoebox and opens it. In it is a polaroid
camera sitting on dozens of old photographs. Matt picks up
the camera and examines it. He puts the camera back down
and begins leafing through the pictures. In many of the
photos appears a beautiful redhead 20-something, Mandi.

> RYAN (O.S.)
> She's a cutie.

Matt turns to find Ryan standing beside him.

> RYAN (CONT'D)
> You want to get that?

Matt closes the shoebox and heads over to the Old Woman at
the table. He shoves the Jacki Box over and sets down the
shoebox.

> MATT
> (motioning)
> I'd like to trade this for this.

> RYAN
> Wait.

Ryan runs back over to the table he was at and yanks the
Sweatin' to the Oldies VHS tape from the Old Man's hands.

> RYAN (CONT'D)
> And this.

> OLD WOMAN
> Five bucks.

Ryan reaches for his wallet.

Schedule stripboard for *Shoebox Redhead*

Shoebox Redhead Schedule

CAST		VEHICLES	
1. Matt		V1.	Station Wagon
2. Ryan		**CAMERA/GRIP**	
3. Ira		C1.	Car Mount
4. Old Woman		C2.	Polaroid Camera & Film
5. Mandi		C3.	Regular Still Camera
		C4.	Jib Arm

SHOOT PHOTO OF CLEAN-SHAVEN MATT & JACKI DURING PREPRODUCTION!

Scenes: 4	EXT	SUBURBAN NEIGHBORHOOD	DAY	Cast: 1, 2	
		Station wagon putters through suburb		Vehicles: V1	
Sheet: 4				Camera/Grip:	
Length: 1/8				Extras:	
Scenes: 11	EXT	ONE LANE ROAD	DAY	Cast: 1, 2	
		Station Wagon speeds down road		Vehicles: V1	
Sheet: 11				Camera/Grip:	
Length: 1/8				Extras:	
Scenes: 5	EXT	SUBURBAN NEIGHBORHOOD	DAY	Cast: 1, 2	
		"Meta neighborhood" montage		Vehicles: V1	
Sheet: 5				Camera/Grip: C1	
Length: 1/8				Extras:	

SHOOT POLAROIDS OF MANDI

END DAY ONE - 3/8 PAGE

Scenes: 6 Sheet: 6 Length: 6/8	EXT	GARAGE SALE Ryan & Matt arrive at garage sale	DAY	Cast: 1, 2, 4 Vehicles: V1 Camera/Grip: Extras: [3]
Scenes: 7 Sheet: 7 Length: 1 3/8	EXT	GARAGE SALE Matt & Ryan discover & buy the shoebox	DAY	Cast: 1, 2, 4 Vehicles: V1 Camera/Grip: Extras: [3]
Scenes: 10 Sheet: 10 Length: 5/8	EXT	GARAGE SALE Matt & Ryan seek refund from Old Woman	DAY	Cast: 1, 2, 4 Vehicles: V1 Camera/Grip: Extras:
Scenes: 2 Sheet: 2 Length: 1/8	INT	STATION WAGON - RYAN'S STREET Quick glimpse of air freshener	DAY	Cast: 1 Vehicles: V1 Camera/Grip: C1 Extras:
Scenes: 3 Sheet: 3 Length: 6/8	EXT	STATION WAGON - RYAN'S STREET Matt picks up Ryan	DAY	Cast: 1, 2 Vehicles: V1 Camera/Grip: C1 Extras:

END DAY TWO - 3 5/8 PAGES

Scenes: 1 Sheet: 1 Length: 2/8	EXT	BEACH Ryan sets the shoebox out to sea	DAY	Cast: 2 Vehicles: Camera/Grip: Extras:
Scenes: 19 Sheet: 19 Length: 2/8	EXT	BEACH Ryan watches shoebox sink into water	DAY	Cast: 2, 3 Vehicles: Camera/Grip: Extras:

Shoebox Redhead Schedule

Scenes: 18 Sheet: 18 Length: 1 1/8	EXT	BOARDWALK	Arrival at Pier, Matt disappears	DAY	Cast: 1, 2, 3, 5 Vehicles: V1 Camera/Grip: C2 Extras: [4]
Scenes: 21 Sheet: 21 Length: 1/8	EXT	HIGHWAY	Ryan & Ira drive off into the sunset	DAY	Cast: 2, 3 Vehicles: V1 Camera/Grip: C4 Extras:
Scenes: 20 Sheet: 20 Length: 1/8	INT	STATION WAGON - AT BEACH	Ryan & Ira look at photo of Matt & Mandi	DAY	Cast: 2, 3 Vehicles: V1 Camera/Grip: Extras:

END DAY THREE - 1 7/8 PAGES

Scenes: 9 Sheet: 9 Length: 3/8	EXT	FIELD WITH TREE	Matt takes picture of tree, gets mad	DAY	Cast: 1, 2, 3 Vehicles: V1 Camera/Grip: C2 Extras:
Scenes: 8 Sheet: 8 Length: 1 6/8	INT	STATION WAGON - FIELD WITH TREE	Ryan & Matt try out camera in car	DAY	Cast: 1, 2, 3 Vehicles: V1 Camera/Grip: C1 Extras:
Scenes: 15 Sheet: 15 Length: 1 1/8	INT	STATION WAGON - DRIVING TO PIER	Matt, Ryan & Ira travel to pier	DAY	Cast: 1, 2, 3 Vehicles: V1 Camera/Grip: C1 Extras:
Scenes: 16 Sheet: 16 Length: 2/8	INT	STATION WAGON - NEARING PIER	Ryan sings, Matt ejects tape	DAY	Cast: 1, 2, 3 Vehicles: V1 Camera/Grip: C1 Extras:

Scenes: 17 Sheet: 17 Length: 1	INT	STATION WAGON - ARRIVING AT PIER Ryan & Ira discuss clown job	DAY	Cast: 1, 2, 3 Vehicles: V1 Camera/Grip: C1 Extras:

END DAY FOUR - 4 4/8 PAGES

Scenes: 12 Sheet: 12 Length: 5/8	INT	STATION WAGON - NEAR BIG TOP Matt laments giving up box	DAY	Cast: 1, 2 Vehicles: V1 Camera/Grip: C1 Extras:
Scenes: 13 Sheet: 13 Length: 4/8	EXT	BIG TOP DRIVE-IN Matt & Ryan meet Ira at drive-in	DAY	Cast: 1, 2, 3 Vehicles: V1 Camera/Grip: Extras:
Scenes: 14 Sheet: 14 Length: 1 4/8	EXT	BACK OF DRIVE-IN Ira looks over the polaroids	DAY	Cast: 1, 2, 3 Vehicles: Camera/Grip: Extras:

END DAY FIVE - 2 5/8 PAGES

Detailed schedule for Day 3 of the production of *Shoebox Redhead*

Shooting, Cast, Set-Up, Staging/2nd Unit, Travel & Craft Services

Time	Shooting / Setup	Cast	Staging / 2nd Unit	Travel & Craft Services
6am	Set up Sc. 1 @ Webster Ave. & Boardwalk, Seaside, NJ — 6am - 6:45am	Call: Ryan 6am - 8am		
6:45am	Shoot Sc. 1: Ryan Sets Shoebox to Sea — 6:45am - 7:30am	Call: Ira 6:45am - 6:45am		
7:30am	Set up Sc. 21 — 7:30am - 8am			
8am	Shoot Sc. 21: Ryan Watches Shoebox Sink — 8am - 8:30am	Call: Matt, Mandi & Boardwalk Extras 8am - 8am		
8:30am	Set up Sc. 20 — 8:30am - 9:30am			
9:30am	Shoot Sc. 20: Boardwalk Arrival; Matt Disappears — 9:30am - 11am		Set Up Jib 9:30am - 11am	Order Lunch: Midway Steak House, Boardwalk (732) 793-6617
11am	Lunch — 11am - 12pm	Sign Out Matt, Mandi and Extras 11am - 11am		
12pm	Set up Sc. 23 — 12pm - 1pm			
1pm	Shoot Sc. 23: Drive Off into Sunset. Crane Shot! — 1pm - 2pm			
2pm	Break — 2pm - 2:15pm		Break Down Jib 2:15pm - 3:30pm	
2:15pm			Set up Sc. 22 2:15pm - 3pm	
3pm	Shoot Sc. 22: Ryan and Ira Look at Photo of Matt in Car			
3:30pm	Wrap Location — 3:30pm - 4:15pm	Sign Out Ryan & Ira 3:30pm - 3:30pm		

Chapter 12

The Shoot

Once More With Feeling: Safety Matters

I have tried to stress the importance of safety throughout this text, but now that we have arrived at the moment of truth—the management of the production phase—it is worth underscoring how important it is to take precautions to ensure the safety of everyone on your set.

Running a safe production largely comes down to exercising forethought, judgment and common sense. Here are some basic principles to follow:

- *Safe production practices*: Before production starts, assign a member of the crew to be the designated production safety officer. This person should not be the producer, director or assistant director. All those crew positions have an inherent interest in staying on budget and on schedule, and this can pose a potential conflict when it comes to enforcing safety measures. Delegate this job instead to someone like the assistant camera—a person who is on set virtually all the time and can watch for any lapses in safety etiquette. Have the production safety officer run a meeting on the first day of the shoot to establish basic safety practices.

- *No stunts, staged combat or pyrotechnics without professional oversight*: If you have ever spent time with professional stuntpeople, firearms experts or pyrotechnicians, you'll likely be astonished at the degree of care they take in their work. These are the people you want on your team, not amateurs who are out to prove something or, worse yet, to get a cheap thrill.

- *Use of special equipment*: Do not let any member of your crew or cast operate heavy machinery or power tools until you have ascertained that this person has been trained in their use. This is precisely the kind of slip-up that the production safety officer should flag.

- *Lifesaving*: Determine who on your crew is trained in CPR. If you are working around water, find out who has lifesaving training. Go over basic first aid procedures for dealing with cuts, sprains and burns.

- *Safety equipment*: Have a fire extinguisher and a first aid kit on hand at all times.

- *Exposure to the elements*: If your shoot takes place in extreme weather, take all possible steps to protect your cast and crew from the conditions, but also be prepared to deal with adverse consequences. There are established protocols for treating frostbite, hypothermia, dehydration and heat exhaustion. Be sure to familiarize yourself with these steps.

- *Electrical dangers*: A revolution in film lighting is under way, giving us more bang for every watt we burn. Even so, the lighting units used for filmmaking can be very powerful. This fact, as well as the labyrinths of cables laid around sets, means that we must always be vigilant against the possibility of causing fire or electrocution. Keep light units away from walls, curtains and ceilings. Most of us have a well-founded fear of electrocution, but how many of us would know what to do if we witnessed a person getting electrocuted? The instinctive response—reaching out to help—can be very dangerous, as the electrical current could also travel to the rescuer. When possible, the first course of action is to cut the power to the electrical instrument. If this isn't possible, the next step would be to use some non-conductive item like a wooden broom to push the person away from the source of the electrocution.

- *Secure your gear*: Every light and gobo stand should be secured with at least one sand bag. Whenever cables run across trafficked areas, they should be secured with sandbags or **gaffer tape**.

- *In case of emergency*: If you are working with stunts, pyrotechnics, groups of children or crowd scenes, you will want to have a licensed nurse or trained EMT personnel on set. Remember that the nearest urgent care facility is noted on the call sheet.

Pro Tip

"Going into a location, you should look at the location, you should look at any safety concerns. Whether it's a warehouse with a raw floor with some nails protruding from the wall, talk to your entire crew about it, before you start shooting, before you unload your cameras. Spend time with the crew, make them all look around the area and identify the risks. That's the most important thing you can do as a producer in any shooting situation."

—*Leah Culton Gonzalez*

Riding the Whirlwind

Though the concept may not hold up so well today, it was once commonplace for veterans to refer to their war years as "the best years of their lives." When asked how a regimented life punctuated by bad food and face-to-face encounters with death could stand as the pinnacle of one's existence, many an old soldier would wax nostalgic about how simple and focused life was at that time. In the foxhole, there was no past or future, only the present, where one had to depend on an instinct for survival that could turn complete strangers into blood brothers in the instant it took for a grenade to explode.

While the comparison may sound absurd (hopefully, no one on a film set is putting their life on the line), people often bring a similar in-the-trenches attitude to a movie shoot. They may not enjoy the stress and the long hours, but they love how the rigors of production magically make every other concern in life seem remote and insignificant. So consuming is this effect, I often find, that coming home from a long weekend of filming can feel like returning from a strange and distant land. Before we succumb to the adrenalized, existential condition that is the production phase, let's step back and remind ourselves of a key fact: while we are off in the altered state of production, the world goes on spinning. Loved ones still need attention, the garbage still needs to be put out and bills need to be paid. As we'll see, perhaps more than any other person on the set, it's always important for the producer to keep things in perspective, and this includes being able to see the production itself in the context of everything else.

Pro Tip

"I always say, 'You've got to be the grown-up on the set.' The producer is the grown-up; everyone else can be kids."

—*Michael Nozik*

Conceding, Settling, Hanging Tough and Whittling

The moment has arrived. Quiet on the set! Roll sound! Roll camera! And . . . start compromising! It's true: despite all our assiduous planning and hard work, as soon as production begins, elements begin to shift and accommodations must be made. This is true even if you are operating the most well-oiled production machine ever invented. The flies that get into the ointment are inherently unpredictable. Perhaps a busted water main prevents access to your location, or a custodian who is supposed to unlock the premises oversleeps.

Whether dealing with a minor hiccup or a major calamity, the producer must be ready to make adjustments and keep the ship on course.

In the pressure-cooker atmosphere that takes hold during production, we all tend to turn into caricatures of ourselves. Like someone running from a burning house who must quickly choose one precious possession to take with them, when the exigencies of production start to take their toll on cast and crew, we all hold tight to the thing that is most important to us. The cinematographer frets over the framing and lighting of each shot; the actor obsesses over his close-up; the director fixates on preserving her vision on-screen by any means necessary. In this scenario, what becomes of the producer? Too often, she becomes focused on keeping on schedule and under budget to the exclusion of everything else. This leads to an all-too-common division on the set between the director, who is defending the project's artistic merits, and the producer, who is watching the bottom line.

Such schisms don't serve the interests of the production. Don't get me wrong: any producer who loses sight of the constraints of the schedule and the budget won't be a producer for long. But the producer who thinks only in terms of deadlines and subtotals is little more than a drone mindlessly following rules. While a producer must work within a set of logistical limitations, she mustn't let those boundaries become an end in themselves. No one would take seriously a producer who trumpets, "My movies don't come out so great, but I always stay on schedule!" A good producer–director team is one where both leaders are dedicated to the story they have to tell. When adjustments and tough choices must be made during production—as they inevitably do—the producer and director should both weigh their decisions first and foremost in terms of which choice best serves the story. The clarity of purpose this fundamental question brings will not only make it easier for them to work together in the short run but will also lead to a final product of which they can both be proud.

Pro Tip

"I think it's inexcusable today to make a film today without coverage. You don't know how your film is going to pace out, and getting coverage is easier than you think. Get something to give yourself an option in post. Because you don't know how your film is going to turn out. Nobody does."

—*Glenn Gainor*

Keeping that goal of serving the story as our lodestar, let's now consider the day-to-day reality that a producer faces on set: when push comes to shove,

having to decide which elements of the production to bolster and which to let go of. It's too easy to stand for lofty principles ("Preserve the story!") in the abstract; it's when we must deal with concrete choices that the often agonizing nature of the process becomes more tangible. Therefore, let's imagine we're shooting Scene 18 of *Shoebox Redhead*. This is the climax of the movie, the scene where Ryan confronts Matt on the boardwalk, Matt reveals his vulnerability, and finally Matt magically disappears with Mandi, the redhead. To capture the rising tension at the start of this scene, the director wants to break out of the buttoned-down look of the film as a whole and shoot the confrontation between Ryan and Matt using a handheld camera. This portion of the scene concludes with Matt acknowledging his crippling depression and his solipsism. So, there we are, on the busy boardwalk, trying to capture this crucial dramatic moment. Things go well shooting the angle on Ryan, and now it's time to get the reverse angle on Matt. As he responds to Ryan, the camera is supposed to move in on Matt. The first take feels stiff, both in terms of performance and camera move. The second take is much better on those counts, but a helicopter is now buzzing the boardwalk, rendering the sound unusable. We lose fifteen minutes as we wait for the helicopter to depart. Finally, the sound recordist determines that the sound is acceptable and we shoot take three. Camera and performance are perfect, but the script supervisor points out that the boom (actually the microphone, which is suspended on a boom pole) continually bobs in and out of the shot. Worse yet, there is a bystander in the background who spends the whole take staring at the camera in frozen wonder. Now we are getting seriously behind schedule. We shoot take four, and now Matt really nails his part, showing us a side of his character we haven't seen before. The only problem this time is that the focus (always tricky when shooting handheld) goes soft for a moment as the camera moves in on Matt. The cinematographer wants to do another take. The director asks: can we afford it? You review your schedule and see that you are now half an hour behind. What's your decision?

This is a really tough call. You have sworn to serve the story, and this moment might well be the very heart of our narrative. You must reckon with some hard facts. Fact 1: you have no perfect take, nor a satisfactory backup or "safety" take. Fact 2: the takes marred by the helicopter and the boom and bystander are patently unusable. This leaves you with only a lousy first take and a flawed last take. You review take four. By the way, if you make a habit of reviewing every viable take on set, your production will proceed at a snail's pace. That said, this is the kind of high-stakes decision that merits reviewing the footage. Upon examination, you determine that the focus problem is certainly there, but it lasts only a moment. It's not pretty, but it doesn't obscure Matt's performance. Here, at last, is where the primacy of telling the story must come into play. The take captures the key dramatic moment in the scene. There is a degree of roughness in the execution, but why did we choose

to shoot the scene handheld if we aren't going to allow for that unvarnished quality? The decision isn't easy, but in the end, you tell the director that you believe it's best to move on.

Every time a difficult judgment like this must be rendered, your choices fall somewhere on a spectrum from conceding to hanging tough—from giving in to fighting to the death. Often you'll find that the solution lies somewhere in the middle, a decision that will require that you settle for something acceptable or at least workable rather than ideal. One pitfall to watch out for is falling into a pattern where your concessions have the cumulative effect of gutting the project. I call this process "whittling" in reference to the image of an old timer who keeps whittling on a stick of wood until he eventually finds that he has nothing in his hand and just a pile of shavings at his feet. The process of whittling can start in preproduction. Suppose your script is about the dangerous passage across the Mediterranean by a boat overloaded with Middle Eastern refugees. You are based in central Ohio. Shooting in the Mediterranean is out of the question. As you start to plan the production, you mull over options: perhaps you could make an old salvage barge on Lake Erie double for open boat on the ocean? Flash forward to the start of your shoot, and somehow you now find yourself at a local farm pond, making a movie about two Midwestern lads trying to get their broken sailboat ashore. Perhaps there is a compelling narrative to be found here, but it's not the one you set out to tell.

If this sounds like ridiculous hyperbole, all I can tell you is that I have seen all too many productions go through a similar sort of watering down. Of course, many of these projects suffer the same basic defect found in my example: the scope of the saga of Middle Eastern refugees was unrealistic to begin with. The key, therefore, is first to ensure that you take on a story that is within your grasp. Once you have signed on to tell that tale, beware of whittling.

How to Manage Crises and Tiffs (and How to Tell Them Apart)

Perhaps you have read stories in the annals of Hollywood of producers throwing tantrums, firing everyone in sight, hurling paperweights at assistants and so on. Before you settle on any of these folks as role models, do a little homework. Remember that there are many kinds of producers. Upon closer inspection, I think you'll find that the paperweight-throwers are not line producers or production managers. Motion picture production draws on many artistic disciplines, and at times artists can live up to the stereotype of being temperamental and dramatic. Be that as it may, in overseeing the whole creative enterprise, the line producer can't afford to indulge in these tendencies. Indeed, when emotions flare on the set, it's imperative that the producer keeps a level head.

A degree of tension, if not conflict, is built into the very structure of a film crew. For instance, because lighting tends to be the most time-consuming part of setting up a shot, and because assistant directors are always worried about keeping a shoot on schedule, assistant directors and cinematographers can sometimes seem like the cinematic counterpart of cats and dogs. There often comes a time in the heat of production when the AD asks once too often for the camera/lighting crew to pick up the pace. When this happens, even the most professional cinematographer is apt to let a few choice words fly. The next thing you know, you've got two of your key crew members locked in a stare-down or perhaps even a shouting match. How should you respond to this turn of events? Of course, the answer ultimately depends on the specific personalities involved, but before you jump into the fray, ask yourself: are these people veterans or relative novices in their respective jobs? If they are seasoned pros, they probably understand the nature of the conflict at least as well as you do. Chances are, once they have blown off some steam, they can shake off the confrontation and get back to work. Neophytes are trickier to deal with because they are often insecure and don't have the experience necessary to put this momentary flare-up in perspective. Whatever the case, there is seldom anything to be gained by cranking up the drama. Jumping into the dispute like a boxing referee or barking orders like a drill sergeant is like pouring gasoline on the fire. Usually the best strategy is to get the angered parties to separate, and then talk quietly and calmly to each person. If necessary, call for a ten-minute break, but don't try to arbitrate differences on the set. Hear each person out briefly and privately. Listen to what they have to say. Be warm and supportive, not distracted or glib. If one of the parties insists that there is a real grievance to pursue, set up a time after the shoot to air the issue.

Pro Tip

"When there's bad blood developing on the set, I try to figure out what the source of it is. A lot of times, it's about time—people feeling the pressures of time. And I'll tell you, when that happens, one of the best things to do is to literally take a 'time out' and stop, so everyone can regroup."

—*Marie Cantin*

At the end of the day, you have to determine which conflicts are substantive and which are just a by-product of the strains of production. The stark reality of any short production is that, regardless of the circumstances, there usually isn't sufficient time to change course or right wrongs during production. In almost

all cases, the only pragmatic choice is to calm the waters and keep things moving forward.

The Shoebox Diaries

"We ended up shooting a bunch of scenes at dawn. Making people wake up after you work sixteen, eighteen hours—then asking them to wake up at 5:00 A.M. to shoot . . . I mean, at a point, I thought I was going to have a mutiny."
—*Matt Lawrence, Producer, Director, Writer & Editor*

"I think after about three days of working really long days and only having a four- or five-hour turnaround, the crew was starting to say, 'We're not making our schedule, and it's kind of getting taken out on us. Maybe we need to start cutting some shots or working it out, solving the bigger problem so we don't just keep losing sleep.'"
—*Samara Vise, Assistant Camera*

"I think Matt made the decision finally, if I remember correctly, to let people have from 10:00 P.M. to 8:00 A.M. or something like that. That doesn't sound like a lot, but it was a huge deal—just to say, 'Sleep a full night.' So, I think he made the call in the end and it all turned out all right."
—*Ryan Conrath, Actor*

Revising the Schedule During Production

Productions seldom follow a shooting schedule to the letter. Yes, delays of one sort or another are often the culprit, wreaking havoc with plans. But it's not just bad news that can alter the course of events. There are those rare days where everything unfolds without struggle or fuss, and you find yourself cruising toward an early wrap. If you are in the midst of a longer shooting schedule— a week or longer—the right move might well be to let everyone go home. In these situations, an early sign-out can be a great morale booster. On shorter productions, however, you should consider shifting a scene up in the schedule. By taking something out of the schedule for the coming days, you are in effect banking the time you've saved. Those spare minutes and hours will come in very handy if there are delays down the stretch.

Whenever adjustments must be made to the schedule—whether to catch up or to capitalize on some opportunity to get ahead—you must involve the director in the deliberations. Don't make the mistake of getting so immersed in

the logistics that you lose sight of the concerns and priorities of the director. Whether you want to simplify coverage of a scene in order to save time or to move a scene up in the shooting schedule, any number of creative consider- ations might come into play. If you make the director a partner in the schedul- ing process, she can help with the problem-solving. If you box her out of the process, you'll only engender confusion and suspicion.

The stripboard and other schedule documents should be updated to reflect any changes in the schedule. The ease with which such changes could be made was the reason stripboards were invented in the first place all those decades ago, and the ability to make quick revisions remains one of the big appeals of professional scheduling software. If you use the spreadsheet version of the stripboard available through *theshortseries.com*, you'll find that, with some practice, you can pick up the cells associated with a particular strip and move them wherever you need to.

Pro Tip

"I think probably the biggest problem that I've had is the director underesti- mating how much time something's going to take—wanting to get the moon and back when you've only got Pasadena."

—*Don Daniel*

Tracking the Budget Through Production

We've all seen those images that document the impact of a natural disaster through before and after photos. In the first picture, everything is orderly and peaceful. Then the tornado hits, leaving us with the second picture, in which the world has been turned upside down. The relationship between all the pre- production planning that goes on before the camera rolls and the shoot itself can sometimes feel like that.

No producer wants to see his shoot go off the rails, but there is an important distinction to be made between losing and relinquishing control. During pro- duction, delegation of authority is essential, and this requires some loosening of the reins. During preproduction, you may have been the one who deter- mined when things would happen and what things would cost, but now it's up to others to carry out those plans. So, how does the producer stay in charge of the production without micromanaging it?

This is a particularly vexing issue when it comes to spending money. If the producer alone holds the purse strings, a bottleneck results. Things slow down or grind to a halt altogether as the crew and suppliers wait for the producer to

settle accounts. Of course, the other extreme—letting everyone on the production have spending authority—is an even less workable option. There are various middle paths for managing expenditures that provide a balance of oversight and flexibility. One essential rule that would apply in all cases is that the producer needs to be consulted before any commitment is made for a major outlay of funds. Where you set the bar for "major outlay" is up to you. It might be $50 or $100. As for the plethora of smaller expenses, this is where you have a few options. If you have a relatively large crew, you may want to allocate a certain amount of cash to each department head. The heads keep track of expenses and ultimately report back to you. The old-school method for tracking expenses—still used by some productions—is to have people spend their own money, bring in a receipt for the expense, and then be reimbursed. In more recent years, it has become more common to set up a petty cash account at a bank and then give the department keys bank cards so they can pay for things directly. It's important to note that these are debit cards, not credit cards. On a short production, no one should be running around with a credit card that might well have a credit line that matches or exceeds the entire budget.

Pro Tip

"The advent of credit cards has brought in this sort of trust relationship, where you trust your department heads to not go over budget with the credit card. I've gotten in trouble with that. Art departments, particularly, might have relationships at prop houses or rental houses where they can just go pick up stuff and they bill you later because they have such a great relationship with this prop house. Then they hand the bill to the producer, and it's $5,000 over what you'd agreed to."

—*Evan Astrowsky*

Whether you use the reimbursement method, issue the crew debit cards or use some combination of the two approaches, it's essential that expenses be documented with receipts. As the producer, you also need to study the spending habits of your department heads and monitor their expenses accordingly. People's ability to manage money does not seem to correlate with talent or intelligence. If you determine that your cinematographer is a spendthrift, you won't want to give him a debit card and you'll need to dole out petty cash to that department in smaller increments. As with so much of the producer's job, when it comes to spending money, the key is to delegate when you can and take charge when you have to.

The budget you drew up in preproduction is just a projection of the expenditures that will be required. What happens once the camera actually rolls? How do we track these sundry outlays? Here is a straightforward approach to keeping your books. First, duplicate your budget on your computer and then open up the copy of your budget. Now add a couple of columns to the right of your existing budget that reflect the dollars spent. To see how this would work, let's return to the wardrobe budget for *Shoebox Redhead*. See Table 12.1.

Suppose I got lucky and found two jogging suits at the local thrift shop for $10 apiece. Meanwhile, our clown wardrobe purchases went entirely according to plan, except for the cheap clown nose, which was out of stock. We were able to buy a nose, but at the higher price of $9, shipping included. In our bookkeeping budget, I could record these wardrobe expenses as shown in Table 12.2.

Table 12.1 Wardrobe Account

Account	Item	Qty	Units	X	Rate	Subtotal	Total
3100	**Wardrobe**						
3101	Wardrobe Purchases						
	Nylon Jogging Suits	2	items	1	25	50	
	Clown Suit	1	item	1	21	21	
	Clown Wig	1	item	1	10	10	
	Clown Nose	1	item	1	3	3	
	Clown Shoes	1	item	1	26	26	110
3102	Wardrobe Rentals		allow				0
	Account Total						**110**

Table 12.2 Wardrobe Account With Actual Expenses

Account	Item	Qty	Units	X	Rate	Subtotal	Total	Actual	Total
3100	**Wardrobe**								
3101	Wardrobe Purchases								
	Nylon Jogging Suits	2	items	1	25	50		20	
	Clown Suit	1	item	1	21	21		21	
	Clown Wig	1	item	1	10	10		10	
	Clown Nose	1	item	1	3	3		9	
	Clown Shoes	1	item	1	26	26	110	26	86
3102	Wardrobe Rentals		allow				0		0
	Account Total						**110**		**86**

The second Total column on the far right is really the total for actual expenses. For each account, I'll need to format this second Total column so that it tallies up the category subtotals and account totals for actual expenses. This makes it easy for me to compare the money spent to date in each account with my budget projections. In this case, after registering all wardrobe expenditures, I find that I'm $24 ahead of the game. That's $24 that I can save for a rainy day or allocate to an account where we're overspending.

As simple as this method looks, it's hard to keep accounts fully up-to-date during production. The expenditures are occurring on so many fronts, and your attention is constantly being divided between several important tasks. Nevertheless, setting aside half an hour each day to register the latest receipts in your accounts is time very well spent. If you can keep your records reasonably up-to-date, you'll be able to maintain some perspective on your budget. As you determine that you are running over or under your target, you can adjust accordingly. This is really the only way to keep your fiscal house in order.

Chapter 13

Music

Kinds of Film Music

If you are in the habit of watching movies until the last credit has rolled (a very instructive practice for any budding filmmaker, by the way), you've no doubt become accustomed to the blizzard of text that appears on-screen as soon as the music credits begin. Typically, a song title is accompanied by a cluster of credits that identify the song's lyricist, composer and performer. Various companies associated with the composition or recording are often mentioned as well. If you can take in all this information as it flies by, you may be surprised by some of the entries. You recognize a favorite tune, but you'd swear that you never heard a note of it in the film. Guess what? You may be right: sometimes credit is given on-screen for music that was secured or "cleared" for use in the film but that didn't make the final cut. In other cases, the music might have been so buried in the audio mix that you missed it. Suppose, for instance, a scene takes place in which our protagonist steps into an elevator. As the doors close, "elevator music" plays very faintly in the background. You may recall from the script breakdown in Chapter 3 that music that comes from an identifiable source within the scene (presumably a loudspeaker in the elevator ceiling, in this case) is called source music and it plays a very different role from the underscore, or music that is added to a scene to affect the audience's response to the story.

As a rule, any recorded music that is reproduced in your movie—even that barely audible tune playing over the elevator speakers, which escaped most viewers' notice—must be acknowledged and cleared. Many films incorporate a combination of original and existing music as both source music and underscore. When you add up all the many ways that music can be used on-screen, it's easy to see how you might end up with a dozen or more compositions listed in your closing credits.

> ## Pro Tip
>
> "There is no such thing as a guaranteed clearance. So, if you're going into a scene and you have a song written in, or you're going into a verité shoot and there's music in the background, fix it there. Get it cleared and then shoot your scene, or shoot it without music and add the music later. It is a world of pain from a financial and clearance perspective if you can't make that work, and you just can't use uncleared music."
>
> —*Leah Culton Gonzalez*

Ask veteran producers about securing the rights to all that music, and you are likely to elicit a collective groan. The rights and logistics associated with using music in a film are complicated, and negotiating music rights can therefore be one of the most fraught and time-consuming aspects of the producer's job. Before we dive into these murky waters, let's put on a virtual life vest by laying out some practical guidelines. First rule: don't delay in discussing music plans with the director. In most cases, the director will be the arbiter of what sort of music goes into your production. It's essential that the two of you come to an understanding of the music the project requires. Although music usually gets added to a film only in the editing stage, you mustn't wait until you are in the postproduction phase to discuss your plans. A fantasy film might depend a great deal on underscore to set the mood, whereas a family comedy set in a barrio in southern California might require a lot of source music cues to evoke the specific cultural setting. Once you know the role music is to play in your movie, you can weigh various strategies for securing the needed material. The options available to you will largely be determined by the way music rights work.

Music Rights

Music has a way of sweeping us off our feet. Nothing summons emotions so directly or immediately. We hear a melody and are instantly transported to a land of shadows, to the Casbah, to outer space—you name it. Given music's ability to beguile and seduce, perhaps we can be forgiven for chafing at the notion of music as being something as concrete and pedestrian as a piece of property, but such is the case. Indeed, a musical recording often represents several layers of property. To understand this, consider the first song that pops into your mind. Who wrote it? Did one person or group write the music and another

write the lyrics? Who are the performers? What label released the song? The answers to these questions will almost always result in a list of individuals, partnerships and companies, all of whom may have a stake in the ownership of the song.

Before you press the panic button, keep in mind that we are only concerned with copyrighted material. Music that has fallen into the public domain does not require clearance. Much of what was said about works in the public domain in Chapter 2 applies here, but there will be more to say on this topic once we have established a few more principles. As for any music that still has a valid copyright, we can simplify the clearance process by placing all the various rights stakeholders into three groups.

First, there are the rights associated with the composition of any musical work. These rights are referred to as the **publishing rights**. Let's say that my director is very fond of singer-songwriter Andrew Bird's song "Three White Horses," and he wants a guitarist friend to record a spare instrumental version to use in a scene. For starters, I'll need to secure the publishing rights. To be more precise, since I'm just seeking permission to re-record the song, not to obtain the actual copyright to it, what I need is a **synchronization license**. You'll find an example of such an agreement—often referred to as a sync license—in Appendix C. Here, we need to hit the pause button and insert a word of caution about music contracts. These agreements aren't like the releases we get actors to sign or location contracts. In those cases, the rights we need to secure are relatively unchanging and uniform. Music rights get bought and sold; they get transferred from one party to another or tied up by powerful corporations. Depending on who you are talking to about the use of music, you may need to secure just one or possibly several sets of rights. All of this is to say that one size does not fit all; you will need to tailor your music contracts to fit your needs.

Publishing rights are not necessarily held by the person who wrote the piece of music in question. The publishing rights for the output of most established musicians are held by publishing companies. Nowadays, it's quite common for musicians to operate their own publishing companies. If you can get your hands on the sheet music for the music you need to license, the publishing company that controls the rights should be printed there. A word about terminology: you may have already noticed that legal language can be pretty obscure. In the case of the music industry, a lot of terms that are still in use refer back to earlier eras and outmoded technology. The once-thriving sheet music business is the root of the term *publishing*.

I could try to track down the sheet music for "Three White Horses," but a bit of sleuthing may save me a trip to the music store. Depending on the context, royalties are often due to the holder of publishing rights when a piece of music is performed—even if that "performance" is in the form

of a recording played over the radio, on television, at a coffee shop, in a yoga studio and so on. Good news: as a producer of a short film, you are unlikely to have to concern yourself with the payment or collection of these royalties. Nevertheless, the royalty collection system can in fact guide you through the publishing rights labyrinth. As you might imagine, the collection of royalties from those diverse streams is complicated. Therefore, virtually all publishing companies enlist the services of a **performance rights organization** (PRO) to handle this end of the business. In the United States, three PROs dominate the field: ASCAP, BMI and SESAC. A diligent online search will get you to the databases for these organizations, and you can search until the title turns up. If you come up empty-handed, you can contact the PROs via phone or online chat and see what information they can provide. Another good resource is the Harry Fox Agency (HFA), a company that serves as a go-between for licensing music. HFA maintains a massive searchable database that is available to the public.

Using a combination of these resources, I came up with a lot of useful information about "Three White Horses." The song was released in 2012. The publisher is Wegawam Music Company. Bird, a prolific composer and musician, used Wegawam (apparently a play on his middle name, Wegman) for a number of years to handle licensing and self-produced projects. While working under the Wegawam banner, he used BMI as the PRO for the collection of royalties. As BMI's database helpfully notes, that organization is still in charge of some of Bird's catalog, but more recently, Bird has turned over management of licensing to Wixen Music Publishing, which uses ASCAP to collect royalties for Bird's newer releases. Again, while the PROs can be a good source of information, the crux of the matter is that Wixen Music Publishing now handles licensing of Bird's compositions and music.

As it happens, Wixen Music has very clear guidelines on its website for requesting music licenses (as of this writing, it also offers some rather pointed do's and don'ts about the process). I can certainly approach Wixen with a request for a sync license for "Three White Horses." Once I take that step, however, my plans will live or die according to the verdict of the publishing company executives. Therefore, before taking this step, I might see if I can contact Bird directly and explain my project. Bird has an international following, but he is also very much a self-made artist, so he might be receptive to an appeal from a budding filmmaker. Obviously, I'll be much more likely to negotiate a license with Bird's publishing company if I have secured his prior consent.

The second set of rights that we may be able to group together pertain to the performing and recording of a composition. Securing permission to use a specific recording and performance in your movie can often be done through what is called a **master use license**. Should my director wish to use Bird's

own recording of "Three White Horses," I would need to secure both a sync license for the publishing rights and a master use license for the performance and recording. When applicable, a master use license can greatly cut down on paperwork. Think about it: many songs involve numerous musicians, engineers and producers who have lent their creative talent and energy to the recording. A properly crafted master use license states that the person or company with whom you are negotiating has the authority to speak for all the personnel involved in the performance and recording in granting you permission to reproduce them in your film. In this way, one agreement can potentially take the place of multiple contracts or letters of understanding. We include an example of a master use license in Appendix C.

The third and final set of music rights that pertain to motion pictures go by the gloriously opaque term *mechanicals*. Mechanical royalties come from the sale of music through mechanically produced formats such as CDs and vinyl albums. If all that sounds a bit dated, your ears are not deceiving you. In the era of streaming and downloads, case law and business practices continue to evolve in this area, but as of this writing, a distinction is still made between audio recordings and motion picture media. This is crucial because it means that, as long as we are just making a movie, we needn't concern ourselves with **mechanical rights**. These rights most commonly come into play on film projects when a soundtrack album is produced in connection with the motion picture's release. Needless to say, that is not a scenario that applies to short films.

There are many kinds of music out there and many permutations of music rights. Whether you are using existing music or contracting someone to write and/or perform original music for your movie, you should always run through a checklist of possible rights that need to be cleared:

- *Composition:* Who wrote the piece of music? Is it copyrighted, and if so, is the copyright still in force? Who controls the licensing of publishing rights?
- *Performance:* Who is performing the piece? Is it an individual, an existing ensemble or a disbanded group?
- *Recording:* Who controls the rights to the master recording of the piece? Was it released by the artist, by a small label or by a major media conglomerate?

Going through this checklist as you consider incorporating any composition into your project will help you think clearly about the steps you'll have to take. You might have to license each set of rights separately, or you may be able to group together the rights you need, securing a sync license for publishing rights and a master use license for performance and recording rights.

Using Existing Music

Though Johann Sebastian Bach lived three centuries ago, his music still speaks to us. I once decided that a movement from Bach's first solo cello suite would be just the thing to accompany a montage in a short sales film for a home furnishings company. This was before the era of web video, but I needed the right to show the movie on television, in stores and at public screenings. I thought that getting such a broad license for an existing recording would be a budget buster, so I decided to produce the track myself. Let's go through our rights checklist as it relates to my self-produced recording of Bach cello music. In this case, I'm going to run through the list backward because the last item—the recording rights—is the easiest to handle. Needless to say, I had no worries there, since I was making the recording myself. As for the performance rights, it is far from a coincidence that I settled upon a piece that would only require me to hire a single instrumentalist. I hired a professional cellist who already knew the piece and paid her for an afternoon of her time to make the recording. I seem to recall that the production company I was working with came up with a contract similar to the performer's release we used for actors, stipulating the various uses we would make of the recorded performance.

That brings us back to the first item on our checklist: the composition. You might assume that there can't possibly be any legal claims to be made with a 300-year-old piece of music. That's an understandable assumption, but the truth is more complicated. First of all, while the great-grandparent of our current copyright laws went into effect during Bach's lifetime, Bach's music wasn't copyrighted at the time of its composition. So far, so good, but in most cases, performers today aren't exactly playing the music as Bach wrote it. In Bach's time, many of the most basic elements of music interpretation, from slurs to dynamics and trills, were not written in the manuscript. Over time, music editors and performers have added that information and much more to print editions of the works. Many of those editions *were* copyrighted, and those copyrights may indeed still be in force. In the case of the Bach cello suites, many editions, old and new, share a great deal in common, and any professional cellist adds fingerings and bow markings to make a unique interpretation. Therefore, in this case, I was confident that I didn't need to clear the rights to the edition used by the cellist. In other instances, that would not be a safe assumption. The Bach cello suites have been arranged for all sorts of instruments, from violin to ukulele. Using a distinctive contemporary arrangement without clearing the rights to it is likely to land you in hot water.

Many of us have musician friends who will be very generous in letting us use their music. If you don't raise the issue, they aren't likely to make a fuss about licenses. Peace reigns in the garden—until one of those friends' careers takes off. Seemingly overnight, things change. Rights to the new star's music

catalog might be gobbled up by a company that doesn't consider your cursory agreement with your friend to be binding. Not so many years ago, Andrew Bird operated his career very much as a homegrown affair. Now his business is managed by the company that represents the likes of Neil Young, Missy Elliott and Carlos Santana. But the arrival of fame and fortune isn't the only way that deals can unravel. Sadly, friendships sometimes sour, and many a handshake deal has fallen apart when those hands are no longer shaking. For all these reasons, be sure to get signed agreements for all music outside the public domain—even tunes written and performed by your BFFs.

Production Music and Music Libraries

Most recorded music that can be listened to by strangers (online, on the radio, in stores) is protected in some way. You may be able to listen for free to track after track by your new favorite artist through some online streaming service, but if you want to use any of that music in your movie, you are almost certain to find it copyrighted or protected by a Creative Commons license (the terms of which can be more complicated than copyright law). Seeking refuge in recordings from bygone eras won't make things easier. Before the internet age, recorded music was distributed through commercial media, from wax cylinders to CDs. Virtually all of those recordings were copyrighted, and in the great majority of cases, those copyrights are still in force. Therefore, comparatively few professionally produced recordings are in the public domain.

That might sound grim, but there is a silver lining, because there exists an ever-expanding body of music that, though copyrighted, can be licensed for a broad set of uses and without the need to pay royalties. This music, which is specifically marketed to producers of radio programming and motion picture media, can be separated into two categories. On the one hand, there is **production music**. These are compositions that have been written to fulfill a common need. Looking for a short, propulsive piece with lots of percussion to accompany your sports montage, a solemn track to put behind a memorial tribute or a jaunty bit of ragtime to serve as the score for your political satire? You might find what you are looking for in a production music library. Companies hire composers and musicians to write music in a range of styles, which then gets compiled into audio libraries.

The second variation on royalty-free music works this way: a company acquires all rights to recordings of existing compositions. That Bach cello suite? These days, I might well find a recording of that piece in a music library where I can pay for a master use license, download the recording and be on my way. An enterprising music producer might hire performers to record public domain works, just as I did with the Bach suite. Keep in mind that there is a vast trove of traditional songs that are in the public domain, and producers can

record these in a variety of styles for the cost of renting a studio and hiring the performers.

Alternately, a resourceful businessperson might go to a small classical record label and make a deal for the licensing rights to any of its existing recordings that contain material that is unencumbered by publishing rights. Because the original scores of so much great classical music have passed into the public domain, classical music is fertile territory for this kind of deal-making, but other genres are represented as well. A number of music libraries license both pre-existing recordings and production music written expressly for their collections.

How much does it cost to license a track of royalty-free music? You know the answer, don't you? That's right: it depends! Producers who are regularly turning out content might make a deal with a production music library that gives unrestricted access to the collection in exchange for a hefty subscription fee—the musical equivalent of an all-you-can-eat buffet. More commonly, a producer will license a particular track from the library. When negotiating to license a track, the key variables are commercial versus non-commercial use, the scope of the license and the term of the agreement. Unless you can see a way to make money from your short, you should ask for a non-commercial agreement. This will get you a much better rate. Be careful not to underestimate your needs when it comes to how you can distribute your movie. In addition to whatever specific exhibition needs you foresee for your project, make sure that your license allows for streaming via the internet. You may want to post the entire project online one day. At the very least, you'll want the option of using a clip in a sample reel. As for term—the period covered by the agreement—try to secure an open-ended "in perpetuity" agreement. Once upon a time, media productions had a limited lifespan. These days, everything lives on forever online. Imagine trying to purge the internet of traces of your movie after the five-year term of your music agreement is up. That would not be fun. By mashing up these variables, I have come up with a range of licensing fees from $50 to $500 per track, with a mean rate of around $200.

Licensing Commercially Released Music

If the director has visions of a hit song—whether old or new—playing over the closing credits, you'll need to provide a reality check sooner rather than later. While there is an exception to every rule, securing rights to well-known pop songs is generally a very costly proposition. In recent years, advertisers and television networks have shelled out hundreds of thousands of dollars for the rights to this or that golden oldie. Those kinds of payouts inflate the perceived value of hit tunes and make it very hard for the small-scale movie producer to secure rights for little or no money. Therefore, if your director is fixated on

using a specific song in his movie, have him help you as you start the process of securing the sync and master use license. A day or two on that trail should make him ready to consider alternatives.

Pro Tip

"Whenever a director comes to me and says, 'I want to use a lot of pre-existing music, pop songs, classic rock songs, whatever,' I always laugh and say, 'Yeah, yeah, sure, we'll do that.' And it never happens. It *never* happens. Very rarely with the indie model or the student model can you get away with using existing music. It's just too damned expensive."

—*Evan Astrowsky*

In truth, there is a vast ocean of great music out there, much of which can be licensed for little or nothing. All that's needed is perseverance and zeal—make that lots of perseverance and zeal. The key is to keep an open mind and cast a wide net. Listen to a lot of different music and make as many contacts as you can. If you live near a thriving music scene, make that proximity work to your advantage. The ease with which we can browse music sharing sites like Soundcloud can make us lazy. Don't lose sight of the value of face-to-face contact. Hear a song by a local band that turns you on? Go to their show. If you still like what you hear, don't be afraid to approach the performers on the spot and establish contact. Needless to say, many up-and-coming music acts have lots of beautifully produced tunes that they are flogging directly to the public. Securing all the rights you need for a track is much easier when it's a matter of one-stop shopping.

When you talk to musicians or music producers about using their work in your movie, your job is to convince them that your short film will be a compelling showcase for their talent. Films that are set in a particular subculture or ethnic setting can work particularly well in this regard, in that they can be good matches for music labels that specialize in particular styles or genres. Remember that family comedy set in a barrio? Find a label that represents lots of Spanish-language bands in southern California or northern Mexico. The company might be willing to license several tracks to you in hopes of extending awareness about their brand to other audiences. If you can really sell the "value proposition"—the idea that putting someone's music into your movie is equally beneficial for them and you—then you may well be able to secure all the rights at no cost.

If your director remains fixated on licensing a hit song or a track by an established act, there are two compromises that might work. First, you may

find that just securing the sync rights to the composition will cost far less than acquiring rights to the publishing, performance and master recording. The big hurdle here is that you have to re-record the song with a performer or group that can do a credible job. A second workaround is to seek a more limited set of rights. Before the dawn of YouTube, many short films were mostly seen at film festivals, and it was sometimes possible to get a major label to license huge hits for comparatively little, with the understanding that the film would *only* play at film festivals. As you might imagine, not being able to post your movie online eventually would be a major handicap today, so such a limiting deal should only be made as a last resort.

A final point to consider when negotiating music deals: it is generally fine to seek only non-exclusive rights. This means that the rights holders remain free to license their work to other parties—including that shoe company that's willing to pay a fortune to use a tune in their commercial. Emphasizing that the licensors retain both ownership of the material and the right to license it to others may make them more willing to cut you a break.

Working With a Composer

Bringing a composer on board to write a score for your movie is very much like casting a major role. Given the impact the film score can have on the final product, it's essential to find the right person for the job. This means not simply finding someone with technical prowess or even great talent; you need to find someone whose sensibility is right for the project. This is by far the most important criterion for selecting a composer.

Commissioning a professionally produced score for your movie can be a costly undertaking. In addition to the expense of hiring a composer, you might have to pay for studio time as well as arrangers and performers. For our purposes, we are going to assume that such an à la carte approach is beyond our budget. Even on commercial features, in many cases a producer will place a cap on film scoring costs by hiring a composer to deliver all the music as a package deal. The composer is given a lump sum and then must pay for any costs associated with producing the music. If you go this route, it's important to come to an understanding as to what the producer will deliver. Let's say you hire a composer whose orchestral writing has impressed you. When it comes time to hear what he's produced for your movie, you're shocked to discover that the score consists of the composer noodling on the piano. "Where's the orchestra?" you ask. "An orchestra? With a budget of $200?" is the reply. The moral of the story: don't just share ideas; be sure to define expectations.

How do you find a composer? First, let's be clear about what we are looking for. Film scoring is a highly technical form of music composition. Some composers love the challenge of fitting their music perfectly into the confines of a

pre-existing narrative; others find such restrictions stifling. Consider the two Bernsteins, Elmer and Leonard. These men—who were not related, despite their common surname—were two of the most accomplished American composers of the last century. Elmer wrote the scores for hundreds of productions, while Leonard only wrote one feature film score (he made his one shot count, writing the music for the classic film *On the Waterfront*). You may be able to find a highly trained and accomplished composer who wants to try her hand at writing for film. This could be a great opportunity for all concerned, but you need to make sure that both of you understand the process. Some music conservatories offer courses in film scoring, and a few even have degree programs in the field. Students who have formal training in scoring will of course be more prepared to jump right in. If your budget is tight, you'll want to find a composer who understands film scoring but who is still building a sample reel. Ideally, this composer will work for free, with the understanding that any money you can put into the film scoring budget will go toward paying for studio time or hiring musicians. This is how you get the most bang for your buck.

Once the composer has come on board, you'll want her to get acquainted with the material so she can start developing musical ideas. That said, the composer usually only begins to write music in earnest once a production has reached what is called **picture lock**, the stage of editing where no more changes will be made to the sequence of shots. Once this timeline has been fixed, the composer can write **music cues** that perfectly match the action on-screen. To do this, she typically works from a special copy of the edited film with a time reference that measures the running time of the movie down to a single frame. Using this **window dub** version of the film, the composer will sit down with the director for what is called a **spotting session**. An initial discussion might be just a chance to brainstorm about musical passages and themes, but in a spotting session, the director and composer zero in on what kind of music is needed and precisely where the music cues will fit in. The spotting session represents a key opportunity not just to set forth musical ideas but once again to define the nature and scope of the music that will be produced. The composer will take notes and then—armed with the window dub video as a reference—she will go off to write and arrange the music.

But wait! Before the composer locks herself in a garret to have at the score, be sure to get her to sign a contract. Composers on commercially produced motion pictures generally serve in a work-for-hire capacity, and the sample composer agreement in Appendix C follows this practice. Before you or your composer of choice signs this or any other contract, consider the alternative. As has been established, when someone works for hire, it means that they do not own the product of their labor from the outset. In Hollywood, composers get paid well to relinquish ownership of their music. If you aren't paying your composer or are just covering her costs, your composer might insist that any

agreement be non-exclusive. Look at the issue from the composer's perspective: she only has so many themes inside her. You can't expect her to lock up her best ideas forever in your short production. Indeed, by agreeing to a non-exclusive contract or license, you give the composer an incentive to give you the very best she can offer. Crafting a work-for-hire agreement that also allows the composer to reuse the music or musical concepts in the score is at best a complicated process. In these circumstances, it probably makes more sense to draft sync and master use licenses to cover the various music cues in the movie—agreements much like the ones you might use to secure rights to pre-existing music.

Since the score can't be fully composed until the editor reaches picture lock and editing on the movie can't be completed until the score is added to it, motion picture composers always work under a great deal of time pressure. For this reason, one of the key skills a film composer brings to the job is the ability to compose and arrange music quickly. A less seasoned composer may not be prepared to handle the demands of this process. In these cases, it is advisable to establish a timetable for reviewing the music as it is being produced. Our composer agreement takes a minimalist approach, simply setting a deadline for delivery of the recorded score. You may wish instead to lay out a schedule that covers the writing and recording of the score. This document can be attached to your agreement.

Temp Track Love

While it makes sense for composers to wait until picture lock to start writing music, editors often need to use music as they cut a scene. Perhaps they need to establish a rhythm for a montage, or maybe they just need to set a mood or to draw the audience's attention at a specific moment. Editors resolve this Catch-22 by temporarily dropping pre-existing music into their sound design. Because it's so easy to access and edit music these days, many editors now go considerably further, using their personal greatest hits collection to map out an entire music soundtrack for the movie.

Composers have long railed against these so-called **temp tracks**. It's their job to write the music that will replace that Norah Jones ballad that plays behind the big love scene. As if it weren't already hard enough to write exactly *x* bars of music, rising and falling at precise moments along the way, now the composer also has to match the sound and style of another artist. While this complaint makes sense, in recent years, I have had a couple of composers confide that they rely quite heavily on temp tracks as guides to what the director and editor are looking (or listening) for. One point on which everyone agrees, however, is that there is a danger associated with using temp tracks, and that menace has a name: "temp track love." As you have probably guessed, this

term refers to the condition where the editor and/or director get so used to hearing a particular recording playing at a certain moment in the movie that nothing else will ever quite sound right. As the producer, you need to be alert for this tendency, because it is the main reason underfunded productions waste precious time and money trying to clear expensive tunes by popular artists. To avoid tumbling down this rabbit hole, you might encourage the editor to use tracks from a production music library. They will be less likely to fall in love with the music, and the stuff the composer comes up with may well sound brilliant by comparison.

Chapter 14

Postproduction

The Producer's Role in Postproduction

When a film shoot is done, even on a short production, there is often a sense of relief tinged with sadness. Though the production may have only shot for a handful of days, the work has been so intense and the days so long that cast and crew feel like they have been forged into a battle-tested unit. Now everyone is exchanging hugs at the wrap party and preparing to disperse. It is at this moment, when it feels like the circus is leaving town, that some novice producers make the fatal mistake of thinking that their job is done. Nothing could be further from the truth. Though the postproduction and distribution phases of a project may involve fewer people and move at different rhythms than the production phase, the producer retains a crucial role as manager and advocate.

At its most basic level, much of the producer's job is to oversee the allocation of time and money. During postproduction, there is plenty to worry about with respect to both of these scarce resources. In terms of time concerns, a common challenge that producers face is that of maintaining momentum. Unless there is a firm deadline in place (a festival screening, a broadcast date), the editing stage can feel open-ended. The process of putting shots into a sequence and then layering sounds offers the director and editor an endless series of permutations. It can be very hard for the people deeply immersed in this process to say definitively, "We're done." As for money, take another look at the top sheet of the *Shoebox Redhead* budget in Chapter 7. Setting aside taxes and contingency, the total budget is $18,874. Of that amount, $8,439 is allocated to postproduction. That's 45 percent of the budget. This is not an uncommon expense ratio. Some of the costliest steps in the filmmaking process occur in postproduction.

Viewed in this light, it's easy to see how—without a producer to keep things in perspective, to drive the process forward and to oversee the accounts—a production can quite easily drift into oblivion or run out of money. Before we try to get our arms around the various stages of the postproduction process, let's take a little side step to address a task that hovers in a kind of limbo between the shooting and editing phases.

Pick-Ups

Pick-ups are shots or entire scenes that are filmed either at the end of principal photography or after a production has wrapped. This material might have been shot once already and then found to be defective or unsatisfactory, or it might be wholly new content that is deemed necessary to make a sequence work or to clarify a story point. Almost all directors need to shoot pick-ups. Even Alfred Hitchcock, a master of visual storytelling who was known for his meticulous planning, occasionally had to return to the studio to film additional footage. Some directors consider reshooting scenes to be fundamental to their creative process. Both Charlie Chaplin and Woody Allen were known for this approach. As a producer, it's vital that you know which kind of director you are working with. Shooting an **insert** close-up of a lightbulb turning on is the kind of shot that can be done almost anywhere, anytime (the director Gus Van Sant once actually filmed just such a pick-up in his editing room); re-creating a wider shot—especially one involving actors—is a much more complex undertaking.

Pro Tip

"I see short films improve by as much as 50 percent with just one day of additional photography. Changing the ending or adding close-ups, for example. It's just amazing to see the impact this new footage can have on the project."

—*Marie Cantin*

Short productions often face a particular challenge when it comes to pick-ups. On features, some directors ask to have a few days tacked onto the production schedule to allow for reshoots. Keep in mind that it is the norm on features to have the editing team working throughout the shoot. The editor usually can't assemble an actual cut of the movie as it is being shot, but if a director has concerns about a particular shot or scene during production, she can ask that the editor work with that footage to determine if there is in fact a problem. It is very rare for any real editing to take place on a short during the production phase, so problems tend to surface later. Shorts also tend to be shot on location, which makes returning to a set all the more difficult. For example, the *Shoebox Redhead* shoot was in New Jersey, but cast and crew were based in Massachusetts. Once production wrapped, any substantial reshoots posed a significant logistical problem.

I did not schedule or budget for pick-ups on *Shoebox Redhead*. I reasoned that the script was very clear and complete and that the story didn't call for the kinds of high-risk moments of drama or action that might fall flat in the

editing room. Furthermore, since the creative team was so tight-knit, I figured that, in a worst-case scenario, they could cheat and use Massachusetts locations to shoot any additional shots or scenes. In truth, my logic might not have been entirely sound, since it overlooked the fact that Matt and his cast liked to rework material on set, a practice that increases the chances for creating gaps in the narrative and visual flow.

As I hope will be clear by now, it is exceedingly hard to generalize about how to plan and produce pick-ups. With that caveat in place, I will offer a couple of observations. First, it is often the case that pick-ups can be limited to close-ups. Suppose a man and a woman are sharing an emotional moment. We have a shot favoring the man. The problem is that his performance is uneven: best at the start of one take and then at the end of another take. The director and editor realize that, if they had a close-up **reaction shot** of the woman that they cut into the sequence, they could stitch together the two separate takes favoring the man. If the reaction shot is framed tightly, it need not be shot at the original location. This is not an uncommon development, and the point it illustrates is that, once again, a bit of ingenuity and economy can lead to a satisfactory solution that won't break the bank.

A second proposition that I find usually applies to pick-ups is this: *wait.* Give yourself some time before doing any reshoots. Editing a movie can be an emotional roller coaster. The initial thrill of seeing the project finally unfold on-screen is often tempered by the sinking feeling that certain elements of the director's vision got lost along the way. There is a certain reckoning that takes place in the editing room, where the film you planned must give way to the film you actually made. Make sure that both you and the director have made this adjustment in your outlook before you venture out to shoot pick-ups. You may find that the moments you initially felt were missing aren't needed. Furthermore, movies almost always get tightened up in the editing room. Through successive cuts, the pace becomes more taut and the exposition more brisk. Naturally, in this process, shots and scenes are taken out rather than added to the project. Once again, by waiting, you may find that your "missing moments" were in fact destined for the cutting room floor. I regret to admit that, more than once, I have assembled crew and actors to shoot pick-ups that never made it into the final cut of a movie—a terrible waste. With pick-ups, as with everything else, the fundamental rule applies: are they essential to the story?

Postproduction Workflow

The typical process for editing a short film can be summarized as follows:

- *Edit picture*: When we say that we are "cutting the picture" on a movie, it doesn't mean that we are *only* editing images together. Some basic sound

editing takes place at this stage as well. We make a priority of locking down the sequence of shots because most of the time, the visuals in a motion picture boil down to a single strand or track, whereas we will usually end up with many layers of audio.

- *Shoot pick-ups*: As discussed, it's challenging to gauge the scope and timing for shooting pick-ups, but on the theory that it is often best to wait, we'll put this step after the initial editing phase.

- *Design sound*: Once we have picture lock, we can begin to edit our tracks of audio in earnest. When you add up all the dialog, sound effect, ambience and music tracks, it is quite common to end up with one or two dozen tracks even on a short film.

- *Correct color*: When the editing process is complete, it's time for color correction. Of all the terms associated with postproduction, *color correction* is probably the least accurate. It hearkens back to a time when film labs could make a very limited set of adjustments to the image during the final printing process. In the digital era, color correction has come to encompass a vast range of possibilities. A shot can be cropped or flipped. The exposure in one part of a shot can be altered, or some flaw in the image can be erased. Through **compositing**, multiple images can be combined to create a single shot. Titles, transitions and visual styles (e.g., the look of a grainy home movie or sepia tinting) can also be added at this stage.

- *Mix audio*: The audio mix is the process of combining all the layers of edited audio into a set of balanced tracks.

- *Output final film*: Editing, color correcting and mixing all use various software programs. At the end of the postproduction chain, the movie must be output into the appropriate media format for exhibition.

The great majority of productions follow these steps, though the order may vary somewhat (for example, in the case of a musical or music video, some or all of the soundtrack might be mixed at the very outset, even before any footage is shot). Depending on the technology being used, there are also many additional steps that might be necessary. Working in ultra high-definition, 3-D or shooting film—these are all choices that would complicate the production workflow. For our purposes, we are going to work from the assumption that we need a final product that will be in a standard high-definition video format and is ready to be submitted to and exhibited at film festivals.

As with so many aspects of postproduction, it's hard to generalize about how long the editing process should take. An inexperienced editor will need to use a lot more trial and error to find his way to a cut that works than would a

professional. A rule of thumb that applies equally well to novices and veterans is that cutting sound takes roughly twice as long as cutting picture. That's not so surprising when you consider that there are many soundtracks and really only one strand of picture. Another factor that will play into the editing time-frame is the extent to which professionals are contracted to help with various parts of the process. In an age when a commercially released feature can be shot with smartphones, it might be hard to countenance spending thousands of dollars for something that can be done on a laptop with off-the-shelf software. Two big-ticket items boosted my budget for *Shoebox Redhead* well above the norm for a student film: I have opted to pay for a professional color correction session and an audio mix at a sound studio. Understanding why I made this choice requires that we look more closely at these two costly processes.

Fixing It in Post: Color Correction and Other Adjustments

At its most basic level, color correction involves the painstaking task of ensuring that exposure, contrast and color balance are consistent within a scene and that all those levels meet the technical specifications of the intended distribution channels. These days, many skilled editors will make these adjustments using standard editing software. This trend has certainly taken a bite out of the business of **post houses** around the world. At the same time, postproduction specialists have found new ways to add value to media projects by installing machines and software that can make image adjustments far beyond the traditional province of color correction. In today's high-end color correction suites, day can become night, buildings can disappear and time can run backward.

Because the possibilities for image manipulation have become almost infinite, a philosophical divide has opened up in postproduction. On one side are the postproduction specialists—not just editors but **colorists** and visual effects artists. These folks understand and have access to all the levers that can be pressed and pulleys that can be pulled to transform an image. Their position is that it is best to shoot everything "flat," by which they mean you should get a healthy exposure but not inflect the image with a defined degree of contrast or a pronounced color cast. According to this approach, you should just capture as much detail in the image as possible and then make all decisions about what you leave in or take out in the color correction suite. The argument for this method is that, by making all the stylistic and technical adjustments at the end of the line, you have more control over the image than you have on a film set. The editing process may also bring aesthetic or practical considerations to light that weren't apparent during production and that can now be addressed. On

the other side of the argument are those who believe that "shooting flat" just delays and complicates the task of imposing a visual style on a project. They share Benjamin Franklin's concern: "Tomorrow every fault is to be amended; but that tomorrow never comes."

As with any good debate, each side of this rift has its merits. Nevertheless, most short film producers will want to be on Poor Richard's team, taking the position that it is best to shoot the material so that it requires little adjustment in postproduction. It is certainly true that, as long as you are working with clear, well-exposed original material, the possibilities to transform an image in post are limitless. However, the equipment and expertise to effectuate that transformation is extremely costly. Time in a state-of-the-art color correction suite can run anywhere from a couple hundred to a couple thousand dollars *per hour*. And the process isn't fast: any kind of detailed image adjustment is a painstaking process, often requiring tweaks to every frame of picture. As any Super Bowl ad will demonstrate, the effects that all these bells and whistles can bring to the screen are astounding, but if you want to preserve your budget, you should aim to dazzle your viewers with what can be achieved on set and in the camera rather than at the post house.

Given my position, it may come as a surprise to learn that I still firmly believe that most short films should allocate some real money for professional color correction. Ironically, my reasons hearken back to those basic functions that were the mainstay of color correction before the start of today's digital arms race. It's true that standard editing software comes with powerful color correction tools built in, and many professional visual effects programs from companies like DaVinci and Autodesk are now widely available. Be that as it may, as an editor friend of mine likes to say, "It ain't the horse, it's the jockey." There are plenty of thoroughbred horses around, but I won't be winning any races riding them. Many editors are very adept at color correction, but very few of them can achieve the level of polish that can be attained in a bona fide color correction suite. To be clear: I'm speaking here not of any visual effects wizardry, but rather of the subtle but critical adjustments that can be made so that images flow together fluidly and look their best. Some of this has to do with the fact that professional colorists devote all day, every day to the minute examination of images. But there may be a technical component to the "secret sauce" that a professional color correction session will bring to your production. The equipment in color correction suites is routinely calibrated to meet precise specifications. The rooms are usually equipped with very pricey monitors that give a totally honest representation of your movie. The same cannot be said of 99 percent of all editing setups, especially in an age where many of us are editing on laptop computers. It is therefore my position that, if at all possible, you should budget for a basic color correction session. If your production was well photographed, you may not emerge from the suite with a dramatically

different-looking movie, but the subtle distinctions may provide just the level of polish needed to elevate your work to the professional level.

If your color correction needs are straightforward, you can correct ten to twelve shots per hour. I am counting on your excellent bargaining skills to lock in an indie producer rate of $250/hour. When it comes to negotiating for services in postproduction—and this is true of both color correction and audio mixing—the adage "good things come to those who wait" is very apt. If you can afford to be flexible about when you do the work, even coming in after hours if necessary, you will secure a much lower rate.

In budgeting color correction for *Shoebox Redhead*, I was comforted somewhat by the fact that the film mostly read as a series of "master scenes": dialog-heavy scenes that could be covered relatively simply. This means that the film would not be particularly montage-driven or visually choppy. I estimated that Matt and his team would need about 50 shots to tell the story. If we can achieve a pace of twelve shots per hour, we'll need just a little over four hours for color correction. If you look at the *Shoebox Redhead* budget, you'll see that I have allocated 4 × $250, or $1,000, for color correction. Just one small problem: I failed to budget for any setup or wrap-up in the suite. Once we have completed the color correction process, we'll need to get our material off the proprietary technology that was used in the suite and back into a format that we can use. Setting up and outputting takes time—time for which we will be charged.

Gulp.

I might be able to get the post house to waive the setup and outputting time, but given that I've already driven a hard bargain to get the $250/hour rate, that's probably wishful thinking. In fact, with all the tight assumptions and economies I'm banking on, I am feeling very grateful for the 10 percent contingency I built into my budget. Color correction could very well be an area where my budget projections are too rosy. If so, the contingency buffer will be my life raft.

Mixing and Outputting

Much of what was said about color correction applies to audio mixing. As with color correction, standard editing software comes loaded with abundant tools for adjusting audio. In addition to balancing levels, you can add equalization and reverb as well as numerous filters. Just as with color correction, audio professionals will often counsel you to wait until you are in the studio to make audio adjustments. Once again, the counterargument to this position is that while everything is theoretically possible in an audio mix, everything takes time, and time is money. I have had a sound engineer fuss around for half an hour to find a filter that would make a person's voice sound as though it were coming over a telephone line. Had I simply recorded the actor talking

over the phone, I could have saved myself a bundle. Much the same could be said for **ADR**, or automatic dialog replacement. Suppose you are shooting a dialog scene at the beach. Chances are that you are going to be combating fierce wind noise. Moreover, once you edit the footage, you may also find that the rhythm of the waves crashing in the background is uneven. You can effectively give yourself a clean slate with the audio for this scene by bringing the actors into an ADR studio where they match their voices to the picture playback (think of it as the opposite of lip-synching). ADR is a useful tool, but it is expensive and very difficult to do well, so just because you can do it doesn't mean that you should. A final comparison between postproduction audio adjustments and color correction: just as with color correction, the true value of doing an audio mix lies not in the esoteric and amazing effects that can be achieved in a sound studio but in the subtle refinements that will yield a polished, professional final product.

The Shoebox Diaries

"It sort of surprises me that a lot of students think they can just ADR lines of dialog. This happens on Hollywood movies, when actors are brought back into state-of-the-art sound studios to do automatic dialog replacement. They watch themselves on a screen and try to repeat what they said on location. But we're talking about actors who are paid $20 million, highly seasoned professionals. And they must hate doing that stuff, because you're taking them out of the moment, putting them in a studio and asking them to re-create emotional performances that they originally created months ago."

—*Charlie Anderson, Sound Recordist*

Budgeting for audio mixing is an especially tricky guessing game. A short film might have a dozen dense tracks of audio—not a vast number by any means—and if we tally up the individual sound clips on all those tracks, we could easily reach a total that ran into the hundreds. Imagine how many possibilities there are for treating each individual clip and then mixing them together. Just as post houses have found ways to add value to the color correction process in the form of a mind-boggling array of visual effects, audio studios that specialize in motion picture mixes work magic by manufacturing sound effects or replacing dialog on the spot.

Because there are so many variables in play, producers tend to fall back on budgeting formulas that have little bearing on the specifics of the project being

mixed. If a producer says, "We're going to mix ten minutes of the film each day," this doesn't mean "It will take us a day to mix ten minutes," but rather "We must find a way to mix ten minutes each day." In the case of *Shoebox Red-head*, we have allocated one eight-hour day to mixing the film. Keep in mind that the film will run somewhere between twelve and fourteen minutes. That makes for a full day in the studio, especially when you consider that, as with color correction, there is time involved in loading all the tracks into the mixing system and then outputting the final product.

Before a frame of picture gets cut, have your editor talk to the mix facility. All sound engineers have preferences in terms of how material will be prepared for a mix. They will have recommendations on everything from what sort of extra footage or "handles" to leave on clips to ways of adjusting levels in an editing timeline. This chat between editor and sound engineer is always a good idea, but it's essential if you're going to get in and out of the studio in eight short hours, as I plan to do with *Shoebox Redhead*.

Here's a story that reveals how thinking and planning ahead can save time and money in the mixing process. I knew a student filmmaker who was producing an ambitious dystopian sci-fi thriller on a shoestring budget. He knew that sound could potentially play a critical role in selling the film's vision of a dark future, but he was also rightly concerned about tumbling into an expensive time warp in the mix. He came up with a clever strategy: when the film was at picture lock, he took the cut to the audio mixing facility. He paid the engineer a few hundred dollars, and in exchange the engineer flagged areas that needed work and came up with dozens of eerie effects that helped round out the sound design. Because the engineer was familiar with the project and had already fattened up and "sweetened" the tracks, when it came time to do the actual mix, they could work very quickly. In this case, spending dollars up front almost certainly saved money in the long run—and resulted in a much richer-sounding final product.

Stereo sound became the norm in recorded media half a century ago. In the intervening years, audio formats have multiplied many times over. I refer here not to kinds of audio media or audio file formats—though those have also proliferated—but to the configuration of audio channels for playback in a variety of settings. Consider a feature film. You might hear it played over a bank of speakers in a theater, or over your surround sound system in your living room, or even over earbuds on an airplane. When producers can afford to do so, they will make two or three mixes that are optimized for different playback configurations. On my tight budget for *Shoebox Redhead*, I have not allocated for multiple mixes; one mix will cost enough. Therefore, in that first conversation with the audio engineer, I must make sure the editor explains that we will need a mix that can play well both on a festival curator's laptop and at a festival screening in a movie theater.

The Shoebox Diaries

"I've tried it on my own. For me, just with my skill level, I know that I can't provide an adequate sound mix—something that would please me, that I would walk away from and be like, 'Wow, that's amazing.' I think sound—especially sound design and sound mixing—is something that is often overlooked. Going to film festivals, watching student films, watching other short films, the one thing that separates a lot of great films will be great sound design or a great sound mix."

—*Matt Lawrence, Producer, Director, Writer & Editor*

Budgeting for Postproduction

Now that we have the twin postproduction behemoths of color correction and audio mixing out of the way, let's make an annotated shopping list of additional services and supplies that we'll need:

- *Media storage*
- *Editing software*
- *Exhibition media*
- *Archival storage*
- *Miscellaneous postproduction expenses*

With respect to the last item—those pesky miscellaneous expenses—if you look at the postproduction budget for *Shoebox Redhead*, you'll find little items like the flash drive needed to share media with your composer. Nothing too exciting. As for the rest of the list, a closer examination is in order.

Media storage: Our project was shot on a camera that recorded to SDHC cards, small and inexpensive media. Some filmmakers are in the habit of copying media off their camera cards and then reformatting the cards for reuse during the shoot. This is a classic penny-wise, pound-foolish maneuver. All the hundreds of hours and thousands of dollars that went into bringing our story to the screen are contained on those tiny cards. It is far too easy to overlook a file and lose it forever by reformatting the card. Given how cheap they are, you should buy enough cards so you don't have to erase any of them until you are done with postproduction. It is imperative that the recordings (both sound and picture) be backed up onto hard drives during the shoot. A baseline standard is to have two backup copies of all recordings. This means that, in addition to the cards that were used in the camera and the sound recorder (the original media), we need to copy everything to two hard drives. Those drives can be used in the

editing process. One drive becomes the editing drive and the other the editing backup. These drives need to have enough storage capacity to hold both the original media files and all the edited files. If you look in the *Shoebox Redhead* budget, you'll see that I planned to buy two hard drives for $156 per unit.

Two more points about backing up your data. First, though I have not mentioned it, cloud storage—storing your data on third-party remote servers—can certainly serve as one of your backup options. We could debate the pros and cons of hard drives and cloud storage in terms of cost, security and efficiency for hours. You'll need to do your own research and decide what option works best for you. Whether you are shopping for terrestrial or cloud-based storage, be sure to make reliability a paramount concern. Finally, don't put all your eggs in one basket. The point of backing up your data is to protect it from multiple threats—everything from mechanical failure to fire. The more you spread out and diversify your back-ups, the safer you'll be. By "spread out," I mean that you shouldn't store your backup copies in the same place. If you put your two backup drives into a file cabinet in your office, it will only take one sprinkler system malfunction to destroy both copies of your data. In this regard, there is an inherent advantage to using cloud storage as one of your back-ups, since by definition the cloud data is stored in a remote location.

Editing software: Adobe Premiere and Avid Media Composer are the dominant editing software programs in the realm of professional motion picture editing, but there are a number of other editing programs on the market. The software marketplace is constantly in flux—so much so that the pricing model has changed even since I drew up the budget for *Shoebox Redhead*. I projected that I would buy a license for a software package at a discounted student rate of $295. Today, both Avid and Premiere have moved to a subscription model where you pay a monthly fee to have access to their programs. In truth, the shift to this new model won't affect our bottom line significantly, since covering the subscription fee for several months will come pretty close to the cost of buying a license in the past.

Exhibition media: Twenty years ago, if we said we were making a short film, we were doing just that. At the end of the process, we had a reel of film that we could carry under our arm. These days, when we say we're making a short film, it's hard to generalize about what in fact the final product will be. Even if we stick to our very narrowly defined notion of making a movie for exhibition at film festivals, the film could be delivered on a hard drive, on a Blu-Ray disc, or simply as a file uploaded to the cloud. For the moment, at least, the prudent course is to be prepared to deliver the movie in at least these three ways.

Of these options, the first—delivery via hard drive—is the one that will have the most impact on our budget. Now that virtually all U.S. movie theaters have converted to digital projection, most films are now distributed commercially using **DCP** (digital cinema package) technology. People will talk about

"sending a DCP," but in reality, a DCP isn't a tangible object; it's a set of computer files. A movie is encoded into a DCP both to ensure that it will be projected properly and to avoid piracy. The DCP is copied to a hard drive that can then be shipped to theaters and connected to projectors. We are still in the early stages of the DCP era. I suspect that, before long, filmmakers will be able to use off-the-shelf software to make their own DCPs. Even today, if you search online you will find step-by-step guides to making DCPs. The process is not simple. Therefore, most people opt to have a specialist make the DCP of their movie. If DCPs continue to be the coin of the realm for exhibition, we can expect the market for them to expand and prices to come down, but for now, getting a DCP made is quite expensive. I would estimate it to cost between $750 and $1,000 to make a DCP of a short film like *Shoebox Redhead*. The DCP then has to be distributed via those hard drives, but on that note, there is some good news. While the data required to make DCPs of feature films calls for them to be distributed on full-scale hard drives, the DCP for a short film may well fit onto a much cheaper flash drive.

At the time I drew up the budget for *Shoebox Redhead*, many film festivals were still asking for shorts on HDCAM, a high-definition videotape format that was widely used for about a decade. Today, HDCAM, along with all other videotape formats, has gone the way of the dodo. It would have been easy to update my budget to reflect this development, but I decided to leave this anachronism in place to make a point about managing a budget. With technology evolving at warp speed, assumptions you make today about gear and workflow could be out-of-date tomorrow. What to do? You adjust. Though circumstances change, the numbers don't. If you look into the postproduction budget for *Shoebox Redhead*, you'll find the line items "Tape Stock for Master & Submaster," "Duplication of Exhibition Copies" and "Tape Stock for Exhibition Copies." These are the subcategories associated with making the master, backup and exhibition copies of the movie. Add them up and you get a total of more than $400. That amount probably won't cover the cost of making a DCP instead of outputting to tape, but it's a start. Economies will have to be made elsewhere to cover the shortfall. Such constant reshuffling of the cards in our hand is fundamental to the game of producing.

Archival storage: When editing is complete and your movie is ready to be distributed, there is another cycle of winding down and cranking up. Once again, a circus leaves town. As the producer, the demands of shepherding your project into the world push all other concerns out of the way. Before you know it, a couple of years have gone by, and you may very well have lost track of much of the media that went into making your movie. The unedited camera footage, the flash drive that the composer gave you with all the music cues, the editing drive—where are they now? Unless you take a moment in the heat of

battle to establish a protocol for warehousing your media, you are likely to lose track of things faster than you think.

Unfortunately, even the world's greatest media management aces have yet to resolve one of the great conundrums of the digital age: the long-term storage of media. On the one hand, storage is abundant and cheap; on the other hand, we don't know if any of the common digital storage methods will hold up over time. It's a safe bet that anything that depends on mechanical parts (such as a hard drive) will not respond well to being left to gather dust on a shelf for decades. Media that can be printed or "burned," such as Blu-Ray discs, don't provide an escape route, since they are thought to disintegrate over time, and even if these media hold up, they depend on our having Blu-Ray players at hand in the distant future.

I don't have the magic solution here, and indeed in my budget for *Shoebox Redhead*, I made no special provisions for archiving media associated with the production. Ironically, however, the outdated workflow I used, outputting to HDCAM tape, might come in handy if we were to budget for archival storage, since there are engineers out there who believe that magnetic media such as videotape will last longer than newer forms of digital storage. Given how hard it is to scare up an HDCAM deck today, however, I find it hard to be sanguine about the prospects of being able to play those tapes two or three decades from now. Unfortunately, turning our backs on this problem won't make it go away. When your own short film starts to head into postproduction, spare a thought for the future. In the longer term, where will your cherished production end up?

Chapter 15

Promotion and Distribution

The Ladder to Success

Congratulations: you have made a short film! Set up a private screening where you can get the cast and crew together for a reunion and show them the product of their hard work. Send a copy of the movie to your parents. Take a long weekend to celebrate your accomplishment and recharge your batteries prior to launching your distribution campaign. Do all these things and more, but whatever you do, *do not make your film available to the public via YouTube, Facebook, Vimeo or any other video streaming service*. As we will see, there are many ways to strategize when it comes to distributing a short film, but most of the avenues you'll want to pursue will be blocked off as soon as your project becomes widely available online.

As we established at the outset, short films are seldom moneymakers. There have always been a few brave souls who tried to make a living through short-form distribution, and some of these ventures continue to sputter along in the internet age. Not surprisingly, however, they face an uphill climb in the face of purveyors of free content like YouTube. If you search, you may find quirky side markets for shorts that operate in the fringes. One example: in recent years, a couple of airlines have joined forces with short film competitions or shorts distributors to acquire shorts packages for in-flight entertainment. Opportunities like this tend to be short-lived, but you should keep an eye out for them.

Most short films aren't principally business ventures; they are, to paraphrase Norman Mailer, "advertisements for yourself," and as with any ad campaign, you want the distribution of your movie to have the broadest reach and greatest impact possible. This being the case, it may seem strange to start out with an admonition not to share your work too freely. The realm of media distribution is fairly littered with paradoxes. Some of this stems from the nature of both art and entertainment. Audiences are looking for the new and the unexpected. Therefore, every route to success turns into a pathway to failure as soon as it

has been laid out. The short film that rides a hypothetical surge of interest in barbershop quartets will be the talk of the town, but the *next* short film about barbershop quartets is... just another movie about barbershop quartets. No matter how good your short film is, getting it out into the world will require not just deliberation and hard work but also real ingenuity. In the pages that follow, I will present lot of pointers based on my witnessing the fate of several thousand short films. Keep in mind, however, that the winning distribution strategy that leads to the *next* breakout success story is one that cannot be foretold. The good news is that there are many ladders that lead to success; the bad news is that you must build your own ladder.

Distribution Strategies for the Short Film

When you think about the potential impact your film might have, how would you define success? For some, the obvious answer might be that you just want your movie to flicker in front of as many eyeballs as possible. Even if that's the case, let's consider the question more deeply. In terms of distribution, there are three kinds of short films:

- *Mass audience films*: Here, the aim is indeed to reach the broadest possible viewership.
- *Niche films*: In this case, the goal is to reach a specific audience, such as survivors of abuse or evangelical Christians.
- *Stepping-stone films*: Here, the object is to use the film as proof that your creative team could make a larger-scale project in the same vein.

These categories aren't mutually exclusive. For example, a stepping-stone film could certainly benefit from finding a mass audience. Having a short film go viral and be viewed by millions might be an excellent way to convince a studio or private investors of the viability of a longer or more complex project. That said, it's important to keep your central purpose in focus. Aiming for one target and hitting another doesn't make you a sharpshooter. Suppose I make a short film with the aim of attracting young a cappella enthusiasts to the exciting world of barbershop quartets. I get in touch with a national organization supporting barbershop music. To my delight, they love my movie. They even set up a couple of screenings at the organization's national convention. When I show up at the conference, I'm treated like a star. I bask in a few moments of glory before reality sets in. Looking around the theater, I realize that none of these conventioneers needs to be converted to barbershop music. Their very attendance indicates that they are already devotees. Moreover, I note that relatively few of them are young. In sum, while it's nice to be loved, this is not my target audience. As this example illustrates, not all eyeballs are of equal value;

my short film may have attracted fans, but my distribution strategy failed to appeal to the audience that mattered most.

We tend to talk about movies "finding their audience" without realizing how apt that term is. Audiences don't find films; films find audiences. The process is very much like fishing. We could just throw a hook in the water and hope that a hungry fish wanders by, but if we have a fish finder and a boat and can go to where the fish are feeding, clearly, we're going to have a much better haul. Our job is to locate where our viewers are and then take our movie to them.

The appeal of a particular project may be broad or narrow, but it is almost never universal. Even viral videos that draw in millions of viewers tend to attract a particular demographic. Is there a specific demographic or audience for your movie? Do they have identifiable activities and habits? Where do they live, work and play? Do they hang out at skate parks, in executive suites or in retirement communities? Before you do anything else, make a list of the kinds of places where your primary audience can be found. Then think about the steps you could take to reach that audience. Suppose we do this as an exercise with my fictitious barbershop quartet movie. How do I reach those youthful a cappella enthusiasts? An obvious starting point would be to target the a cappella ensembles that can be found on most college campuses. An online search will quickly provide a list of such groups. It will also turn up broadcast and internet-based a cappella radio shows. All of this is useful information in locating my audience, but it hardly constitutes a strategy for getting that audience to watch and like my movie.

What would appeal to the a cappella crowd and get their attention? This requires some careful thought and research about a number of issues, including basic considerations such as how these singers consume media. If my prospective audience considers DVDs to be quaint relics of the past century, it makes little sense to hand out screener discs. I can put the trailer or the full movie (if I'm willing to give it away) on a dedicated website, but I still have to get viewers to find and click on the link. How can I get the necessary information—at a minimum, the movie title and website address—into their minds, or at least into their hands? I start to think about accoutrements of a cappella. At performances, many groups use a pitch pipe to ensure they are in tune. Perhaps I could put the title and website on a tuner device? Preliminary searches for pitch pipes suggest that they will cost around twenty bucks a pop, before labeling. That's a steep price tag for a freebie. Another angle: bow ties are popular in the world of a cappella. What if I had ties made with the promotional information embroidered along the neck band? I get a quote: 100 custom-embroidered bow ties will cost me around $15 apiece. That's better, but it's still too expensive to allow for a broad campaign.

Then it comes to me: throat lozenges! My research revealed that—big surprise—throat care is a common concern for singers. There are lots of companies that sell lozenges (okay, they're really breath mints) in boxes or individually wrapped packages featuring whatever message I come up with. If I buy in bulk,

I can get these items for as little as a few cents apiece. At that price, I can afford to share the joy. Not only can I ship care packages of lozenges to the various ensembles, but I can also attend concerts and leave bowls of the packaged candy in the lobby. This way, I'm targeting not just performers but also listeners.

Now a plan is beginning to come together, but will it work? Before I go through the time and expense of rolling out such a multifaceted strategy, I would do well to run it by my local a cappella aficionados. While I'm at it, I should ask about the methods and channels they use to promote their shows. What forms of social media do they favor? Such "intel" will inform the steps I ultimately settle upon. As I trust this example makes clear, whatever promotional plan emerges must cater to the specific nature of a given project.

Scarcity Versus Ubiquity

We are cursed to live in interesting times. Until the dawn of the new millennium—which happened to coincide roughly with the arrival of cheap, fast ways to watch video online—the business of motion pictures was predicated on scarcity. Whether you were running a film festival, a cable network or a movie theater, there was great value in claiming to be the only place where someone could see this or that content. I deliberately started our consideration of distribution strategies by emphasizing grassroots outreach. Our culture is no longer controlled by overlords, be they critics, network executives or talk show hosts. The contemporary communication landscape is chaotic and noisy, but it is largely unfettered and open. A culture that once prized scarcity is morphing into one that values ubiquity.

It can be argued that the first viral video was a short film called *405*, about an airliner making an emergency landing on a Los Angeles freeway. The video was made by two enterprising visual effects artists, Bruce Branit and Jeremy Hunt. It appeared online way back in 2000, before either YouTube or Facebook existed. Using the social media of that era—not the least of which was good old e-mail—news of this short soon spread far and wide, garnering its creators enormous amounts of attention and taking their careers to new levels.

The attributes that made *405* work so well online have been proven to be hallmarks of countless subsequent viral hits: it had a hook (in this case, splashy visual effects, which were impressive for their time), a compelling creation myth (made by two guys for $300!) and a short running time (three minutes, including titles). The fact is that most short films—and this includes the shorts that are nominated for Oscars each year—don't fit this formula. Just like features, most shorts need some sort of promotional push. Since a nationwide ad campaign is not an option, what can you do to help your short production break through? As of this writing, for most projects, a trip through the film festival circuit remains the best investment of time and money.

The Festival Circuit

To an extent, film festivals are anachronisms. In an era of crowdsourcing, they depend upon the judgment of a few; in a world where "information wants to be free," they sell exclusive access to a rarified selection of content. It isn't hard to imagine a time in the not-too-distant future when the traditional film festival fades away, but that day has not yet come. The curatorial process of a film festival, however capricious, confers on selected entries a stamp of approval. People seem to understand on some gut level that "likes" on YouTube or Facebook don't require much effort, whereas running the gauntlet of the festival circuit takes a lot of work. As the refrigerator magnet saying goes, "Everything looks more official with tiny leaves around it," which is to say that those "official selection" laurels that you see at the head of movies do seem to elevate films above the unfiltered chatter that dominates our culture. This is doubly true when festivals confer awards (assuming your movie wins something). Another potential benefit of festivals is the possibility of getting reviewed, or at least getting mentioned in the press. Festivals can also be a way to meet industry professionals whose doors might otherwise be closed, and they are a great way to meet other filmmakers.

This last point bears special emphasis. A common bond shared by virtually all film festivals, large and small, is that they are frequented by... filmmakers. In a memorable *Saturday Night Live* skit about film festivals, the cast and crew of a short film are asked to come up on stage, and every audience seat but one empties out. There is more than an ounce of truth to that spoof, but it misses a subtle distinction: while many film festivals largely seem to exist for the filmmakers, they are less about self-congratulation and more about mutual admiration. It's not uncommon for much of the audience at a festival screening to consist of the cast and crew of other festival entries, but that's not a bad thing. Those fellow filmmakers aren't rivals; they are potential allies. Many of the darlings of today's media landscape made contacts with peers on the festival circuit that led to breakout projects. Actor/director Greta Gerwig, the producing/acting/directing team of Mark and Jay Duplass, cinematographer Reed Morano and actor/director Alex Karpovsky all trod this path.

The Shoebox Diaries

"That's why I love the festival process: this idea of going, watching films, meeting other filmmakers. Another thing that kind of gets overlooked is meeting filmmakers from around the world, talking, collaborating about film, and having fans of film come and see your film, give you feedback, talk to you about it. Good or bad, it's all useful in the process, if you plan on making another film."

—*Matt Lawrence, Producer, Director, Writer & Editor*

The great majority of film festivals now accept submissions online. A few maintain their own admissions portals, but most use a third-party service to solicit and accept submissions. Of these online services, the most widely used are *withoutabox.com* and *filmfreeway.com*. Before you log in to one of these sites and start sending your movie out to festivals far and wide, let's do some math. Over 500 film festivals take place in the United States each year. Some estimates run as high as 2,000 festivals. Some of these events last only a year or two, while others are firmly established. The fly-by-night festivals have to work hard to solicit submissions, whereas the household name institutions like the Sundance Film Festival attract thousands of entries. Given the bewildering range of choices and vastly divergent odds for success, how do you decide which festivals to apply to? To complicate the selection process further, here's one more set of numbers to reckon with: applying to film festivals costs money. Application fees for short subjects range from $10 to $70, with the average cost being about $35. Therefore, even if you have the fortitude to do it, simply working your way down the list of festivals until you get into five, ten or twenty isn't a viable plan, since you are likely to bleed your budget dry before you reach your goal.

Achieving success on the festival circuit is a bit like playing the stock market: diversification is key. Festivals can be placed into five categories, each of which has its pros and cons:

- **Elite festivals**: Cannes, Sundance, Berlin, Toronto, Venice. These storied events are like suns around which the planets of film buffs, celebrities, financiers and the press revolve. Sadly, many of these behemoths of film culture aren't especially oriented toward shorts. In the United States, the most illustrious festivals that program shorts are Sundance, Tribeca, Telluride, South by Southwest and the New York Film Festival (not to be confused with several other festivals with "New York" in their titles). *Pros*: Selection confers prestige. Opportunities to rub shoulders with stars, power brokers and new talent. *Cons*: Shorts can be ghettoized and ignored by the press. You can feel like you are attending a very costly circus.

- **Short film festivals**: There is a subcategory of elite international festivals that focus solely on the short film. This would include the festivals in Oberhausen (Germany), Clermont-Ferrand (France), Ann Arbor and Palm Springs (both in the United States). *Pros*: For once, shorts are the main event! To the extent that there is a market for shorts, you will find the buyers at these festivals. *Cons*: Shorts festivals are largely ignored by the film industry. Playing to an audience at an international festival can be tricky, especially if your movie is very dialog-driven.

- **Second-tier festivals**: There is a fairly long list of very fine festivals, each of which would probably protest being left out of the elite group. In the United States, at or near the top of this list would be four very prominent

festivals, all on the West Coast: San Francisco, Seattle, Santa Barbara and San Jose. Other prominent American showcases include Slamdance, Atlanta, Chicago, Newport Beach, the Hamptons, Sarasota, Nantucket and the Independent Film Festival Boston (not to be confused with several other festivals with "Boston" in their titles). Broadening to a worldwide scope, the field rapidly becomes cluttered. Almost every developed country has at least one festival of note, but a short list would have to include the festivals in Sydney (Australia), Rotterdam (the Netherlands), Busan (South Korea) and Turin (Italy). *Pros*: These festivals can provide the best opportunities to meet other filmmakers. Events are well organized and accessible. Audiences can be large and enthusiastic. *Cons*: Far less involvement from the film industry and coverage by the film press than at the elite festivals.

- *Festivals with a special focus*: In addition to garden-variety festivals, there are many film festivals around the world that are focused on a theme or aimed at a specific audience. There are festivals devoted to content about indigenous peoples, Jewish life, gay culture, dance, wildlife and children. Some of these festivals have a mission to encourage filmmakers to address a particular underserved audience. In these cases, you may actually get paid to screen your film. Furthermore, if your movie has an advocacy agenda, then attending festivals focused on your subject may connect you with special interest groups that will rent or buy your movie. There are also genre-oriented festivals, such as events dedicated to comedy or horror. If you are looking to raise your profile with a niche audience, it makes sense to target these festivals. *Pros*: Audiences are passionate about the subject. May be a money-making proposition. *Cons*: Once you are perceived as playing in a specialized sector of festivals, you may be ghettoized. It may be harder to get programmers at festivals aimed at general audiences to watch your film.

- *Student film festivals*: Obviously, works admitted to these events must be made by student filmmakers, but it is not always the case that they be produced as part of an academic program. Many of the larger film schools in the world hold their own festivals, but in the great majority of cases, entry is restricted to students enrolled in those institutions. There are notable exceptions. The Tel Aviv International Student Film Festival in Israel and the Filmschoolfest in Munich are annual celebrations of student work from all over the globe. *Pros*: These are often juried festivals, and you are competing against your peers rather than professionals. This might improve your odds of winning awards and prizes. These festivals provide a good opportunity to mingle with the rising stars at the very outset of their careers. *Cons*: The "student" label translates in some people's mind as "still in training."

- *Regional festivals*: This is by far the largest category. There are hundreds of small festivals in cities and towns around the world. In the United States, in addition to virtually all major cities, many suburban and rural communities now host film festivals. In some cases, these events are expressly designed to celebrate locally produced work, while in others, the aim is to let local audiences see interesting work from far and wide that otherwise would pass them by. *Pros*: You are a big fish in a little pond. These very small festivals may represent your best chance to garner press coverage. A few kind words in the *Sand Creek Intelligencer* might provide a worthwhile quote for your website. *Cons*: Yes, you are a big fish, but it's a little pond. Audiences may be small and fewer filmmakers will attend.

Your goal should be to put together what a financial manager would call "a balanced portfolio," a selection of festivals that is evenly distributed across these categories. As you weigh the various options, you'll still have to do a lot of picking and choosing. All other things being equal, here are a few key factors that will help you decide between two or more festivals in the same category:

- Is this a judged festival that awards prizes?
- Can I attend the festival?
- Which festival has the lowest entry fee?

Three notes of caution about the application process. First, pay attention to deadlines. Many festivals offer discounts for early admission. Add those early-bird deadlines to your calendar and then work backward from those dates, giving yourself enough time to submit your materials. Second, as you draw up your list of festivals, pay heed to those events (generally in the elite category) that insist upon being a premiere screening. In some cases, it's enough to be able to offer a festival regional premiere status. In any case, you don't want to throw away your premiere status on a tiny local festival when you could have used it as bait for a prominent showcase. Finally, one more reminder to be cautious about how you share your film, even when dealing with festival programmers. These days, it is common practice for filmmakers to put cuts of their movies up for review online under password protection. Make sure anyone who is given the password does not pass it along. If programmers see that your privately posted video on YouTube has hundreds of views, they are likely to assume that the movie already has too much exposure to be of interest to festival audiences.

Time to get down to brass tacks. Armed with all this information, how many festivals should you apply to? Using our diversified portfolio strategy, you could pick a few festivals from each category—perhaps a total of ten or twelve entries—and see how you do. The problem with this approach is that

the odds of being selected by any of the upper-echelon events are against you. If you just want a couple of laurels to decorate your website, perhaps you can take your chances. On the other hand, if the project is intended to be a calling card, then you need to get into events where you can hand out your *real* calling card. This means, at a minimum, that you need to get into one or two festivals near the top of the second tier—events where at least you'll be able to meet other talented filmmakers. This is how I envisioned positioning *Shoebox Redhead*. I budgeted for twenty festival submissions. Getting into any festival is never a sure thing, but the fact that Matt had made another short just a year earlier that played in a couple of festivals gave me hope. Success breeds success: nothing improves your chances of getting into a festival like having already played the event.

The Shoebox Diaries

"For *Shoebox Redhead*, it was the first time that I wanted to seriously hit the film festival circuit. With my previous film, I sent it to maybe six festivals and I got into two or three. I thought it was great, but I didn't understand the beast, really. I think overall for *Shoebox Redhead*, I submitted to between 50 and 60 festivals—I think closer to 50—and we ended up getting into fifteen."

—*Matt Lawrence, Producer, Director, Writer & Editor*

The extent to which you want to play the festival game depends on what you need to get out of it. If you are primarily trying to find an audience online, then festival play will only be of marginal use. If you are trying to meet film insiders, you should lay siege to as many of the first- and second-tier festivals as you can manage. A friend of mine recently completed a short film. He drew up a very diverse list of almost 90 film festivals. The combined cost of applying to all these events came to over $3,000. His film was very well made and light on dialog, which meant it could play well internationally. To date, he has gotten into over twenty festivals. That might seem like overkill, but this filmmaker has a particular agenda: in addition to continuing to develop his directing career, he wants to teach. Therefore, he is not simply interested in laurels; he is looking to add entries to his curriculum vitae. In academic circles, when it comes to the exhibition of your work, "more is more." Just as every film is different, so too is every promotional campaign. Think about your goals and design a festival strategy that fits both those aims and the nature of your movie.

The Shoebox Diaries

"Be prepared for rejection. You're submitting to 50 festivals; you're only getting into fifteen. Do the math: that's maybe 35 rejection e-mails—if you're *lucky* you'll get a rejection e-mail. So, it's important to also know that, percentage-wise, you're lucky if you get into 20 or 30 percent of the festivals you apply to."

—*Matt Lawrence, Producer, Director, Writer & Editor*

The Press Kit and Other Promotional Materials

Once upon a time, a film **press kit** was a physical object. Frequently, all the materials in the kit were gathered into a folder or binder. Today, for both environmental and practical reasons, printing hard copies of promotional materials is wasteful and unnecessary. There are a few items that you will still want to print out or produce, but most of your press and marketing materials can be shared electronically. This is why a press kit is often referred to as an **EPK**, which stands for "electronic press kit."

Let's make two lists of the items that could go into a press kit. First, here are the essentials:

- *Tagline*: A **tagline** is a catchy phrase that will draw your audience in. Note that I didn't say that it tells your story or makes people want to watch your movie. Director Ridley Scott's scary sci-fi feature *Alien* has one of the most famous taglines in cinema: "In space, no one can hear you scream." That statement is not going to make *everyone* want to watch *Alien*, but it perfectly targets the film's audience.

- *Production stills*: In our snap-happy age, it can seem that there is visual documentation of our every moment. That being the case, it is ironic how few press kits for shorts have good production stills. If you pay attention to the images that are used to promote major motion pictures, you will start to notice that very often just one photo is used repeatedly in ads, magazine articles, blog posts and so on. Tens of millions of dollars and years of labor go in to bringing a production of that scale to the screen, and yet the whole endeavor is distilled down to a single image. What's true for Hollywood's massive marketing machinery also applies to your short. You do not need scores of funny, candid behind-the-scenes shots or stills that document each scene or every dramatic moment in your story. What you emphatically *do* need are a few images that distill the tone and substance of your movie into strong graphic statements. You want stills

that summon up feelings and that make the viewer think, "Something happens in this movie." These stills are going to be used in festival programs and promotional materials and (if you are really lucky) by press covering your movie. In these contexts, candid shots are of little use. If you have four production stills, perhaps one of these could be a shot of the crew at work or a group portrait of the lead actors. Make sure any digital file of a still is labeled by the movie title. In other words, label the file *Shoebox_Redhead-1. jpg*, not *Ryan_at_Beach.jpg*. In your written materials, be sure to include a one-sentence description of each still and a credit for the photographer.

- *Photo portrait of the director*: Some festival programs include thumbnail shots of the director in program materials, and a portrait shot is handy if a journalist wants to write a profile piece on some of the festival's rising talent.

- *Short summary*: Sometimes called a **logline**, this is a 25–50-word summary of your story. These synopses often end up in festival catalogs, so take care not to spoil your narrative by revealing too much.

- *Synopsis*: A statement of one to three paragraphs that tells your story in full. In the case of this and all the other written material in your kit, make sure the style is polished and natural, not overly clever, hip or pretentious.

- *Cast and crew bios*: You should provide biographical sketches for principal cast and crew. Unless someone has a remarkable human interest story to share, these bios should be kept to a single paragraph per person.

- *Director's statement*: A few paragraphs that express the director's purpose for making the project. What drew her to the material? What does she hope audiences will take from watching the film? The statement should be personal and passionate. As with the short summary, you may find that festival programmers crib from this statement for their promotional materials, and occasionally journalists will even copy passages into their articles. Many filmmakers can attest that the best press they ever received was written by themselves, so edit all your written material carefully.

- *Technical specifications*: This would include the running time, the video format, aspect ratio and audio format. If your film is available with subtitles, note this as well.

- *Contact information*: Name of principal contact, e-mail address, phone number, social media contact info, URL (if there is a website for the film and/or the production company).

- *Online promotional art*: Think of this as a flyer for your movie that will be posted online. It is most likely to be shared via e-mail, Twitter or Facebook. The design therefore should be relatively simple and bold, because most people are going to be viewing it on a phone screen. This is the first of several graphic designs that you may need to develop for your movie.

Try to come up with a single concept that can be adapted to several uses. Seeing the same design in various formats builds awareness of your project. Leave room in the design so that you can easily incorporate information about fundraisers, screenings and so on.

- *Postcard or small flyer*: Everything I just said about online art applies to any printed graphics. If you make a flyer, don't make it larger than a standard 8 ½" × 11" sheet, and really a design half that size could work fine. Whether you are screening your movie on a campus or at a film festival, wall space for posting information will be scarce. Better to put up lots of small announcements than to hold out for a large, open expanse. I am particularly partial to postcards because they are so versatile. In addition to posting them as mini-posters, you can use them as notecards. Make sure you leave plenty of blank space somewhere on the card. This will permit you to write on it and to include additional information in the space. When they attend festivals, many filmmakers make up stickers with the latest screening information that they can stick onto their postcards.

Next, the optional items:

- *Blurbs*: By now, we are all a bit inured to the hyperbolic testimonials that festoon movie posters at the multiplex. In the realm of shorts, it's less common to see quotes from celebrities and critics touting a movie. A good blurb from a respected source might just get a festival programmer to press play. There is no sure path to landing a useful quote. Maybe your cousin was roommates with Jordan Peele in the early days. Perhaps you just write a fan letter to your favorite critic and ask him to watch your movie. You will often find that you have better opportunities to glean blurbs once you are on the festival circuit and mingling with the cool kids.

- *Poster*: I certainly understand the allure of a great poster. For many of us, movie posters are inextricably linked to our love of cinema. It may therefore be hard to accept the fact that full-sized posters have virtually no role in the promotion of short films. They are expensive, bulky and impractical. As already noted, the wall space needed to post large-scale graphics is always at a premium. If you are absolutely set on producing a poster, limit the size to 11" × 17". This is the equivalent of two standard sheets of paper side by side and is a format that can be printed at your neighborhood copy shop.

- *Trailer*: Movie trailers are another staple of motion picture marketing that has limited utility in the realm of shorts. They can be useful for fundraising, but there isn't much role for them once the film is completed. After all, rather than watch a trailer, audiences can just *watch the movie*. Unless you have a very clever and very concise concept for a trailer, there is little

reason to make a trailer for a film with a running time of less than fifteen minutes. Films with running times creeping up to half an hour might benefit from a trailer that gets viewers to invest the time to watch the whole show. Even so, a trailer for any short film must be . . . short.

- *Behind-the-scenes videos*: This is a tricky area. While distributors, broadcasters and festival programmers are not going to be interested in your on-set adventures, fun, candid videos from your shoot or pithy interviews with cast and crew can be useful tools for building awareness of your short through social media. Just take care that the tail doesn't start wagging the dog. Filmmakers can too easily get caught up in their own self-mythologizing, only to wind up shortchanging their production in terms of time, focus and energy. Make sure that you and your entire team never lose sight of the fact that you are making a movie, not cell phone videos for social media.

- *Promotional items*: If they can be produced and shared cheaply, clever gimmicks that keep your movie front and center in people's minds can be a worthwhile investment. If your story features a lot of classic cars, you might make up a keychain with your title and contact information on it. If your movie is about skateboard culture, you might design a sticker worthy of decorating a board or a lamppost. Note that in these examples, there is a clear correlation between the theme or subject of the movie and the nature of the freebie. If a person actually uses your promotional item, it will deepen their awareness of your movie with that individual and spread the word to a wider public.

- *Transcript*: Some festivals request a transcript of your movie as a matter of course. A transcript is like a film script without the formatting and screen directions. Festivals may use them for closed captioning or as an aid to the press. In truth, this requirement is aimed at feature entries. Except perhaps in the case of the very largest international showcases for shorts, festivals don't do anything with transcripts of short films. However, transcripts do have three potential uses elsewhere. First, you'll need a transcript if you are making a subtitled version of the film for international distribution. Second, if your film has potential for distribution in education or advocacy circles, a transcript can be helpful for teachers or discussion leaders. Finally, if your film truly lives or dies by its scintillating dialog—for example, if your movie is a comedy filled with one-liners—then transcribing portions of the film for inclusion in promotional materials might be a smart move.

- *DVDs and Blu-Ray discs*: We are certainly nearing the end of the disc era. You may already have kicked your prized DVD collection to the curb. What, then, is the utility of copying your movie to discs? First of all, some of the regional festivals still screen movies on Blu-Ray players,

and even those that don't often ask for a disc as a backup in case there is a snag in projecting your film from the DCP or other media. Second, there can be advantages to having a DVD that you can hand to a critic, studio executive or prospective investor in your next project. A DVD is a tangible object. It has a cover that can serve as both a calling card for you and a miniature billboard for your movie. If you need to control access to your film while it's on the market or making the rounds at festivals, a DVD offers a measure of security. None of this can be said of the online version of your movie.

When you submit your film to festivals through portals like *withoutabox.com* and *filmfreeway.com*, you will be asked to provide a plethora of information about your movie—everything from a synopsis to production stills. By the time you have satisfied the submission requirements on these sites, you will probably have produced most of the items needed for a press kit. That effort is great preparation, but make sure you don't only post the information on those submission sites. You'll want to make it readily available to anyone who takes an interest in you or your project. I have made a few passing references to posting things on a website. Your movie needs some kind of base of operations online, even if this home is merely a Facebook page set up expressly for your movie.

If you want to set up a website dedicated to your movie or your production company, you can do this quite simply. There are plenty of companies out there, large and small, that would be happy to take your money in exchange for designing or running your website. Here's a way to set up and operate your website at a cost of a few cents a day:

- **Purchase your web address**: If you plan to make a series of movies, you might want to create a website for your company and then make a page on the website to promote your current project. Think up a name that is short and easy to remember, and then see if that domain name is available. If you shop around, you can find a company that will register your URL and provide basic web hosting services for as little as $9.99 a year.

- **Design your website**: If you or someone you know is able to design a website from the ground up, then have at it. Writing your own website code has its pros and cons. On the plus side, it gives you complete control over its design. On the downside, you'll probably need to spend a bit more (perhaps $60–80 per year) for web hosting. If you plan to follow this path, you can skip the remaining steps here. If writing your site from scratch is not an option, then fear not: there are companies that provide free templates for websites that can be attractive and versatile. Weebly and Wix are two such services that you might check out. These companies offer lots of additional

amenities and support—for a price. Do your own homework. You may determine that you don't need to spend any extra money for add-ons.

- *Direct traffic to your web address*: You want folks to be able to type your pithy little web address into their browser of choice and then have your website pop up, right? To make this happen requires a couple of additional steps. When you design your website using a third-party company's templates, you'll be assigned a long and confusing web address. Using a function called "masking," you can make it so that your web address appears to take the place of that ungainly third-party address. Go back to the web hosting company's site. It will take some tinkering with your account settings, but you should be able to mask the long address, effectively replacing it with your customized web address. This should not cost any extra dough.

Deliverables

If yours is the rare short film that secures some form of commercial distribution, you are likely to receive a list of deliverables. These are a miscellany of documentation and digital files that allow the distributor to promote and exhibit your movie. You may be asked to provide copies of your production in a very specific video format, or possibly several formats (different regions of the globe have different standards for video). Other common items are proof of copyright and a letter from your errors and omissions insurer verifying your coverage. Then there are more obscure requests, such as a printout of the full cast and crew credits. If your deliverables list is as long as your arm, don't panic. Chances are that any very long set of deliverables was drawn up for the distribution of a television series or feature film. Before you start running over hill and dale to pull together all the items, check with the distributor. When asked to explain why you need to provide behind-the-scenes footage, a letter from a bond company or audio recordings of all the music cues in your movie, the distributor is likely to backpedal on these and other demands. A quick phone call could save you a lot of time and money.

Pro Tip

"If you aren't sure of what you're delivering and when, then you have no idea how much money to spend in post. So, a lot of projects make the mistake of spending all their money in production. Then they don't have the money in post to actually finish a project and they have to go look for more funding."

—*Mark DiCristofaro*

Online Distribution

The process of fully exploiting a short production's potential can feel interminable. Just as with raising a child, every film needs some personal attention as it transitions from one stage to the next. If you have plans that go beyond building your résumé or making connections, you should keep your eye on the calendar. A well-received film can easily play the festival circuit for two years. Let's say you have made a raucous comedy that could be a hit on a humor website. Playing in some reputable festivals and acquiring some admiring blurbs could help get the short viewed by the editors of a top comedy site. Waiting two years to test those waters is *not* a good plan. Deciding when a film has run its course on the festival circuit or has been shopped around to commercial prospects long enough requires careful consideration. Once upon a time, some short films could circulate for years or even decades through educational distributors or other specialized channels. For better or worse, we now live in an era when people expect short content to be available at the click of a mouse. There will come a time when you'll want anyone and everyone to be able to see your movie.

If you time the release just right, you might find a whole new kind of glory online. The Australian film collective Blue-Tongue Films is an example of how this can work. This group of young filmmakers produced several short films. Many of these projects did well on the international film festival circuit, making contacts for the filmmakers and creating buzz for the films. The shorts were then put on YouTube, where one of them (*Spider*) collected over a million views. The combined critical and popular success of this work led to deals which allowed members of the group to make the feature films *Hesher* and *Animal Kingdom*.

The talented husband-and-wife team of Ben Sinclair and Katja Blichfeld have also successfully used their short films as auditions for the big leagues, but they have forgone the detour through the festival circuit. Sinclair and Blichfeld initially made *High Maintenance* as a series of webisodes all connected by the recurring character of a marijuana dealer. They launched the series by posting the videos on Vimeo and on their own website, *helpingyoumaintain.com*. Sinclair and Blichfeld were based in New York and drew on a pool of talented actors and crew to make the shorts. This creative network helped spread word about the series and soon it gained a cult following online. Vimeo commissioned the filmmaking duo to produce more episodes of the web series as a test of a new pay-per-view model. Eventually, HBO bought up the rights to the series, completing the metamorphosis from free, bootstrapped content to the gold standard of subscription-based entertainment. Sinclair and Blichfeld have been able to achieve all this without blue ribbons, trophies or laurel leaves. Instead, they have taken their work directly to the people through social

networks. Their triumph may be an anomaly, or it may be a sign that the old methods for finding cultural validation have exceeded their shelf life.

Whatever the case, there is a common thread connecting the work of the Australian collective and the *High Maintenance* team. In both cases, the film-makers created a body of work and exploited it over time through a variety of channels. As fine as their work is, if either team had just dumped their short films online and walked away, we would not be talking about them today.

Conclusion
The Long and the Short of It

In writing this book, my aim has been to clear away the clutter and focus on the skills and tasks that pertain to producing a short motion picture. In order to live up to that goal and stay true to the title of this tome, I have necessarily omitted a number of topics that come into play when producing in a longer form. Feature producers must know their way around agents and managers, tax credit programs and **completion bonds**. They have to give some thought to the extra content that might go on the DVD release of the movie. They must leave open the option of making dubbed foreign language releases of their films. The producer of short content has none of these concerns.

Pro Tip

"One of the things I often see people trying to do with a short is trying to tell a big story in a limited amount of time, on a limited budget. It's great to aspire to wonderful ideas, wonderful thoughts, but at the end of the day, you have to be realistic about the resources and the framework within which you are working. So, I'm not looking for the trailer for the feature film you're going to make in five years. Tell me a story with a few people that has emotional resonance, and if that works, I'm going to give you more money, I'm going to give you the opportunity to go to that next level."

—Jay Roewe

Rather like that familiar closing shot in a movie where the camera pulls up and back to take in a wide view, I'd like to conclude by putting the job of producing a short into the broader context of managing other kinds of productions. As a rule, the tools of the producing trade used throughout this text are the same as you would find on a large-scale feature production. The stripboard

and budgets are longer on features, but they follow some variant of the formats I have discussed here. If anything, the procedures I have demonstrated have erred on the side of being even more detailed than might be the norm on feature productions. There is a reason for this. Consider the daily production schedule—the hourly timetable for the shooting day. On a big-budget feature, it's unlikely that you would encounter anything like the daily production schedule I have presented. As a cast or crew member, if you saw a daily schedule at all, it might take the form of a printed summary that just identified the location and stated which scenes would be shot before and after lunch. Moreover, you would probably never see any such document prior to the start of the shoot. If large-scale productions, with all their resources, don't bother with this kind of advance planning and detail, why should we toe a different line on our humble short?

It is precisely the vastly different level of resources available to a big-budget production that makes a crucial difference. Large-scale productions hire a lot of crew. They routinely have producers, production managers, production coordinators and assistant directors whose jobs are to keep the production on track. Most of those crew members have many years of experience. When you have a small army of professionals dealing with production logistics—everything from parking to toilets—there is no need to share detailed documentation about the day's game plan. On a Hollywood feature, you don't need a reminder to order lunch; you have an entire crew devoted just to craft services. They will deal with it.

On features, the assistant director is the person who oversees the daily schedule, and it is true that the AD will often be tweaking the next day's schedule during production. Why is this the case, and why won't this approach work on a short? First, if you are shooting a motion picture over 40 or 50 days, there can be a lot more give and take in your schedule. Second, experience is again a factor. An assistant director who makes her living making and enforcing production schedules draws from a vast reservoir of know-how that lets her analyze and address conditions with less preparation and forethought. It's like a studio musician who can sit down with a score, sight-read it and then be ready to record the track, whereas even a good amateur musician might need months of practice to achieve the same results.

As this case illustrates, size matters, and with the greater size of a feature crew comes the need to define each crew member's role more precisely. This is especially true in the case of union shoots, where the production must follow rules regarding who does what. For example, the assistant camera must not operate the camera dolly; that is the job of the dolly grip. Naturally, when working with such larger, more rigidly defined crews, it is not possible to practice the kind of all-for-one-and-one-for-all producing whereby the sound

recordist might be sent to pick up lunch or the gaffer might lend a hand with dressing a set.

The Shoebox Diaries

"When you work on a film that has anywhere from a $10 million to a $40 million budget and a crew of a hundred or more, everyone has their role and unions are very strictly regulated. And it makes me miss the indie world a little bit, you know, where everyone can do everything."

—*Samara Vise, Assistant Camera*

If you use union talent or crew on your short, you are supposed to abide by all union rules regarding working conditions, but the fact is that many of those rules simply don't come into play on a four- or five-day shoot. The unions have firm edicts about work hours, including how much time off workers need during a 24-hour period and how long a weekend must be. In order to monitor this and other provisions, union representatives will usually ask feature productions for a **day-out-of-days report**. This report is a special calendar that shows when workers start and finish work on a production, as well as any breaks in the worker's employment during the shoot. Unions have complex rules about what is called "continuous employment," a provision that restricts how and when you can **drop and pick up** a union member on the production schedule. Feature producers become expert at tweaking the schedule to lessen the impact of these provisions.

Learning these tricks of the trade is a task for another day, but don't worry: if you learn to be an effective producer of shorts, you will certainly be able to rise to the challenge of producing a feature when the time comes. The scope is grander and the organization more complex on a feature, but the fundamental work of producing doesn't change.

Pro Tip

"Back when I was a student producer and I was making films with my buddies and we were in a van in New Jersey, eating take-out, versus today, it's actually very similar. A lot of the challenges are, funny enough, the same. The same ingenuity, creativity, chutzpah—whatever it takes to get a short film off the ground—you need all those things to get a feature off the ground."

—*Evan Astrowsky*

At its essence, producing is always about creative problem-solving. While I hope I have equipped you with a wide range of useful principles and handy techniques, at the end of the day, the most valuable skill a producer can develop is this ability to be resourceful and inventive in solving real-world problems. If you have that restive, shrewd mindset and can apply it to the myriad challenges that arise in the making of even the shortest of shorts, then you are thinking like a producer, and you're already well on your way.

Appendix A

Script for *Shoebox Redhead*

In the pages that follow, you'll find the complete script for *Shoebox Redhead*. This is the final draft of Matt Lawrence's script, in precisely the format and layout that was used to produce the film.

You can find the marked-up and color-coded version of the script that I used to break out the production elements at *theshortseries.com*. On that site, you can also find a link to a video of the completed film of *Shoebox Redhead*, or you can watch the short on Vimeo.

EXT. BEACH -- SUNSET

RYAN CONRATH stands in front of a vast ocean, shoebox in
hand. The waves crash and come up to his shoes.

Trash is scattered across the sand. Ryan finds a butt to a
half-smoked cigarette. He picks it up and lights it.

Ryan places the shoebox in the sand in front of him. A wave
breaks and rushes forward, enveloping the shoebox in water.

 DISSOLVE TO:

INT. BEAT UP STATION WAGON -- DAY

An air freshener with a photo of MATT LAWRENCE, shaven and
clean cut, and JACKI hangs on the rear view mirror.

EXT. BEAT UP STATION WAGON -- DAY

Matt, now bearded and haggard, sits in the driver side seat.
He stares at the air freshener.

Matt reaches for the air freshener and yanks on it, breaking
the elastic. He rolls down his window and tosses it out.

Matt closes his eyes and covers the bridge of his nose with
his hand. Silence.

Matt makes a loud snorting sound.

A KNOCK comes from the passenger side window. Matt snaps
out of his shame spiral and looks over.

Ryan stares into the car. He knocks again.

Matt reaches over and unlocks the passenger door. Ryan enters
the car and shuts the door behind him.

 RYAN
 Yo. You ready to do this?

A beat. Ryan looks over at his friend.

 RYAN (CONT'D)
 Have you been crying?

Matt shakes his head "no." He doesn't make eye contact.

 MATT
 It's a high pollen count today.

Matt puts the car in drive and pulls away.

TITLE CARD: SHOEBOX REDHEAD

EXT. BEAT UP STATION WAGON -- MOMENTS LATER

The vehicle putters through a suburban neighborhood. Tied
to the top of the wagon is a box labeled "Jacki."

EXT. SUBURBAN NEIGHBORHOODS -- DAY

Shots of suburban homes, one after another. Each one
indiscernible from the next and the one that came before.
The cuts signify a change in neighborhood but this could be
a single neighborhood. A meta neighborhood.

A house having a garage sale is passed and then the car
(camera, whatever) slows down, almost to a stop. It backs
up slowly and stops, looking straight at the house holding
the garage sale.

An OLD WOMAN sits at a table in the center. Rummaging around
is an OLD MAN and TWO MIDDLE-AGED WOMEN with teased out hair
and wearing nylon jogging suits.

We cut 180 degrees to reveal Ryan, sitting in the passenger
side of a beat up wagon. After a few seconds, Matt appears
from behind his friend. Matt yanks up on the emergency break.

EXT. SUBURBAN HOUSE -- DAY

Ryan and Matt, who is carrying the box, walk to the front of
the driveway, passing tables full of junk and blankets below
those tables, full of more junk. They approach the Old Woman.
Matt drops the box on the table in front of the her.

 MATT
 Hi. Do you want to buy this stuff?

 OLD WOMAN
 Why would I want to buy your stuff?

 RYAN
 Well, he can just trade it in for
 credit, right?

A beat.

 OLD WOMAN
 If you want to take a look around.

 RYAN
 Yeah. Thanks.

EXT. SUBURBAN HOUSE -- MOMENTS LATER

Matt and Ryan approach different tables. Ryan picks through
VHS tapes.

 RYAN
 Matt, they've got Richard Simmons'
 Sweatin' to the Oldies over here for
 only a buck.

 MATT
 Wow.

Matt comes upon a shoebox and opens it. In it is a polaroid
camera sitting on dozens of old photographs. Matt picks up
the camera and examines it. He puts the camera back down
and begins leafing through the pictures. In many of the
photos appears a beautiful redhead 20-something, Mandi.

 RYAN (O.S.)
 She's a cutie.

Matt turns to find Ryan standing beside him.

 RYAN (CONT'D)
 You want to get that?

Matt closes the shoebox and heads over to the Old Woman at
the table. He shoves the Jacki Box over and sets down the
shoebox.

 MATT
 (motioning)
 I'd like to trade this for this.

 RYAN
 Wait.

Ryan runs back over to the table he was at and yanks the
Sweatin' to the Oldies VHS tape from the Old Man's hands.

 RYAN (CONT'D)
 And this.

 OLD WOMAN
 Five bucks.

Ryan reaches for his wallet.

 MATT
 Five bucks? There's a lot of
 sentimental value in this box.

 OLD WOMAN
 Then take it with you.

A beat. Matt touches the Jacki Box. Ryan grabs his hand.
He hands the Old Woman a bill.

 RYAN
 No. Five bucks sounds good to me.

Ryan puts the VHS tape on the shoebox.

 RYAN (CONT'D)
 Mazel tov.

The two exit.

INT. BEAT UP STATION WAGON -- DAY

Ryan inspects the polaroid camera.

 MATT
 You know, I didn't even check to see
 if the thing worked at the garage
 sale. So, knowing my luck, it's
 probably some broke piece of shit.

Ryan pushes the flash to the "on" position. The charge makes
a high pitched sound. Matt looks over.

Ryan takes a picture of Matt. Out pops the picture.

 RYAN
 Oh yee of little faith.

Ryan takes the picture and begins to shake it.

 MATT
 How do I look?

Ryan's POV: In his hands, Ryan holds a photo of Ira
Livingston, a clown, in much the same position as Matt.

 RYAN
 You're an clown.

 MATT
 What?

Ryan hands Matt the photo. Matt tries studying it while
still keeping his eyes on the road.

 RYAN
 Do you think it's warped?

 MATT
 No. Warped film doesn't cause a
 person to magically appear in place
 of another.

A beat.

 MATT (CONT'D)
 Take a picture of yourself.

Ryan points the camera at himself and makes a funny face.
He takes a picture. The photo comes out. Ryan starts shaking
it. Matt keeps looking over.

 RYAN
 I'm gonna myspace this one for sure,
 man.

A beat.

 MATT
 How's it look?

Matt grabs the photo and looks at it.

Matt's POV: Another photo of Ira. It looks like he was
taking the photo of himself, much like the way Ryan took
his.

Ryan leans in, looking at the photo.

 RYAN
 Well, that's distressing.

A beat.

Matt pulls over.

 MATT
 Give me the camera. Give me the
 camera. Give me--am I fucking
 speaking to myself?

Matt grabs the camera and gets out of the car, slamming his
door.

 RYAN
 What are you doing?

EXT. ROAD -- DAY

Matt exits the car, followed by Ryan. Matt walks out into
an open field where a lone tree stands.

Matt kneels down and takes a picture of the tree. A picture
comes out of the polaroid. Matt shakes it.

A few moments pass. Ryan sits on the front hood of the car,
smoking a cigarette. Matt comes back to him and hands him
the picture.

 MATT
 We're going to get our money back
 from that gypsy.

Matt hands Ryan the photo.

Ryan's POV: A picture of Ira, standing next to the tree, in
the open field.

EXT. SUBURBAN HOUSE -- DAY

 OLD WOMAN
 No refunds.

 MATT
 Well, what if the camera only takes
 pictures of a clown man?

 OLD WOMAN
 No refunds.

Matt turns to Ryan

 RYAN
 If you look at the pictures, I think
 you'll see what we mean.

Ryan hands her the photos of Ira. The Old Woman examines
them and hands them back.

 OLD WOMAN
 (shaking her head)
 Nope.

Matt throws his hands up and begins to leave.

Ryan follows suit. He grabs a stuffed duck from the table
and turns back to the Old Woman.

 RYAN
 I'm taking this. This is mine.

EXT. ROADWAY -- DAY

The beat up station wagon speeds down the one-lane road.

INT. BEAT UP STATION WAGON -- DAY

Silence.

Ryan shakes his head.

 RYAN
 You know, that woman should never
 work in retail. Terrible
 interpersonal skills. By the way,
 do you think I could borrow five
 bucks? I spent the last of what I
 had at the garage sale.

Matt stares straight ahead.

 RYAN (CONT'D)
 What?

 MATT
 I shouldn't have gotten rid of the
 box.

 RYAN
 Are you going to start on this again?

 MATT
 What if we get back together?

 RYAN
 Not happening.

A beat.

 RYAN (CONT'D)
 Holy shit. Look at that. Pull over.

EXT. BIG TOP DRIVE-IN -- DAY

Ira, the clown, holding balloons in one hand and a tray in
another, stands near the side of the road. The beat up wagon
pulls over, backs up quickly and pulls right beside him.

Matt rolls the window down. The two stare at the mysterious
clown in the flesh.

 IRA
 Hi, welcome to the Circus Drive In.
 Would you like one of our Big Top
 Burgers?

 MATT
 (to Ryan)
 Get them out.

Ryan opens the shoebox and grabs the photos. He hands them
to Matt who in turns hands them to Ira.

EXT. BACK OF BIG TOP BURGER -- LATER

Ira sits on the curb, holding the photos. Matt and Ryan sit
on either side of him, eating the burger samples.

 IRA
 Well, that's bizarre.

 RYAN
 And you have no idea why this is
 happening?

 IRA
 I don't, actually.

A beat.

 IRA (CONT'D)
 Wait.

 RYAN
 What?

 IRA
 I did have a twin brother and he had
 a camera just like this one. He
 carried it with him all the time.
 And when he died, my family used to
 say that maybe his soul got
 transported into the camera. So
 maybe that's it. Maybe you found my
 brother's camera.

Deafening silence. Matt and Ryan sink closer to Ira.

 RYAN
 Really?

 MATT
 You're kidding.

 IRA
 How could you believe that?
 (under his breath)
 Jesus.

A beat.

 RYAN
 Wait. Give me the camera.

Matt hands Ryan the camera.

 RYAN (CONT'D)
 (to Ira)
 Could you.

Ryan motions for Ira to turn and face him. Ryan takes Ira's
picture. He shakes the photo. It's a picture of a bench
overlooking the beach with a pier to the right.

The three crowd around, looking at the picture.

 MATT
 Now what does that mean?

A beat. The three study the photo.

 IRA
 Wait. That's Rigby Pier.

 RYAN
 You know this place?

 IRA
 Yeah, they have a roller coaster
 that goes right over the ocean.

Ira points to the upper right hand portion of the picture.

 IRA (CONT'D)
 I used to do balloon shows there a
 few years back. Yeah, it's only
 about 40 minutes away from here.

INT. BEAT UP STATION WAGON -- DAY

Matt drives. Ryan sits in the passenger seat. Ira sifts
through the shoebox of pictures. He takes one of the photos
out and examines it.

 RYAN
 Feeling pretty good about this, man.
 I think this is going to be a fun
 adventure we're on here. I'm excited.

A beat.

 IRA
 Wait. Who is this?

Matt looks over and grabs the photo. He hides it in his
dashboard.

 MATT
 No one.

 RYAN
 Oh, she's cute. That's Matt's Russian
 mail order bride. She's going to be
 coming in in a couple of weeks.
 It's gonna be a spicy affair. It's
 gonna be fun.

 IRA
 Nice.

 RYAN
 Yeah.

Matt shakes his head.

 MATT
 Yeah, that's funny. Actually, my
 fiancée recently broke off our
 engagement so, at the moment, not
 quite ready to enter into the dating
 game.

 RYAN
 Yeah, dude. I don't mean to define
 things, or whatever, but six months
 doesn't seem like a recent thing.
 So when do you think you're going to
 get back on that horse...with the
 dating...if ever. Why are you
 stopping the car? Are you ever going
 to enter the dating game?

A beat.

INT. BEAT UP STATION WAGON -- LATER

Ryan sings passionately to a song playing on the stereo.
Matt and Ira stare straight ahead at the road.

After a few moments Matt ejects the tape, stopping the song.
He grabs the tape from the deck and throws it out the window.

Silence.

INT. BEAT UP STATION WAGON -- LATER

Matt drives. The car is silent.

 RYAN
 So do you think that guy really fired
 you?

 IRA
 Yeah, Wally's a big tool but the job
 honked anyway so it's cool.

 RYAN
 Hey, that rhymed!

 IRA
 Well, I'm also a lyricist.

 RYAN
 Are you really?

 IRA
 No.

 RYAN
 Do you mind?

Ryan reaches for Ira's clown nose.

 RYAN (CONT'D)
 So can you make a living off the
 clown thing?

 IRA
 No, not really. But I did just get
 this sweet gig where I started
 breeding these snakes. And those
 thing--

 MATT
 Wait. Is that it? Is this it?

 IRA
 Yeah. It's the roller coaster going
 over the ocean.

 MATT
 Okay am I speaking to myself? Where's
 the parking?

The three men look outside to be greeted by a gigantic sign
reading, "Welcome to Rigby Pier!"

EXT. BOARDWALK -- DAY

Matt holds up the photograph of the bench overlooking the
ocean. The picture matches exactly what lies before the
three of them.

Matt reaches down into the shoebox and takes out the camera.
He takes a photograph. He shakes the photo. The three men
look.

It's the same picture of the bench overlooking the ocean,
only now the red-headed girl, Mandi, is sitting on the bench.

 MATT
 Alright. Fuck this.

Matt throws the camera into the shoebox and begins to walk
off.

 RYAN
 Will you quit feeling sorry for
 yourself?

Matt turns around.

 MATT
 Excuse me?

 RYAN
 It's just that this is the first
 time, in I don't know how long, where
 I haven't seen you cry? Or better
 yet, where you've spent more than a
 half an hour outside of your
 apartment.

A beat.

 MATT
 I was crying when I came to pick you
 up this morning.

A beat. Matt pulls out his wallet and takes a bill out. He
walks over and hands it to Ryan.

 MATT (CONT'D)
 Here. I owe you this.

Matt turns and walks to the bench. He takes a seat.

Ryan looks at Ira and then pulls the camera up and snaps a
photo of Matt sitting on the bench, alone. When Ryan pulls
down the camera, Matt is gone.

The two stare in disbelief. They turn to look at the
photograph which is now of Matt and Mandi, sitting on the
bench together.

EXT. BEACH -- LATER

The water engulfs the shoebox, dragging it slowly to its
watery grave.

Ryan takes a last drag from his found cigarette and turns
around to Ira, who has been watching from back where the
beach begins. Ira waves. Around his neck hangs the camera.

INT. BEAT UP STATION WAGON -- DAY

The picture of Matt and Mandi hangs from the rear view mirror,
much like an air freshener. Ryan drives as Ira sits in the
passenger seat.

EXT. HIGHWAY -- DAY

The beat up station wagon races forward, into the sunset.

Budget for *Shoebox Redhead*

What follows is the budget I created for *Shoebox Redhead*. As with the production schedule included elsewhere, this is not the actual budget Matt Lawrence used for his production, but rather an orthodox, "textbook" version that I drew up.

You can find the template that I used to write this budget as a downloadable document at *theshortseries.com*.

Shoebox Redhead
Budget

Producer: Alan Smithee
Director: Matt Lawrence

Runcible Pictures
7 Lear Lane
Phone: (555) 555-1212
E-Mail: smithee@theshortseries.com

Notes/Assumptions: This budget is based on the following assumptions:
• Producer, Director and all postproduction services are based in Massachusetts
• Shoot will be entirely in New Jersey
• Cast will be based in New Jersey/New York area or can relocate to that area for shoot
• All cast and crew can lodge with friends and family in New Jersey
• Core camera and lighting packages will be provided by university
• Film will be exhibited in the following formats: DVD, Blu-Ray disc, HDCam

Account	Item	Total
1000	Script	71
1100	Fundraising	452
1200	Casting	121
1300	Location Scouting	146
1400	Other Preproduction Expenses	98
	Total Preproduction	**888**
2000	Crew	180
2100	Cast	60
2200	Extras	260
2300	Camera/Lighting/Grip	3800
2400	Production Audio	90
2500	Production Media	210
2600	Craft Services	1917
2700	Transportation	1576
2800	Lodging	0
2900	Locations	300
3000	Props	470
3100	Wardrobe	110
3200	Make-up & Hairdressing	82
3300	Stunts	
3400	Weapons	
3500	Sets	
3600	Production Insurance	443
3700	Other Production Expenses	50
	Total Production	**9548**
4000	Editing	1545
4100	Postproduction Media	440
4200	Music	500
4300	Postproduction Audio	2100
4400	Titles & Effects	
4500	Publicity & Distribution	3710
4600	Other Postproduction Expenses	144
	Total Postproduction	**8439**
	Total Prepro/Production/Post	**18875**
	Sales Tax Total Taxable Goods: 9432 Tax Rate: 6.25	**590**
	Contingency - 10%	**1946**
	Grand Total	**21411**

Shoebox Redhead
Budget

Account	Item	Qty	Units	X	Rate	Subtotal	Total
1000	**Script**						
1001	Story Rights						0
1002	Writer's Fee						0
1003	Registration	1	work	1	35		35
1004	Copying	35	copies	13	0.08		36
1005	Postage						0
	Account Total						**71**
1100	**Fundraising**						
1101	Support Materials	12	portfolios	1	4.25		51
1102	Travel	3	trips	1	100		300
1103	Postage	5	packages	1	5.15		26
1104	Phone						0
1105	Thank-you Gifts	5	allow	1	15		75
	Account Total						**452**
1200	**Casting**						
1201	Director's Travel for Casting	1	trip	1	85		85
1202	Snacks & Water	3	sessions	1	12		36
1203	Casting Studio Space						0
1204	Casting Agency Fee						0
	Account Total						**121**
1300	**Location Scouting**						
1301	Travel	150	miles	1	0.58		86
1302	Parking	8	hours	1	1.50		12
1303	Meals	4	meals	1	12		48
	Account Total						**146**
1400	**Other Preproduction Expenses**						
1401	Meals with Prospective Cast & Crew	4	meals	1	12		48
1402	Miscellaneous Phone Use	1	allow	1	50		50
	Account Total						**98**
	Total Preproduction						**888**

Shoebox Redhead
Budget

Account	Item	Qty	Units	X	Rate	Subtotal	Total
2000	**Crew**						
2001	Producer						
	Prep	50	days	1	0.00	0	
	Shoot	4	days	1	0.00	0	
	Post	23	days	1	0.00	0	0
2002	Director						
	Prep	50	days	1	0.00	0	
	Shoot	4	days	1	0.00	0	
	Post	23	days	1	0.00	0	0
2003	Director of Photography						
	Prep	10	days	1	0.00	0	
	Shoot	4	days	1	0.00	0	
	Wrap	4	days	1	0.00	0	0
2004	Assistant Camera						
	Prep	2	days	1	0.00	0	
	Shoot	4	days	1	0.00	0	
	Wrap	2	days	1	0.00	0	0
2005	Gaffer/Grip						
	Prep	2	days	1	0.00	0	
	Shoot	4	days	1	0.00	0	
	Wrap	2	days	1	0.00	0	0
2006	Sound Recordist						
	Prep	1	days	1	0.00	0	
	Shoot	4	days	1	0.00	0	
	Wrap	1	days	1	0.00	0	0
2007	Boom Operator						
	Shoot	4	days	1	0.00		0
2008	Production Designer						
	Prep	10	days	1	0.00	0	
	Shoot	4	days	1	0.00	0	
	Wrap	2	days	1	0.00	0	0
2009	Assistant Director						
	Prep	2	days	1	0.00	0	
	Shoot	4	days	1	0.00	0	0
2010	Makeup/Hair/Wardrobe Personnel						
	Prep		days	1		0	
	Shoot		days	1		0	0
2011	Digital Imaging Technician						
	Prep		days	1		0	
	Shoot		days	1		0	
	Wrap		days	1		0	0
2012	Script Supervisor						
	Prep	2	days	1	0.00	0	
	Shoot	4	days	1	0.00	0	
	Wrap	2	days	1	0.00	0	0
2013	Production Assistants						
	Prep	2	days	1	0.00	0	
	Shoot	4	days	1	0.00	0	
	Wrap	2	days	1	0.00	0	0

Budget

Account	Item	Qty	Units	X	Rate	Subtotal	Total
2014	Gifts & Considerations for Crew	9	gifts	1	20		180
	Account Total						**180**
2100	**Cast**						
2101	Matt						
	Rehearsal	3	days	1	0.00	0	
	Shoot	5	days	1	0.00	0	0
2102	Ryan						
	Rehearsal	3	days	1	0.00	0	
	Shoot	4	days	1	0.00	0	0
2103	Ira						
	Rehearsal	2	days	1	0.00	0	
	Shoot	2	days	1	0.00	0	0
2104	Old Woman						
	Rehearsal	1	days	1	0.00	0	
	Shoot	1	days	1	0.00	0	0
2105	Mandi						
	Rehearsal	0	days	1	0.00	0	
	Shoot	2	days	1	0.00	0	0
2105	Jacki						
	Rehearsal	0	days	1	0.00	0	
	Shoot	1	days	1	0.00	0	0
2107	Gifts & Considerations for Cast	3	gifts	1	20		60
	Account Total						**60**
2200	**Extras**						
2201	Fees for Extras						
2202	Gifts & Considerations for Extras	7	gifts	1	20		140
	Account Total						**260**
2300	**Camera, Lighting & Grip**						
2301	Camera Package	1	package	1	0.00		0
2302	Camera Support Rentals						
	Tripod	1	item	1	0.00	0	
	Baby Legs	1	item	1	0.00	0	
	Hi-Hat	1	item	1	0.00	0	0
2303	Prime Lens Kit	2.7	days	1	250		675
2304	Matte Box & Follow Focus Kit	1	kit	1	0.00		0
2305	Filters	2.7	days	3	7		57
2306	Monitor	2.7	days	1	190		513
2307	SDHC Card Adapter	1	adapter	1	45		45
2308	Camera Department Expendables	1	allow	1	77.95		78
2309	Lighting Rentals						
	Light Kit	1	kit	1	0.00	0	
	Portable LED Kit	2	kits	1	37	74	74
	Lighting Department Expendables	1	allow	1	205		205
2310	Grip Rentals						
	Dolly	2.7	days	1	300	810	
	Car Mount	2.7	days	2	90	486	

Shoebox Redhead
Budget

Account	Item	Qty	Units	X	Rate	Subtotal	Total
	Jib Arm	2.7	days	1	180	486	
	Gobos & Stands	6	items	1	0.00	0	
	12 x 12 Silk with Stand	3	days	1	65	195	
	Apple Boxes	6	items	1	0.00	0	
	Sandbags	3	days	4	1.50	18	1995
2311	Grip Department Expendables	1	allow	1	58		58
2312	Loss & Damage for Camera, Lighting & Grip	1	allow	1	100		100
	Account Total						**3800**
2400	**Production Audio**						
2401	Audio Kit Rental	1	package	1	0.00		0
2402	Additional Audio Rentals						0
2403	Audio Expendables	1	allow	1	90		90
	Account Total						**90**
2500	**Production Media**						
2501	Camera Media	4	cards	1	48		192
2502	Audio Media	1	cards	1	17.50		18
	Account Total						**210**
2600	**Craft Services**						
2601	Breakfast						
	Day 1	13	meals	1	4.50	59	
	Day 2	14	meals	1	4.50	63	
	Day 3	15	meals	1	4.50	68	
	Day 4	14	meals	1	4.50	63	
	Day 5	14	meals	1	4.50	63	316
2602	Lunch						
	Day 1	13	meals	1	8	104	
	Day 2	14	meals	1	8	112	
	Day 3	15	meals	1	8	120	
	Day 4	14	meals	1	8	112	
	Day 5	14	meals	1	8	112	560
2603	Dinner						
	Day 1	4	meals	1	6.50	26	
	Day 2	4	meals	1	6.50	26	
	Day 3	14	meals	1	14	196	
	Day 4	4	meals	1	27	108	
	Day 5	4	meals	1	14	56	412
2604	Snacks and Beverages						
	Day 1	14	snacks	1	5	70	
	Day 2	17	snacks	1	5	85	
	Day 3	19	snacks	1	5	95	
	Day 4	14	snacks	1	5	70	
	Day 5	14	snacks	1	5	70	390
2605	Wrap Party						
	Food	25	people	1	6	150	
	Drinks	25	people	1	2	50	200

Shoebox Redhead
Budget

Account	Item	Qty	Units	X	Rate	Subtotal	Total
2606	Craft Services Expendables	4	days	1	10	40	40
	Account Total						**1917**
2700	**Transportation**						
2701	Production Transportation						
	Mini-Van					0	
	Cube Truck or Cargo Van	6	days	1	31.95	192	
	Production Transportation Mileage	800	miles	1	0.58	460	
	Production Transportation Gas	47	gallons	1	3.75	176	828
2702	Crew Transportation						
	Flights					0	
	Train/Bus					0	
	Mileage Reimbursement	800	miles	3	0.58	1380	1380
2703	Cast Transportation						
	Flights					0	
	Train/Bus					0	
	Mileage Reimbursement	170	miles	2	0.58	196	196
2704	Extra Transportation						
	Bus Rental					0	
	Mileage Reimbursement		miles			0	0
2705	Tolls	1	allow	1	120		120
2706	Parking	6	vehicles	1	75		450
	Account Total						**1576**
2800	**Lodging**						
2801	Crew Lodging	6	nights	11	0.00		0
2802	Cast Lodging	6	nights	3	0.00		0
	Account Total						**0**
2900	**Locations**						
2901	Location Rentals						
	Bowling Alley Bar	1	days	1	0.00	0	
	Deal Lake Point Road	1	days	1	0.00	0	
	Garage Sale House	1	days	1	0.00	0	
	Fourth Avenue Field	1	days	1	0.00	0	
	Big Top Drive-In	1	days	1	0.00	0	
	Webster Avenue	1	days	1	0.00	0	
	Seaside Beach	1	days	1	0.00	0	0
2902	Location Permits	2	permits	1	20		40
2903	Security & Police Details	4	hours	1	50		200
2902	Gifts & Considerations for Locations	3	gifts	1	20		60
	Account Total						**300**
3000	**Props**						
3001	Prop Purchases						
	Air Freshener	2	items	1	8.50	17	
	Card Tables	2	items	1	72	144	
	Sweatin to the Oldies Tape	1	item	1	15	15	
	Polaroid Camera	1	item	1	80	80	

Account	Item	Qty	Units	X	Rate	Subtotal	Total
	Polaroid Film	5	packs	1	22	110	
	Cigarettes	1	pack	1	7	7	
	Misc. Garage Sale Junk	1	allow	1	20	20	
	Folding Chairs	4	items	1	13	52	
	Burger Samples	5	items	1	4.50	23	
	Old Cassette Tapes	4	items	1	0.50	2	470
3002	Prop Rentals		allow				0
	Account Total						**470**
3100	**Wardrobe**						
3101	Wardrobe Purchases						
	Nylon Jogging Suits	2	items	1	25	50	
	Clown Suit	1	item	1	21	21	
	Clown Wig	1	item	1	10	10	
	Clown Nose	1	item	1	3	3	
	Clown Shoes	1	item	1	26	26	110
3102	Wardrobe Rentals		allow				0
	Account Total						**110**
3200	**Makeup & Hairdressing**						
3201	Makeup Kit Rental	1	kit	1	50		50
3202	Clown Makeup Kit	1	kit	1	20		20
3203	Hair Spray	2	cans	1	6		12
	Account Total						**82**
3300	**Stunts**						
3301	Stunt Person						0
3302	Stunt Supplies						0
	Account Total						**0**
3400	**Weapons**						
3401	Weapons Specialist						0
3402	Weapons Supplies						
	Weapons Rentals					0	
	Blanks					0	
	Squibs					0	0
	Account Total						**0**
3500	**Sets**						
3501	Studio Expenses						
	Studio Rental					0	
	Studio Personnel					0	0
3502	Set Construction						
	Lumber					0	
	Hardware					0	
	Fixtures					0	0
	Account Total						**0**

Budget

Account	Item	Qty	Units	X	Rate	Subtotal	Total
3600	**Production Insurance**						
3601	Insurance for Shoot	1	Policy	1	443		443
	Account Total						**443**
3700	**Other Production Expenses**						
3701	Miscellaneous Gratuities	5	tips	1	10		50
	Account Total						**50**
	Total Production						**9548**

Shoebox Redhead
Budget

Account	Item	Qty	Units	X	Rate	Subtotal	Total
4000	**Editing**						
4001	Editor	35	days	1	0.00		0
4002	Editing Software	1	license	1	295		295
4003	Mastering Expenses						
	Color Grading	4	hours	1	250	1000	
	Output to Tape	1	hour	1	250	250	1250
	Account Total						**1545**
4100	**Postproduction Media**						
4101	Hard Drives	2	drives	1	156		312
4102	Music Recording Media	2	flash	1	16		32
4103	Media for Final Audio Mix	2	flash	1	16		32
4104	Tape Stock for Master & Submaster	2	tapes	1	32		64
	Account Total						**440**
4200	**Music**						
4201	Stock Music Licenses	1	license	1	50		50
4202	Publishing Rights						0
4203	Synchronization Rights						0
4204	Scoring						
	Composer	2	weeks	1	0.00	0	
	Musicians	4	hours	4	0.00	0	
	Recording Studio	5	hours	1	50	250	
	Music Mix	2	hours	1	50	100	
	Gifts & Consideration for Musicians	5	gifts	1	20	100	450
	Account Total						**500**
4300	**Postproduction Audio**						
4301	Sound Effects						0
4302	Sweetening	1	allow	1	500		500
4303	Final Audio Mix	8	hours	1	200		1600
	Account Total						**2100**
4400	**Titles & Effects**						
4401	Graphic Artist for Title Design						0
4402	Title Supplies						0
4403	Visual Efffects Artist						0
4404	Visual Effect Supplies						0
	Account Total						**0**
4500	**Publicity & Distribution**						
4501	Publicity Materials						
	Graphic Artist for Publicity						
	Flyer Duplication	100	copies	1	0.89	89	
	Postcard Duplication	500	cards	1	0.50	250	339
4502	Tape Duplication						
	Duplication of Exhibition Copies	1	hour	1	250	250	
	Tape Stock for Exhibition Copies	4	tapes	1	32	128	378
4502	DVD Duplication						

Shoebox Redhead
Budget

Account	Item	Qty	Units	X	Rate	Subtotal	Total
	DVD Authoring					0	
	Disc Duplication	500	copies	1	2	1000	
	Covers & Sleeves					0	1000
4503	Blu-Ray Duplication						
	Blu-Ray Authoring					0	
	Disc Duplication	1	spindle	1	23	23	
	Covers & Sleeves	2	packs	1	5	10	33
4504	Film Festivals						
	Entry Fees	20	entries	1	40	800	
	Postage for Festival Entry					0	
	Postage for Shipping Tapes & Flyers	20	itmes	1	4	80	
	Travel					0	
	Lodging	2	trips	1	350	700	
	Food	8	meals	1	15	120	1700
4505	Website						
	Web Designer	1	flat	1	200	200	
	Registration and Hosting Fees	2	years	1	30	60	260
	Account Total						**3710**
4600	**Other Postproduction Expenses**						
4601	Postproduction Meals	12	meals	1	12		144
	Account Total						**144**
	Total Postproduction						**8439**

STANDARD RATES

HOW TO USE THIS TOOL:

If you are repeatedly using a standard rate for a budget item, you can use the rates in the chart below to make sure whatever value you use is applied consistently throughout your budget. Using these shortcuts also allows you to revise or update rates easily and uniformly. In drawing up your budget, simply enter the cell reference from the table below (e.g. H433) for the relevant rate. The figure in the cell then will be "plugged in" automatically anywhere it is cited. When you change an amount in the table, that change then is also immediately reflected anywhere that the rate is used within the budget. The items included in the table are just examples; you can edit and add to the table to make it suit your needs. The last item (Three Day Week) is a way of indicating in the budget where a weekly rate based on the standard three-day rate is in use.

ITEM	RATE
Mileage	0.575
Massachusetts Sales Tax	6.25
Will Work for Food/No Charge	0
Uniform Flat Day Rate	100
Three-Day Week Rate	3
10% Student Discount (use in multiplier column)	0.9
10% Student Discount Applied to Three-Day Week	2.7

Contract Templates

The contracts provided here are a good starting point for agreements you should enter into with your crew, cast and location contacts. They are provided with a couple strong caveats. First and foremost, I am not a lawyer and therefore don't claim to be providing documents that will withstand legal challenge. Second, every production has its special considerations, and these distinctive qualities may need to be addressed in your legal documents. If you are at all concerned about safeguarding your work from a legal standpoint, you should seek the advice of a lawyer. If you genuinely can't afford to have a lawyer draft agreements from scratch, you might be able to save money by having a lawyer review and edit documents that you have already drafted.

You can find downloadable versions of these documents at *theshortseries. com*.

Purchase Agreement Template for Acquisition of Underlying Story Rights

When to Use: When the basis for your screenplay is someone else's life, story, book, article, blog, plot, character or other literary or artistic work.

Why It's Important: Underlying rights to the story of a film are often separate from rights in the film itself. Unless your film is a strictly factual documentary or is based on an original story of your own creation, you'll need to acquire the right to use the story you want to tell before adapting it for the screen.

This Agreement is made as of **[DATE]**, by and between **[PRODUCER'S NAME]**, located at [PRODUCER'S **ADDRESS**] ("Producer"), and **[RIGHTS HOLDER]**, an individual with an address at **[ADDRESS]** ("Owner"). This Agreement will set forth the terms under which Producer may acquire motion picture rights in an original work of authorship owned by Owner (the "Work").

1. Description of the Work

The Work covered by this Agreement is **[TITLE]**, written by **[AUTHOR]**. The Work includes all materials upon which it is based, and all titles, actions, storylines, dialog, plots, phrases, compositions, illustrations, characters, characterizations, specific themes, and names contained therein, as well as any elements added or incorporated into the Work at any time, and all versions of the Work, past, present, or future, in any form.

2. Consideration

As full and complete consideration for all rights, property, and promises granted herein, Producer shall remit compensation to Owner in the form of **[INSERT AGREED-UPON CONSIDERATION]**. Both parties agree that this constitutes adequate consideration to support the rights granted to Producer by Owner herein. For purposes of this paragraph, "consideration" means something of value to which Owner is not already entitled.

3. Scope of Rights

Owner sells, grants, and assigns to Producer all motion picture rights in and to the Work, throughout the universe, in perpetuity, in any and all media and formats now known or hereafter devised. This grant of rights expressly includes the right to produce remakes, sequels, versions, series, derivative works, and adaptations of any motion picture based on the Work, and the right to broadcast, distribute, and publish synopses, clips, reviews, trailers, and promotional materials in connection with any such motion picture. All rights not specifically granted to Producer pursuant to this Agreement are reserved to Owner, including the right to produce and

created by Bricolage Law, LLC • www.bricolagelaw.com

commercialize printed versions of the Work and author-written sequels in book form.

4. Screen Credit

In the event Producer completes a motion picture based substantially on the Work, Owner shall receive credit in the following form: _____. Such credit shall be included in the main titles of the motion picture. Placement, size, style, and duration of said credits shall be in Producer's sole discretion.

5. No Obligation to Produce

While Producer shall use best efforts to affect a production hereunder, nothing herein shall be construed to obligate Producer to produce, distribute, release, perform, or exhibit a motion picture based upon the Work, in whole or in part, or otherwise to exercise, exploit or make any use of the rights, license, privileges, or property granted herein.

6. Relationship of Parties

Producer and Owner are entering into this Agreement as independent contractors, and no partnership or joint venture or other association shall be deemed created by this Agreement.

7. Editorial and Artistic Control

Owner waives any right to interfere with or to prevent the exercise of Producer's sole and absolute discretion with regard to Producer's adaptation of the Work into a motion picture. It is understood and agreed that Producer shall retain full editorial control of any motion picture based upon the Work at all times.

8. Representations and Warranties

Owner hereby warrants and represents that Owner is the true, correct, and current rights holder with respect to the Work, and that Owner is not now, and will not in the future become, subject to any obligation, contractual limitation, lien, license, agreement, or assignment that might prevent or materially

interfere with Producer's use of the Work in the manner contemplated by this Agreement.

9. Indemnification

Owner shall indemnify and hold Producer harmless from any and all claims, causes of action, losses, damage, liabilities, costs, and expenses, including attorney fees, arising from the breach of Owner's warranties contained in this Agreement or related to material licensed and/or supplied to Producer by Owner.

10. Entire Agreement

This Agreement represents the entire agreement of the parties hereto relating to the subject matter hereof, and any prior agreements, promises, negotiations, or representations, whether oral or written, not expressly set forth in this Agreement are of no force and effect. This Agreement may be modified only by a writing signed by both parties.

11. Governing Law

This Agreement shall take effect under and be governed by the laws of the State of **[STATE WHERE PRODUCER IS LOCATED].**

12. Authority

The undersigned has full power and authority to enter into this Agreement and does so voluntarily, knowingly, and without duress.

PRODUCER:

By:

Date:

OWNER:

By:

Date:

Screenwriter Agreement Template

When to Use: After selecting and hiring a writer but before beginning filming based on the writer's manuscript.

Why It's Important: The default rule of copyright law is that whoever creates a work owns it. In the case of screenwriters, this fact is vitally important. It means that, without a contract in place between the writer and the producer, the writer may automatically own all rights to the content, dialog, setting, and scene directions of the film. The following agreement keeps the rights in the film with the producer, allowing the producer to freely develop and commercialize the script into a motion picture.

This Agreement is made as of **[DATE]**, by and between **[PRODUCER'S NAME]**, located at **[PRODUCER'S ADDRESS]** ("Producer"), and **[WRITER]**, an individual with an address at **[WRITER'S ADDRESS]** ("Screenwriter"). This Agreement will set forth the terms under which Producer has agreed to engage Screenwriter to render services to Producer in connection with the film currently entitled **[NAME OF FILM]** (the "Film").

1. Provision of Services by Independent Screenwriter

Screenwriter shall prepare and deliver the script for the Film in accordance with the terms and conditions of this Agreement. Screenwriter shall perform said services at the times and places required by Producer and in a conscientious and professional manner, consistent with Screenwriter's best efforts, talents, and abilities. It is understood that Screenwriter is an independent contractor in the performance of this Agreement and not an employee of Producer. Nothing contained herein shall be construed to imply an employment, joint venture, or principal-and-agent relationship between the parties; and neither party shall have any right, power, or authority to create any obligation, express or implied, on behalf of the other. Screenwriter shall not be entitled to participate in any plans, benefits, or distributions intended for Producer employees. Screenwriter agrees that Producer will make no deductions from any compensation paid to Screenwriter for, and Screenwriter shall have full and exclusive liability for, the payment of any taxes and/or contributions for unemployment insurance, workers' compensation, or any other employment-related costs or obligations related to the provision of the Screenwriter's services.

2. Term

Time is of the essence in the provision of Screenwriter's services under this Agreement. Screenwriter shall deliver completed work to Producer according to the schedule set forth in Exhibit A. Should any scheduling conflict or impediment to completion of the services or to any portion thereof arise, Screenwriter will promptly contact Producer. This Agreement shall terminate upon completion of editing of the film.

3. Consideration

As full and complete consideration for all rights, property, and promises granted herein, Producer shall remit compensation to Screenwriter in the form of **[INSERT AGREED-UPON CONSIDERATION]**. Both parties agree that this constitutes adequate consideration to support the rights granted to Producer by Screenwriter herein. For purposes of this paragraph, "consideration" means something of value to which Screenwriter is not already entitled.

4. Screen Credit

Producer shall accord Screenwriter the following screen credit on the Film: **[SCREEN CREDIT]**. All aspects of such credit, including but not limited to placement, size, type, and duration, shall be determined by Producer in Producer's sole discretion.

5. Ownership of Intellectual Property; Work-For-Hire

Screenwriter acknowledges and agrees that the Film script and all results, product, and proceeds therefrom, including the Film itself and all manuscripts, drafts, notes, formats, versions, and portions thereof (collectively, the "Work"), are works-for-hire under the United States Copyright Act. Producer shall solely and exclusively own all right, title, and interest to the Work, including, but not limited to, worldwide copyrights, moral rights, trademarks, rights of publicity, merchandising rights, and all other rights of whatever kind and character throughout the world, in perpetuity. Producer may add to, subtract from, change, arrange, revise, adapt for alternate mediums and venues, rearrange, translate into any and all

created by Bricolage Law, LLC • www.bricolagelaw.com

languages, change the sequence, change the characters and the descriptions thereof, change the title, record, photograph, make derivative and sequential works from, produce, reproduce, broadcast, use, perform, commercialize, distribute, register, protect, and enforce the Work, or any portion, character, or composition thereof, in Producer's sole and absolute discretion.

6. Editorial and Artistic Control

Screenwriter waives any right to interfere with or to prevent the exercise of Producer's sole and absolute discretion with regard to the Work, including all matters of direction, artistic taste, and judgment. It is understood and agreed that Producer shall retain content, editorial, and technical control of the Work at all times.

7. Confidentiality

Screenwriter acknowledges and agrees that: (a) the Work and any information, work in progress, storyboards, concepts, artwork, casting, release dates, locations, trade secrets, or other confidential matter related to the Film and to any other business or projects of Producer constitute confidential information ("Confidential Information"), and (b) that Screenwriter shall not use, copy, or disclose to any person or entity any such Confidential Information, unless such use, copying, or disclosure is necessary to accomplish Screenwriter's duties hereunder and has been preauthorized in writing by Producer. In keeping with Screenwriter's confidentiality obligations, Screenwriter will not directly or indirectly create, circulate, publish, or otherwise disseminate any news story, article, book, social media post, image, interview, or other media concerning *the Work, at any stage or period of development or production*, without Producer's prior written consent.

8. Indemnity and Warranty

Screenwriter warrants and represents that: (a) all of the Work shall be wholly original, except as to matters within the public domain; and (b) none of the Work shall infringe upon or violate the intellectual property, privacy, or publicity rights

of, or constitute defamation against, or violate any common law or any other rights of, any person, group, or entity. Screenwriter shall indemnify and hold Producer harmless from any and all claims, causes of action, losses, damage, liabilities, costs, and expenses, including attorney fees, arising from the breach of the warranties in this paragraph.

9. Termination

Screenwriter's connection to the Film is at-will and may be terminated at any time, for any reason or for no reason, upon written notice thereof to Screenwriter. Termination of this Agreement, whether by exercise of a right of termination, lapse of time, mutual consent, operation of law, or otherwise shall terminate Producer's obligation to pay Screenwriter any further compensation.

10. Assignment

This Agreement is personal to Screenwriter. Neither this Agreement nor any rights or duties hereunder may be assigned or delegated to any other person or entity. Any such purported assignment or subcontract shall be void.

11. Entire Agreement

This Agreement represents the entire agreement of the parties hereto relating to the subject matter hereof, and any prior agreements, promises, negotiations, or representations, whether oral or written, not expressly set forth in this Agreement are of no force and effect. This Agreement may be modified only by a writing signed by both parties.

12. Governing Law

This Agreement shall take effect under and be governed by the laws of the State of **[STATE WHERE PRODUCER IS LOCATED]**.

13. Authority

The undersigned warrants and represents that the undersigned has full power and authority to enter into this

The obligatory fine print: This sample document is for informational and educational purposes, and does not constitute the provision of legal or other professional advice. You should seek counsel from an attorney licensed in your state before relying on or using any sample agreement or template so that the document may be adapted to your specific circumstances and needs.

created by Bricolage Law, LLC • www.bricolagelaw.com

Agreement, to bind Contractor hereto, and to grant the rights set forth herein.

PRODUCER:

By:
Address:
Telephone Number:
SCREENWRITER:

By:
Address:
Telephone Number:

Exhibit A

When to Use: _Below is an example of Exhibit A, which would accompany the Screenwriter Agreement. As protracted as this process looks when outlined on paper, this schedule is actually quite optimistic in terms of the number of drafts that will be required. It lays out what should be viewed as only the minimum contractual expectations in terms of notes and revisions._

Exhibit A: Deadlines for Drafts, Revisions, and Final Manuscript of the Screenplay for "[Name of Film]"

Producer and Screenwriter agree to adhere to the following deadlines:

[21 WEEKS PRIOR TO START OF PRODUCTION]: Screenwriter delivers first draft

[20 WEEKS PRIOR TO START OF PRODUCTION]: Production team delivers notes on first draft

[17 WEEKS PRIOR TO START OF PRODUCTION]: Screenwriter delivers second draft

[16 WEEKS PRIOR TO START OF PRODUCTION]: Production team delivers notes on second draft

[14 WEEKS PRIOR TO START OF PRODUCTION]: Screenwriter delivers polished draft

[13 WEEKS PRIOR TO START OF PRODUCTION]: Production team delivers final notes (if necessary)

[12 WEEKS PRIOR TO START OF PRODUCTION]: Final manuscript delivered

Services Agreement Template for Crew

When to Use: Unless you have created a formal company and hired full-time employees, the members of your crew need to agree to and sign a work-for-hire agreement. This agreement should be entered into and signed before any person performs work on your film. This includes members of the camera, lighting, grip, sound, art, makeup, wardrobe and continuity departments—in other words, all the crew hired to work on your film. If you are making a student film and using your classmates as crew, you are unlikely to be paying for those services. Even so, you need to get your classmates to sign off on this agreement.

Why It's Important: The default rule of copyright law is that whoever creates a work owns it. If more than one person contributes to the final product, there is a risk that ownership rights will be shared by all contributors. The way to override that default rule is through contract. By contractually agreeing that all work, services and contributions provided by crew members are performed on behalf of and explicitly assigned to the production, you can ensure that ownership rights to the film remain with the producer and are not owned piecemeal by each person who worked on it. The agreement also ensures that your project remains confidential before it is released, both from the public and from other filmmakers for whom your temporary crew may be working.

This Independent Contractor Services Agreement is made as of **[DATE]**, by and between **[PRODUCER'S NAME]**, located at **[PRODUCER'S ADDRESS]** ("Producer"), and **[CREW MEMBER'S NAME]**, an individual with an address at **[CREW MEMBER'S ADDRESS]** ("Contractor").

1. Provision of Services

Contractor agrees to provide Services in connection with a film currently entitled **"[FILM TITLE]"** (the "Film"), in accordance with the terms and conditions of this Agreement, and as described on Exhibit A hereto. It is understood that Contractor is an independent contractor in the performance of this Agreement and not an employee of Producer. Nothing contained herein shall be construed to imply an employment, joint venture, or principal-and-agent relationship between the parties; and neither party shall have any right, power, or authority to create any obligation, express or implied, on behalf of the other. Contractor shall not be entitled to participate in any plans, benefits, or distributions intended for Producer employees. Contractor agrees that Producer

will make no deductions from any compensation paid to Contractor for, and Contractor shall have full and exclusive liability for, the payment of any taxes and/or contributions for unemployment insurance, workers' compensation, or any other employment-related costs or obligations related to the provision of the Services.

2. Additional Services

Exhibit A may be modified, from time to time, upon agreement of the parties. If Producer requests modified or additional Services, Contractor shall provide Producer with an estimate of changes to the compensation payable and impact upon milestone or completion dates, if any. Contractor shall proceed with such modified or additional Services only upon Producer's written approval.

3. Term

Time is of the essence in the provision of Services under this Agreement. Contractor shall commence provision of Services on **[DATE].** This Agreement shall terminate upon Contractor's completion of the Services in accordance with Exhibit A, unless earlier terminated in accordance with Paragraph 10 below.

4. Consideration

Important Note: *Federal laws require that all workers be paid minimum wage. This includes all crew members and applies equally to blockbuster movies, low-budget productions, short films, crowdfunded projects and web productions. The only exceptions are: (a) student films not intended to make a profit; (b) production companies organized as non-profit corporations; and (c) crew members receiving verifiable college credit for their contributions in lieu of payment. In other words, if you are a* **for-profit** *production, you cannot employ unpaid "volunteers," even if the volunteer genuinely wants to work for free. If you are providing in-kind services, items (like a copy of the finished film), or other non-cash compensation, make sure that the value exchanged is comparable to what the crew member would have earned if you had paid in cash.*

As full and complete consideration for all rights, property, and promises granted herein, Producer shall remit compensation to Contractor in the form of **[INSERT AGREED-UPON CONSIDERATION]**. Both parties agree that this constitutes adequate consideration to meet all financial obligations of Producer to Contractor, including services rendered on nights, weekends, and/or holidays, and including travel, food, lodging, and all miscellaneous expenses.

5. Screen Credit

Producer shall accord Contractor the following screen credit on the Film: **[SCREEN CREDIT FOR CREW POSITION]**. All aspects of such credit, including but not limited to placement, size, type, and duration, shall be determined by Producer in Producer's sole discretion.

6. Ownership of Intellectual Property; Work-For-Hire

Contractor acknowledges and agrees that the Services will be rendered as a work-for-hire under the United States Copyright Act in effect as of the date of this Agreement, notwithstanding any changes, modifications, or amendments which may hereafter be made to said Act. Contractor further acknowledges and agrees that the Film, all derivatives, sequels, and versions of the Film, all Contractor's contributions thereto, all materials used in the production of the Film, all results and proceeds of the Film, and all work product created or developed and Services rendered by Contractor in connection with the Film are created for exclusive use by Producer. Producer shall own all right, title, and interest to the Film and to any ideas, improvements, developments, and other contributions by Contractor to the Film, including, without limitation, worldwide copyrights, moral rights, patents, trademarks, rights of publicity, and any and all other such rights of whatever kind, and the right to obtain registrations, renewals, reissues, and extensions of the same. Consistent with those rights, Producer may use, copy, publish, reproduce, distribute, choose not to distribute, assign, alter, or destroy the Film or any portion thereof in Producer's sole and absolute discretion, without notice or further compensation to Contractor. Contractor shall acquire no right and has no

authority to use the names, characters, artwork, designs, tradenames, copyrighted materials, trademarks, or service marks of Producer in any manner to express or to imply any ownership interests in the Film or any endorsement by Producer of Contractor or Contractor's Services.

7. Editorial and Artistic Control

Contractor waives any right to interfere with or to prevent the exercise of Producer's sole and absolute discretion with regard to the Film, including all matters of direction, artistic taste, and judgment. It is understood and agreed that Producer shall retain content, editorial, and technical control of the Services and the Film at all times.

8. Confidentiality

Contractor acknowledges and agrees that: (a) the Film and all materials and Services related thereto and any information, work in progress, storyboards, concepts, artwork, casting, release dates, locations, trade secrets, or other confidential matter related to the Film and to any other business or projects of Producer constitute confidential information ("Confidential Information"), and (b) that Contractor shall not use, copy, or disclose to any person or entity any such Confidential Information, unless such use, copying, or disclosure is necessary to accomplish Contractor's duties hereunder and has been preauthorized in writing by Producer. In keeping with Contractor's confidentiality obligations, Contractor will not directly or indirectly create, circulate, publish, or otherwise disseminate any news story, article, book, social media post, image, interview, or other media concerning *the Film* without Producer's prior written consent. Immediately upon termination of this Agreement, Contractor agrees to deliver all copies of Producer's property, including, without limitation, Confidential Information used, maintained, recorded, or accessed by Contractor in the performance of Services.

9. Waiver of Publicity Rights; Advertising and Promotion

Contractor authorizes Producer and other persons and entities designated by Producer to use Contractor's name, voice, biography, and likeness in such manner as Producer

may determine for promotion and advertising purposes in connection with the Film.

10. Insurance

Producer shall not provide insurance coverage of any kind for Contractor. Contractor shall be solely responsible for obtaining comprehensive general liability insurance coverage, including coverage for bodily injury, personal injury, property damage, contractual liability, and cross-liability. If Contractor owns or uses a vehicle in connection with the Services, including for transportation to and from the Film's location, Contractor must also maintain automobile liability insurance at all times during the term of this Agreement.

11. Indemnity and Warranty

Contractor shall at all times comply with all applicable laws, statutes, ordinances, employment eligibility rules, license, permit, and certificate requirements, and other governmental requirements. Contractor shall indemnify and hold Producer harmless from any and all claims, causes of action, losses, damage, liabilities, costs, and expenses, including attorney fees, arising from the death of or injury to any person, from damage to or destruction of property, or from breach of the warranties in this paragraph, arising from the provision of Services by Contractor. Contractor warrants that the Services provided by Contractor and/or work delivered to Producer does not infringe upon or violate the rights of any third party, and that use of same by Producer will not violate or infringe the rights of any person or party.

12. Termination

Producer reserves the right to terminate this Agreement at any time, for any reason or for no reason. Contractor shall be compensated for all Services provided prior to termination, except in the case of Contractor's material breach of Contractor's obligations, covenants, or representations under this Agreement or under any applicable laws, rules, or government regulations.

13. Assignment

This Agreement is personal to Contractor. Neither this Agreement nor any rights or duties hereunder may be assigned or delegated to any other person or entity by Contractor without the prior written consent of Producer. Any such purported assignment or subcontract shall be void.

14. Entire Agreement

This Agreement represents the entire agreement of the parties hereto relating to the subject matter hereof, and any prior agreements, promises, negotiations, or representations, whether oral or written, not expressly set forth in this Agreement are of no force and effect. This Agreement may be modified only by a writing signed by both parties.

15. Governing Law

This Agreement shall take effect under and be governed by the laws of the State of **[STATE WHERE PRODUCER IS LOCATED]**.

16. Authority

The undersigned warrants and represents that the undersigned has full power and authority to enter into this Agreement, to bind Contractor hereto, and to grant the rights set forth herein.

PRODUCER:

By:
Address:
Telephone Number:

CONTRACTOR:

By:
Address:
Telephone Number:

Performer Agreement Template for Cast Members

When to Use: *This agreement should be signed by all persons appearing in your film. If the performer is a minor or is otherwise unable to legally sign on his or her own behalf (think animal actors), be sure to have an authorized representative or legal guardian sign before production begins.*

If you are working with performers covered by the SAG-AFTRA contract, many points in this agreement will be superseded by the terms of the union agreement.

Why It's Important: *Everyone who works on a film, from best boy to lead actor, contributes to the ultimate product. By agreeing in advance about each person's roles, responsibilities, rights, compensation and other terms and conditions of the producer/cast relationship, you can lower the risk of misunderstanding and discord that could delay or halt production later.*

This Agreement is made as of **[DATE]**, by and between **[PRODUCER'S NAME]**, located at **[PRODUCER'S ADDRESS]** ("Producer"), and **[PERFORMER'S NAME]**, an individual with an address at **[PERFORMER'S ADDRESS]** ("Performer").

1. Provision of Services

Producer hereby engages Performer to render services in the role of **[ROLE]** in the film currently entitled **"[FILM TITLE]"** (the "Film"). Rehearsals and filming shall take place at **[SHOOT LOCATION(S)]** on or around **[SHOOT DATES]** and are tentatively scheduled to end on or around **[ANTICIPATED WRAP DATES]**.

2. Non-Union Film [OPTIONAL]

Producer makes the material representation that it is not a signatory to the Screen Actors Guild collective bargaining agreement or any other union or guild agreement. Performer warrants that Performer is not a member of any union or guild memberships that would prevent Performer from working on the Film.

created by Bricolage Law, LLC • www.bricolagelaw.com

3. Consideration

Important Note: Federal laws require that all workers, including actors, be paid at least minimum wage. If you are a **for-profit** *production, you cannot hire volunteer actors, even if the performer wants to appear in the film for free. If you are creating a student film or non-profit production, then you may be able to use volunteers in your work or offer screen credit, publicity, or other perks to your actors in lieu of financial compensation.*

Upon the condition that Performer fully performs all services and material obligations required hereunder, Producer shall pay Performer, as full and complete consideration for Performer's appearance, portrayal, artistic contributions, efforts, and services, and all results and proceeds thereof (the "Performance"), the total sum of **[DOLLAR AMOUNT]**. This sum represents all financial obligations of Producer to Performer, including services rendered on nights, weekends, and/or holidays, re-takes and reshoots, sound dubbing and postproduction voice work, filming for trailers, previews, and special releases, promotional appearances, transportation and travel, food, lodging, and all miscellaneous and incidental expenses. Producer further agrees to provide Contractor with a digital copy of the completed Film.

4. Credit

Producer shall accord Performer the following screen credit on the Film: **[SCREEN CREDIT]**. All aspects of such credit, including but not limited to placement, size, type, and duration, shall be determined by Producer in Producer's sole discretion.

5. Name and Likeness

Performer irrevocably and voluntarily grants Producer the unrestricted right in perpetuity to record, reproduce, edit, alter, license, exhibit, distribute, display, promote, publicize, commercialize, add special effects and/or sound to, and

otherwise make use of the Performance and of Performer's name, image, likeness, voice, biographical information, and other elements or attributes of Performer's persona or appearance in connection with the Film in any manner, media, and format now known or hereafter devised, in Producer's sole and absolute discretion. Nothing contained herein shall obligate Producer or any other entity to develop, produce, distribute, or otherwise exploit the Performance or the Film in any way, to use Performer's name or likeness in any version of the Film, or to include Performer in promotional activities and efforts for the Film.

6. Ownership of Intellectual Property; Work-For-Hire

Performer acknowledges and agrees that the Performance is a work-for-hire under the United States Copyright Act in effect as of the date of this Agreement, notwithstanding any changes, modifications, or amendments which may hereafter be made to said Act. Performer further acknowledges and agrees that the Film, all derivatives, sequels, and versions of the Film, all Performer's contributions thereto, all materials used in the production of the Film, including master media and outtakes, all results and proceeds of the Film, and all work product created or developed and services rendered by Performer in connection with the Film are created for exclusive use by Producer. Producer shall own all right, title, and interest to the Film and to any ideas, improvements, developments, and other contributions by Performer to the Film, including, without limitation, worldwide copyrights, moral rights, patents, trademarks, rights of publicity, and any and all other such rights of whatever kind, and the right to obtain registrations, renewals, reissues, and extensions of the same. Consistent with those rights, Producer may use, copy, publish, reproduce, distribute, choose not to distribute, assign, alter, or destroy the Film or any portion thereof in Producer's sole and absolute discretion, without notice or further compensation to Performer. Performer shall acquire no right and has no authority to use the names, characters, artwork, designs, tradenames, copyrighted materials, trademarks, or service marks of Producer in any manner to express or to imply any ownership interests in the Film or

any endorsement by Producer of Performer or Performer's Services.

7. Editorial and Artistic Control

Performer waives any right to interfere with or to prevent the exercise of Producer's sole and absolute discretion with regard to the Film, including all matters of direction, artistic taste, and judgment. It is understood and agreed that Producer shall retain content, editorial, and technical control of the Film at all times.

8. Confidentiality

Performer acknowledges and agrees that: (a) the Film and all materials related thereto and any information, works in progress, recordings, edits, storyboards, concepts, artwork, casting, release dates, locations, trade secrets, or other confidential matter related to the Film and to any other business or projects of Producer constitute confidential information ("Confidential Information"), and (b) that Performer shall not use, copy, or disclose to any person or entity any such Confidential Information, unless such use, copying, or disclosure is necessary to accomplish Performer's duties hereunder and has been preauthorized in writing by Producer. In keeping with Performer's confidentiality obligations, Performer will not directly or indirectly create, circulate, publish, or otherwise disseminate any news story, article, book, social media post, image, interview, or other media concerning *the Film* without Producer's prior written consent, provided, however, that Performer may use portions of the Film in which Performer appears for Performer's demo reel.

9. Rules of Production

Performer agrees to adhere to the schedule set by Producer for all preproduction, production, and postproduction activities, including any necessary reshoots or re-recordings. Should any scheduling conflict or impediment to performance arise, Performer will promptly contact Producer. At all times, Performer will act in accordance with the reasonable directions

of Producer and will devote Performer's best talents, efforts, and abilities to the Film.

10. Performer as Freelancer

Performer is contracted exclusively on a freelance basis in connection with the Film. Should Performer retain or make use of an agent at any time during the term of this Agreement, the relationship between Producer and Performer shall not be altered in any way, nor shall either party's rights and obligations under this Agreement be modified or transferred.

11. Indemnity and Warranty

Performer shall at all times comply with all applicable laws, statutes, ordinances, employment eligibility rules, license, permit, and certificate requirements, and other governmental requirements. Performer shall indemnify and hold Producer harmless from any and all claims, causes of action, losses, damage, liabilities, costs, and expenses, including attorney fees, arising from Performer's actions or omissions or from the actions or omissions of Performer's agents or invitees.

12. Termination

Producer reserves the right to terminate this Agreement at any time, for any reason or for no reason. Performer shall be compensated for all services provided prior to termination. Producer shall retain all rights to Performer's name, likeness, image, and any portion of the Performance performed or recorded prior to termination.

13. Assignment

This Agreement is personal to Performer. Neither this Agreement nor any rights or duties hereunder may be assigned or delegated to any other person or entity by Performer without the prior written consent of Producer. Any such purported assignment or subcontract shall be void.

14. Available Remedies

In the event of any breach of this Agreement by Producer, Performer's remedy shall be limited to an action at law for damages, if any. In no event shall Performer have the right to enjoin or interfere with the production, distribution, advertising, promotion, or exploitation of the Film or any derivatives thereof by Producer or its designees.

15. Entire Agreement

This Agreement represents the entire agreement of the parties hereto relating to the subject matter hereof, and any prior agreements, promises, negotiations, or representations, whether oral or written, not expressly set forth in this Agreement are of no force and effect. This Agreement may be modified only by a writing signed by both parties.

16. Governing Law

This Agreement shall take effect under and be governed by the laws of the State of **[STATE WHERE PRODUCER IS LOCATED].**

17. Authority

The undersigned warrants and represents that the undersigned has full power and authority to enter into this Agreement, to bind Performer hereto, and to grant the rights set forth herein.

PRODUCER:

By:
Address:
Telephone Number:

PERFORMER:

By:
Address:
Telephone Number:

Location Agreement Template

When to Use: *Whenever you are filming in a location that you do not own, including exteriors, interiors and any surroundings. Some property owners who rent their properties to crews on a regular basis will have their own location agreement. That's fine—just be sure that you read their contract and that you fully understand each term and its implications for your plans. A good way of assessing a third-party contract is to compare it to the templates in this book, as well as to other sample agreements available online.*

Why It's Important: *Finding and securing the right location for a film can be one of the most crucial (and expensive) aspects of the production process. Making sure that the expectations and requirements of the property owner are known, understood and followed by the cast and crew will help ensure that you are invited back to the location as needed.*

This Location Agreement is made as of **[DATE]**, by and between **[PRODUCER]**, located at **[ADDRESS]** ("Producer"), and **[NAME OF LOCATION]** ("Licensor"), for the use of the property and adjacent area located at **[LOCATION ADDRESS]** ("Location") in connection with a film currently entitled **[FILM TITLE]** (the "Film").

1. Grant of License

Producer and Producer's employees, representatives, agents, contractors, and invitees (together, the "Production Team") are hereby granted a license to use and depict the interiors, exteriors, name, and surroundings of the Location, including all signage and ornamentation, for the purposes of rehearsing, photographing, filming, and recording scenes and sounds for the Film (the "License"). The License shall include the right of the Production Team to bring personnel, sets, props, and equipment onto Location, and to remove the same from Location after completion of work, provided that doing so does not cause undue damage or harm to the Location and that the Production Team returns the Location to its original condition at the termination of this Agreement, normal wear and tear excepted.

2. Time of Access

The License shall grant the Production Team access to the Location for the period commencing on or about **[DATE USE**

OF PROPERTY WILL BEGIN] and continuing until **[DATE USE WILL END**]. The period may be extended by agreement of the parties if there are changes in the production schedule or delays due to weather conditions. The Production Team shall also be permitted access to the Location for a reasonable time period following the above end date as necessary to film reshoots and/or added scenes.

3. Consideration

Producer shall remit compensation to Licensor in the form of **[INSERT AGREED-UPON CONSIDERATION]**. Both parties agree that this constitutes adequate consideration to support the rights granted to Producer by Licensor herein. For purposes of this paragraph, "consideration" means something of value to which Licensor is not already entitled.

4. Ownership of Intellectual Property Rights

Ownership of the Film, all audio and video recordings, images, derivatives, sequels, versions, results, and proceeds thereof, all materials used in production, and all work product created or developed in connection with the Film belong exclusively to Producer. Producer shall own all right, title, and interest to the Film, including, without limitation, worldwide copyrights, moral rights, patents, trademarks, rights of publicity, and any and all other such rights of whatever kind, and the right to obtain registrations, renewals, reissues, and extensions of the same. Consistent with those rights, Producer may use, copy, publish, reproduce, distribute, assign, edit, abridge, or alter the Film or any portion thereof in Producer's sole and absolute discretion, without any further obligation, notice, or compensation to Licensor. Nothing contained herein shall be deemed to obligate Producer or any other entity to develop, produce, distribute, or otherwise exploit the Film or to utilize the Location in any way.

5. Editorial and Artistic Control

Producer retains sole and absolute discretion with regard to the appearance and use of the Location in the Film, including the right to obscure or change the name, nature, or identity of the Location for storytelling or artistic purposes.

6. Confidentiality

The Film and all materials related thereto and any information, works in progress, images, recordings, and other work product related to the Film and to any other business or projects of Producer constitute the confidential information of Producer. Neither Licensor nor any representative, agent, invitee, or resident of the Location shall use, copy, or disclose in any format or manner, including social media, any such confidential information unless such use, copying, or disclosure has been preauthorized in writing by Producer.

7. Indemnification

Producer agrees to indemnify and hold harmless Licensor from and against any and all liabilities, damages, and claims of third parties arising from the Production Team's use of the Location, and from any physical damage to the Location proximately caused by the Production Team, unless such liabilities, damages, or claims arise from Licensor's own negligent or intentional acts or omissions or from Licensor's breach of the warranties set forth in this Agreement. Licensor releases and discharges the Production Team from any and all claims, demands, or causes of actions that Licensor may now have or may from now on have for libel, defamation, invasion of privacy or right of publicity, infringement of copyright or trademark, or violation of any other right arising out of or relating to the Production Team's use of the Location in connection with the Film.

8. Entire Agreement

This Agreement represents the entire agreement of the parties hereto relating to the subject matter hereof, and any prior agreements, promises, negotiations, or representations, whether oral or written, not expressly set forth in this Agreement are of no force and effect. This Agreement may be modified only by a writing signed by both parties.

9. Governing Law

This Agreement shall take effect under and be governed by the laws of the State of **[STATE WHERE PRODUCER IS LOCATED].**

10. Authority

The undersigned warrants and represents that s/he has the full right and authority to grant the License, and that the exercise by Producer of the rights granted in this Agreement shall not violate or infringe upon the rights of any person or entity whatsoever, or create any liability of any kind.

PRODUCER:

By:
Address:
Telephone Number:

LICENSOR:

By:
Address:
Telephone Number:

Synchronization License Agreement Template

When to Use: When you want to use or re-record a musical composition in your film. Keep in mind that, when you want to incorporate existing music into your film, the sync license is typically only half the battle. Because a sync license does not include the right to use the master recording of a particular performance, you will likely need to obtain an additional master use license from the record label or publisher to supplement the sync license you will get from the actual author or copyright owner.

Why It's Important: Rights to music may belong to more than one person or entity. Securing the rights to a song does not necessarily grant you the right to play a specific recording of that song; similarly, getting permission or a license from the publisher of a particular recording does not automatically grant you rights to the song itself. Making sure that you have the rights to both the song you want to use and the recording of that song is essential to the proper incorporation of music into your movie.

This Synchronization License Agreement is made as of **[DATE]**, by and between **[PRODUCER'S NAME]**, located at **[PRODUCER'S ADDRESS]** ("Producer"), and **[RIGHTS HOLDER]**, an [individual, partnership, or corporation] with an address at **[RIGHTS HOLDER'S ADDRESS]** ("Licensor").

1. Description of the Composition

The musical composition ("Composition") covered by this Agreement is: **[TITLE]**, written by **[AUTHOR],** published by **[PUBLISHER]** in the year **[YEAR],** and currently owned by Licensor.

2. Nature of License

Licensor grants to Producer the non-exclusive right and license to use, perform, reproduce, display, distribute, and publish the Composition, either for profit or not for profit, and to authorize others to use, perform, reproduce, display, distribute, and publish the Composition in synchronization or timed relationship to the Film currently titled **[FILM TITLE]** (the "Film").

3. Term and Scope

This license is valid throughout the world, in all formats and languages, and for all Film-related uses, including use of the Composition in the Film, trailers, teasers, promotions, soundtracks, and all other directly integrated media in any and all formats now known or hereafter devised. The license shall remain in effect for the entire duration of the copyright in the Composition, including all renewals and extensions thereof.

4. Licensing Fee

Licensor shall be compensated a flat fee in the amount of **[AMOUNT]**. In addition to the flat fee, Licensor shall receive **[PERCENTAGE]**% of net profits earned by the Film in perpetuity **[OR INSERT A FIXED TIME]**.

5. Intellectual Property Rights

This Agreement constitutes a license only, and not a transfer of ownership. Licensor shall retain 100% of the ownership rights for the Composition. Producer shall have no right or authority to make any use of the Composition not expressly authorized herein.

6. Relationship of Parties

Producer and Licensor are entering into this Agreement as independent contractors, and no partnership or joint venture or other association shall be deemed created by this Agreement.

7. Licensor Credit

Producer shall list Licensor as the **[LYRICIST, COMPOSER, PUBLISHER]** of the Composition in all instances in which credit is displayed, whether in film, digital, or print format. Placement, size, type, and duration of any screen credit shall be determined by Producer in Producer's sole discretion.

8. Editorial and Artistic Control

Licensor waives any right to interfere with or to prevent the exercise of Producer's sole and absolute discretion with regard to Producer's use of the Composition in connection with the Film, provided that Producer does not make any change in the original lyrics or in the fundamental character of the Composition. It is understood and agreed that Producer shall retain full editorial control of the Film at all times.

9. Representations and Warranties

Licensor hereby warrants and represents that Licensor is the true, correct, and current holder of the synchronization rights with respect to the Composition, and that Licensor is not subject to any obligation, contractual limitation, lien, or assignment that might prevent or materially interfere with the full grant of the license hereunder. Licensor further warrants and represents that Producer's exercise of the license shall not infringe upon or violate the rights of any person or entity.

10. Indemnification

Licensor shall indemnify and hold Producer harmless from any and all claims, causes of action, losses, damage, liabilities, costs, and expenses, including attorney fees, arising from the breach of Licensor's warranties contained in this Agreement.

11. No Obligation

Producer does not represent or warrant any obligation to make the Film, release the Film, or use the Composition in the Film.

12. Entire Agreement

This Agreement represents the entire agreement of the parties hereto relating to the subject matter hereof, and any prior agreements, promises, negotiations, or representations, whether oral or written, not expressly set forth in this Agreement are of no force and effect. This Agreement may be modified only by a writing signed by both parties.

13. Governing Law

This Agreement shall take effect under and be governed by the laws of the State of **[STATE WHERE PRODUCER IS LOCATED]**.

14. Authority

The undersigned has full power and authority to enter into this Agreement and does so voluntarily, knowingly, and without duress.

PRODUCER:

By:

Date:

LICENSOR:

By:

Date:

Master Use License Agreement Template

When to Use: Whenever you want to incorporate a pre-existing recording made by a third party into your film. Often, you will need to secure both a master use license, which, broadly speaking, covers the rights associated with the master recording of a performance, and a synchronization license, which covers the rights associated with the underlying musical composition. Generally, you will need to seek the master use license from the record label or publisher of the recording you want to use. You will obtain the sync license, on the other hand, from the author or copyright owner of the composition itself.

Why It's Important: From a legal perspective, properly clearing the rights to a sound recording before including it in your film minimizes your liability for copyright infringement. A common misconception is that simply giving credit to the author or owner is sufficient. It is not. Plan to obtain actual permission from the owner in advance of using, performing, displaying, distributing, or reproducing any protected composition. From a professional and personal perspective, it is in your own best interest to maintain a positive and professional relationship with industry artists, musicians, and labels by making sure that you don't exploit their work without their knowledge or permission. Finally, being able to show that you have a formal master use license will be a benefit in the event that a distributor is interested in purchasing your film.

This Master Use License Agreement is made as of **[DATE]**, by and between **[PRODUCER'S NAME]**, located at **[PRODUCER'S ADDRESS]** ("Producer"), and **[RIGHTS HOLDER]**, an **[INDIVIDUAL, PARTNERSHIP, OR CORPORATION]** with an address at **[RIGHTS HOLDER'S ADDRESS]** ("Licensor").

1. Description of the Recording

The recording ("Recording") covered by this Agreement is: **[TITLE]**, written by **[AUTHOR]**, published by **[PUBLISHER]** in the year **[YEAR],** and currently owned by Licensor.

2. Nature of License

Licensor grants to Producer the non-exclusive right and license to use, perform, copy, reproduce, display, publish, advertise, and promote the Recording, either for profit or not for profit, and to authorize others to use, perform, copy, reproduce, display, publish, advertise, and promote the

Recording, in connection with the Film currently titled **[FILM TITLE]** (the "Film").

3. Term and Scope

This license is valid throughout the universe, in all media, languages, and formats now known or hereafter devised, and for all Film-related uses, including use of the Recording in the Film, trailers, teasers, promotions, and soundtracks. The license shall remain in effect for the entire duration of the copyright in the Recording, including all renewals and extensions thereof.

4. Licensing Fee

Licensor shall be compensated a flat fee in the amount of **[AMOUNT]**. In addition to the flat fee, Licensor shall receive **[PERCENTAGE]**% of net profits earned by the Film in perpetuity **[OR INSERT A FIXED TIME]**.

5. Intellectual Property Rights

This Agreement constitutes a license only, and not a transfer of ownership. Licensor shall retain 100% of the ownership rights for the Recording. Producer shall have no right or authority to make any use of the Recording not expressly authorized herein.

6. Relationship of Parties

Producer and Licensor are entering into this Agreement as independent contractors, and no partnership or joint venture or other association shall be deemed created by this Agreement.

7. Licensor Credit

Producer shall list Licensor as the **[PERFORMER, PRODUCER, LICENSOR]** of the Composition in all instances in which credit is displayed, whether in film, digital, or print format. Placement, size, type, and duration of any screen credit shall be determined by Producer in Producer's sole discretion.

8. Editorial and Artistic Control

Licensor waives any right to interfere with or to prevent the exercise of Producer's sole and absolute discretion with regard to Producer's use of the Recording in connection with the Film, provided that Producer does not make any change in the original lyrics or in the fundamental character of the Recording. It is understood and agreed that Producer shall retain full editorial control of the Film at all times.

9. Representations and Warranties

Licensor hereby warrants and represents that Licensor is the true, correct, and current rights holder with respect to the Recording, and that Licensor is not subject to any obligation, contractual limitation, lien, or assignment that might prevent or materially interfere with the full grant of the license hereunder. Licensor further warrants and represents that Producer's exercise of the license shall not infringe upon or violate the rights of any person or entity.

10. Indemnification

Licensor shall indemnify and hold Producer harmless from any and all claims, causes of action, losses, damage, liabilities, costs, and expenses, including attorney fees, arising from the breach of Licensor's warranties contained in this Agreement or related to material licensed and/or supplied to Producer by Licensor.

11. No Obligation

Producer does not represent or warrant any obligation to make the Film, release the Film, or use the Recording in the Film.

12. Entire Agreement

This Agreement represents the entire agreement of the parties hereto relating to the subject matter hereof, and any prior agreements, promises, negotiations, or representations, whether oral or written, not expressly set forth in this Agreement are of no force and effect. This Agreement may be modified only by a writing signed by both parties.

13. Governing Law

This Agreement shall take effect under and be governed by the laws of the State of **[STATE WHERE PRODUCER IS LOCATED]**.

14. Authority

The undersigned has full power and authority to enter into this Agreement and does so voluntarily, knowingly, and without duress.

PRODUCER:

By:
Date:

LICENSOR:

By:
Date:

created by Bricolage Law, LLC • www.bricolagelaw.com

Composer Agreement Template

When to Use: After selecting and hiring a composer, but before any music is written and recorded expressly for the film.

Why It's Important: As with many other contracts related to motion pictures, this agreement defines a work-for-hire relationship. The composer is writing music for the production and the producer retains the rights to the resulting film score. This agreement is comprehensive: it covers all the rights related to using the composition, performance and recording of the score in the movie and any related promotional materials. You may choose to pursue a more limited set of rights to the score than are covered here. For instance, you may choose to negotiate for the non-exclusive use of the composed music. In that case, instead of using this agreement, you might treat the music cues as you would any pre-existing music and draw up sync and master use licenses for the tracks you wish to use.

This Agreement is made as of **[DATE]**, by and between **[PRODUCER'S NAME]**, located at **[PRODUCER'S ADDRESS]** ("Producer"), and **[COMPOSER]**, an individual with an address at **[COMPOSER'S ADDRESS]** ("Composer"). This Agreement will set forth the terms under which Producer has agreed to engage Composer to render services to Producer in connection with the film currently entitled **[NAME OF FILM]** (the "Film").

1. Provision of Services by Independent Contractor

Composer shall prepare and deliver the recorded music score (the "Score") for the Film in accordance with the terms and conditions of this Agreement. The Score shall comprise all the individual compositions ("Cues") devised and agreed to by the Composer and Film Director, as well as the performance and recording of those Cues. Composer shall assume all responsibility for the composition, performance, and recording of the entire Score. These services shall include, but are not limited to, the subcontracting of performers and the rental of recording studio facilities. Composer shall perform said services at the times and places required by Producer and in a conscientious and professional manner, consistent with Composer's best efforts, talents, and abilities. It is understood that Composer is an independent contractor in the performance of this Agreement and not an employee

of Producer. Nothing contained herein shall be construed to imply an employment, joint venture, or principal-and-agent relationship between the parties; and neither party shall have any right, power, or authority to create any obligation, express or implied, on behalf of the other. Composer shall not be entitled to participate in any plans, benefits, or distributions intended for Producer employees. Composer agrees that Producer will make no deductions from any compensation paid to Composer for, and Composer shall have full and exclusive liability for, the payment of any taxes and/ or contributions for unemployment insurance, workers' compensation, or any other employment-related costs or obligations related to the provision of the Composer's services.

2. Delivery Format

Composer shall deliver a complete recording of the Score in a digital audio recording that meets or exceeds these standards: 24-bit, 48 kHz stereo recording in .WAV format.

3. Term

Time is of the essence in the provision of Composer's services under this Agreement. Composer shall deliver the completed Score to Producer on or before **[DELIVERY DATE]**. Should any scheduling conflict or impediment to completion of the services or to any portion thereof arise, Composer will promptly contact Producer. This Agreement shall terminate upon completion of editing of the film.

4. Consideration

As full and complete consideration for all rights, property, and promises granted herein, Producer shall remit compensation to Composer a flat fee in the amount of **[AMOUNT]**. Both parties agree that this constitutes adequate consideration to support the rights granted to Producer by Composer herein.

5. Screen Credit

Producer shall accord Composer the following screen credit on the Film: **[SCREEN CREDIT]**. All aspects of such credit, including but not limited to placement, size, type, and

duration, shall be determined by Producer in Producer's sole discretion.

6. Ownership of Intellectual Property; Work-For-Hire

Composer acknowledges and agrees that the Score and all results, product, and proceeds therefrom, including the Film itself and all manuscripts, drafts, notes, recordings, formats, versions, and portions thereof (collectively, the "Work") are works-for-hire under the United States Copyright Act. Producer shall solely and exclusively own all right, title, and interest to the Work, including, but not limited to, worldwide copyrights, moral rights, trademarks, rights of publicity, merchandising rights, and all other rights of whatever kind and character throughout the world, in perpetuity. Producer may add to, subtract from, change, arrange, revise, adapt for alternate mediums and venues, rearrange, make derivative and sequential works from, produce, reproduce, broadcast, use, perform, commercialize, distribute, register, protect, and enforce the Work, or any portion thereof, in Producer's sole and absolute discretion.

7. Editorial and Artistic Control

Composer waives any right to interfere with or to prevent the exercise of Producer's sole and absolute discretion with regard to the Work, including all matters of direction, artistic taste, and judgment. It is understood and agreed that Producer shall retain content, editorial, and technical control of the Work at all times.

8. Indemnity and Warranty

Composer warrants and represents that: (a) all of the Work shall be wholly original, except as to matters within the public domain; and (b) none of the Work shall infringe upon or violate the intellectual property, privacy, or publicity rights of, or constitute defamation against, or violate any common law or any other rights of, any person, group, or entity. Composer shall indemnify and hold Producer harmless from any and all claims, causes of action, losses, damage, liabilities, costs, and expenses, including attorney fees, arising from the breach of the warranties in this paragraph.

9. Termination

Composer's connection to the Film is at-will and may be terminated at any time, for any reason or for no reason, upon written notice thereof to Composer. Termination of this Agreement, whether by exercise of a right of termination, lapse of time, mutual consent, operation of law, or otherwise shall terminate Producer's obligation to pay Composer any further compensation.

10. Assignment

This Agreement is personal to Composer. Neither this Agreement nor any rights or duties hereunder may be assigned or delegated to any other person or entity. Any such purported assignment or subcontract shall be void.

11. No Obligation

Producer does not represent or warrant any obligation to make the Film, release the Film, or use the Score or any of its constituent Cues in the Film.

11. Entire Agreement

This Agreement represents the entire agreement of the parties hereto relating to the subject matter hereof, and any prior agreements, promises, negotiations, or representations, whether oral or written, not expressly set forth in this Agreement are of no force and effect. This Agreement may be modified only by a writing signed by both parties.

12. Governing Law

This Agreement shall take effect under and be governed by the laws of the State of **[STATE WHERE PRODUCER IS LOCATED]**.

13. Authority

The undersigned warrants and represents that the undersigned has full power and authority to enter into this Agreement, to bind Contractor hereto, and to grant the rights set forth herein.

PRODUCER:

By:
Address:
Telephone Number:

COMPOSER:

By:
Address:
Telephone Number:

Further Reading

This book was written to fill a need for a text focused particularly on the issues related to producing short films. There is much more that could be said about any given topic I have addressed. Fortunately, there is a large library of additional resources that can be accessed by searching online or by visiting your local library or bookstore. The short list below does not aim to summarize the literature on producing. It is meant to direct the reader toward a few useful texts that expand on concepts only touched upon in this book.

Overviews

Hurbis-Cherrier, Mick. *Voice & Vision: A Creative Approach to Narrative Film and DV Production.* 3rd ed. New York: Focal Press, 2018.

An encyclopedic overview of film production. Hurbis-Cherrier covers all aspects of filmmaking technique while also delving into the art of audiovisual storytelling.

Rea, Peter, and David Irving. *Producing and Directing the Short Film and Video.* 5th ed. New York: Focal Press, 2015.

Rea and Irving's book cleverly views each step of the filmmaking process from the perspective of both producer (Rea) and director (Irving).

Production Management

Brown, Robert Latham. *Planning the Low-Budget Film.* 2nd ed. Woodland Hills, CA: Chalk Hill Books, 2013.

Brown draws on his career as a producer, unit production manager and assistant director in laying out the steps of producing a low-budget independent feature film.

Honthaner, Eve Light. *The Complete Film Production Handbook.* 4th ed. New York: Focal Press, 2010.

A veteran of many studio features, including *Titanic*, Honthaner provides a comprehensive guide to the process of managing large-scale productions.

Singleton, Ralph. *Film Scheduling: Or, How Long Will It Take to Shoot Your Movie?* **2nd ed. Los Angeles: Lone Eagle Publishing, 1997.**

Singleton had a long and distinguished career as a line producer in Hollywood. He wrote this book at the dawn of the digital age, and the methods he outlines in it are decidedly old-school. Even so, the book holds up as a detailed study of the science of film scheduling.

Film Festivals

Gore, Chris. *Chris Gore's Ultimate Film Festival Survival Guide.* **4th ed. New York: Watson-Guptill, 2009.**

An opinionated how-to manual for navigating the film festival circuit. Gore outlines a clear strategy for making the most of your short's festival run and provides clear instructions for optimizing your festival submissions.

Legal Issues

Donaldson, Michael C., and Lisa A. Callif. *Clearance & Copyright: Everything You Need to Know for Film and Television.* **4th ed. West Hollywood, CA: Silman-James Press, 2014.**

This book's title undersells its contents, which address many of the legal issues related to filmmaking. There is a great deal of detail and practical information here, including guidance and contracts related to licensing music for media productions.

Litwak, Mark. *Contracts for the Film & Television Industry.* **3rd ed. West Hollywood, CA: Silman-James Press, 2012.**

A collection of sample contracts related to media production and distribution. Many of the examples Litwak presents seem to have been drawn from real-world cases (the author is both a lawyer and a producer), which may account for some of the rather specific concerns that are addressed in the fine print of the agreements.

Documents From American University's Center for Media & Social Impact

For the past decade, American University's Center for Media & Social Impact has played a leading role in clarifying and strengthening the application of the principle of fair use. The CMSI website (*cmsimpact.org/program/fair-use*) has links to a number of documents related to fair use, including the *Documentary Filmmakers' Statement of Best Practices in Fair Use* and the *Code of Best Practices in Fair Use for Online Video*. While these publications primarily address issues related to documentary filmmaking, many of the concepts covered in them can be applied to dramatic filmmaking.

Contributor Biographies

The words of wisdom and personal experiences that can be found throughout this text were culled from many days spent interviewing veteran production professionals and several members of the cast and crew of Shoebox Redhead. *I remain enormously grateful for the time they took from their busy lives to share their insights, which greatly enriched this book.*

Production Veterans

Evan Astrowsky traces his career as a film producer back to his days in film school at New York University. While at NYU, he produced *Eclipse*, a short film that went on to win a Student Academy Award. After moving to Los Angeles, he continued to draw on film school contacts to develop a number of feature films. He produced Eli Roth's first feature, *Cabin Fever*, which spawned a series of sequels and even a remake. Astrowsky also served for several years as an executive at Trigger Street, where he helped produce a slate of projects, including the features *21*, *Fanboys* and *Columbus Day*. Some of his other feature credits include *Mini's First Time* with Alec Baldwin, David Arquette's feature debut, *The Tripper*, and the cult hit *Zombeavers*.

Marie Cantin is the 2017 recipient of the Frank Capra Achievement Award from the Directors Guild of America. She began producing in the heyday of music videos and then embarked on a filmmaking career as producer, executive producer, co-producer, and UPM. She has overseen film and television productions for numerous studios, production companies and networks, including Universal Pictures, Paramount Pictures, 20th Century Fox, New Line Cinema, Miramax Films and Warner Bros. Television. Cantin is also experienced in media education, having overseen M.F.A. thesis projects at the American Film Institute, where she taught producing and served as an associate dean.

Leah Culton Gonzalez is a prominent figure in the New York television production landscape and currently serves as executive vice president of production at Matador Content. She has also served as co-executive producer for three seasons of Spike's *Lip Sync Battle* as well as producer on the iconic *Unplugged* series for MTV/VH1. Her other producing credits include ABC's *Boy Band*, *The Who Was! Show* on Netflix, *Banksy Does New York* on HBO, Viceland's first scripted project, *What Would Diplo Do?* and *Storm Chasers* on Discovery.

Don Daniel is a producer who came to filmmaking by way of live concert production and radio and television management. After attending the American Film Institute, he honed his skills producing cult fare for Roger Corman and Charlie Band. Daniel went on to serve as an assistant director, production manager and producer on numerous feature films. Producing a concert film with Stevie Wonder was a high point of his career and permitted him to draw on all his background in music and media production. Daniel has also overseen many major motion picture productions as a representative of bonding and insurance companies.

Bob Degus is a feature film producer, director and writer; he likes to say that he has "done every job on a movie set." He came up through line producing and production managing. Degus was the producer on *Pleasantville*, *Set It Off* and *A Man Apart*, among many other titles. His résumé is unusual in that he has worked extensively in both creative producing and physical production. He has also produced a great number of short films. His career started with Chanticleer Films, a prominent production company for short films. As a member of the short film branch of the Academy of Motion Picture Arts and Sciences, he helps judge the nominees for Oscars in the live-action short film category.

Mark DiCristofaro studied at Boston University, after which he participated in a film and television internship program that moved him out to Los Angeles. From that entry point, DiCristofaro spent the past decade climbing the production ladder, eventually landing jobs as a producer and line producer. Throughout his career, he has crossed freely back and forth between the worlds of scripted and unscripted entertainment. In addition to producing feature films such as *The Escort* and *Brampton's Own*, he has overseen production on a variety of television series for Netflix, Viceland, AMC, Spike, VH1 and the History Channel.

Barbara Doyle has had enough careers—in music, filmmaking, television production and education—to last several lifetimes. She served as production supervisor or unit manager on major productions for numerous studios and networks, including Disney, Showtime, 20th Century Fox, CBS and

NBC. Doyle has chaired the film programs at Chapman University and Belmont University, and she has served as associate dean of production at the American Film Institute. She also writes about producing. Her book, *Before You Make Your Movie: What You Need to Know About the Business of Filmmaking*, is available from Focal Press.

Glenn Gainor wrote, produced and starred in a short film intended to be a television pilot while he was in college. This ambitious project kickstarted his career, leading him first into various producing roles on independent features. For the past decade, Gainor has been head of physical production for Screen Gems, a division of Sony Pictures. At Screen Gems, Gainor has executive produced and overseen the production of several number one movies in America, such as *Think Like a Man*, *Friends With Benefits* and *The Wedding Ringer*. Gainor has also used his leadership position to champion the adoption of innovative technology and environmentally friendly production practices.

Erika Hampson graduated from Boston College and found production assistant work on the long-running television series *Law & Order: Criminal Intent*. When the show's star, Vincent D'Onofrio, needed help producing a short film, he turned to Hampson. This happenstance launched a career. For more than a dozen years, Hampson has worked primarily on independently produced feature films. With over 30 producing credits to her name, she is known for her association with rising filmmakers and with character-driven work. Recent projects include *Life Itself*, *The Layover*, *Stealing Cars*, *Tumbledown*, *Meadowland*, *Infinitely Polar Bear* and *God's Pocket*.

Georgia Kacandes's professional filmmaking career began before she had completed her college studies. Even in those early days, she gravitated toward projects helmed by directors with distinctive visions. As she rose through the ranks in the production department, she worked with many of the titans of contemporary cinema, including Francis Ford Coppola, Quentin Tarantino, Stephen Soderbergh, John Sayles and Jim Jarmusch. Her long collaboration with Martin Scorsese is particularly noteworthy. Kacandes has served as unit production manager and/or executive producer on several of Scorsese's films, including *Casino*, *The Wolf of Wall Street* and *Hugo*.

Klaudia Kovacs, AKA "The Crowdfunding Queen," is a director of film and theater who has won over 35 awards for her work. After struggling in Hollywood for a decade, she raised $1.7 million for her first film. The success of that campaign put her on the map. She has been crowdfunding her creative projects ever since and teaches her clients how to do the same. Kovacs is also a frequent guest speaker at universities, where she lectures on effective

fundraising techniques. Contact her at her website: *klaudiakovacs.com/publicspeakingandconsulting*

Corinne Marrinan started her career in theater and found that the skills she learned as a stage manager translated well to producing for film and television. She began producing documentaries—one of which went on to win an Oscar for Best Documentary (Short Subject)—then transitioned into serving as an associate producer and writer on the long-running *CSI* television franchise. More recently, Marrinan has produced and written for the series *Seal Team, Code Black, Murder in the First, Crossing Lines* and *Will*.

Michael Nozik, through his long producing career, has worked with an enviable roster of internationally recognized filmmakers, including Robert Redford, Mira Nair, Paul Haggis and Walter Salles. He wore many hats on his way to becoming a creative producer, serving as everything from movie theater manager to assistant prop man, location manager and production manager in his early years. His producing credits include *Mississippi Masala, Quiz Show, The Motorcycle Diaries, Syriana* and *Love in the Time of Cholera*.

Jay Roewe has worked for more than two decades at HBO and has seen this premiere subscription network evolve into a source of must-see original programming. Roewe was involved with in-house production at HBO from the start, first supervising a slate of original features for television, then taking on miniseries such as the award-winning *John Adams* and ultimately overseeing physical production of all of the network's scripted series. As senior vice president of production at HBO, Roewe administers a roster of hit series shooting in locations around the world. Recent series include *Game of Thrones, Silicon Valley* and *Veep*. He also manages the film and television tax incentive credits for all of HBO's original programming.

Legal Expertise

Eve J. Brown is an intellectual property attorney, author, speaker and professor. She is the co-founder of Bricolage Law, a Massachusetts-based law firm focused on counseling artists and independent business owners. She has taught intellectual property, entertainment and business law at Boston University, Boston College, Northeastern, Suffolk University, Indiana University and MIT. Brown is co-author of the book *IP Strategy: Complete Intellectual Property Planning, Access and Protection*, and she has published articles on entrepreneurship, intellectual property and education.

Members of the *Shoebox Redhead* Cast and Crew

Charlie Anderson was the principal sound recordist on *Shoebox Redhead*. His short films *Werewolf Trouble*, *All Day Yeah* and *We Could Be Your Parents* have toured extensively on the film festival circuit. In addition to his work as writer, director and sound recordist, he has served on productions as an actor, photographer and makeup effects artist. Anderson now teaches film production and screenwriting at Valparaiso University.

Ryan Conrath is a filmmaker and film scholar. He became an actor by chance. Conrath was close friends with Matt Lawrence and Charlie Anderson when all three were enrolled in Boston University's graduate film program, and their brainstorming sessions frequently led to his taking on roles in front of the camera for their film projects. After costarring with Lawrence in *Shoebox Redhead*, Conrath was cast as the lead in both Lawrence's first feature and his next short film. The recipient of a Ph.D. in Visual and Cultural Studies from The University of Rochester, Conrath has also worked as a professor, film curator, producer and editor.

Matt Lawrence was finishing his graduate degree in Boston University's film production program when he wrote, directed, produced and edited *Shoebox Redhead*. The film spent a couple of years on the film festival circuit, during which time Lawrence served an apprenticeship with cult film producer/ director Lloyd Kaufman. Lawrence then wrote and directed his debut feature film, a blood-sucking romance entitled *Two Pints Lighter*. This was followed by *Larry Gone Demon*, a hilariously dark short about the perils of having a possessed roommate, which has played in 50 festivals and won dozens of awards. Lawrence is now a full-time specialist professor of video production at Monmouth University and is developing a second feature film. He lives in New York City.

Samara Vise was a junior at Boston University when she served as assistant camera on *Shoebox Redhead*. After completing her degree work in BU's Los Angeles internship program, Vise stayed on to work in Hollywood. She soon migrated from the camera assistant track to set production jobs on films like *Easy A* and *Friends With Benefits*, with additional experience working in production management on commercials and reality TV shows. Vise is currently back in her native Cambridge, Massachusetts, where she is putting her lifelong love of photography to use as a freelance photographer. Examples of her work can be viewed at *samaravise.com* and at the companion website for this book, *theshortseries.com*.

Appendix F

Glossary of Terms

This glossary of filmmaking terms is not meant to be comprehensive. For instance, common crew positions are not defined. This list concentrates instead on words and phrases that might be less familiar or that might have a different meaning in other contexts.

Above-the-Line: See definition for Line.

Account: In the many tiers of a budget, the account is the first level of division. Each department in a production is tracked under a separate account.

ADR: Automatic Dialog Replacement. A process of dubbing clean, studio-recorded dialog over a scene when the original production audio is defective.

Allow: A round figure entered into a budget in lieu of a reasoned calculation.

Assignment: A legal term that refers to the ability to transfer rights or terms of an agreement from one party to another.

Available Light: The existing illumination at a location, without the use of trucked-in lighting.

Barndoors: Metal frames with adjustable flaps (or "doors") that are attached to lights in order to control the path of the illumination and to hold gels.

Below-the-Line: See definition for Line.

Bond Company: Also known as a Completion Bond Company. Independent films are often produced by small companies with limited assets. Since they lack the infrastructure and financial reserves of a motion picture studio, they need to assure their backers that they have the resources to complete the production. The bond provided by a bond company is precisely such a guarantee. A completion bond is virtually never needed for short productions, but some of the requirements typically imposed by bond companies—such as a 10 percent contingency—have been widely adopted in short filmmaking.

Book Rate: The publicly posted price for goods or services.

Breakdown Sheets: Forms that list the materials and personnel required for a scene or group of scenes. These sheets are a useful tool for keeping track

of the materials required for a shoot, but they are also a necessary step in the drafting of a production schedule.

Business Plan: A document that serves as a prospectus for a project. The plan provides a summary of the project's goals, budget and schedule information and an explanation of how the project could be profitable.

C47: This is the code name for the humble clothespin. Clothespins have lots of uses on a movie set. They are especially popular in the lighting department, where gaffers often use them to secure gels to barndoors.

Callback: A second audition. After a large number of actors audition for a role, just a few may be called back for another look. At a callback, the actors might be asked to read a scene with another prospective cast member or even to perform it "off book" (from memory).

Call Sheet: A summary of the day's activity during a film shoot. The sheet is distributed in advance to cast and crew. At a minimum, it provides call times for all personnel and states any locations that will be used that day.

Call Time: This is the time when a cast or crew member is needed on set.

Car Mount: A platform or bracket used to attach a camera to a vehicle when filming scenes involving driving.

Carnet: A French term for "notebook." In the context of international media production, this refers to the equipment inventory and documentation required by customs agents in many countries.

Category: In a budget, the top level of division within an account.

Clearance: In legal parlance, the process of obtaining permission to use intellectual or physical property.

Color Correction: Sometimes referred to by its British equivalent, "color grading," color correction refers to the critical final adjustments made to the image before a movie is released to the public. Color correction can involve simply ensuring that shots within the same scene have the same color balance, contrast and exposure levels, but it can also require complex adjustments that come close to being visual effects. For example, the colorist might be asked to make a scene shot in the daylight look like it takes place at night.

Colorist: The person who operates the equipment in a color correction suite. This is a highly trained position: the colorist must not only be able to execute complex technical tasks but also to make sophisticated aesthetic judgments.

Company Move: Moving from one location to another. Usually refers to having to relocate in the middle of a shooting day—often a time-consuming and complicated process.

Completion Bond: See Bond Company.

Compositing: A core element in visual effects, this is the process whereby multiple visual elements are seamlessly woven into a single image.

Consideration: A legal term for the compensation a person or group receives for goods or services rendered. Keep in mind that the compensation can

be anything of value, large or small; it does not have to take the form of money.

Contingency: A buffer built into a budget to allow for errors, omissions and acts of God.

Cookie: The short form of *cucoloris*, a device that is put in front of a light to cast a pattern. A cookie commonly found on film sets is a sheet of plywood with random shapes cut out. This is used to create the effect of dappled light.

Coverage: A scene can be said to be "covered" (as in "We've got that covered") when it is shot from a given camera angle. So, coverage refers to various perspectives from which a scene is shot or covered. If we cover the same scene from a variety of camera angles, we give the editor more options for telling the story on-screen. In the studios and networks, coverage has another meaning; it refers to a report that synopsizes a script and summarizes a story editor's views on it.

Cover Set: A covered or interior location that the producer keeps at hand in the event of bad weather. With luck and good planning, when it rains, we can retreat to a cover set to continue filming.

Craft Services: Catering on a film set. Craft services provides not just meals but also snacks and drinks throughout the day on set.

Day-out-of-Days Report: A spreadsheet or form rather like a calendar that indicates when workers will be working. Unions often require productions to submit "DOOD reports" as a way of tracking not just when their members start and finish work on a production but also if and when they are on hold or are dropped and picked up from the schedule.

DBA: Doing Business As. Registering a company name as a DBA permits a person to use that name in business dealings, such as on signs, checks and documents.

DCP: Digital Cinema Package. A standardized series of digital files that is used to distribute motion pictures. Because a DCP is loaded into a hard drive that attaches to a projector, some mistake the hardware for the DCP, but in fact the "package" consists entirely of data.

DP: Director of Photography. Another name for the cinematographer.

Drive-by Scene: A shot in which a car is seen driving through a landscape. A fixture of film narrative, these scenes (sometimes simply called drive-bys) are often used as a transition to show a character getting from Point A to Point B.

Drop and Pick Up: A shorthand term related to the labor unions' provisions for "continuous employment." If a union worker is to be dropped from the payroll of a production during a period when she is not working, she must be "dropped" for a sufficient number of days to allow her potentially to undertake other paid work. If there is an insufficient number of days

between the proposed dates for being dropped and then "picked up" (put back on the payroll), then the union member must be paid even for those days when she is not working.

EPK: Electronic Press Kit (while people still refer to "press kits," when using this term, everyone shortens it to EPK). Often, many elements of the EPK can be viewed or downloaded from a website specifically designed to promote a movie.

Errors and Omissions Insurance: Also known as E&O, this coverage protects filmmakers and the distributors of their work in the event that some aspect of a production provokes a legal challenge.

Exhibit G: The form used by SAG-AFTRA to track the days and hours an actor has worked on a production.

Fair Use: A legal principle that permits a piece of intellectual property to be quoted or excerpted without the permission of the rights holder, provided the use meets very specific requirements.

Favored Nations: A set of provisions that will apply equally to all members of a defined group. For example, crew members working under a favored nations agreement would all receive the same compensation. Sometimes referred to by the Latin expression *pari passu* ("equal step").

Film Score: A production's musical soundtrack.

Fine Cut: An edited version of a production that is at or near picture lock. Sound design is either under way or about to begin.

Fiscal Sponsor: An enterprise—often a non-profit arts organization—that vouches for the legitimacy of a production and processes payments made through grants and contributions. Many grants require that the filmmaker be represented by a fiscal sponsor. The fiscal sponsor receives a small commission (e.g., 10 percent) from funds collected to defray overhead costs.

Flat: The movable section of wall that can be used in a studio to construct an interior set. Though flats vary in size, 4 feet wide and 8 feet tall would be common dimensions for a flat.

Flat Rate: A lump sum to be paid for goods or services.

Foreign Sales Representative: An agent who sells the rights to your project to various overseas territories. The sale of these rights requires not only a lot of hustle and hard work but also a highly developed network of contacts and a great deal of legal savvy. In exchange for providing these services, the sales rep pockets a significant portion of the proceeds from any deals.

Fringes: A wide range of additional charges that can be attached to a line item in a budget. Often applies to labor costs, as when unemployment insurance and pension and welfare contributions must be factored into a worker's pay.

Gaffer: The personnel who manipulate lights on the set are called electricians. If we stop to think about the potential risks associated with powerful motion picture lighting, that label takes on special weight. The lead or key electrician is called the gaffer. Just to keep things interesting, however, occasionally the term *gaffer* is used more generically to refer to any level of lighting electrician.

Gaffer Tape: A rubberized cloth adhesive that has a multitude of uses on a film set. Not to be confused with duct tape, gaffer tape is designed to be both tough and temporary. Even so, never assume that it can be applied to painted surfaces without causing damage.

Gel: A filtering device that is put in front of a light source to change the light's quality and/or color. Gels are often sheets of heat-resistant, transparent film that can be affixed to a pair of barndoors with C47s.

General Liability Insurance: Coverage that protects the policyholder in the event of damage to property or harm to persons not covered by workers' compensation. This insurance is often required to rent equipment or secure locations.

Gobo: In theater, this term often refers to a metal stencil or glass device used to project a pattern of light. On film sets, a gobo is more likely to be a flag or frame that, when rigged on an arm or stand, cuts, shapes or otherwise modifies a light source.

Green Screen: Literally a green backdrop used for visual effects, this term is often used as shorthand for any process where one image is superimposed over another so that the composited elements create a single, unified picture.

Grip: The grip department is in charge of all the rigging associated with cinematography. This could range from blacking out windows with curtains to laying track for the camera dolly. If camera support equipment needs to be moved—and this includes movement during a shot—that is the grip department's job as well. For example, the person who moves the dolly is called the dolly grip.

Header Board: The area on a production stripboard that serves as a key to the coded elements in the board.

Hold Harmless: A legal term that protects a party from liability in case of a mishap.

IATSE: International Alliance of Theatrical Stage Employees, the union that covers many of the crew positions on film and television productions.

In-Kind: Goods or services that are provided in lieu of a monetary outlay.

Insert: A close-up that points out some salient detail within a scene. For example, if someone is seen handing someone else a business card and we want the audience to catch the name on the card, we might shoot an insert close-up revealing that information.

Intellectual Property: A blanket term that covers creative content that can be copyrighted or trademarked. Any intellectual property that is incorporated into a media production must either be purchased, licensed or used under the terms of the fair use doctrine.

In the Can: A project that has been shot but not yet edited. The term hearkens back to shooting film, when exposed film was put back into metal cans and shipped to the lab for processing.

Jib Arm: A device that allows the camera to move up or down or in an arc. Jibs use the principle of the fulcrum to create fluid movement. The camera sits on one end of a beam, and a counterweight is attached to the other.

Key: A crew is organized into various departments (sound, cinematography, direction, art, etc.). These departments then have categories that fall under them. For example, camera, lighting and grip all fall under the cinematography department. The head of each of these categories is often referred to as the "key." In some—but certainly not all—cases, the term *key* gets attached to the job title, as in "key grip."

Kit Rental: Fee paid to craftspeople for the use of their personal gear. Also called a box rental.

Likeness: A legal term that refers to the representation of a person through a medium such as a motion picture. This could include any identifiable attributes, such as a person's image, voice or other recognizable traits.

Limited Liability Company (LLC): A popular business structure for collaborative commercial ventures, including motion picture productions. In an LLC, a group of members shares in the ownership and operation of the enterprise.

Line: A distinction made in the entertainment industry. Fixed costs, such as those related to star salaries, the services of the producer and director and the development and purchase of the screenplay, are referred to as "above-the-line." Everything else is termed "below-the-line."

Line Item: An individual entry in a budget.

Line Producing: The oversight of physical production.

Logline: A 25–50-word summary of a movie's narrative.

Master Use License: A legal agreement that grants the right to use both the performance and the recording of a musical composition in a motion picture.

Mechanical Effect: Also called a practical effect, this is a special effect that must be created on set. The term is frequently used to differentiate effects that must be done in front of the camera (mechanical effects) and effects done by manipulation of the image in postproduction (visual effects).

Mechanical Rights: Permission to reproduce a music recording through media other than a motion picture, such as a compact disc. These rights are usually not essential when simply using a piece of music in a short film.

Mixing: The process of blending the many audio tracks in a production's sound design into a seamless whole.

Moral Rights: A legal concept that comes to us by way of the French. Moral rights attempt to define and defend the authority of the creator of a work. Among other things, they allow authors and artists to prevent unsanctioned alterations to their works.

Multiplier: An all-purpose entry in a budget spreadsheet that can be used whenever an additional variable is needed in a calculation.

Music Cue: A section of a film score that plays under a specific sequence or scene. A film's musical soundtrack is the sum of all of its music cues.

Neutral Density Filters: Also called ND filters. These are tinted glass filters that cut the amount of light going through a lens. They are often used on very bright locations to bring the camera's exposure levels down to a more desirable level.

Overhead: A term that encompasses the miscellaneous and hard-to-quantify expenses related to keeping a company running. Broadly speaking, this is the cost of doing business.

PA: Production Assistant. An entry-level position. A PA may be assigned to a specific department or may serve the production as an all-around roustabout.

Padding: The controversial practice of inflating costs in a budget in order to ensure a profit or to cover overhead.

Parallel Action: A sequence where two or more scenes are intercut to imply that actions taking place in different settings are occurring simultaneously.

Parity: When dealing with labor unions, this concept stipulates that the privileges and protections provided to one worker must apply to all, irrespective of their union affiliation.

Per Diem: A sum paid to cover some daily expense, such as a meal, transportation or housing.

Performance Rights Organization (PRO): A company that tracks the use of musical compositions and then oversees the payment of royalties due to the music publishers that the company represents. The most prominent PROs in North America are ASCAP, BMI and SESAC.

Personal Rights: In the context of film, personal rights are those that protect personal attributes or aspects of identity from unauthorized use and distribution.

Physical Production: An umbrella term for all the concrete actions and arrangements that go into the making of any kind of motion picture, as distinct from the deal-making and oversight that takes place off-set and behind the scenes.

Pick-Up: A shot or series of shots that are filmed after principal photography is completed in order to fill a gap in the narrative or visual design. The

term *pick-up* is also used when filming to indicate that the action in a take starts further along in the script than previous takes of the same shot.

Picture Car: Any vehicle that has been specifically chosen to appear in a scene. Not to be confused with a "camera car," which is a vehicle used to mount a camera for filming a moving shot.

Picture Lock: The stage of editing where no further changes will be made to the sequence of shots. The term refers to the fact that, usually, the visual structure of a film must be firmly set down before sound design can begin in earnest.

Plate: A shot, some or all of which will be used as a background in a scene. Once upon a time, plates were used for rear projection shots, such as when we saw the scenery passing outside the window of a car. These days, the background plate is much more likely to be combined with the foreground footage in the editing process.

Post House: A facility that specializes in postproduction services. This would almost certainly include editing but can also cover color correction, sound design, title design, visual effects and duplication of media.

Postproduction: The third phase in the making of a motion picture, which encompasses the editing, mixing, duplicating and distribution of the project.

Practical: As an adjective, *practical* defines any item on a film set that must really function. Therefore, a "practical sink" is a sink that actually operates, with running water and a drain. *Practical* is sometimes used as a noun, most commonly to differentiate prop lights from set lighting. The ordinary lightbulb in a desk lamp on a set could be referred to as "a practical."

Preproduction: The first phase in the making of a motion picture, which encompasses scheduling, budgeting, casting, location scouting and securing the crew.

Press Kit: A package of information and promotional materials that is used to spread word about a movie. A press kit includes synopses, bios on cast and crew, stills, promotional graphics and technical specifications. Press kits for major motion pictures often include making-of and behind-the-scenes videos. See EPK.

Principal Photography: The period of production during which the bulk of a film is shot. While it is common practice for the great majority of a film to be shot during principal photography, examples of the kind of material that might be shot outside of this period are establishing shots or montage footage shot by a second unit, effects shots or pick-ups.

Process Shot: An umbrella term for all sorts of camera-based trickery. These days, more often than not, a process shot is a shot that requires two or more pieces of footage to be composited into a single image.

Production: The second phase in the making of a motion picture, which encompasses the shoot.

Production Music: Sometimes referred to by other names, such as "stock music," this is music that is written and produced to be licensed for all manner of media productions, from radio spots to documentaries. Many production music libraries can be found and searched online.

Production Value: Bluntly put, production value equates to money on-screen. When something looks like it cost a lot of money (whether it did or not), we say that it adds production value.

Public Domain: The designation for intellectual property that is not protected by copyright, either because the copyright has lapsed or because the work was never copyrighted in the first place.

Publishing Rights: Rights associated with a musical composition (as opposed to a musical performance or recording).

Purchase Order: Also called a PO. A purchase order is a written document in which a buyer states the amount of goods he is buying or renting from a vendor and the price he agrees to pay for the goods. To facilitate tracking, it is advisable to date and number POs.

Reaction Shot: An angle that registers the response of one or more characters to something another character says or does. Reaction shots are often brief and usually don't require any dialog from the character(s) featured in them.

Reverse Angle: When you shoot a scene in one direction and then shoot it in the opposite direction, generally from the complementary angle, this is called "shooting the reverse."

Rider: A provision added to a legal agreement. This term is often used in connection with insurance to address coverage that is obtained to address specific situations or needs.

Rough Cut: The first pass at editing a project. At this stage, the picture (the visual sequence) has often been edited, whereas the sound design is still very minimal.

SAG-AFTRA: The union that represents actors and other performers in film, television and radio. The name represents the merger of two labor organizations: the Screen Actors Guild and the American Federation of Television and Radio Artists.

Script Breakdown: The process of identifying all the production requirements in a screenplay. This highly codified and systematic activity is the first step in drawing up a production schedule.

Seconds: On larger-scale productions, this term refers collectively to the craftspeople who report directly to the key personnel in charge of the various departments and divisions.

Second Unit: An additional crew—often consisting primarily of camera and lighting personnel—that shoots apart from the principal production. A second unit can operate before, during or after principal photography.

Sides: Pages from a screenplay that are used for auditions. Usually, an actor is provided with a couple of pages from a script, perhaps a short scene. If these sides are provided at the audition, the actor must do a "cold read." Veteran actors—and the agents and unions that often represent them—like sides to be provided a day or two prior to an audition so they can prepare.

Signatory: In the broadest sense, this refers to anyone who signs their name to an agreement. In the context of labor law, a signatory is an individual or company that agrees to use union labor and follow union work guidelines.

Slate: At its most basic, a slate refers to any marker—perhaps just a sheet of paper—that identifies a camera take. On film shoots, slates are usually part of a clapperboard, a device made up of a board on which information can be written and a striped clapper (often called "sticks"). The clapping of the sticks is used to provide a precise moment (the clap) where audio and picture can be linked to ensure perfect synchronization between sound and image. The term *slate* is also used in postproduction to refer to a title card that appears as a label at the head of a production.

Slug Line: The heading that identifies the location and time of day in either a screenplay or a script breakdown.

Source Music: Music that comes from an identifiable source within a scene; for example, if a song is playing on a radio, then the song is source music.

Spotting Session: A meeting between the composer and the director to identify scenes in a movie where music will be needed. This discussion usually also touches upon the style and tone that will be needed for each music cue.

Sticks: Usually refers to the clapper on the slate, but occasionally used to mean the camera tripod, as in, "We're going to shoot this on sticks."

Storyboards: Classically, these are drawings that represent the various shots that make up a movie. Today, there are numerous apps that can help the filmmaker render approximations of what each shot is supposed to look like. Some people like to use stand-ins and a camera to create photographic storyboards or "photoboards."

Stripboard: A physical representation of the production schedule. A stripboard, which resembles a color-coded spreadsheet, shows the order in which scenes will be shot and summarizes the cast and equipment requirements for each scene.

Stunt Double: A stand-in who performs a potentially harmful maneuver on behalf of a cast member. This is just one of many designations related to stunts and staged combat.

Synchronization License: Legal permission to record a musical composition for use in a motion picture. Often referred to as a sync license.

Tagline: A catchy phrase used to promote a production.

Temp Track: A soundtrack created from pre-existing music that the editor uses as a substitute for the production's score while waiting for the actual music to be composed and produced.

Top Sheet: The summary of accounts that generally goes on the first page of a budget.

Trade Libel: The act of casting unfounded aspersions on a commercial product.

Transpo: Shorthand for the Transportation department on a production.

Turnaround: In the context of labor rules, this term refers to the amount of downtime a worker gets before having to be back on set. The unions have minimum requirements for both daily and weekly time off.

Underscore: Music composed expressly to accompany a scene in a film.

Visual Effects: Elements that are added into an image in postproduction. We can use the magic of digital manipulation to make a genie come out of a bottle, but these days, visual effects are often less obvious. Visual effects (or CGI, computer-generated images) can be used to add foliage to a background or to add architectural details to a building.

Window Dub: A copy of a fine cut of a movie that the composer uses as a reference. The "window" refers to the time reference that is often visible in a box on-screen. This permits the composer to synchronize music cues very precisely to action in the film.

Workers' Compensation: Also known as "workers' comp," this insurance addresses the needs of employees who are injured or incapacitated while working. This coverage is often mandated by labor unions.

Work-for-Hire: A distinction made about certain creative contributions to a motion picture production. Most creative projects are thought to be the work of a single author. Motion pictures are granted an important exception to this assumption. Because film is a collaborative art, producers are allowed to license many of the elements that go into a production in such a way that the fruit of the collaborators' efforts belong not to the individual creators but to the production.

Acknowledgements

The task of thanking everyone who helped me as I researched and wrote this book is daunting, but the obvious starting point is to acknowledge the role played by the students, faculty and staff at Boston University. Serving on the faculty at BU has been the highest privilege of my professional life. It was by teaching line producing at BU that I discovered the need for this book, and it was by overseeing scores of BU student productions that I refined the methods shared here. In particular, I want to thank my colleagues in the Production area: Paul Schneider, Sam Kauffmann, Mary Jane Doherty, Geoff Poister, Jan Egleson, Joel San Juan, Chris Cavalieri, Amy Geller, Don Daniel, John Gates, Alvaro Congosto and Emily Sheehan. Thanks go out as well to Dean Tom Fiedler at the College of Communication.

I have learned a great deal from all my students, but I want to share my deep gratitude with one group of student filmmakers in particular. Matt Lawrence and the talented cast and crew of the short film *Shoebox Redhead* have been extraordinarily generous in sharing their work and their insights. In addition to Matt, I must thank Ryan Conrath, Charlie Anderson, Scott Ballard, Dave Rosenblum, Rob Ribera, Evan Scott and especially Samara Vise, who gets a standing ovation for sharing her lovely production stills. *Shoebox Redhead* was produced when all these good folks were students at BU. It is a source of great pride to know that they have subsequently gone on to establish themselves in the professional realm. A final thank-you note with regard to *Shoebox Redhead* goes out to Matt Lawrence's wonderfully supportive family in New Jersey, without whose support the film could not have been made.

I cannot overstate how grateful I am to Eve J. Brown at Bricolage Law for her contributions to this book. The templates readers will find in the text and at *theshortseries.com* are tangible evidence of Eve's wise and generous counsel. The motto of Bricolage Law is "Lawyers you won't hate." An even more accurate description (though they are too modest to use it) would be "Lawyers you'll really like!"

The filmmaking contacts who have helped me over the years are certainly too numerous to catalog, but of course I owe a special debt to all the exceptionally talented and experienced producers and executives who agreed to be interviewed for this project: Jay Roewe, Michael Nozik, Corinne Marrinan, Klaudia Kovacs, Georgia Kacandes, Erika Hampson, Glenn Gainor, Mark DiCristofaro, Leah Culton Gonzalez, Barbara Doyle, Bob Degus, Don Daniel, Marie Cantin and Evan Astrowsky.

I must also single out my great friend and collaborator Terry J. Field, who has been both a sterling role model as a producer and a reliable sounding board. Jason Ruscio and Petra Wright offered friendship and advice. A number of my colleagues in the Massachusetts Production Coalition provided guidance in all manner of production-related topics. This group includes Don Packer, Margie Sullivan, Bill Goodell, John Cini, Dona Sommers, David Hartman, Susan Gorvine Nelson, Chris O'Donnell, Susi Walsh and Sandra Forman.

A remarkable brain trust of filmmakers and educators around the globe provided invaluable insights into production methods in different regions. My all-star team of international advisors includes Sue Austen, Richard Kwietniowski and Shuku Anderson in the United Kingdom, Garth Holmes in South Africa, Stanislav Semerdjiev in Bulgaria, Fredrik Graver in Norway, Mario Santos in Argentina, Geoffrey Marschall in China, Aaron Chi-Yung Chiu in Taiwan and Kirsi Rinne in Finland. Other helpful colleagues in media education include Will Akers, Francisco Menendez, Dennis Aig, Bob Bassett, Kevin Cooper, Mick Hurbis-Cherrier, Kelly Kiernan, Peter Kiwitt, Larry Marschall, Peter Rea, Steve Snediker, Joe Wallenstein, Alyn Warren and Don Zirpola. Special thanks to Alexandra Rose and David O. Thomas for their thoughtful and detailed feedback on the manuscript. The editors at Focal Press—most especially Simon Jacobs and John Makowski—have been helpful, forthright and supportive.

Two women have played outsized roles in developing and writing this book. My mother, Ann Merzbacher, barely watched movies, much less produced them, yet she was a producer at heart. She taught me how to be organized and how to be a creative problem-solver. My wife, Marcia Dworkind, has not only supported me through the long gestation of this project; she has provided a model of passion, tenacity and exactitude for me to follow. This book is dedicated to them both.

About the Author

As a filmmaker, Charles Merzbacher has won several awards for his many short productions. His work has been exhibited around the world, including at the Sundance, San Francisco, Seattle and Montreal International Film Festivals. He is active in developing media culture and industry in New England through his work on the board of the Massachusetts Production Coalition.

As a media educator, Merzbacher has overseen the production of several thousand student films. For more than twenty years, he has been a member of Boston University's Film and Television faculty. He frequently delivers workshops and lectures at other institutions at home and abroad.

Index

Note: references to material in the "Pro Tips" and "Shoebox Diaries" sidebar passages are indicated by the letter "n" following the page number.